Artists Communities

ΓΙΟΝ

Artists Communities

A Directory of Residencies That Offer Time and Space for Creativity

Introduction by **Robert MacNeil**

Edited by **Deborah Obalil** and **Caitlin S. Glass**

ALLIANCE OF ARTISTS COMMUNITIES

ALLWORTH PRESS
NEW YORK

© 2005 Alliance of Artists Communities

09 08 07 06 05 5 4 3 2 1

Published by Allworth Press
An imprint of Allworth Communications, Inc.
10 East 23rd Street, New York, NY 10010

Cover and Interior design by Malcolm Grear Designers

Page composition/typography by Malcolm Grear Designers

Cover Photo Credit: Arts Council of New Orleans, James Baker,
and Amy Snyder

ISBN: 1-58115-404-6

Library of Congress Cataloging-in-Publication Data:

Artists communities : a directory of residencies that offer time
and space for creativity / introduction by Robert MacNeil ;
edited by Deborah Obalil & Caitlin S. Glass.—3rd ed.
 p. cm.
 Includes index.
1. Artist colonies—United States—Directories. 2. Artists—
Housing—United States—Directories. I. Obalil, Deborah.
II. Glass, Caitlin S. III. Alliance of Artists Communities. IV. Title.

NX110.A767 2005
700'.25'73—dc22

 2004028832

Printed in Canada

Contents

Acknowledgments

We would like to express our thanks to:

The staff of all of the artists' communities listed in this directory for their cooperation in providing data and images of their wonderful facilities and the artists at work in them.

Maggie Baez, the Alliance's Administrative Assistant, for tenaciously pursuing the important details so that this directory could be as complete and comprehensive as possible.

The Alliance's Board of Trustees, both past and present, whose steadfast support and guidance make our work possible.

Res Artis and Maria Tuerlings for providing the Alliance with an extensive list of international residency programs for this directory.

Tad Crawford, Robert Porter, Mónica P. Lugo, Anne Hellman, and the staff at Allworth Press for the excellent care they have put into publishing this directory.

Malcolm Grear Designers for the beautiful design of this third edition, and for providing the Alliance with a sophisticated visual identity.

Ree Schonlau and Jun Kaneko for their consistent support of the Alliance from the very beginning, and for helping to fund this edition of the directory.

Therman Statom for serving as a role model for all artists in paying it forward to other artists through his support and funding for this edition of the directory.

The Ford Foundation, and especially Roberta Uno and Eddie Torres, whose vision for supporting independent artists is inspiring, and whose funding of the Alliance made the research and production of this directory possible.

Mary T. Wolfe for her amazingly generous and gracious support of the Alliance over the past few years. Without her unwavering belief in artists and the Alliance, this directory would not have been possible.

Tricia Snell, David Biespiel, Katherine Deumling, Miriam Fuerle, Michael Wilkerson, Mary Carswell, Theodore S. Berger, Mary Griffin, the National Endowment for the Arts, The John D. and Catherine T. MacArthur Foundation, The Pew Charitable Trusts, The Elizabeth Firestone-Graham Foundation, the Bank of America, the Fulton County Arts Council and all others who made the first two editions of this directory possible. It is their work that we build on with this third edition.

All of the individuals and institutions named above, as well as others too numerous to name here, have allowed us to present you with this book. Our thanks to all of them for helping artists and other innovators find the time and space to pursue their work.

DEBORAH OBALIL & CAITLIN S. GLASS, *Editors*

Introduction

ROBERT MACNEIL

Chairman,
The MacDowell Colony

Yann Martel, author of the amazingly imaginative novel *The Life of Pi*, says that, "If we, citizens, do not support our artists, then we sacrifice our imagination on an altar of crude reality and we end up believing in nothing and having worthless dreams." Martel, a Canadian, says he could not have "brought together" this book, a global bestseller, without the support of the Canada Council for the Arts.

In the United States, Martel would have been much less likely to receive such a grant of "public" money, since years of political pressure have driven our National Endowment to limit grants to individual artists. While the Endowment still makes grants to individuals through its Literature Fellowships, Jazz Masters Fellowships, and National Heritage Fellowships for folk and traditional artists, political survival has meant seeking safety in more grants to institutions, over as wide a spectrum of geographical, racial, ethnic, and gender diversity as political correctness can devise. In making grants to individual artists, the NEA not only has to identify the deserving individuals, but it also has to take the heat if anyone produces work that someone considers offensive—a common occurrence in a political climate that is often obtuse, mean-spirited, or deliberately know-nothing. Art has too easily become a target in the culture wars upon which some politicians thrive. Artists' communities provide a way for public money to go to individual artists, without performing awful inquisitions about what the artists think they're up to. Not only public money (in fact, often far from public money), but foundation money, corporate money, or the money of individuals, can benefit from artists' communities both on that level—the level of protection—and another: selection.

Most artists' communities are exacting in whom they choose for residencies, so there are always more applicants than places. Any donor can be sure that a gift will support people of genuine talent—not dilettantes, not amateurs, not people with political pull, not people with rich uncles who think it "might be fun" to try a novel—professional artists. Artists-in-residence are people who have given their lives to art, usually renouncing what motivates most of their countrymen: the pursuit of happiness through the pursuit of wealth. Artists are poor. Most of them survive close to the poverty line. It is not easy for people who wish to support the arts to identify such talent, but artists' communities do it for them.

Two things in life always find ways to communicate: moneymaking and love. A few years ago, a security guard at the Whitney Museum of American Art wrote on a Roy Lichtenstein painting with a felt pen: "I love you, Tushee. Love, Buns." Then he drew a heart and dated it—a true marriage of love and art. Or, perhaps, art, love, and money. The Whitney was sued by the painting's owner for $2.5 million. For such a grandiose gesture, I hope Tushee appropriately expressed her gratitude to Buns.

More and more frequently in this culture it is demanded of creative people to succeed by one criterion: what sells and, inevitably, what sells best. But for most creative people, the marketplace is at the *end* of the process. If they land there, and are commercially successful, it is wonderful. Their paintings sell, their music is played, their novels are published, and so on. But that is the end of the process. If it were the beginning, the creative force might quickly wither, or be smothered, as we see too often in art created solely for the market.

Any serious work begins as a small seed planted in a soil of lonely confidence. The artist who plants it certainly hungers for recognition and, perhaps ultimately, fame. But the first spur is recognition by those who know the craft—fellow practitioners, peers, and critics.

The marketplace cannot always provide that spur. Some artists who can find their way through the labyrinth of personal dialogue and their own vision may ultimately be recognized and rewarded by the marketplace—some in months, most in years, some after lifetimes, some only after they are dead. Vincent van Gogh, notoriously, never

sold a painting during his lifetime, but until this year (when a Picasso bettered him at auction), a van Gogh commanded the highest price ever paid for a painting.

Artists' communities exist to nurture creative people in that first stage, a stage each creative person has to relive again and again. In the artists' community I know best, the MacDowell Colony, the benefit is extraordinary. A glance at our newsletters will show you the range of talent, some young and unrecognized, some well established, even famous, in residence at any time. You can see the quality of their work in the awards, performances, publications, and showings they have earned.

But MacDowell is only one of the oldest and as such a prototype of artists' communities that have burgeoned in this country and abroad, as this directory shows. Artists have always needed patrons and that is what our artists' communities have become—the least interfering, the least demanding, and the most nourishing patrons of artists. And their continuous selection of new fellows and residents is proof that beneath the subsoil of commercialized culture, there is a deep aquifer of pure, new creativity to be tapped.

It is not true that our culture despises artists until they are hugely successful, but it is true that the culture is largely indifferent to the *need* for art and artists when compared with all the things that have automatic priority—national defense, war, the terrorist threat, health care, education— all the things that command public attention. But I believe, especially today, that the art America sends out into the world has enormous national importance. American art, from the most popular, mass-appeal TV shows and movies, to books by a Philip Roth or music by a Philip Glass, are cultural exports of immense value, not only for the cash they bring in but for what they do for the image of America. At a time when the world's opinion of this country is distorted by Iraq, Afghanistan, the war on terrorism, and its conduct as a world citizen, what American artists produce is admired, even loved (except by fundamentalists, but that's true at home as well).

Supporting institutions that feed artistic creativity is definitely in the national interest. And that puts artists' communities on the front lines.

Preface

DEBORAH OBALIL

Editor and Executive Director,
Alliance of Artists Communities

What Is an Artists' Community?

We at the Alliance of Artists Communities are often asked to define exactly what qualifies as an artists' community. In the broadest sense, any congregation of artists—from visual and performing to literary and other media—could constitute a community. For the purposes of organizing and representing a field, as well as for creating this directory, we do use certain criteria:

1. Artists' communities are professionally run organizations that provide dedicated time and space for creative work.

2. Artists are "in residence" for a specified period of time; whether two weeks or two years, the time period is generally predetermined and the residency is not meant to be endless.

3. Residencies are provided at no cost to the artists, or are heavily subsidized by other revenue sources, thus offering significant financial support to artists.

These factual criteria are all superseded by the philosophical ties that bind this field together. First and foremost is belief in the creative process and trust in the artist. While residency programs are tremendously diverse in how they nurture the creative process, the fundamental intention of all artists' communities is to provide a supportive environment for experimentation, innovation, collaboration, and, within all of that, failure. By taking the expectation of production out of the equation, artists' communities create an environment that puts artists and their own unique processes at the center. Not surprisingly, artists often find residencies to be among the most productive times of their careers. The freedom to take a step back and ponder the possibilities, without the requirement to do anything specific, often leads artists to work at a pace not otherwise found in daily life.

The exchange of ideas is also at the heart of any artists' community. Most residency programs bring a number of creative individuals together in a setting that encourages conversation, collaboration, and sharing of perspectives. Even those programs that serve only one resident artist at a time offer interaction with a broader community as a core part of the experience.

While these shared beliefs resonate throughout the field, it is the diversity in all other aspects of artists' communities that makes the field so vibrant, and so relevant to creators of all kinds. There are artists' communities in urban centers, rural outposts, and every size town in between. You can find an artists' community in nearly every state of the nation, and many, many more internationally. Some specialize in a particular discipline while others actively promote exchange across disciplines. Many residency programs encourage such cross-disciplinary discourse by offering residencies to a variety of creative thinkers, including scientists, humanists, scholars, culinary artists, and designers.

I've always found this diversity to be most appropriate for a field dedicated to supporting the creative process. No two people create in exactly the same way, no two artists work through the same process. Therefore, no two artists' communities should be exactly alike. Different artists require different environments at various points in their creative work. The range of residency opportunities presented in this directory is a tremendous resource for artists working in all disciplines, from all backgrounds. The only question that matters as an artist is: *Which are best for you?*

Changes to This Edition

Those of you familiar with the previous two editions of this directory will find some changes in this version, all intended to make the book as useful and informative as possible. The first edition in 1996 included information on seventy artists' communities. This third edition now includes detailed, in-depth profiles on ninety-five artists' communities,

with more than 350 programs now listed in the index at the front of the book. This growth is fantastic news for artists, as more opportunities for residencies exist now than at any previous moment in history.

The nature of how artists create, as well as at what point they engage others in their work, also continues to evolve. Recognizing this, we have attempted to provide more detailed information on programmatic opportunities provided by artists' communities to their artists-in-residence. Whether they offer access to cutting-edge equipment and technical assistance in learning to use it, or open studio programs that provide exposure to new audiences, patrons, and critics, most artists' communities have expanded beyond the initial model of time and space to one that more broadly supports artists and their careers. Protected time is still at the core of residencies, but users of this directory will find that the opportunities for support extend well beyond that core today.

For those artists with families, we've added more explicit information on which programs accommodate spouses/partners and/or children, and to what degree. Generally speaking, the longer the residency, the more accommodating the program, but be sure to inquire about current policies if this is an issue of concern for you.

As with the previous editions, tremendous care and effort has been taken to insure that this directory is the most accurate reflection of the field to date. Still, deadlines change, fees rise or fall, funding for special stipends comes and goes. Application forms and requirements seem to change most of all, and this is why we have not included specific information about them in this directory. *Artists should visit the Alliance Web site at www.artistcommunities.org, or contact the communities directly to find out exact, up-to-date requirements for applications, fees, and documentation necessary to apply and attend.*

The Alliance of Artists Communities

The Alliance of Artists Communities is the national service organization for the field, and the entity responsible for compiling this directory. Our mission is to contribute to America's cultural vitality by supporting our membership of diverse residency programs and advocating for creative environments that advance the endeavors of artists. As a connector, we seek to provide artists with the information they need to make educated decisions about residency opportunities. We also work to provide artists' communities with the support they need—professional development, networking, advocacy to policy-makers and funders—to continue providing artists with the highest level of support possible.

All of the artists' communities profiled in-depth in this book (see Extended Profiles) are members of the Alliance. They believe in the value of participating in this network of dedicated and passionate organizations and individuals, all of whom share a primary mission of supporting creativity and nurturing artists. The Alliance membership also includes emerging artists' communities—programs not yet up and running, but hoping to add their names to the impressive list of organizations highlighted in this book. And lastly, we count among us many individuals who simply realize the power of supporting this field and the artists who benefit from its existence.

The Alliance organizational membership serves more than twelve thousand artists annually, at all stages of career development. Collectively, artists' communities represent a century-old, international support system for artists and thinkers. It is our vision to strengthen and expand this support system, encourage more artists of diverse back-grounds and disciplines to participate in it, and, by doing so, nurture the new cultural work of our time.

eteam
Hajoe Moderegger and Franziska Lamprecht

the office. What a great moment. It felt like a wealthy, understanding, and supportive—but so far missing—relative had emerged and decided it was time to support our work by treating us like prince and princess.

After we spent the first days mainly sleeping, walking, and enjoying the good food, we started to love the bubble life. Not because we felt we were enclosed in one (human nature adjusts fast, even to luxury), but because we were able to produce them. Here a bubble, there a bubble, it bubbled everywhere, and not only around our studios. MacDowell turned out to be the perfect setting to shoot the cowboy scenes for our video. Yaddo's infrastructure, on the other hand, prevented us from becoming isolated in the lonesome process of video editing. The mansion enabled frequent encounters, followed by valuable feedback on our almost-finished piece, and the basketball court offered space for physical exercise in the form of scrapper.

Even though we spent a lot of concentrated time working on the project we had planned to accomplish, we still had enough energy, inspiration, and fun to experiment with new thoughts and ideas. Only after we had returned to New York did we realize that these ventures, which had not felt like working but more like playing around, had become an important part of our project—almost the piece itself. The fact that other people at the MacDowell Colony and Yaddo had partly collaborated on these experiments made them even more special. We are extremely thankful for the time and support at both residencies, and can't even imagine how our project would have developed if we had not been invited to these unique places.

When we received the invitations to stay at the MacDowell Colony and at Yaddo in the spring and summer of 2003, we felt excited and anxious at the same time. We had never been at a live-in artist residency before and did not know what to expect. We had applied, because we needed time to work: time nobody else wanted, required, wasted, and cared about—no boss, no bill, no bar, no bus, no post-office waiting-line. A residency seemed to offer that. But was it really the right decision to spend three weeks in the countryside mainly surrounded by other artists? Wouldn't that get boring? Wasn't that artificial? What if this environment forced us to socialize all day long? Did we really want to trade our daily New York City subway trip for a free ride in a bubble floating over green meadows?

Being this skeptical, we arrived a little shy at the Macdowell office, where we received the keys to two amazingly spacious and comfort-able studios and bedrooms to stay and work in. We were shown the main house, the bicycles and the way to town, the library, the rose garden, the trails through the woods, the ping-pong table, the swimming pool, and the wood for the fireplace. There was a bed for naps, a bed for sleeping, a couch for reading, a desk for writing, a bench for talking, a rocking chair for thinking, a dining room for breakfast and dinner, and a picnic basket for lunch. If we should need anything else, we could contact

Andrew Ginzel

Consider silence, consider time and concentration: can one hear oneself think? Is time the litany of minutes passing in a waking day? Or is there another more acute time made manifest when conditions align, and one's potentials arise?

Considering these things I reminisce about visits to artists' communities and I long for yet another time out of time. To feel the energy of compatriots intensely working nearby yet all respectfully distant when required, or of dining night after night with others who would normally never cross my path is a rare and illuminating experience. What wonders poets are to painters. Composers awe novelists. Video makers enthrall playwrights! Every time I witness this phenomenon it has consistently nurtured my processes of creation. Djerassi, Bellagio, Virginia Center for the Creative Arts, Blue Mountain Center, the American Academy in Rome, the MacDowell Colony, Yaddo, among others, are planets in distinct orbits yet allegiant to one sun, and that sun can be you.

When I encounter people with excuses—jobs, families, homes, pets—I plead: Apply! Be good to your equilibrium. Take advantage of these opportunities to transform. You need not surrender your autonomy, eccentricities, or even a wild disposition. Urban calluses soften in forests, mountains, and on the plains while, conversely, a new city can be a source for unforeseen vitality. Worries often melt and procrastinations dissolve with the elixir of a nurturing environment.

We all wish conditions were always ripe for creativity in normal life, yet they are often not. At residencies, colonies, and retreats, however, most external distraction is vanquished. Paradisiacal environments are constructed to catalyze and cultivate you. Legions of dedicated souls (heroes, really) are, at this very moment, raising funds, cooking, cleaning, gardening, mowing, and fixing in the spirit of the potential of your creativity.

Something special happens in these places. Consider that it may be something unexpected. At times I come with an empty slate; I cast aside every preconceived plan and just see what happens. In other instances I come with deadlines. Always I come away with something beyond what I could have imagined.

Then there is the reflective quality of having access to new minds around you, each person a treasure of intriguing life experiences and an archive of knowledge.

What fertile ground for reference or even collaboration!

Many speak of weeks' worth of work produced in days, months' worth in weeks. This is true. Yet one can also just sing, read, and/or think. My accountant wonders out loud why there are not these places for the likes of him. As does my dentist.

So for those who have not applied: Try. For those who have applied: Try and try again. And for all those curious as to what will come next in the arts: Consider how you can help to support, improve, and expand these wondrous opportunities.

Jhumpa Lahiri

I kept a journal while I was at the Fine Arts Work Center in Provincetown, Massachusetts, and before sitting down to write this essay, I decided to have a look at it. I was in the middle of reading when my young son woke up from his nap, and as I held the journal in one hand, and soothed my son with the other, I realized how profoundly my life had changed in the past six years. In 1997 I was thirty years old and had just finished graduate school in Boston. I was an aspiring writer, and on a lark, instead of applying for academic jobs, I applied for a fellowship at the Work Center. Even after the call came, offering me a place, I was unsure whether to accept. New York, where my now-husband lived, beckoned. I wanted to write, and part of me believed that I could find part-time work and write stories just as easily in New York.

In order to help make my decision, I decided to visit the Work Center. I had grown up near the ocean in Rhode Island and assumed Provincetown would be a similar sort of setting. I was wholly unprepared for the remote, magnificent, minuscule place I found. I was greeted by Roger Skillings, long-time Chair of the Work Center's Writing Committee, who kindly showed me around the property. He led me into a shingled barn, up two sets of crude wooden steps and through a door in the ceiling, into a raw, loft-like space under the roof. Roughly in the center, there was a white picnic table, to be used as a desk, set out like an island on a patch of carpet. The windows were small, but light poured in from a cupola overhead. In that brief glimpse, the value of my fellowship was revealed to me. It was a combination of things: the silence; the pure, almost sacred atmosphere of that room; the separation from ordinary life I felt upon arrival in Provincetown; and finally, the gentle affirmation that I was invited there to be a writer and nothing else.

In my journal I write frequently about that beautiful space where I did indeed live and work for seven months. I write about the rain that drummed, sometimes for days at a stretch, on the roof and the cupola that leaked occasionally, so that I had to keep a bucket below it to collect water. I write about my solitary evenings, when I heard nothing but the howling wind, and the sound of a fog-horn, and occasionally, through the gaps in the floorboards, the murmurs of the couple downstairs as they prepared their meals. But mainly I write about time: the unfettered hours of each day, and learning to adjust to them. Somewhere in the course of my stay, a routine had emerged: writing in the morning, errands or exercise in the afternoon, reading at night. These days that routine is an unquestioned ritual, and in spite of my new responsibilities as a wife and a mother, it is how I organize my days. It was Provincetown that taught me that discipline, which must be born from within, and which can only result from total freedom.

A few things happened during my residency that seem momentous in the arc of an emerging writer's life. I found an agent to represent me, and she sold my first book and also sold my first story to the *New Yorker*. While I like to think that it was the magic of Provincetown that made those wonderful things possible, I know that they might have happened eventually, even if I had not gone there. What would not have happened—what is far more profound—is that I left Provincetown forever changed, forever marked as a person. I left with the certainty that I am a writer, with a commitment to the creative life that I have never since questioned or doubted. I left understanding that separation and seclusion are essential in order to create, but also that life must necessarily surround us at all times, shaping and inspiring and even distracting us. At Provincetown that life was the sea, the sky, walks with my fellow artists and writers across the breakwater, glorious hikes across the dunes. It was the cupola that leaked during rainstorms and the picnic table that was my desk. These days I sit at a different desk, in a different room, and light pours through a different window. Instead of a foghorn I hear a subway rumbling past. But those details are insignificant; for the few hours each day I try to write, I return to my room at the Work Center, a place in which I was blessed to have set foot, and which, in my heart, I have never left.

Seiko Tachibana

I came to Kala Art Institute in 1996, under the auspices of a fellowship that provided for a six-month stay at the Institute and culminated in an exhibition in the gallery. The fellowship allowed me to create a large installation entitled *Michi*, which consisted of prints on *washi* (a Japanese paper) pressed from over two hundred 2.5-inch by 5-inch etched zinc plates. The resulting work, whose Japanese name means "road," measures approximately 360 by 40 inches. Hung from the ceiling of the Kala gallery, *Michi* extended to and across the floor, representing the long path of life, and, through its hundreds of distinct, individual elements, the different twists and turns that make each life unique.

When I first came to Kala I was somewhat intimidated by the facility's three large etching presses and was hesitant to use them, so I instead gravitated toward a tiny press and set to work. One day another artist asked if I liked that particular press—a question that left me wondering why she asked. Later, I realized why my devotion to the small machine must have seemed peculiar: with so many larger, more capable presses available, hardly anyone in the studio ever used that lonely, neglected, and forgotten little press.

Interestingly, the limitations imposed by the small press became an important part of the creative journey that led to *Michi*. When I began working with it, I was contemplating the ever-insistent question, "What is life?" I drew and etched a line on one small plate, and then drew another line and etched again, repeating the process until I suddenly realized that I had drawn more than two hundred lines on as many plates. And so the large work *Michi* became a reality, a story of life as told through many small chapters. The tiny press had become a central character in one small but memorable chapter of my own life.

I have been an artist-in-residence at several other centers in Japan, Belgium, Finland, and the United States, and while each of those experiences was artistically and intellectually invigorating, I returned to the Bay Area with a renewed appreciation for that which I often take for granted. Kala's large, 8,500-square-foot space may lack the coziness and immediacy of smaller studios, but it inspires me to think and work on a larger scale. The busy urban setting fills me with a sense of energy and resolve, and the support and camaraderie of Kala's artists lend the strength and inspiration necessary to grapple with the inevitable difficulties that arise during the course of a project. Artists from many countries come to work at Kala, and the rich cultural diversity there encompasses a world of creative thought and perspective. In Kala's kitchen, artists often share their perspectives on their work, their lives, the arts, current events, and other topics over a communal meal. I find it interesting to observe the ways in which our ideas and philosophies differ, and fascinating to see just how much we have in common.

Intaglio brought me to Kala, and its direct/indirect nature continues to be the most comfortable and appealing to me. Working at Kala, I learn from my interaction with other artists and incorporate those experiences into my work, and I gain new understanding of myself with respect to the larger societies of art, America, and the world. Under the direction of Nakano and Archana, Kala Art Institute is more than just a place to create art: it is a family and a home.

Michael White

My introduction to A Studio in the Woods happened when I played there for a friend's wedding. There was something about the location that immediately drew my attention and curiosity. I remember asking a staff member: "What exactly do you all do out here?"—and the rest is history. My two-month residency at the Studio was somewhat experimental for proprietors Joe and Lucianne Carmichael, because I was their first musician resident. Having a solitary retreat to compose new traditional jazz music was a foreign but appealing concept for my career as a jazz clarinetist. What I initially viewed as just a good opportunity to "rest, listen to music, and maybe write a new song or two" turned into much more. By the residency's end, I had taken a frighteningly intense soul-searching journey that led to a new spiritual consciousness, heightened musical awareness, and new levels of creativity—and nearly two-dozen original compositions.

The physical and psychological separation between central New Orleans and the peace, quiet, and isolation of the Studio's natural rural environment became the catalyst for a dualistic consciousness that greatly affected my mood, thinking, and creativity. Without really knowing exactly where to begin writing new songs, I settled into a routine of intense practicing, listening to recordings of different musical styles, and writing down harmonic structures that might serve as new and inter-esting forms for traditional jazz melodies and improvisation.

These conscious musical activities were greatly enhanced by the Studio's natural surroundings: woods, a pond, and a variety of animals. Solitary practice sessions and walks there and along the Studio's front yard—the Mississippi River—contributed to a sense of oneness and harmony with nature that inspired and transformed me. My clarinet became involved in call-and-response conversations with birds. The trees gently echoed the instrument's phrases. There were regular visits by curious animals (obviously jazz fans) that would fearlessly venture close and listen for hours. Facing and feeling the sheer magnitude and power of the Mississippi River was a hypnotic and humbling experience, which brought on self-confrontation and much reflection. The river took on new meaning for me: it seemed to come alive as a nurturing entity that gently lulled me to sleep at night, leading me to connect with untapped levels of my unconscious spirit.

Soon new themes, melodies, harmonies, and rhythms began to fill and flow out of my head. Many ideas were written down, but others were lost before I could sketch them out. At one point I had to consciously stop the flow of new ideas to complete others. More surprising than the amount of new songs was their source. In those themes I could hear my life story being told: from my early years to recent events that occurred during the residency. Rather than reflecting a nostalgic view of the oldest jazz form, these new pieces were influenced by my experiences, knowledge, character, sense of humor, emotions, human contacts, travels, dreams, as well as by various music styles. The essence of a contemporary life was being converted into the sounds and rhythms of traditional New Orleans jazz. The songs were designed for configurations of three to seven musicians, and represented a new way of viewing, writing, and performing traditional jazz.

My residency at the Studio was a life-changing experience, which opened many doors in my quest to both preserve tradition and find valid ways of contributing fresh, personal, and contemporary material to the genre. It also unlocked the door to a rich source of internal inspiration and creative potential that I will probably explore for the rest of my life. Among the many rewarding aspects of my stay at A Studio in the Woods has been the organization's support and encouragement to share the results of my residency experience by sponsoring a concert and workshop premiering and discussing the new music. The desire to preserve and spread the fruits of my retreat experience are also incorporated in a new CD, *Dancing in the Sky*, which contains ten of the songs originally written at the Studio. The benefits of my time at A Studio in the Woods extend beyond a new phase of learning, development, and musical output. The benefits include new directions in local cultural preservation that will inspire musicians and artists of all kinds, as well as serve as an example of the positive value of developing, supporting, and seeking out the artists' residency experience.

U.S. Residencies

18th Street Arts Center
1639 18th Street
Santa Monica, CA 90404
www.18thstreet.org
See page 52 for more information.

Abrons Art Center/Henry Street Settlement
466 Grand Street
New York, NY 10002
www.henrystreet.org/abronsartscenter
See page 54 for more information.

Academy for Leadership and Governance
65 Jefferson Avenue
Columbus, OH 43215
www.thejeffersoncenter.org/alg
The Academy offers fellowships for leaders in arts and culture, with highly individualized attention to the professional development needs of the partici-pants in the context of the multiple demands of leadership.

Edward F. Albee Foundation/William Flanagan Memorial Creative Persons Center
(Site location: Montauk, NY)
14 Harrison Street
New York, NY 10013
www.pipeline.com/~jtnyc/albeefdtn.html
See page 56 for more information.

American Dance Festival
P.O. Box 90772
Durham, NC 27708
www.americandancefestival.org
The International Choreographer's Residency Program runs concurrently with the 6-week summer festival. The residency fee includes tuition, festival performance tickets, room, board, and a health fee. Participants are responsible for their own transporta-tion to and from the United States.

Mary Anderson Center
101 St. Francis Drive
Mount St. Francis, IN 47146
www.maryandersoncenter.org
Writers, visual artists, and musicians come for varying-length residencies on 400 acres of natural landscape. Room/board and studio space are included. Residency fee applies, although partially and fully funded residencies, as well as work-exchange, are available.

Anderson Center for Interdisciplinary Studies
163 Tower View Drive
Red Wing, MN 55066
www.andersoncenter.org
See page 60 for more information.

Anderson Ranch Arts Center
5263 Owl Creek Road
Snowmass Village, CO 81615
www.andersonranch.org
See page 62 for more information.

Aperture Foundation Work Scholar Program
20 East 23rd Street
New York, NY 10010
www.aperture.org
The Work Scholar Program offers 6-month full-time residencies, January–June or July–December. Interns receive a stipend of $250 per month; college credit is available. Room/board not included.

Arrowmont School of Arts and Crafts
556 Parkway
Gatlinburg, TN 37738
www.arrowmont.org
See page 66 for more information.

ArtCenter/South Florida
924 Lincoln Road #205
Miami Beach, FL 33139
www.artcentersf.org
See page 68 for more information.

Artcroft Center for Arts and Humanities
2075 Johnston Road
Carlisle, KY 40311
www.artcroft.org
See page 70 for more information.

Art Farm
1306 West 21st Road
Marquette, NE 68854-2112
www.artfarmnebraska.org
See page 72 for more information.

Art in General
79 Walker Street
New York, NY 10013
www.artingeneral.org
The Artist-in-Residence Program is designed to
give local, national, and international artists the
opportunity to present and create new work. Open
submissions process/guidelines under revision.
Please check Web site for more information.

**The Artist House at St. Mary's College
of Maryland**
c/o Sue Johnson and Michael S. Glaser
Montgomery Hall
St. Mary's City, MD 20686
www.smcm.edu/art/artist_house
See page 74 for more information.

Artists' Enclave at I-Park
428 Hopyard Road, P.O. Box 124
East Haddam, CT 06423
www.i-park.org
See page 76 for more information.

Art Omi International Arts Center
(Site location: Omi, NY)
55 Fifth Avenue, 15th Floor
New York, NY 10003
www.artomi.org
See page 78 for more information.

ArtPace
445 North Main Avenue
San Antonio, TX 78205
www.artpace.org
See page 80 for more information.

ArtPark
P.O. Box 371
Lewiston, NY 14092
www.artpark.net
Artists-in-residence spend 1–3 weeks in the park
developing work and interacting with other artists.
Individual studio space is free of charge, and
reasonable housing just outside the park grounds
is available.

Asian Cultural Council
437 Madison Avenue, 37th Floor
New York, NY 10022-7001
www.asianculturalcouncil.org
The Council supports cultural exchange between the
United States and Asia, with fellowships for visual
and performing artists, scholars, and specialists
from Asia for research, study, and creative work in
the United States. Some grants are also made to
Americans pursuing similar activities in Asia, and to
educational and cultural institutions engaged in
projects of special significance to Asian-American
exchange.

Atlantic Center for the Arts
1414 Art Center Avenue
New Smyrna Beach, FL 32168
www.atlanticcenterforthearts.org
See page 84 for more information.

Aurora Project
RR 1, Box 224, U.S. Route 50
Aurora, WV 26705
www.auroraproject.org
See page 86 for more information.

Austin Arts Center
Trinity College, 300 Summit Street
Hartford, CT 06106
www.austinarts.org
The Arts Center is in the process of developing a
residency program in rural Ashford, CT; please see
Web site for more information.

Bemis Center for Contemporary Arts
724 South 12th Street
Omaha, NE 68102
www.bemiscenter.org
See page 90 for more information.

George Bennett Fellowship Program
20 Main Street, Phillips Exeter Academy
Exeter, NH 03833-2460
www.exeter.edu/english/bennett.html
The Fellowship Program provides a writer (with
preference given to fiction writers) and his/her
family with a stipend, as well as room and board at
Phillips Exeter Academy, for one academic year.
Candidates must have already embarked on a writing
project, and are chosen primarily on the basis of
the manuscript.

Bernheim Arboretum and Research Forest
P.O. Box 130
Clermont, KY 40110
www.bernheim.org

Artists- and writers-in-residence live at Bernheim for up to 3 months while working on their projects. Bernheim will provide housing in a beautiful wooded setting, plus a financial grant to cover travel, materials, and personal expenses.

Blacklock Nature Sanctuary
3232 Harriet Avenue South
Minneapolis, MN 55408
www.blacklock.org

For Minnesota residents only. Month-long and 2-week residencies for emerging artists to work solo, collaboratively, or with a mentor (stipend to cover food and supplies). Month-long residencies for nature photographers (women only); successful proposals will connect with and build upon Nadine Blacklock's aesthetic sensibilities (no stipend currently available).

Brandywine Graphic Workshop
730 South Broad Street
Philadelphia, PA 19146
www.brandywineworkshop.com

No further information currently available; please contact the organization.

Archie Bray Foundation
2915 Country Club Avenue
Helena, MT 59602
www.archiebray.org

See page 64 for more information.

The Bullseye Connection
3601 SE 21st Avenue
Portland, OR 97202
www.bullseyeconnection.com

See page 94 for more information.

The Byrdcliffe Colony/Woodstock Guild
34 Tinker Street
Woodstock, NY 12498
www.woodstockguild.org

See page 96 for more information.

Caldera
(Site location: near Sisters, OR)
224 NW 13th Avenue
Portland, OR 97209
www.calderaarts.org

See page 98 for more information.

Carbondale Clay Center
135 Main Street
Carbondale, CO 81623
www.carbondaleclay.org

No further information currently available (program is in the process of being restructured); please contact the organization.

Carina House, The Farnsworth Art Museum
P.O. Box 466
Rockland, ME 04841
www.monhegan.com/marc/index.htm

Full-time emerging artists living in Maine (2 per year) are eligible for 5-week summer residencies on Monhegan Island, one of the state's natural wonders and a haven for artists for over a century.

The Carving Studio and Sculpture Center
636 Marble Street, P.O. Box 495
West Rutland, VT 05777
www.carvingstudio.org

See page 100 for more information.

Center for Contemporary Printmaking
Mathews Park, 299 West Avenue
Norwalk, CT 06850
www.centerforcontemporaryprintmaking.org

See page 102 for more information.

Center for Craft, Creativity, and Design
P.O. Box 1127
Hendersonville, NC 28793-1127
www.craftcreativitydesign.org

The Center supports collaborative residency programs, with the aim to bring internationally recognized artists to the region; support international residencies for regional artists; and support regional corporate and community artist residencies.

Center for Furniture Craftsmanship
25 Mill Street
Rockport, ME 04856
www.woodschool.org

The Studio Fellowship Program provides emerging and established furniture makers with an encouraging, stimulating environment for the exploration of new work. The program offers free studio space to furniture makers for 1 month to 1 year. Preference for 1 of the 6 fellowships is given to Maine-based woodworkers, with particular emphasis on emerging makers.

Center for Photography at Woodstock
59 Tinker Street
Woodstock, NY 12498
www.cpw.org

The Center offers 2 photographers a 2- to 4-week residency. Artists receive a stipend for food and travel, free access to the Center's black-and-white darkroom and digital-imaging station, and an honorarium.

Centrum
P.O. Box 1158
Port Townsend, WA 98368
www.centrum.org

Creative Residencies are offered January–May and September–December, for 1 week to 1 month. Residencies may involve individual or collaborative work, in a single genre or in several. Residents are provided with housing and studio space. Centrum is located at historic Fort Worden State Park, a short ferry ride from Seattle.

CEPA Gallery
617 Main Street
Buffalo, NY 14203
www.cepagallery.com

Western New York artists are eligible for 4-week residencies (4 awarded each year), providing emerging artists with technical assistance, fabrication support, exhibition and publication opportunities, and honoraria.

Chautauqua Institute, Writers' Center
P.O. Box 408
Chautauqua, NY 14722
www.ciweb.org/writers.html

The Writers' Center offers programs in poetry, fiction, and nonfiction, providing a high-level common ground for the advancement of writers of all degrees of accomplishment, and of all geographical, educational, racial, and cultural backgrounds.

Chester Springs Studio
1668 & 1671 Art School Road, P.O. Box 329
Chester Springs, PA 19425
www.chesterspringsstudio.org

Residencies are offerred to visual artists of all media. Long-term residencies (up to 1 year) provide working artists with extensive studio time, materials, and a solo exhibition. Short-term residencies invite artists to lead workshops or to partner with community groups to design and create art projects, and provide a stipend, studio space, materials, and a model or firing allowance; in certain instances, a final exhibition and room/board are also provided.

The Chinati Foundation
P.O. Box 1135
Marfa, TX 79843
www.chinati.org

The Chinati Foundation provides artists-in-residence with a furnished apartment on the museum's grounds and a studio in Marfa, unlimited access to Chinati's collection and archive, assistance in securing materials and preparing exhibitions, and a stipend to assist with travel and art materials. The average residency lasts 2–3 months.

The Clay Studio
139 North 2nd Street
Philadelphia, PA 19106
www.theclaystudio.org

Three residency programs are provided; clay must be the primary medium used in all. Resident Artist Program: Geared toward individuals transitioning from academia to professional studio practice; artists can remain up to 5 years. Evelyn Shapiro Foundation Fellowship: 1-year residency serving potters/vessel makers (in even years) and sculptors/installation artists (odd years); studio space, monthly stipend, materials allowance, and exhibition included. Guest Artist in Residence Program: International residency, for 8–12 weeks, with studio space, monthly stipend, materials allowance, and housing included.

Collingwood Arts Center
2413 Collingwood Avenue
Toledo, OH 43620
www.collingwoodartscenter.org

A former convent in Toledo's historic Old West End, the Center creatively serves the residents' needs for supportive services, collaboration, studios, exhibition space, and residential areas in a dormitory-style environment (housing fee applies).

Compost Art Center
P.O. Box 1213
Hardwick, VT 05843
www.compostartcenter.com

Compost Art Center provides studio space and a professional studio for visual and performing artists, designers, writers and musicians. Housing for artists-in-residence is in an 1800s farmhouse on 25 rolling acres, and a private studio is located in the historic former Hardwick Knitwear Building downtown. Residency fees apply.

Contemporary Artists Center
189 Beaver Street
North Adams, MA 01247
www.thecac.org

The Center offers residencies (1 week to whole summer) from May to October for emerging, professional contemporary artists. Residency fee includes accommodations and access to all CAC facilities.

The Cooper Union School of Art
Summer Residency Program
30 Cooper Square
New York, NY 10003
www.cooper.edu/artsummer

See page 106 for more information.

Corning Museum of Glass
One Museum Way
Corning, NY 14803-2253
www.cmog.org

The Museum Studio offers month-long artist- and researcher-in-residence programs in the spring and fall (1–2 residents per month). Transportation, room and board, and all basic supplies are provided, as well as access to the Rakow Research Library and the collection of the Corning Museum of Glass.

Cornucopia Art Center,
Lanesboro Residency Program
103 Parkway Avenue North, P.O. Box 152
Lanesboro, MN 55949
www.lanesboroarts.org

Located in the historic downtown, the Center offers 4–6 residencies per year (1–4 weeks each) to emerging artists. Artists from all disciplines are encouraged to apply, though primary consideration will be given to sculptors, painters, poets, and writers; all applicants must reside in the United States. Housing, studio space, and stipends are provided.

Creative Alliance
3134 Eastern Avenue
Baltimore, MD 21224
www.creativealliance.org

The Residency Program accommodates 8 artists or artist groups, 1 per studio, for 1–3 years. Residencies are intended for emerging as well as mid-career artists. Artists are encouraged (but not required) to use the live/work studios as their primary residence.

Creative Glass Center of America,
Wheaton Village
1501 Glasstown Road
Millville, NJ 08332
www.wheatonvillage.org

Applicants for 6-week and 3-month fellowships must have basic hot glassworking skills, be at least 21 years of age, have basic English language skills, reside in the residency house during the fellowship term, be a U.S. citizen or have a valid entry Visa for the period of the fellowship, and be willing to work in view of visitors 12 hours weekly (not including assisting time). Fellowships include monthly stipend, free housing, 24-hour access to facilities, and individual studio spaces.

Cub Creek Foundation
Route 1, Box 483
Appomattox, VA 24522
www.cubcreek.org

Cub Creek offers 6 residencies in ceramic arts, up to one year in length. The residency fee includes studio space and housing. Residents participate in outreach programs and have the opportunity to show work in Cub Creek's gallery.

Delaware Center for Contemporary Arts
200 South Madison Street
Wilmington, DE 19801
www.thedcca.org

In the Visual Arts Residency Program, artists make a full-time commitment to collaborate with an underserved community group to create artwork based on issues relevant to the participants' lives. The residency offers artists an onsite apartment/studio space and stipend for 8 weeks, inclusion in a nationally distributed catalog, and possible exhibition. Only U.S. citizens are eligible to apply.

Dieu Donne Papermill
433 Broome Street
New York, NY 10013
www.dieudonne.org

Hand-papermaking residencies for emerging and mid-career artists. Lab Space Program: 2 artists annually receive a 12-day residency, with an honorarium, full technical assistance on the main wet-floor studio, all papermaking materials, and the option to present an exhibition. Work Space Program: 7-day collaborative residency offered to 3 New York–based emerging artists, with an honorarium, advance preparation of materials, and professional assistance.

Djerassi Resident Artists Program
2325 Bear Gulch Road
Woodside, CA 94062-4405
www.djerassi.org
See page 108 for more information.

Dobie Paisano Fellowship Project, University of Texas, Austin
702 E. Dean Keeton Street
J. Frank Dobie House
Austin, TX 78712
www.utexas.edu/ogs/Paisano
The fellowship residencies are available to writers who are Texas natives, have resided in Texas for at least 3 years at some time, or have published work with a Texas subject.

Doghaven Center for the Arts
P.O. Box 283
Three Oaks, MI 49128
The Doghaven Center, located in rural southwest Michigan, offers 2–6-month residencies for artists in all disciplines. Send SASE for more information.

Dorland Mountain Arts Colony
P.O. Box 6
Temecula, CA 92593
www.dorlandartscolony.org
See page 110 for more information.

Dorset Colony House
P.O. Box 510
Dorset, VT 05251
www.theatredirectories.com
Spring and fall residencies are available for writers, composers, theater directors, designers, collaborators, and some visual artists, in a small village in southern Vermont. Modest residency fee applies; housing included.

Eastern Frontier Society, Norton Island Residency
(Site location: Norton Island, ME)
446 Long Ridge Road
Bedford, NY 10506
www.easternfrontier.com
The Norton Island Residency Program offers residencies on remote, rustic Norton Island, off the coast of Maine. Writers of fiction, poetry, plays or nonfiction; composer/songwriters; and visual artists are welcome to apply. Room and board are provided at no cost.

Emerson Umbrella Center for the Arts
40 Stow Street
Concord, MA 01742
www.emersonumbrella.org
Studio residencies are provided for more than 60 artists in 2 former school buildings in historic Concord and neighboring Carlisle, MA. Artists-in-residence pay a nominal studio rent, and are expected to use the studio a minimum of 20 hours per month, to participate in annual open studios, and to contribute time and talent to the community.

Willard R. Espy Literary Foundation
P.O. Box 614
Oysterville, WA 98641
www.espyfoundation.org
See page 112 for more information.

Evergreen House, Johns Hopkins University
4545 North Charles Street
Baltimore, MD 21210
www.jhu.edu/historichouses
See page 114 for more information.

The Exploratorium
3601 Lyon Street
San Francisco, CA 94123
www.exploratorium.edu
See page 116 for more information.

Eyebeam
45 Main Street, 12th Floor
Brooklyn, NY 11201
www.eyebeam.org
Eyebeam's Artist-In-Residence program is a multi-disciplinary initiative that supports creative research, production and presentation of projects that query art, technology and culture. Studio residencies vary from 3 to 12 months. Room and board are not provided; however, artists outside New York are welcome to apply and Eyebeam may assist applicants in finding additional funding for travel and accommodations.

Fabric Workshop and Museum
1315 Cherry Street, 5th and 6th Floors
Philadelphia, PA 19107-2026
www.fabricworkshopandmuseum.org
The Artist-in-Residence Program hosts emerging and established regional, national, and international contemporary artists from all disciplines—including painting, sculpture, architecture and design, conceptual and installation art, performance and video—who have a demonstrated commitment to innovation and exploration. Stipends, materials, and technical/administrative support are provided.

Fine Arts Museums of San Francisco
Legion of Honor Museum, 100 34th Avenue
San Francisco, CA 94121-1693
www.thinker.org
See page 118 for more information.

Fine Arts Work Center
24 Pearl Street
Provincetown, MA 02657
www.FAWC.org
See page 120 for more information.

Franconia Sculpture Park
29815 Unity Avenue
Shafer, MN 55074
www.franconia.org
The 16-acre sculpture park, located in the scenic
St. Croix River Valley, is open to artist/sculptors for
a work-exchange residency/internship, 6 weeks to
6 months. Student, graduate, and post-grad artists
participate in the intern/mentor program; recent
grads and students of museum studies/arts adminis-
tration are encouraged to apply. Intern artists are
encouraged to create their own work, and up to 6
interns are provided room and board.

Isabella Stewart Gardner Museum
2 Palace Road
Boston, MA 02115
www.isgm.org
See page 122 for more information.

A Gathering of the Tribes
285 E. 3rd Street
New York, NY 10009
www.tribes.org
Tribes is a pan-disciplinary, multicultural organization,
that offers a new emerging writers-in-residence series;
please contact the organization for more information.

Grand Arts
1819 Grand Boulevard
Kansas City, MO 64108
www.grandarts.com
Grand Arts, with a 3,000-square-foot gallery and
5,000-square-foot studio, provides studio residen-
cies for the creation and exhibition of new work in
sculpture. Grand Arts provides substantial financial,
technical, and logistical support to emerging or
established artists, and solicits proposals for projects
locally, nationally, and internationally from both
emerging and established artists.

Griffis Art Center
147 State Street
New London, CT 06320
www.GriffisArtCenter.com
Artists from around the world are eligible for
5-month residencies at Griffis Art Center. Each artist
is provided with a private, fully furnished apartment,
studio space, and an open studio exhibition.

Hall Farm Center for Arts and Education
392 Hall Drive
Townshend, VT 05353
www.hallfarm.org
See page 124 for more information.

**Hambidge Center for Creative Arts
and Sciences**
105 Hambidge Court
Rabun Gap, GA 30568
www.hambidge.org
See page 126 for more information.

Headlands Center for the Arts
944 Fort Barry
Sausalito, CA 94965
www.headlands.org
See page 128 for more information.

Hedgebrook
2197 East Millman Road
Langley, WA 98260
www.hedgebrook.org
See page 130 for more information.

The Hermitage
RD 1, Box 149
Pitmann, PA 17964
www.ic.org/thehermitage
Located in the Adirondacks, the Hermitage offers
residencies for gay artists and craftsmen. The 3 1-week
summer residencies provide room and board and
time to work in exchange for 2–3 hours of work per
day. The studios do not have electricity, plumbing,
or running water.

Hermitage Artists Retreat
6650 Manasota Key Road
Englewood, FL 34223
www.hermitage-fl.org
See page 132 for more information.

Highpoint Center for Printmaking
2638 Lyndale Avenue South
Minneapolis, MN 55408
www.highpointprintmaking.org

Highpoint provides a collaborative, professional printshop for local and visiting artists to create small, fine art editions under the guidance and support of a master printer. Educational opportunities and ongoing print shows in the gallery are offered during the artist's visit.

HOME, Inc.
731 Harrison Avenue
Boston, MA 02118
www.homeinc.org

See page 134 for more information.

Hopscotch House / Kentucky Foundation for Women
8221 Wolf Pen Branch Road
Prospect, KY 40059
www.kfw.org

See page 136 for more information.

Richard Hugo House
1634 11th Avenue
Seattle, WA 98122
www.hugohouse.org

Hugo House's Writers-in-Residency Program offers a 9-month residency, and each writer may serve up to two terms. The residents serve the community by holding office hours, designing and implementing an innovative program to serve the Seattle community, and serving as master teachers in the Inquiry Through Writing Program.

Hurricane Mountain: A Center for Earth Arts
501 Hurricane Road
Keene, NY 12942
www.hurricanemountain.org

Hurricane Mountain, on 25 acres surrounded by the Adirondacks, provides residencies in the summer and winter, for ~20 artists a year, including potters, woodworkers, stone-carvers, fiber artists, plein-air painters, poets, and other Earth-inspired people. The Winter Residency offers 9 months to ceramic artists who are at a transitional stage in their lives and work. The Summer Residency provides professional artists and teachers with 1–3 weeks for personal growth and artistic exchange.

Institute for Electronic Arts
2 Pine Street, Alfred University
Alfred, NY 14802
http://iea.art.alfred.edu

The Institute offers an artist-in-residency program for visual and performing artists and writers. Contact the organization for more information.

International Studio and Curatorial Program
323 West 39th Street, Suite 806
New York, NY 10018
www.iscp-nyc.org

Studio residencies (2 months–2 years) are provided in midtown Manhattan, to non-U.S. artists. The program includes visits by guest critics, open studio exhibitions, and field trips to art centers. Participants are sponsored by governments, corporations, foundations, galleries, or private patrons. Artists are provided with 24-hour access to private studios and (sponsor-permitting) a furnished apartment in Manhattan. In most cases, the sponsor provides the artist with a stipend for living expenses, travel, and materials.

Intersection for the Arts
446 Valencia Street
San Francisco, CA 94103
www.theintersection.org

An alternative arts space in San Francisco, Intersection has long-term studio residencies for writers, a composer, a dance group, and a theater group. Resident artists are involved in the creation as well as exhibition of work.

Island Institute, Alaska Residencies
P.O. Box 2420
Sitka, AK 99835
http://home.gci.net/~island

Residencies are offered to writers whose work demonstrates an interest in the integration of the perspectives of the humanities, arts, and sciences in ways that recognize community values. Three single residencies are offered each year, in January, April, and November. Residents are provided with housing and a stipend toward food costs. There are weekly opportunities for residents to interact with the local community.

Jacob's Pillow Dance Festival
P.O. Box 287
Lee, MA 01238
www.jacobspillow.org

See page 140 for more information.

Jamestown Arts Center
P.O. Box 363
Jamestown, ND 58402-0363
http://t-ad.net/jac

Located in downtown Jamestown, the Arts Center has an exhibition space, a performance stage, and 3 classroom spaces (one dedicated to ceramics and kiln operation). The Arts Center offers 2-week to 3-month residencies, which include housing, a stipend, studio space, and classroom supplies. Responsibilities include teaching in the Arts After School Program for students in grades 4–6.

Jentel Artist Residency Program
130 Lower Piney Creek Road
Banner, WY 82832
www.jentelarts.org

See page 142 for more information.

Kaatsbaan International Dance Center
P.O. Box 482
Tivoli, NY 12583
www.kaatsbaan.org

Residencies are the soul of Kaatsbaan's mission, providing dancers the time, space, and atmosphere to create, rehearse, and grow as performers. The Dancers' Inn can accommodate up to 40 dance artists at a time.

Kala Art Institute
1060 Heinz Avenue
Berkeley, CA 94710
www.kala.org

See page 144 for more information.

Kalani Oceanside Retreat
RR #2, Box 4500
Pahoa, HI 96778
www.kalani.com

Kalani offers visual artists, writers, and dancers simple room and board and limited shared workspace in rural Hawaii, for residencies of 2 weeks to 3 months. Stipends provide 50% of lodging costs and are available from May–July and September–December; artists are responsible for remaining costs.

KHN Center for the Arts
801 3rd Corso
Nebraska City, NE 68410
www.KHNcenterforthearts.org

See page 146 for more information.

John Michael Kohler Arts Center
608 New York Avenue, P.O. Box 489
Sheboygan, WI 53082-0489
www.jmkac.org

See page 148 for more information.

The LAB
2948 16th Street
San Francisco, CA 94103
www.thelab.org

The LAB offers residencies to visual, performing, media, and literary artists, traditionally in late summer or mid-winter. The duration of a residency depends on the artist's proposal and current LAB programming. Contact the organization for more information.

The Lannan Foundation
(Site location: Marfa, TX)
313 Read Street
Santa Fe, NM 87501
www.lannanfoundation.org

The residency program provides uninterrupted writing time for poets, writers, essayists, scholars, art curators, and activists. Residencies last from 2 weeks to 3 months. Unsolicited applications are not accepted.

Lighton International Artists Exchange Program/Kansas City Artists Coalition
201 Wyandotte
Kansas City, MO 64105
www.kansascityartistscoalition.com

See page 155 for more information.

Light Work
316 Waverly Avenue
Syracuse, NY 13244
www.lightwork.org

Light Work invites 12–15 artists for month-long residencies. Each artist is given the opportunity to create new work at the studio facility at Syracuse University. Artists-in-residence receive a stipend, an apartment, private darkroom, and 24-hour access to the facility.

Location One
26 Green Street
New York, NY 10013
www.location1.org

Location One offers residencies for 3–10 months
(up to 9 at one time), with 24-hour studio access.
Residents from abroad are selected by both a panel
in New York and one in their home countries, and
Location One works closely with cosponsors in each
country (co-sponsors are responsible for all residen-
cy costs and stipends). U.S. artists-in-residence are
proposed by curators, critics, and by the staff.

The Loft Literary Center
1011 Washington Avenue South, Suite 200
Minneapolis, MN 55415
www.loft.org

The Loft Writers' Studios at Open Book offer private,
affordable studio space to local writers on a weekly
or monthly basis.

Longwood Arts Project
571 Walton Avenue
Bronx, NY 10451
www.bronxarts.org/gp_longwood.asp

The 9-month Longwood Cyber Residency, in the
Bronx, begins every fall and provides artists with
free access to equipment, workshops, technical
consultants, and honoraria, to experiment with
online technologies as creative tools. The residency
is open to visual artists working in all media; some
computer knowledge is necessary. Full-time graduate
or undergraduate students enrolled in any degree
program, and previous-year recipients of any Bronx
Council on the Arts Awards are not eligible.

Louisiana ArtWorks
725 Howard Avenue
New Orleans, LA 70130
www.artscouncilofneworleans.org

See page 152 for more information.

Lower Eastside Printshop
59-61 East 4th Street, 6th Floor
New York, NY 10003
http://printshop.org

Artists from the United States and around the world
are invited to work in-residence throughout the year.
In collaboration with staff master printers, they
create compelling new work, copublished by the
Printshop. Artists sponsored by other organizations
and foundations may receive housing.

Lower Manhattan Cultural Council
One Wall Street Court, 2nd Floor
New York, NY 10005
www.lmcc.net

LMCC/Workspace offers an innovative site-oriented
studio residency program; encourages an artistic/
political/theoretical consideration of location and
context; and continues LMCC's mission to position
artists in lower Manhattan, create ties between the
arts and business communities, and support the
careers of artists in all fields. In addition, LMCC and
the City of Paris provide New York City artists
with the opportunity to live and work at the Cité
Internationale des Arts in Paris, France.

Lux Art Institute
P.O. Box 9638
Rancho Santa Fe, CA 92067
www.luxartinstitute.org

Lux attracts nationally and internationally recognized
artists to Southern California for its artist-in-residence
program. Residents live and work on-site, and pro-
duce commissioned works inspired by the natural
world. In addition, Lux fosters facilitates opportunities
for active dialogue between visitors and resident artists.

Mabou Mines
150 First Avenue
New York, NY 10009
www.maboumines.org

Mabou Mines/Suite is a laboratory for artists to
experiment with performance ideas, rather than a
showcase or a producing situation. Resident Artists
are appointed to work on a particular idea; new
work must originate in the Suite and will be shown
at the end of the residency at whatever level the
artist feels will benefit its development (audiences
are invited at no charge). Artists may have the use
of Mabou Mines' equipment.

The MacDowell Colony
100 High Street
Peterborough, NH 03458
www.macdowellcolony.org

See page 154 for more information.

Robert M. MacNamara Foundation
241 East Shore Road
Westport Island, ME 04578

See page 156 for more information.

Maryland Hall for the Creative Arts
801 Chase Street
Annapolis, MD 21401
www.mdhallarts.org

MHCA provides residencies to 6–10 multidisciplinary artists (including the performing, visual, and language arts); studio space is subsidized in exchange for services to MHCA or the community. The local artist-in-residence program is designed to allow Maryland artists access to affordable studio space while interfacing with the community. The 1–3-month visiting artist-in-residence program is available to New Jersey, New York, and Pennsylvania artists.

The Mattress Factory
500 Sampsonia Way
Pittsburgh, PA 15212-4444
www.mattress.org

See page 158 for more information.

McColl Center for Visual Art
(formerly Tryon Center for Visual Art)
721 North Tryon Street
Charlotte, NC 28202
www.mccollcenter.org

See page 160 for more information.

The Mesa
P.O. Box 145, 145 Red Rock Trail
Springdale, UT 84767
www.themesa.org

See page 162 for more information.

Mesa Refuge, c/o Common Counsel Foundation
1221 Preservation Park Way, Suite 101
Oakland, CA 94612
www.commoncounsel.org/pages/mesa.html

Eligible artists include directors, performers, writers, poets, dramaturgs, composers, painters, sculptors, photographers, dancers, singers, choreographers, and film-/videomakers. Contact organization for more information.

Millay Colony for the Arts
454 East Hill Road, P.O. Box 3
Austerlitz, NY 12017
www.millaycolony.org

See page 164 for more information.

Minnesota Center for Book Arts
1011 Washington Avenue South, Suite 100
Minneapolis, MN 55415
www.mnbookarts.org

The MCBA artists-in-residence are required to work within the genres of printmaking, papermaking, and/or bookbinding; this can include nontraditional methods and materials. Studio residencies vary in length, and include secure access to MCBA's facilities and dedicated, secure storage space for work and supplies. Limited exhibition space is also available for the duration of the residency.

Montalvo
15400 Montalvo Road, P.O. Box 158
Saratoga, CA 95071
www.villamontalvo.org

See page 166 for more information.

Montana Artists Refuge
101 & 103 Basin Street, P.O. Box 8
Basin, MT 59631
www.montanarefuge.org

See page 168 for more information.

Montpelier Cultural Arts Center
12826 Laurel-Bowie Road
Laurel, MD 20708
www.pgparks.com/places/artsfac/mcac.html

The Center offers 1–5-year studio residencies to visual artists. Studio spaces are juried once a year, and a waiting list is maintained in the event that studios become available mid-year. Studios are open to the public, in order to offer insight into the process of creating artwork. Studio artists are able to show their work in the Resident Artists' Gallery.

Nantucket Island School of Design and the Arts
P.O. Box 958
Nantucket, MA 02554
www.nisda.org

See page 170 for more information.

National Park Service

The National Park Services offers opportunities for 2D visual artists, photographers, sculptors, performers, writers, composers, and craft artists to live and work in the parks. Significant exceptions to artists served, and length of residencies are noted below. The programs are compiled on the NPS Web site, at www.nps.gov/volunteer/air.htm, where you can find contact information and program details for each site.

Acadia National Park
Bar Harbor, ME
Length: 3 weeks.

Amistad National Park
Del Rio, TX
2D visual artists and photographers only.
Length: 4 weeks.

Badlands National Park
Interior, SD
Length: 4–6 weeks.

Boston National Historical Park
Boston, MA
In partnership with the Institute of Contemporary Art; by invitation only. Length: 12 months.

Buffalo National River
Harrison, AR
Length: 3 weeks.

Cape Cod National Seashore / C-Scape Dune Shack
Provincetown, MA
Length: 1 week–3 months.

Cape Cod National Seashore / The Margo-Gelb Shack
Provincetown, MA
Length: 2 weeks.

Cuyahoga Valley Environmental Education Center
Peninsula, OH
Length: 6–8 weeks.

Denali National Park and Preserve
Denali Park, AK
2D visual artists and sculptors only.
Length: 3–10 days.

Devils Tower National Monument
Wyoming, MT
Writers only.
Length: 1 week.

Everglades National Park
Homestead, FL
Length: 2–4 weeks.

Glacier National Park
West Glacier, MT
2D visual artists, photographers, sculptors, and film-/videomakers.
Length: 3 weeks.

Grand Canyon National Park
Grand Canyon, AZ
Length: 3 weeks.

Herbert Hoover National Historical Site
West Branch, IA
Length: 3 weeks.

Indiana Dunes National Lakeshore
Porter, IN
Length: 2–4 weeks.

Isle Royale National Park
Houghton, MI
Length: 2–3 weeks.

Joshua Tree National Park
Twentynine Palms, CA
Length: 4 weeks.

Klondike Gold Rush National Historic Park
Skagway, AK
Length: 6–8 weeks.

Mammoth Cave National Park
Mammoth Cave, KY
Length: 2–4 weeks.

Mount Rushmore National Memorial
Keystone, SD
Traditional sculptors working in stone only.
Length: 12–16 weeks (paid summer residency) or 1 week (unpaid fall residency).

Pictured Rocks National Lakeshore
Munising, MI
2D visual artists and photographers only.
Length: 4 weeks.

Rocky Mountain National Park
Estes Park, CO
Length: 2 weeks.

Saint-Gaudens National Historic Site
Cornish, NH
Sculptors only.
Length: 12–24 weeks.

Sleeping Bear Dunes National Lakeshore
Empire, MI
Length: 3 weeks.

Voyageurs National Park
International Falls, MN
Length: 2 weeks.

Yosemite National Park
Yosemite National Park, CA
2D visual artists, photographers, and sculptors only.
Length: up to 1 month.

New Pacific Studio
(Site locations: Mount Bruce, New Zealand
and Vallejo, CA)
Mount Bruce R.D.1
Masterton, New Zealand
www.newpacificstudio.org
New Pacific Studio offers residencies for artists,
writers and environmentalists from all over the world
who are established in their field. In Vallejo, artists
are in residence for 1–2 weeks during the summer.
In Mount Bruce, artists are in residence for 3 months
year-round.

New York Mills Arts Retreat
P.O. Box 246
New York Mills, MN 56567
www.kulcher.org/html/artsretreat.html
The Center's program provides artists with 2–4
weeks in rural Minnesota to immerse themselves in
their artwork. Housed in a restored 1885 general
store, the Center includes 2 galleries and a large
dance/studio space. Minnesota and New York City
artists, and artists of color are encouraged to apply.

Northern Clay Center
2424 Franklin Avenue East
Minneapolis, MN 55406
www.northernclaycenter.org
The Center provides 3-month residencies to 4 indi-
vidual, mid-career ceramic artists, based outside
Minnesota, each year. Residencies include a
monetary award, studio space, and glaze and firing
allowances (housing not included). Artists-in-
residence present a public workshop/lecture, and
receive an honorarium.

**Northwood University Alden B. Dow
Creativity Center**
4000 Whiting Drive
Midland, MI 48640
www.northwood.edu/abd
See page 172 for more information.

Oregon College of Art and Craft
8245 SW Barnes Road
Portland, OR 97225
www.ocac.edu
See page 174 for more information.

Ox-Bow
(Site location: Saugatuck, MI)
37 S Wabash Avenue
School of the Art Institute of Chicago, Room 44
Chicago, IL 60603
www.ox-bow.org
The Professional Artists' Residencies for practicing
visual artists and writers offer a secluded, natural
environment, for 1–2 weeks during the summer
(students are not eligible). Recipients receive a
small private studio and room and board. Residency
fee applies; a limited number of one-week residency
scholarships are available.

Penland School of Crafts
P.O. Box 37
Penland, NC 28765-0037
www.penland.org
See page 176 for more information.

Peters Valley Craft Education Center
19 Kuhn Road
Layton, NJ 07851
www.pvcrafts.org
Associate Residency Program: Up to 7-month resi-
dency (Oct.–April) offered to emerging artists or
artists in transition, including housing and studio
space (nominal residency fee). Summer Assistant

Residency Program: Accommodations, studio space, and a workshop offered in exchange for assisting instructors and studio heads. Full-time artist residencies are also available; contact organization for more information.

Pilchuck Glass School

(Site location: Stanwood, WA)
430 Yale Avenue North
Seattle, WA 98109-5431
www.pilchuck.com

See page 178 for more information.

Plains Art Museum

P.O. Box 2338
Fargo, ND 58102-2338
www.plainsart.org

The Museum offers 4 5-week residencies in print-making each year, April–October, which include a private apartment and stipend. The Museum and artists' apartment are in the historic heart of downtown. Residents are required to have prior printmaking experience and be able to work independently.

Portland Institute for Contemporary Art

219 NW 12th Street
Portland, OR 97209
www.pica.org

PICA offers residencies to 6 artists each year, in all disciplines. Each artist works closely with the curators to design the residency, and determine how to best connect artists to the local community.

Prairie Center of the Arts

1412 SW Washington Street
Peoria, IL 61602

See page 180 for more information.

Pratt Fine Arts Center/City Art Works

1902 South Main Street
Seattle, WA 98144
www.pratt.org

Pratt's Master Artist Program brings visual artists of national and international renown to the Pacific Northwest, fostering experimentation and innovation, helping the careers of working and emerging artists long after their week-long intensives end. The program includes a wide range of media, including glass, jewelry/metalsmithing, printmaking, painting, drawing, and sculpture.

Project Row Houses

2500 Holman, P.O. Box 1011
Houston, TX 77251-1011
www.projectrowhouses.org

Project Row Houses involves artists in issues of neighborhood revitalization, historic preservation, community service, and youth education. Each artist-in-residence works for 6 months in one of 8 houses on an installation project, with one house devoted to performance art.

PS1 Contemporary Art Center

22-25 Jackson Avenue
Long Island City, NY 11101-5324
www.ps1.org

PS1's studio residency program has brought together artists from around the world since 1976. The current program is being redeveloped; please see Web site for updated information.

Radcliffe Institute for Advanced Study, Fellowship Program

Radcliffe College, 34 Concord Avenue
Cambridge, MA 02138
www.radcliffe.edu

The fellowships support scholars, scientists, artists, and writers of exceptional promise and demonstrated accomplishments who wish to pursue work in academic and professional fields and in the creative arts. The Institute sustains a continuing commitment to the study of women, gender, and society; women and men from the United States and throughout the world, including developing countries, are encouraged to apply, and are expected to live and work in the Boston area. Fellows receive office/studio space, access to libraries and other resources of Harvard University, and a stipend for 1 year, with additional funds for project expenses.

Ragdale Foundation

1260 North Green Bay
Lake Forest, IL 60045
www.ragdale.org

See page 182 for more information.

Red Cinder Creativity Center

P.O. Box 527
Na'alehu, HI 96772
www.red-cinder.com

See page 184 for more information.

Rockmirth
HC 69, Box 20H
Sapello, NM 87745
www.rockmirth.com
See page 186 for more information.

Rocky Mountain Women's Institute
7150 Montview Blvd
Denver, CO 80220
No further information currently available; please
contact the organization.

Roswell Artist-in-Residence Program
1404 West Berrendo Road
Roswell, NM 88202
www.rair.org
See page 188 for more information.

Saint Louis University
221 N Grand Blvd, DB 261
St. Louis, MO 63103
www.slu.edu/events/lay.html
The McElwee Artist Residencies offers 6 artists the
opportunity to live at Lay Center, develop work that
is pertinent to the region, work with students as
part of a teaching program sponsored by Saint Louis
University, and exhibit on-site and at the University
Museum. The summer program also includes 1-day
workshops.

Saltonstall Arts Colony
P.O. Box 6607
Ithaca, NY 14850
www.saltonstall.org
For each of the summer months, 5 artists in literary
and visual arts are invited to live at the Saltonstall
Arts Colony, located within a serene rural area. All
applicants must be at least 21 years old, live in New
York State, and be able to firmly commit to spending
4 weeks at the Colony. Each artist is given a private
apartment and workspace (including large studios
for the painters and a black-and-white darkroom
for the photographer).

**San Anto Cultural Arts, Muralist-in-
Residence Project**
1300 Chihuahua Street
San Antonio, TX 78201
www.sananto.org
San Anto Cultural Arts sponsors a Muralist-in-
Residence Project; please contact organization for
more information.

San Francisco Recycling and Disposal
501 Tunnel Avenue
San Francisco, CA 94134-2939
www.norcalwaste.com
SFR&D's Artist-in-Residence Program uses art to
inspire people to recycle more and conserve natural
resources. The company provides selected local
professional artists with the opportunity to make
art from materials they gather from San Francisco's
refuse, 24-hour access to a well-equipped studio,
and an exhibit at the end of their residency.

Santa Fe Art Institute
P.O. Box 24044
Santa Fe, NM 87502
www.sfai.org
See page 192 for more information.

Sculpture Space
12 Gates Street
Utica, NY 13502
www.sculpturespace.org
See page 194 for more information.

Sea Change Residencies/Gaea Foundation
(Site location: Provincetown, MA)
1611 Connecticut Avenue NW
Washington, DC 20009-1033
www.gaeafoundation.org
See page 198 for more information.

Seaside Institute/Escape to Create
P.O. Box 4730
Santa Rosa Beach, FL 32459
www.theseasideinstitute.org
Escape to Create offers 1 month-long residency each
January. Artists from varying disciplines are chosen
through an application process to work on a specific
project. At the end of the month, artists present
their work to the community.

Sitka Center for Art and Ecology
P.O. Box 65
Otis, OR 97368
www.sitkacenter.org
See page 200 for more information.

Skowhegan School of Painting and Sculpture

(Site location: Skowhegan, ME)
200 Park Avenue South, Suite 1116
New York, NY 10003
www.skowheganart.org

Skowhegan selects 65 emerging visual artists annually for an intensive 9-week summer residency program in Maine. Applicants must be at least 21 years old before the session begins; an academic background in art is not required. Current students and independent artists are eligible. Contact organization for information on resident faculty artists and visiting artists opportunities for established artists.

Smack Mellon Studios, Studio Residency Program

70 Washington
Brooklyn, NY 11201
www.smackmellon.org

Smack Mellon offers free studio space to eligible artists for 1 year, along with a fellowship award and access to the fabrication shop and digital media center (housing is not provided). All applicants must be residents of the United States, 18 years or older, may not be enrolled in any degree program, and must be able to demonstrate need for a studio.

Lillian E. Smith Center for the Creative Arts

(Site location: Clayton, GA)
710 Waverly Road
Tallahassee, FL 32312
www.lilliansmith.org

See page 202 for more information.

Snug Harbor Cultural Center, Newhouse Center for Contemporary Art

1000 Richmond Terrace
Staten Island, NY 10301
www.snug-harbor.org

See page 204 for more information.

Soapstone: A Writing Retreat for Women

(Site location: near Nehalem, OR)
622 SE 29th Avenue
Portland, OR 97214
www.soapstone.org

Soapstone is located on Oregon's Coast Range, in 22 acres of forest, along the banks of Soapstone Creek. Residencies are 2–4 weeks and are provided without charge. Women writers only, single or in pairs, are eligible. Two writers at a time can be accommodated, and each is given a private space.

Soaring Gardens Artists' Retreat / Ora Lerman Charitable Trust Artists' Residency

160 Erica Way
Portola Valley, CA 94028
www.lermantrust.org

Soaring Gardens Artists' Retreat, in beautiful dairy country near Laceyville, Pennsylvania, provides 3–6-week residencies to visual artists, writers, and composers between May and September. The Trust particularly encourages applications from emerging women artists. Artists are encouraged to apply in groups of 2 or 3.

Socrates Sculpture Park

P.O. Box 6259
Long Island City, NY 11106
www.socratessculptuprepark.org

Socrates Sculpture Park offers 2 residency programs on their waterfront park, overlooking the Manhattan skyline. Emerging Artist Fellowships, open to emerging New York State artists in need of financial assistance, include a 2- to 6-month residency in the outdoor studio; stipend; access to facilities, materials, equipment, and technical assistance to create a work for exhibition; and administrative assistance. The Open Space Program provides U.S. and international artists with a 1- to 6-month residency in the outdoor studio; stipend; administrative and technical assistance; access to facilities, materials, and equipment; and exhibition in the Park (funding varies from year to year, and housing and transportation are not provided). Socrates grants are also awarded for single artist projects and collaborations.

Spring Island Trust

42 Mobley Oaks Lane
Okatie, SC 29909-4012

Approximately 12 residencies are offered per year to visual artists and ecologists in a small island community. Write for more information.

Squeeky Wheel / Buffalo Media Resources

175 Elmwood Avenue
Buffalo, NY 14201
www.squeaky.org

The International Digital Filmmakers Residency is offered to mid-career experimental filmmakers who are not yet trained in digital editing. The 4-week residency includes housing, travel, 24-hour access to digital equipment, and technical assistance.

Stonehouse Residency for the Contemporary Arts
47694 Dunlap Road
Miramonte, CA 93641
www.stonehouseresidency.org
See page 206 for more information.

Stonington Village Improvement Association
P.O. Box 18
Stonington, CT 06378
www.stoningtonvia.org
The James Merrill Writer-in-Residence Program provides live/work space for an academic year to a writer or scholar with a specific project, who is committed to full-time residence in Stonington during the residency, can be entrusted with the historic Merrill apartment, is willing to make a cultural contribution to the local community, and is financially self-sufficient for the length of his or her stay.

St. Petersburg Clay Company
420 22nd Street South
St. Petersburg, FL 33712
www.stpeteclay.com
One-year residencies (which may be extended) are offered to pre-professional emerging artists, at least 18 years of age, who have completed a reasonable amount of secondary education, can demonstrate adequate experience in ceramics, and can submit evidence of a body of work to support the application. Residencies include studio space, 24-hour access to the facilities, discounted firings, display space for finished work, teaching opportunities, free admission to workshops, and an exhibit. Artists are required to work 12 hours/week under the direction of artists-in-residence managers.

A Studio in the Woods
13401 River Road
New Orleans, LA 70131
www.astudiointhewoods.org
See page 208 for more information.

STUDIO for Creative Inquiry
College of Fine Arts Bldg., Room 111
Carnegie Mellon, 5000 Forbes Avenue
Pittsburgh, PA 15213-3890
www.cmu.edu/studio
See page 210 for more information.

Studio Museum in Harlem
144 West 125th Street
New York, NY 10027
www.studiomuseum.org
The Museum offers a 12-month residency for 3 emerging artists who are granted studio space and a fellowship award. Artists' media is not limited and may include sculpture, painting, printmaking, digital art, mixed media, photography, and film and video. African-American artists and artists of African descent internationally, who are able to demonstrate at least 3 years of professional commitment and are currently engaged in studio work, are eligible to apply. Artists who will be attending school during the residency, or who produce art as a hobby, are not eligible.

Studios Midwest
P.O. Box 291
Galesburg, IL 61402
www.galesburgarts.org/pages/studiosmidwest.html
Studios Midwest provides 5 visiting artists with an 8-week summer residency, which includes housing, studio space, a public slide show and exhibition, publicity, and discounts on art supplies. Artists are expected to have slides of their artwork available for informal presentation; participate in media publicity; show results of their summer work; and complete a program evaluation on departure.

Sundance Institute
(Site location: Sundance, UT)
8857 West Olympic Blvd
Beverly Hills, CA 90211
http://institute.sundance.org
The Sundance Institute provides emerging filmmakers with an opportunity to work and develop their projects and skills through a variety of programs. Contact organization for more information.

Torpedo Factory Art Center
105 N Union Street
Alexandria, VA 22314-3217
www.torpedofactory.org
The Torpedo Factory is the largest visual arts center in the United States, and includes 84 working studios and 6 galleries. The Factory provides studio space to artists working in fine arts and fine crafts. Juries are held annually in March, and artists are waitlisted for available studios.

Ucross Foundation Residency Program

30 Big Red Lane
Clearmont, WY 82835
www.ucrossfoundation.org
See page 214 for more information.

UrbanGlass

647 Fulton Street
Brooklyn, NY 11217
www.urbanglass.org
Visiting Artist Fellowships are granted to 3 international artists wishing to work in glass (2 fellowships to emerging artists, and one fellowship to an established artist). The 8-week residency includes access to all areas of the studio, technical support, materials, and a possible honorarium (room and board are not included).

USDA Forest Service

The USDA Forest Service sponsors artist-, teachers-, and scholars-in-residence through their Conservation and the Arts Program. For an overview of the program and specific information on each site, please visit *www.fs.fed.us/conservation-arts/residencies/index.htm.*

Hiawatha National Forest

Munising, MI
Professional working artists in various disciplines, media, and styles stay in remote Hiawatha National Forest facilities (cabins, camps, cottages) for up to 2 weeks.

Grey Towers National Historic Park

Milford, PA
The Artist-in-Residence Program at Grey Towers seeks to reestablish the connection between the arts and conservation, in the historic home of Gifford Pinchot, one of America's leading advocates of environmental conservation.

Aspen Guard Station, San Juan National Forest

Durango, CO
The Artist-in-Residence Program at the Aspen Guard Station is designed to promote creative means to communicate the values, processes, features, or resource management issues of the San Juan National Forest. Literary, visual, and performing artists from local, regional, and national sources are sought.

Vermont Studio Center

P.O. Box 613
Johnson, VT 05656
www.vermontstudiocenter.org
See page 218 for more information.

Villa Aurora

(Site locations: Berlin, Germany and
Los Angeles, CA)
520 Paseo Miramar
Pacific Palisades, CA 90272
www.villa-aurora.org
Villa Aurora is operated by sister German and U.S. organizations. The Los Angeles program accepts up to 16 writers, visual artists, photographers, musicians, composers, art historians, and filmmakers from Europe annually for 3-month residencies. In Berlin, 3-month residencies are awarded each year in literature, music composition, and film to 12 young (up to 40 years old) writers and artists living and working in Germany; 2 artists working together may share one grant. Visual artists are accepted by invitation only; students are not eligible.

Virginia Center for the Creative Arts

154 San Angelo Drive
Amherst, VA 24521
www.vcca.com
See page 220 for more information.

Visual Studies Workshop

31 Prince Street
Rochester, NY 14607
www.vsw.org
VSW sponsors artists' residencies in photography, artists' books, digital video and multimedia, 16mm film, and analog video. Residencies are project-based and last up to 1 month. VSW provides housing, access to facilities, and an honorarium, as funding allows.

Watershed Center for the Ceramic Arts

19 Brick Hill Road
Newcastle, ME 04553-9716
www.watershedcenterceramicarts.org
Watershed offers up to 20 summer residencies, and 4 winter (September–May) residencies to ceramic artists. Fully funded residents receive housing, meals, and studio space. Partially funded and work-exchange residencies are also available. Clay artists from across the country and abroad are welcome to apply.

Weir Farm Tust
735 Nod Hill Road
Wilton, CT 06897
www.nps.gov/wefa
See page 220 for more information.

Wellspring House
P.O. Box 2006
Ashfield, MA 01330
www.wellspringhouse.net
Wellspring House, located in the hills just east of
the Berkshires, is open from April until December.
Up to 5 writers and artists at a time are welcome for
periods of a week to a month or longer. Residency
fee applies. The House includes an extensive library
and a meditation room.

Weymouth Center
P.O. Box 939
Southern Pines, NC 28388
www.weymouthcenter.org
The Writers-in-Residence Program offers writers
stays of up to 2 weeks to pursue their work. The
former Boyd family estate is listed on the National
Historic Register, and was once host to F. Scott
Fitzgerald and Thomas Wolfe.

Wildacres Retreat
P.O. Box 280
Little Switzerland, NC 28749
www.wildacres.org
See page 226 for more information.

Women's Art Colony Farm
20 Overlook Road
Poughkeepsie, NY 12603
www.katemillett.com
Women writers, visual artists, and musicians are
welcome to apply for a summer residency at Millett
Farm, a self-supporting cooperative farm and art
colony. In exchange for housing, all residents
contribute 5 hours of work each morning, and chip
in for food.

Women's Studio Workshop
P.O. Box 489, 722 Binnewater Lane
Rosendale, NY 12472
www.wsworkshop.org
See page 228 for more information.

Woodstock School of Art
Route 212, P.O. Box 338
Woodstock, NY 12498
http://woodstockschoolofart.com
The Woodstock School of Art classes and workshops
in the visual arts are held year-round, and foster an
atmosphere of both freedom and seriousness. Artist
Residencies, as well as tuition scholarships, work-
exchange scholarships, and studio workspace are
available.

Workspace for Choreographers
567 Woodward Road
Sperryville, VA 22740
See page 230 for more information.

**Writers and Books Gell Center of the
Finger Lakes**
740 University Avenue
Rochester, NY 14607-1259
www.wab.org/gell
See page 232 for more information.

Writers' Colony at Dairy Hollow
515 Spring Street
Eureka Springs, AR 72632-3032
www.writerscolony.org
See page 234 for more information.

Helene Wurlitzer Foundation of New Mexico
P.O. Box 1891
Taos, NM 87571
The Foundation provides 3-month residencies to
up to 11 artists (painters, poets, sculptors, writers,
playwrights, composers, and occasionally photogra-
phers) at a time. Artists-in-residence are provided
with a private guest house, as well as studio space,
within walking distance of downtown Taos.

Yaddo
P.O. Box 395
Saratoga Springs, NY 12866
www.yaddo.org
See page 236 for more information.

The Yard
P.O. Box 405
Chilmark, MA 02535
www.dancetheyard.org
See page 238 for more information.

International Residencies

The following list represents residency opportunities outside the United States (though several maintain a U.S. office). The field of international residency programs is served by Res Artis: The International Association of Residential Arts Centres and Networks. In addition, Trans Artists maintains an extensive guide to resources for artists internationally. Due to research limitations, we are not able to provide more than the basic contact information for the majority of these programs; however, we encourage those in search of international residencies to supplement this listing with information available through Res Artis and Trans Artists.

Res Artis is a worldwide network of residential arts centers and programs, providing a forum to support, and representing the interests of, residential arts centers and programs internationally.

Keizersgracht 462 sous
1016 GE Amsterdam
The Netherlands
+31 (0) 20 612 6600
office@resartis.org
www.resartis.org

Trans Artists offers information on cultural exchanges, artist-in-residence programs, and work opportunities in the Netherlands and abroad. Trans Artists stimulates artists to create networks of their own, and promotes international contacts and cooperation between artists, artist-in-residence centers, artists' initiatives, cultural institutions, and art councils.

Keizersgracht 462 sous
1016 GE Amsterdam
The Netherlands
+31 (0) 20 612 7400
info@transartists.nl
www.transartists.nl

UNESCO, International Fund for the Promotion of Culture offers bursaries for artists to participate in residencies.

1 Rue Miollis
Paris Cedex 15, 75732
France
www.unesco.org/culture/ifpc

Artists-in-Residence, CH is an additional network of residency programs.

Pelzgasse 26
Aarau 5000
Switzerland
www.artists-in-residence.ch

The following list represents the most current Res Artis members (as of April 2004), as well as several additional programs. Although every effort was made to check spellings and addresses, there may be errors or omissions.

AUSTRALIA

Artspace the Gunnery
43-51 Cowper Wharf Road Woolloomooloo
Sydney 2011
Australia
www.artspace.org.au

Bundanon Trust
P.O. Box 3343 NSW
North Nowra 2541
Australia
www.bundanon.com.au

Gertrude Contemporary Art Spaces
200 Gertrude Street Fitzroy
Melbourne Victoria 3065
Australia
www.gertrude.org.au

Hill End Artist-in-Residence Program, Bathurst Regional Art Gallery
70-78 Keppel Street NSW
Bathhurst 2795
Australia
www.hillendart.com

International Art Space / IASKA
Perth Business Centre, P.O. Box 8087
Perth Western Australia 6849
Australia
www.iaska.com.au

Salamanca Arts Centre
77 Salamanca Place TAS
Hobart 7004
Australia
www.salarts.org.au

Union Bank Arts Centre
22 Fraser Street
Clunes Victoria 3370
Australia
www.unionbankartscentre.com.au

Visual Arts/Craft Fund of the Australia Council for the Arts
372 Elizabeth Street, Surry Hills NSW
Sydney 2010
Australia
www.ozco.gov.au

AUSTRIA

Artists-in-Residence, Vienna
Schottengasse 1
Vienna 1014
Austria
karin.zimmer@bka.gv.at

Artists-in-Residence, Leube Baustoffe GMBH
Gartenauerplatz 9
Gartenau 5083
Austria

Künstlerhaus Büchsenhausen
Weiherburggasse 13/12 A
Innsbruck 6020
Austria
www.buchsenhausen.at

WUK
Währinger Strasse 59
Wien 1090
Austria
www.wuk.at

BELGIUM

Air-Antwerpen
Oosterweelsesteenweg 3
Antwerpen 2030
Belgium
http://users.pandora.be/hal-antwerpen

BRAZIL

Sacatar Foundation
Rua da Alegria 10
Itaparica Bahia 44460-000
Brazil
www.sacatar.org
See page 190 for more information.

CANADA

The Banff Centre/Leighton Studios
107 Tunnel Mountain Drive
Banff Alberta T1L 1H5
Canada
www.banffcentre.ca
See page 88 for more information.

Bishogama International Ceramic Workshop Alberta Society (BICWA)
Box 144
Hythe Alberta T0H 2C0
Canada
bibipot@telusplanet.net

Centre de Sculpture Est-Nord-Est
335 Avenue de Gaspé Ouest
Saint-Jean-Port-Joli, Québec G0R 3G0
Canada
www.estnordest.org

Conseil des Arts et des Lettres du Québec
500 Place d'Armes, 15e étage
Montréal Québec H2Y 2W2
Canada
www.calq.gouv.qc.ca

Regroupement des Centres D'Artistes Autogérés du Québec
3995 Rue Berri, bureau 100
Montréal Québec H2L 4H2
Canada
www.rcaaq.org

University of Saskatchewan, Emma Lake Kenderdine Campus
Room 133, Kirk Hall, 117 Science Place
Saskatoon, Saskatchewan S7N 5C8
Canada
www.emmalake.usask.ca
See page 216 for more information.

CHINA

Chinese European Art Center
Xiamen University Art Center
Xiamen Fujian Province 361005
China
www.ceac99.com

Imagine Gallery, Western Academy of Beijing
P.O. Box 8547, #10 Laiguangyingdonglu
Chaoyang District
Beijing 100103
China
www.imagine-gallery.com

Jingdezhen Sanbao Ceramic Art Institute
Sijiali Sanbao Jingcheng Town
Jingdezhen, Jiangxi Province 333001
China
www.chinaclayart.com

Red Gate Artists Residency Program
International P.O. Box 9039
Beijing 100600
China
www.redgategallery.com

COLOMBIA

Centro Colombo Americano
Carrera 45 No. 53-24 AA 8734
Medellin
Colombia
www.colomboworld.com

COSTA RICA

The Julia and David White Artists' Colony
Apdo. 102-6100
Ciudad Colón
Costa Rica
www.forjuliaanddavid.org
See page 234 for more information.

DENMARK

Council of Danish Artists
Rosenvaengets Allé 37, 1
Copenhagen 2100
Denmark
dkr@dansk-kunstnerraad.dk

National Workshop for Arts and Crafts
Strandade 27B
Copenhagen 2300
Denmark
uh@arts-crafts.dk

ESTONIA

Estonian Artists Association, c/o Tallinn Art Hall
Vabaduse Väljak 6
Tallinn 10146
Estonia
www.eaa.ee

Polli Talu Arts Center
Rame küla
Vatla 90103
Estonia
www.pollitalu.org

FINLAND

Finnish Artist Studio Foundation
Lemuntie 6
Helsinki 00510
Finland
www.artists.fi/studio

Galleria Nunes
Pohloinen Rautatiekatu 17
Helsinki 00100
Finland
www.galleria-nunes.com

HIAP Helsinki International Artist-in-Residence Programme
Tallberginkatu 1 C/97
Helsinki 00180
Finland
www.kaapeli.fi/hiap

Kolin Ryynänen Art and Culture Center, c/o The Arts Council of North Karelia
P.O. Box 90
Joensuu 80101
Finland
www.pktaidetoimikunta.net

Nordic Institute for Contemporary Art/NIFCA
Suomenlinna/Sveaborg B
Helsinki 28190
Finland
www.nifca.org

Raumars Artist-in-Residence Programme, Association c/o Lönnström Art Museum
Suvi Valtakatu 7 26100
Rauma 26100
Finland
www.raumars.org

Salo Art Museum Veturitalli Salon Taidemuseo
Mariankatu 14
Salo 24240
Finland
www.salo.fi

Stiftelsen Pro Artibus
Villa Ormnäs
Ekenäs 10600
Finland
www.proartibus.fi

The Aland Archipelago Guestartist Residence, Kökarkultur
Hellsö
Kökar-Aland 22730
Finland
www.kokarkultur.com

FRANCE

Air-Vallauris
Place Lisnard, 1 Boulevard des Deux Vallons
Nice-Vallauris 06220
France
www.air-vallauris.com

The Camargo Foundation
P.O. Box 75
Cassis Cedex 13714
France
www.camargofoundation.org

Centre d'Art de Marnay Arts Centre (CAMAC)
1 Grande Rue
Marnay-sur-Seine 10400
France
www.camac.org

La Belle Auriole
Mas de la Belle Auriole
Opoul 66600
France
www.labelleauriole.co.uk

La Napoule Art Foundation
BP 940
Mandelieu-La Napoule 06210
France
www.lnaf.org

Le Moulin à Nef
Le Port
Auvillar 82340
France
www.moulinanef.org

Les Ateliers Fourwinds
La Julière
Aureille 13930
France
www.ateliersfourwinds.org

Pépiniéres Européennes pour Jeunes Artistes
Rue Paul Leplat 9/11
Marly-Le-Roi Cedex 78164
France
www.art4eu.net

Triangle France, Friche la Belle de Mai
41, Rue Jobin
Marseille Cedex 03 13331
France
www.lafriche.org/triangle

GERMANY

Akademie Schloss Solitude
Schloss Solitude Haus 3
Stuttgart 70197
Germany
www.akademie-solitude.de

American Academy in Berlin
14 East 60th Street, Suite 604
New York, NY 10022-1001
USA
www.americanacademy.de
See page 58 for more information.

International Cultural Center Ufa-Fabrik Berlin
Victoriastr. 10-18
Berlin 12105
Germany
www.ufafabrik.de

Internationales Künstlerhaus Villa Concordia
Unterer Kaulberg 4
Bamberg 96049
Germany
www.villa-concordia.de

Künstlerhaus Bethanien
Mariannenplatz 2
Berlin 10997
Germany
www.bethanien.de

Künstlerhaus Schloss Balmoral
Villenpromenade 11
Bad Ems 56130
Germany
www.balmoral.de

Künstlerhäuser Worpsweded
Bergstr. 1
Worpswede 27726
Germany
www.kuenstlerhaeuser-worpswede.de

Künstlerinnenhof Die Höge
Högenhausen 2
Bassum 27211
Germany
www.hoege.org

Oberpfälzer Künstlerhaus
Fronberger Strasse 31
Schwandorf 92421
Germany
www.schwandorf.de

Schloss Bröllin International Theatre Research Location
Dorfstr. 3
Bröllin 17309
Germany
www.broellin.de

Schloss Plüschow, Mecklenburgisches Künstlerhaus
Am Park 6
Plüschow 23936
Germany
www.plueshow.de

Villa Aurora
Jägerstrasse 23 / Zimmer 312
D-10117 Berlin
Germany
www.villa-aurora.org

HUNGARY

League of Nonprofit Art Spaces, Studio Gallery
Kópiró uten 6 1053
Budapest
Hungary
studgal@c3.hu

ICELAND

Esjuberg International Culture Center
Esjuberg 2 116 Kjalarnes
Reykjavik
Iceland
solart@simnet.is

INDIA

Auroville Centre, Kala Khoj, Culture and Exchange
Prarthana Community
Auroville-605 101 Tamil Nadu
India
kalakhoj@auroville.org.in

Kanoria Centre for Arts
Navarangpura 390009
Ahmedabad
India
www.kanoriacorp.com

Sanskriti Foundation
C-11 qutab Institutional area 110016
New Delhi
India
www.sanskritifoundation.org

IRAN

Paradise, The International Center for Creation and Exhibition of Art in Nature
no. 94 Shahid Saheb Zamani, Sad Dastgah.
Pirozist. 17657
Tehran
Iran
www.RiverArt.Net/Paradise

IRELAND

National Sculpture Factory
Albert Road
Cork
Ireland
www.nationalsculpturefactory.com

The Fire Station Artists' Studios
9-11 Buckingham Street, Lower 1
Dublin
Ireland
www.firestation.ie

The Tyrone Guthrie Centre
Annaghmakerrig, Newbliss County
Monaghan
Ireland
www.tyroneguthrie.ie

ISRAEL

Herzeliya Artists' Residence
7 Yodffat St.
Herzeliya 46583
Israel

Kea-Project, c/o Givon Gallery
35 Gordon Street
Tel Aviv 63414
Israel
givonn@bezegint.net

ITALY

American Academy in Rome
7 East 60th Street
New York, NY 10022
USA
www.aarome.org

Bellagio Study and Conference Center
420 Fifth Avenue, Rockefeller Foundation
New York, NY 10018-2702
USA
www.rockfound.org

Bogliasco Foundation, Liguria Study Center
10 Rockefeller Plaza, 16th Floor
New York, NY 10020-1903
USA
www.liguriastudycenter.org
See page 92 for more information.

Civitella Ranieri Foundation
Localita Civitella Ranieri
Umbertide 06019 PG
Italy
www.civitella.org
See page 104 for more information.

International School of Drawing, Painting and Sculpture
via Regina Margherita 6
Montecastello di Vibio 06057 PG
Italy
www.giotto.us
See page 135 for more information.

Scuola Internazionale di Grafica
San Marcuola, Cannaregio
Calle Seconda del Cristo, 1798
Venezia 30121
Italy
www.scuolagrafica.it
See page 196 for more information.

JAPAN

Akiyoshidai International Art Village
50 Nakayamada, Akiyoshi, Shuho-cho
754-0511 Mine-gun Yamaguchi
Japan
www.trans.artnet.or.jp

Arcus
2418 Itatoi
302-0101 Moriya Ibaraki
Japan
www.arcus-project.com

Kyoto Art Center
Muromachi Takoyakushi
604-8156 Nakagyo-ku Kyoto
Japan
www.kac.or.jp

Studio Youkobo
Zempukuji 3-2-10
167-0041 Suginamiku Tokyo
Japan
www.youkobo.co.jp

LATVIA

Open-Air Museum and Sculpture Park at Pedvale
Codes 45A 1058
Riga
Latvia
www.pedvale.lv

The Artists' Union of Latvia, Riga Artist's Residencies and Zvartavas Castle
11. Novembra krastmala 35 LV-1050
Riga
Latvia
makslasmaja@re-lab.net

LITHUANIA

Europos Parkas
Joneikiskiu Kaimas, Azulaukes Pastas 4013
Vilnius
Lithuania
www.europosparkas.lt

THE NETHERLANDS

Amsterdam Fund for the Arts
Herengracht 609
Amsterdam 1017 CE
The Netherlands
www.afk.nl

European Ceramic Work Centre
Zuid-Willemsvaart 215
Hertogenbosch 5211 SG
The Netherlands
www.ekwc.nl

Foundation for Visual Arts Design and Architecture
P.O. Box 773
Amsterdam 1000 AT
The Netherlands
www.fondsbkvb.nl

Jan Van Eyck Academy
Academieplein 1
Maastricht 6211 KM
The Netherlands
www.janvaneyck.nl

Nederlands Instituut Voor Animatiefilm (NIAf)
Willem 2 straat 47, P.O. Box 9358
Tilburg 5000 HJ
The Netherlands
www.niaf.nl

Rijksakademie Van Beeldende Kunsten
Sarphatistraat 470
Amsterdam 1018 GW
The Netherlands
www.rijksakademie.nl

Stichting Atelierbeheer Slak
Utrechtsestraat 12
Arnhem 6811 LT
The Netherlands
www.slak.nl

Thami Mnyele Foundation
Postbus 10768
Amsterdam 1001 ET
The Netherlands
www.thami-mnyele.nl

NEW ZEALAND

New Pacific Studio
Mount Bruce R.D.1
Masterton
New Zealand
www.newpacificstudio.org

NORWAY

Lademoen Kunstnerverksteder/LKV
Mellomveien 5 7042
Trondheim
Norway
www.1-k-v.no

The Nordic Artists' Centre Dalsasen
6963 Dale i Sunnfjord
Norway
www.home.no.net/nkd

PORTUGAL

Clube Português de Artes e Ideas
Largo Rafael Bordalo Pinheiro, 29-2 1200-369
Lisboa
Portugal
www.artesideias.com

**Fundaçao da Casa de Mateus,
Res. de Artistas**
Casa de Mateus 5000
Vila Real
Portugal
www.utad.geira.pt/casamateus

Obras
Herdade da Marmeleira N18 7100 Cp 2
EVORAMENTE (Alentejo)
Portugal
www.obras-art.org

**Projecto Núcleo de Desenvolvimento
Cultural/Bienal de Ceveira**
Mercado Municipal-Apartado 69 4920-275
Vila Nova de Cerveira
Portugal
www.bienaldecerveira.com

REPUBLIC OF CONGO

Afrique Profonde
P.O. Box 4807
Pointe-Noire
Republic of Congo
www.afriqueprofonde.org

SENEGAL

Groupe 30 Afrique
HLM GRAND YOFF 2801
Dakar
Senegal
www.africinfo.org

SINGAPORE

Studio 106/Lasalle-Sia College of the Arts
90 Goodman Road 439053
Singapore
www.lasallesia.edu.org

SOUTH AFRICA

Caversham Trust
P.O. Box 87 Balgowan, 3275
Kwazulu-Natal
South Africa
cavtrust@mweb.co.za

SOUTH KOREA

The Art Studio Changdong and Goyang
601-107 Chang-dong Dobong-gu
Seoul 132-040
South Korea
www.artstudio.or.kr
See page 82 for more information.

SPAIN

**Centre d'Art i Natura, Ajuntament de
Farrera**
La Bastida, S/N 25595
Farrera de Pallars
Spain
http://farrera.ddl.net/can

Fundación Valparaiso
Apartado de correos 836
04638 Mojácar Playa
Almeria
Spain
vparaiso@futurnet.es

Masia Can Serrat, International Art Centre
08294 El Bruc 08294
Barcelona
Spain
www.canserrat.org

Smart Inns Ltd.,
El Refugi Irlandes Farrera
Pallars Sobira 25595
Lleida
Spain
smartinns@worldonline.es

SWEDEN

Baltic Art Center
Skeppsbron 24
Visby SE-62157
Sweden
www.balticartcenter.com

International Artists' Studio Program in Sweden
Box 1610, Fredsgatan
Stockholm 12 11186
Sweden
www.iaspis.com

Konstepidemin
Konstepidemins väg
Göteborg 6 41314
Sweden
www.konstepidemin.com

SWITZERLAND

IAAB International Austausch Ateliers Region Basel
St. Albon Vorstadt 5
BASEL 4002
Switzerland
www.iaab.ch

Künstlerhaus Boswil
Flurstrasse 21
Boswil 5623
Switzerland
www.kuenstlerhausboswil.ch

Stiftung Binz39
Rütistrasse 9
Baden 5401
Switzerland
hanneke.freuhauf@infogem.ch

TAIWAN

Taipei Artist Village
N. 7 Pp 28-37
ge.org
See page 212 for more information.

TURKEY

Pi Artworks
Muallim Naci Cad. No. 63
Ortaköy 80840
Istanbul
Turkey
www.pi-artworks.com

Sea Elephant Travel Agency
Defterdar Yokusu No. 68/24-B Cihangir 80060
Istanbul
Turkey
huseyinalptekin@yahoo.com

UNITED KINGDOM

Arts Centre
8 Priest Hill Caversham
Reading RG4 7RZ
United Kingdom
mdlizieri@aol.com

Cove Park
2 Norfolk Road
London NW8 6AX
United Kingdom
www.covepark.org

Delfina Studio Trust
50 Bermondsey Street
London SE1 3UD
United Kingdom
www.delfina.org.uk

Scottish Sculpture Workshop
1 Main Street, Lumsden
Lumsden Aberdeenshire AB54 4JN
United Kingdom
www.ssw.org.uk

The Patrick Allan-Fraser of Hospitalfield Trust
Hospitalfield House
Arbroath DD11 2N4
United Kingdom
www.hospitalfield.org.uk

Artists Communities

Extended Profiles

18th Street Arts Center

"It's a great experience to be able to share in this community of artists who are open and sharing with each other. It's been a learning experience here really seeing how artists and arts organizations can partner or just be a community together. This is definitely one of the answers for the art world, that there be more places like this." —MICHAEL MASUCCI

1639 18th Street
Santa Monica, CA 90404
Phone: (310) 453-3711
Fax: (310) 453-4347
E-mail: *18thstreet@18thstreet.org*
Web: *www.18thstreet.org*

Mission: Dedicated to the advancement of culture through artists working with issues of social consciousness, community, diversity, and beauty.

Founded: Organization and Residency, 1988.

Location: One and a half miles from the ocean in the heart of Santa Monica, a suburb in the Los Angeles Westside area.

Past Residents: Guillermo Gómez-Peña, Highways Performance Space, Phranc, Cornerstone Theater Company, Barbara T. Smith, The Empowerment Project, *High Performance* magazine, Denise Uyehara, Keith Mason.

From the Director: "18th Street is unique, a genuine artists' community in a city characterized by decentralization."
—CLAYTON CAMPBELL, CO-DIRECTOR

Eligibility: Los Angeles–area resident or resident of countries that 18th Street has cooperative agreements with (as of 2004, France, Australia, and Taiwan).

Studios & Special Equipment Available: Studios for dance/choreography, exhibition/installation, painting, photography, and writing; live/work studios also available for international artists.

Housing, Meals, Other Facilities & Services: *Housing:* International artists are provided with a private, furnished live/work space (with bath and kitchenette). *Meals:* Artists are responsible for their own meals. *Other facilities/services:* Common room or meeting space provided for residents' use; laundry facilities onsite; smoking allowed outdoors, in private living areas, and in studios. Pets allowed (cleaning deposit required). Spouses/partners and children allowed for full stay.

Accessibility: Only public areas are accessible.

Application & Residency Information:

Application available online

Application deadline(s): Ongoing

Resident season(s): Year-round

Average length of residencies: Varies

Number of artists-in-residence in 2003: 35

Average number of artists-in-residence present at one time: 28

Selection process: Outside professional jury/ panel selection for foreign artists; outside selection committee for local residents.

Artists Responsible for: *Local residents:* Materials and monthly (subsidized) studio rent for local artists and organizations well below market value. *International residents:* Food, materials, and travel (varies according to sponsorship).

Organization Provides: *Local residents:* Program administration and studio. *International residents:* Housing, studio, and monthly stipend (varies according to sponsorship).

Other Expectations & Opportunities: Artists are given the option to participate in public exhibitions/presentations and studio tours, and make a donation of artwork. All local artist residents and organizations must contribute a negotiated service on an annual basis.

Abrons Arts Center/Henry Street Settlement

"The most positive aspect of my residency experience was the neighborhood/community of the Lower East Side, which had an unexpectedly strong impact on my work. I also developed relationships with interesting organizations, community people, and stores, as well as other artists who provided me with endless support and encouragement. Through them I have learned how this organization keeps its vitality and diverse function."

466 Grand Street
New York, NY 10002
Phone: (212) 598-0400
Fax: (212) 505-8329
E-mail: *info@henrystreet.org*
Web: *www.henrystreet.org/ abronsartscenter*

Mission: The mission of Henry Street Settlement is to provide opportunities for people to improve their lives. Our Artist-in-Residence Studio Space Program continues this concern with providing exposure, support, and career opportunities for emerging artists, artists of color, and women artists.

Founded: Organization, 1893; Residency, 1976.

Location: At the Abrons Arts Center, a modern visual and performing community arts center on the Lower East Side of Manhattan in New York City. (Currently piloting new components in black-and-white photography and welding with a nearby art school, the Educational Alliance.)

Past Residents: Willie Birch, Nicole Cherubini, Yoko Inoue, Maria Quiterrez, Shirin Neshat, Tara Sabharwal, Juan Sanchez, Koji Shimizu, Danielle Tegeder, Mary Ting, Lynn Yamamoto.

From the Director: "Our Artist-in-Residence Studio Space Program is part of Henry Street Settlement's tradition of valuing art and the artist and providing opportunities, access, and support for people in the early stages of their careers. Over the years, the program has attracted a diverse group of highly talented individuals whose multicultural perspective and interest in materials and process has enriched their own art, their interaction with one another, and their impact on those at the Arts Center and the Settlement. I have greatly enjoyed meeting the artists-in-residence through the years and learning about their work, their ideas, and even about their struggles. Hopefully, their year here provides a productive respite and their experiences can help with taking steps toward their creative goals." — SUSAN FLEMINGER, DIRECTOR, VISUAL ARTS PROGRAM

Eligibility: Practicing fine artist, New York City resident.

Studios & Special Equipment Available:
Ceramics/pottery studio (ceramics artist must
be a sculptor, not a production potter),
exhibition/installation space, painting studio,
small-scale sculpture studio; metal shop and
black-and-white photography studio at a
nearby location, available at specific times.

Housing, Meals, Other Facilities & Services:
Housing and meals are not provided. Common
room is available for residents' use; computer
with Internet connection available in office
areas; Internet connection available in studio
area, but artists must have own laptop. The
building is nonsmoking. Artists are asked to
make use of the studio at least twenty hours
per week; studios are generally available
during the week from 9 A.M. to 9 P.M., as
well as Saturdays and most Sundays.

Accessibility: Studios and public areas are
accessible.

Application & Residency Information:

Application available online

Application deadline(s): May 1

Resident season(s): September 15–August 31

Average length of residencies: 1 year

Number of artists-in-residence in 2003: 6

Average number of artists-in-residence
present at one time: 6

Selection process: Outside professional
jury/panel selection and internal selection.

Artists Responsible for: All materials and
expenses.

Organization Provides: Materials stipend,
studios, and program administration.

Other Expectations & Opportunities:
Artists are expected to participate in public
exhibitions/presentations and studio tours
during the annual Open House in June;
donation of artwork is optional. Henry Street
Settlement is a social service agency that
has programs for seniors, mental health
clients, homeless families, battered women,
preschool age and school children of all ages
both at the Settlement and in NYC public
schools. There are many opportunities for
artists-in-residence to design and lead arts
workshops at various Settlement sites and to
become a docent in the ongoing gallery edu-
cation program based on our contemporary
exhibitions at the Abrons Arts Center. We
welcome the artists as volunteers but prefer,
depending on funding, to pay them for these
services.

Edward F. Albee Foundation / William Flanagan Memorial Creative Persons Center

"My studio at Albee's had what seemed like forty-foot-high ceilings, with huge barn doors open to the woods. It was pure luxury simply to have the time to think and to give the paintings a chance to breathe." — ROBERT FARBER

14 Harrison Street
New York, NY 10013
Phone: (212) 226-2020
Fax: (212) 226-5551
E-mail: *albeefdtn@aol.com*
Web: *www.pipeline.com/ ~jtnyc/albeefdtn.html*

Mission: To provide studio space and housing for visual artists, writers, and composers each month of the summer.

Founded: Organization and Residency, 1967.

Location: Approximately two miles from the center of Montauk, New York, and the Atlantic Ocean, "The Barn" rests in a secluded knoll that offers privacy and a peaceful atmosphere.

Past Residents: Spalding Gray, Christopher Durang, Stephen Buckley, Mia-Westerlund Roosen, David Greenspan, Sean Scully, Alice Adams, A. M. Homes.

From the Director: "After *Who's Afraid of Virginia Woolf*, it occurred to me to do something useful with the money rather than give it to the government . . . We want to take a chance on people." — EDWARD ALBEE

Eligibility: The standards for admission are, simply, talent and need. The Foundation encourages qualified artists from all backgrounds to apply, and does not discriminate against anyone on any basis whatsoever, including preexisting medical conditions such as AIDS.

Studios & Special Equipment Available: General-use studio space.

Housing, Meals, Other Facilities & Services: *Housing:* Private room in a shared facility, which can comfortably accommodate up to five persons at a time. *Meals:* Residents are responsible for their own food and meals. *Other facilities/services:* Common room or meeting space for residents' use; laundry facilities onsite; computer with Internet connection in common area; bicycles available for residentís use; local public transportation. Pets allowed on a per-case basis (please call to make arrangements). Spouses/partners and children allowed for visits only (please call for guidelines).

Accessibility: Facilities are not accessible.

Application & Residency Information:

Application available online

Application deadline(s): April 1 (postmarked)

Resident season(s): June–September

Average length of residencies: 1 calendar month

Number of artists-in-residence in 2003: 20

Average number of artists-in-residence present at one time: 5

Selection process: Outside professional jury/panel selection.

Artists Responsible for: Food, travel, and materials.

Organization Provides: Housing and studios.

American Academy in Berlin

U.S. Office:
14 East 60th Street, Suite 604
New York, NY 10022
Phone: (212) 588-1755
Fax: (212) 588-1758
E-mail: *applications@*
americanacademy.de
Web: *www.americanacademy.de*

Mission: To establish
intellectual and professional
ties between Germans
and Americans in the arts,
humanities, and public affairs.

Founded: Organization, 1997;
Residency, 1998.

Location: The Academy occupies the Hans
Arnhold Center, a historic lakeside villa in the
Wannsee district of Berlin, Germany.

Past Residents: Jenny Holzer, Alex Katz,
Sue de Beer, Xu Bing, Jeffrey Eugenides,
T. J. Clark, Michael Hersch, C. K. Williams,
Jane Kramer.

Eligibility: Candidates must be either
American citizens or permanent residents and
in both cases should be permanently living
and working in the United States.

Studios & Special Equipment Available:
Fellows are given the use of the studio at the
Kunstlerhaus Bethanien.

Housing, Meals, Other Facilities & Services:
Housing: Individual apartment for artist-in-
residence (individual house available on a
very limited basis for families); furnishings
and linens provided. *Meals:* Breakfast and
dinner provided; vegetarian meals available;
kitchen facilities available to residents. *Other
facilities/services:* Common room for residents'
use plus library area for research; laundry
facilities onsite; computer with Internet
connection in living or studio area; local
transportation available. Smoking permitted
outdoors only. Pets allowed. Spouses/partners
and children allowed for full stay (spouses/
partners who stay for the semester will be
charged $450 per month for board; space for
families with children is extremely limited).

Accessibility: Facilities are fully accessible.

Application & Residency Information:
Application available online
Application deadline(s): December 1 for visual
artists; November 1 for all other applicants
Resident season(s): Fall and Spring semesters
Average length of residencies: 4–5 months
Number of artists-in-residence in 2003: 1
Average number of artists-in-residence
present at one time: 1
Selection process: Outside professional
jury/panel selection.

Artists Responsible for: Materials.

Organization Provides: Housing, meals, studio, and roundtrip travel to/from Berlin; general stipend of $3,000–$5,000 per month, depending on level of attainment.

Other Expectations & Opportunities: Artists-in-residence are expected to participate in public exhibitions/presentations onsite, and to donate a piece of artwork.

Anderson Center for Interdisciplinary Studies

"I will always remain in awe of the emotional, physical, philosophical, and spiritual environment that I was allowed to share with a handful of remarkable, dedicated people. Thank you so much for the most memorable and important experience in my life as an artist." —REA MINGEVA

163 Tower View Drive
Red Wing, MN 55066
Phone: (651) 388-2009
Fax: (651) 388-5538
E-mail: *info@andersoncenter.org*
Web: *www.andersoncenter.org*

Mission: The Anderson Center at Tower View is a gathering place rich in historical significance, providing a setting conducive to the pursuit of creative projects and acting as a forum for important contributions to local, regional, and national communities.

Founded: Organization and Residency, 1995.

Location: Five miles north of Red Wing, Minnesota, on 320 acres of farm and bottomlands, near the confluence of the Cannon and Mississippi Rivers. All buildings are on the National Historic Register and contain a rich, storied history.

Past Residents: Maggie Anderson, Greg Pape, Dorianne Laux, Gendron Jensen, Megan Flood, Dean Magraw, Diane Hanson, Shelly Haven.

From the Director: "The Anderson Center honors the immemorial spirit of the creative journey. Artists, writers, and scholars arrive as separate individuals and over the course of their stay are born into a creative family. While at the Center, resident-fellows work on a clearly defined project, engage in the interdisciplinary life of the Center, and make a substantive contribution to the community in the form of an appearance at local civic groups or area schools." — ROBERT HEDIN, EXECUTIVE DIRECTOR

Eligibility: The Anderson Center accepts emerging and established visual and performing artists, writers, and scholars of all kinds. The Anderson Center believes strongly that a mixture of disciplines is stimulating and productive to everyone involved. The Center encourages emerging artists and scholars as well as those at more advanced stages of development and careers.

Studios & Special Equipment Available: Facilities for ceramics/pottery (indoor and outdoor kiln), dance/choreography, exhibition/installation, glassblowing, music/piano studio, painting, photography (black-and-white only), sculpture, woodworking (basic tools and machinery available), and writing.

Housing, Meals, Other Facilities & Services:
Housing: Private room in a shared facility; some shared baths; furnishings and linens provided. *Meals:* Formal dinner served; food provided for other meals; vegetarian meals available; cooking/kitchen facilities available to residents. *Other facilities/services:* Common room or meeting space for residents' use; laundry facilities onsite; smoking allowed outdoors only; computer with Internet connection available; public transportation available. Spouses/partners and children allowed for visits only (nominal fee for meals and one-night weekend stays).

Accessibility: Studios, public areas, and main floor of residence are accessible.

Application & Residency Information:

Application available online

Application deadline(s): February 1 for May–July; March 1 for August–October

Resident season(s): May, June, July; August, September, October

Average length of residencies: 2–4 weeks

Number of artists-in-residence in 2003: 40

Average number of artists-in-residence present at one time: 5

Selection process: Outside professional jury/panel selection.

Artists Responsible for: Travel and materials.

Organization Provides: Housing, meals, and studios.

Additional Support: Special grants/fellowships available in July for emerging artists and writers from New York City or Minnesota only.

Other Expectations & Opportunities:
It is Anderson Center's belief that the organization bears a responsibility to introduce and to broaden the awareness of new and unique disciplines to the community. Artists have the option of participating in public exhibitions/presentations (both onsite and offsite), studio tours, and the donation of artwork.

Anderson Ranch Arts Center

"The last three months were the most productive of my art career. I took risks and pushed the limits of the material and my imagination. Anderson Ranch lent itself to experimentation, where success varied, but failure was never mentioned. It was a nonjudgmental environment; every result was enlightening and to be shared with a supportive and interested community. The residency was a pivotal learning experience in all ways artistically, communally, and personally." — RUTH BORGENICHT

5263 Owl Creek Road
Snowmass Village, CO 81615
Phone: (970) 923-3181
Fax: (970) 923-3871
E-mail: *scasebeer@andersonranch.org*
Web: *www.andersonranch.org*

Mission: Anderson Ranch Arts Center is a learning community dedicated to creativity and growth through the making and understanding of the visual arts.

Founded: Organization, 1966; Residency, 1987.

Location: Anderson Ranch is located in the resort community of Snowmass Village, Colorado, ten miles west of Aspen and 160 miles west of Denver. Formerly a turn-of-the-century sheep ranch, Anderson Ranch was transformed into an artists' community in 1966.

Past Residents: Laurie Anderson, Deborah Butterfield, Bill Jensen, Sally Mann, Wendy Maruyama, Takashi Nakazato, Juan Quezada, Alexis Smith, James Rosenquist, Peter Voulkos.

From the Director: "The Residency program provides artists with focused time for unfettered exploration and completion of work in a supportive setting. The Program encourages personal growth and interchange between artists. Residents use the Ranch's facilities and support staff for conceptual development, intensive production of work, and interaction and collaboration with other residents."
—JAMES BAKER, EXECUTIVE DIRECTOR

Eligibility: The residency program is intended for independent visual artists working in one or more of the following media: ceramics, digital imaging, furniture and woodworking, painting and drawing, installation, photography, printmaking, and sculpture. The program encourages personal growth and interchange between artists.

Studios & Special Equipment Available: Ceramics/pottery (four gas kilns, one-chamber wood kiln, large and small soda kilns, many electric kilns, and a three-chamber noborigama wood kiln); digital media (Apple G4 and G5 computers, Epson Stylus Photo 1280 and 2200 color printers, Epson 9600 side format archival

printer, and several high-resolution scanners); painting (each resident is provided ~300-square-foot studio space, well-lit and ventilated with thirteen-foot ceilings); photography (black-and-white facility with fifteen Saunders 4500 diffusion enlargers, Schneider lenses, JOBO CPP-2 processor, compressed air system at every enlarging station, automatic water temperature control at all sinks, densitometer, and two UV exposure units); printmaking (lithography and etching presses); sculpture (tig, mig, and stick/arc welders, plasma cutter, gas forge, oxygen and acetylene torches, sand-blasting cabinet, air compressor and pneumatic tools, small metal foundry, grinders, table saw, chop saw, band saws, drill press, bench grinder, and sanders); and woodworking (one large machine room, two bench rooms, upstairs turning studio, two 10" table saws, 8" and 12" joiners, 13" and 18" planers, 14" and 20" band saws, crosscut saws, drill press, and state-of-the-art lathes).

Housing, Meals, Other Facilities & Services:
Housing: Private room and private bath in a shared facility; furnishings and linens provided. *Meals:* Breakfast and dinner provided; vege-tarian meals available. *Other facilities/services:* Common room/meeting space for residents' use; laundry facilities onsite; smoking permit-ted outdoors only; computer with Internet connection available in common area; some public transportation. Spouses/partners allowed for visits only.

Accessibility: While the studios and housing are wheelchair accessible, it snows an average of 150 inches per year in Snowmass Village, making the outside paths difficult to maneuver in a wheelchair.

Application & Residency Information:
Application available online
Application deadline(s): April 1
Resident season(s): Fall (October–December), Winter (January–April), or October–April
Average length of residencies: 2, 3, and 6 months
Number of artists-in-residence in 2003: 29
Average number of artists-in-residence present at one time: 25
Selection process: Internal selection.

Artists Responsible for: Application fee—$10; studio fee—$250/month; room and board—$875/month; food, travel, and all studio materials and firings.

Organization Provides: Facilities and equipment, program administration.

Additional Support: Joseph Fellowship available to U.S. citizens of racial minority.

Other Expectations & Opportunities:
Residents are required to work in the café for two hours a night over a two-week period, and are required to work a total of six hours of dorm cleanup during their stay.

Archie Bray Foundation

"I think of the Bray as a central terminal where passengers are always coming and going. Each time someone new arrives, they bring a new perspective, a new talent. Each time someone leaves they take with them a piece of accumulative experience of fifty years." — LUCY BRESLIN

2915 Country Club Avenue
Helena, MT 59602
Phone: (406) 443-3502
Fax: (406) 443-0934
E-mail: *archiebray@archiebray.org*
Web: *www.archiebray.org*

Mission: The founding mission was to make available for all who are seriously and sincerely interested in any of the branches of the ceramic arts, a fine place to work. The primary mission of the Bray is to provide an environment that stimulates creative work in clay—for artists, community members, teachers, children, collectors, and the general public.

Founded: Organization and Residency, 1951.

Location: Three miles west of downtown Helena, Montana, on the twenty-six-acre site of a nineteenth-century brick factory and surrounded by the foothills of the Rocky Mountains. Listed on National Historic Register.

Past Residents: Rudy Autio, Peter Voulkos, Ken Ferguson, David Shaner, Jun Kaneko, Kurt Weiser, Akio Takamori, Carlton Ball, Val Cushing, Matthew Metz, Lucy Breslin.

From the Director: "During an artist's stay at the Bray, they become aware of the Foundation's incredible history, and come to the realization that it is the individuals who work here that make the Bray special. This motivates and inspires artists to do the best work they can, which drives the legacy of the Foundation."

Eligibility: Artists working in clay. No prerequisite degrees or training.

Studios & Special Equipment Available: Ceramics/pottery facilities (wood, gas, soda, salt, raku, and electric kilns); cutting torch, welder, table saw, radial arm saw, band saw, and drill press; a setup for photographing artwork; two galleries; grounds can accommodate site-specific sculpture.

Housing, Meals, Other Facilities & Services: Housing not provided. Cooking/kitchen facilities and common room with computer and Internet connection available for residents' use. Smoking permitted outdoors only.

Accessibility: Studios and public areas are accessible.

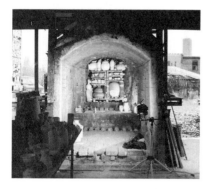

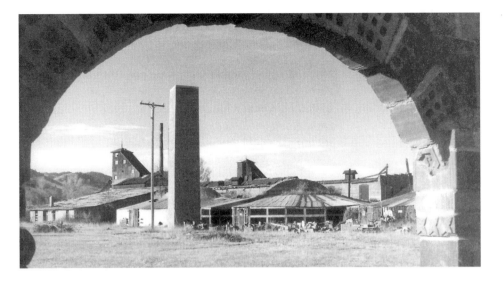

Application & Residency Information:

Application available online

Application deadline(s): March 1 for residencies; February 1 for fellowships

Resident season(s): Year-round

Average length of residencies: 2 months–2 years

Number of artists-in-residence in 2003: 30

Average number of artists-in-residence present at one time: 11 residents working October–May; 21 residents June–September

Selection process: Resident Director heads the selection committee, which includes two ceramic artists/arts professionals.

Artists Responsible for: Application fee—$20 for residency (no fee for fellowship application); food, housing, travel, transportation; artists pay for their own materials and firings, and are eligible for a discount from the Bray's clay and ceramic supply business.

Organization Provides: Studio space and facilities, program administration, discounted supplies.

Additional Support: Currently, the Bray offers three fellowships that each provide $5,000 for a one-year residency. Two scholarships are available for summer residents: one awards $750 to an artist between the ages of eighteen and thirty-five; the other scholarship is an $800 award.

Other Expectations & Opportunities:

Residents are invited to participate in exhibitions that take place at the Bray and at galleries around the nation. Long-term residents organize a solo exhibition at the completion of their residency. In addition to exhibitions, each resident has an opportunity to present a slide lecture at the local art museum, and there are several chances to teach community classes at the Bray and lead workshops at venues around Montana and the Northwest. Each resident leaves a piece for the Bray's permanent collection and donates one or two small works for the Bray's Benefit Auction. Artists also help with general maintenance and operations—general cleanup of common areas, recycling, cataloging library materials, and helping with outreach events.

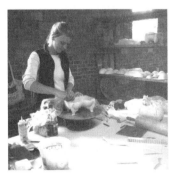

Arrowmont School of Arts and Crafts

"My residency experience was a total immersion in an art environment. It came at a critical step in my career and it pushed me forward. Access to the library, the gallery, teaching opportunities, the rotating workshop faculty members, and students all in one location was an education in itself— something one can't have in an at-home studio."—JONI KOST

556 Parkway
Gatlinburg, TN 37738
Phone: (865) 436-5860
Fax: (865) 430-4101
E-mail: *info@arrowmont.org*
Web: *www.arrowmont.org*

Mission: To enrich lives through art by developing aesthetic appreciation and fostering self-expression through practical hands-on experiences in a variety of media classes, conferences, and seminars; to offer quality educational opportunities for individuals of all ability levels, ages, race, national or ethnic origins, practical backgrounds, and educational attainment in an environment conducive to creative thinking and expression; to offer a year-round gallery exhibition program to supplement educational sessions and provide visual stimulation to a broad public audience; to maintain Arrowmont School as a contributing force in the cultural life of the national, regional, and local communities by preserving the value of craftsmanship of handmade objects in an increasingly technological world.

Founded: Organization, 1945; Residency, 1991.

Location: Tucked away on sixty-eight acres of wooded landscape in the heart of Gatlinburg, Tennessee, just minutes away from the Great Smoky Mountains National Park, Arrowmont offers a unique creative oasis amidst the bustle of a popular tourist destination. Knoxville, Tennessee, and Asheville, North Carolina, are within easy driving time.

Past Residents: Michael Mocho, Diane Rosenmiller, Jill Oberman, Amie Adelman, Emily Puthoff, Christina Miller, Ana Lopez, Kristen Kieffer, Jen Swearington, Brian Hiveley.

From the Director: "Arrowmont's Residency Program provides emerging artists and artists in transition the necessary time, space, and support to experiment, explore, and develop new work within a creative community of visiting artists. The eleven-month program offers residents a wide variety of opportunities to further develop their skills as professional artists and educators."—BILL GRIFFITH, RESIDENCY PROGRAM DIRECTOR

Eligibility: Pre-professional, self-directed artists in all visual art/craft disciplines, who are in transition from academia or making a career change.

Studios & Special Equipment Available: Ceramics/pottery studio (electric kilns available at the studio; access to gas or wood kilns, and other major ceramic equipment at a nominal rental fee); metal shop; fiber arts, painting, photography, and woodworking studios (woodturning equipment in studio as well as some basic woodworking equipment).

Housing, Meals, Other Facilities & Services:
Housing: Private bedroom and bathroom in a shared facility (living room, dining room, and kitchen shared by five residents); all basic bedroom, living, kitchen, and dining room furnishings provided (each resident usually brings along more specific personally preferred items). *Meals:* All meals are provided when the main kitchen is operating (approximately seven months out of eleven); vegetarian meals available; a private full kitchen is located in the residency housing facility. *Other facilities/ services:* Large living room, dining room, and covered decks surrounding the housing facility provide common room for meeting space; pay washer and dryer facilities connected to housing facility. Computer, printer, fax, and scanner are provided for the residents in their common living area (it is the responsibility of the residents to obtain Internet service if desired); a computer with Internet access is available in the main Arrowmont library. A trolley service is available in town, though residents will find having their own means of transportation more efficient. Smoking permitted outdoors only. No pets are allowed on campus except for guide dogs. Spouses, partners, children, and guests are allowed for visits up to a week; guests may stay in other available campus housing at half-price, based on availability.

Accessibility: Living quarters and studios are accessible.

Application & Residency Information:
Application available online
Application deadline(s): February 15
Resident season(s): June 15–May 31
Average length of residencies: 11 months
Number of artists-in-residence in 2003: 5
Average number of artists-in-residence present at one time: 5
Selection process: Internal selection (staff, board, and/or advisory board), including preliminary application review and e-mail/ phone interviews; finalists are invited to campus for interviews.

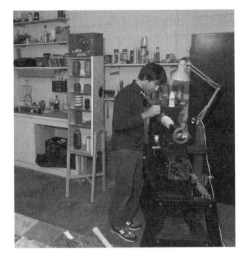

Artists Responsible for: Application fee— $25; $175 refundable damage/security deposit; food (during the approximately four months the main kitchen is closed); materials and personal needs.

Organization Provides: Housing, meals for seven months, studio space, program administration, etc. General stipend—$300 a month. An additional $900 in professional development opportunity funds can be used for travel, conferences, workshops, etc., during the eleven-month residency (proposals must be submitted and approved).

Additional Support: Trabue Family Scholarship for Women—$1,500 awarded based on need.

Other Expectations & Opportunities:
Residents work approximately ten hours per week in the areas of studio maintenance (equipment maintenance or inventory needs), Artists-in-Schools/community outreach programs, gallery installation, book/supply store general needs, conference assistance, and public relations. This schedule is organized at the beginning of the resident calendar year to allow communication and time management. Residents have the option of hosting open studios during the fall, spring, or summer workshops. Christmas open house activities include a resident open studio session. Optional donation of one piece completed during the residency program to Arrowmont's permanent/traveling collection.

ArtCenter/South Florida

"The ArtCenter is an environment that functions in multiple directions and serves many needs at the same time. ArtCenter was the catalyst for me taking a big risk with my life. The ArtCenter provides an environment for like-minded people, so you reside in this amazing creative think-tank, where the individual challenges, teaches, and encourages the whole. The ArtCenter provides community; it fosters relationships of a broad nature; it provides exposure, employment, and teaching opportunities. Through the ArtCenter I found my vehicle of contribution to the world. My experience here has been more than I ever expected."—BABETTE HERSCHBERGER

924 Lincoln Road #205
Miami Beach, FL 33139
Phone: (305) 674-8278
Fax: (305) 674-8278
E-mail: *dbianchino@artcentersf.org*
Web: *www.artcentersf.org*

Mission: ArtCenter's mission is to advance the knowledge and practice of contemporary visual art and culture. In addition to affordable studio spaces for forty-five outstanding visual artists in all stages of career development, access to educational resources and technical support are offered. Opportunities for artistic experimentation and innovation occur through the exchange of ideas across cultures and artistic disciplines. In addition, the ArtCenter conducts an extensive education program for members of the community as well as students from neighboring public schools. The uniqueness that separates this center from all others is the visibility it offers its artists.

Founded: Organization and Residency, 1984.

Location: At the corner of Lincoln Road and Meridian Avenues, in the heart of South Beach, ArtCenter is located in three historic buildings. The ArtCenter's location on chic Lincoln Road attracts more than 500,000 people to its public gallery with more than 1.4 million Florida residents and visitors taking time to view its gallery display windows per year.

Past residents: Jorge Pantoja, Louis Gispert, Babette Herschberger.

From the Director: "Serving as executive director of ArtCenter/South Florida is an opportunity that I was very lucky to get. Working with forty-seven artists from all over the world on everything from exhibits to public education couldn't be more interesting and humbling. I think it takes a great amount of courage to put brush to canvas and I am awed by the art that I see here every day. Whenever I get bored with the bureaucracy of running the ArtCenter, I go to the studios, talk to artists, and see what new work they are up to. It changes my whole perspective."
—DENA BIANCHINO, EXECUTIVE DIRECTOR

Eligibility: Visual artists, media artists, and performance artists (see Indices for specifics).

Studios & Special Equipment Available: Digital media, painting, photography, and sculpture studios; metal shop; exhibition/installation space.

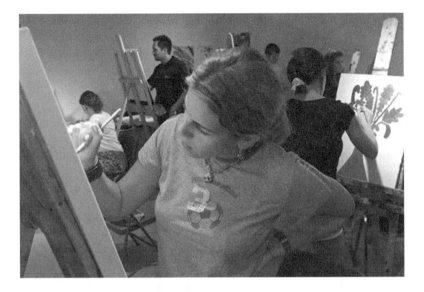

Housing, Meals, Other Facilities & Services: Studio residencies only; housing and meals not provided.

Accessibility: One building is fully accessible; the other two are accessible on the first floor only.

Application & Residency Information:

Application deadline(s): Ongoing

Resident season(s): Year-round

Average length of residencies: Varies

Number of artists-in-residence in 2003: 45

Average number of artists-in-residence present at one time: 45

Selection process: Both outside professionals and representatives of artists on jurying committee.

Artists Responsible for: Application fee, materials, and residency fee. (Residency fee is based on square feet of studio and calculated by income. Rents are greatly subsidized and range from $8.50–$11.50/sq. ft.; comparable commercial rents average $60/sq. ft.)

Organization Provides: Studio subsidy, program administration, exhibitions.

Other Expectations & Opportunities: The ArtCenter has a public gallery open twelve hours a day. Exhibitions are curated by our Exhibitions' Director and can be comprised of Art/Center artists or others or a combination of both. Each artist is required to be in the studio thirty hours per week (at any time during the day or night) so that the public can view them working. Artists are expected to be in their studios for openings and special events or tours. In addition, artists are expected to perform service to the ArtCenter, which may be anything from donating time for graphic work, monitoring open studio nights, obtaining sponsors for special events, or other activities for which they are suited. Each year the ArtCenter holds a fundraising event entitled "Winning Art"; each artist is expected to donate one piece of art to this event.

Artcroft Center for Arts and Humanities

"I am grateful for the company, silly laughter, beautiful light and color of the place, wonderful food for body and soul."
— FLORENCE THORNE

2075 Johnson Road
Carlisle, KY 40311
Phone: (859) 473-0552
E-mail: *artcroft@msn.com*
Web: *www.artcroft.org*

Mission: Artcroft provides direct support to creative individuals through its residency program, offering community development through participation in the arts.

Founded: Organization, 1999; Residency, 2000.

Location: Artcroft is located on a four-hundred-acre working cattle farm in the historic Bluegrass Region of Kentucky, one hour north of Lexington, two hours south of Cincinnati, Ohio.

Past Residents: Florence Thorne, Cheryl Reitan, Polly Singer, Nancy Bronner, Claudia Miller, Gerry Miller, Mary Harrington, Brendan I. Jones, Nicole Ponsler.

From the Director: "Artcroft is committed to honoring the unique genius of each individual, expressed in their art and in the daily acts of living the creative life. Residents are encouraged to jealously value their time, generously share their gifts, and appreciate the opportunities of daily pursuing their craft. Residents are invited to pursue their passions for artistic expression with our surrounding community. As director of Artcroft, I am proud to be part of a dynamic program of new facilities development and work as an advocate for other creative individuals. Our program actively seeks to provide networking opportunities for residents, and we are pleased that three of our nominees have received the Kentucky Governor's Award for the Arts."
— ROBERT BARKER, EXECUTIVE DIRECTOR

Eligibility: Residencies are available to all persons eighteen years of age and older. Creative individuals are welcomed both nationally and internationally, subject to the submission of a proposal of work for the residency. Artcroft does not discriminate on the basis of gender, sexual orientation, race, national origin, religious, or political affiliations. Repeat residencies through application process.

Studios & Special Equipment Available:
Blacksmithing, ceramics/pottery, fiber arts, metalworking, painting, sculpture, woodworking, and writing studios. Artcroft will work to develop studio space via residents' proposals.

Housing, Meals, Other Facilities & Services:
Housing: One log cabin currently (others to be undertaken) with a six-hundred-square-foot studio, private bedroom, and bath. Other shared facility includes four private rooms with shared kitchen, common area, and bath. Each room has bed, desk, clothes storage, bed linens, and towels. *Meals:* Dinner is served, and food is provided for all other meals. Meals are organized cooperatively and vegetarian meals are available. *Other facilities/services:* Extensive library available for use; smoking permitted outdoors only; wireless network for personal laptops in common and private areas. Spouses and partners allowed for visits off-grounds only.

Accessibility: Facilities are generally one-story structures. Artcroft will work to accommodate individuals with special needs, with prior notice.

Application & Residency Information:

Application available online

Application deadline(s): January 1 for April–June; April 1 for July–September; July 1 for October–December; October 1 for January–March

Resident season(s): Year-round

Average length of residencies: 2–8 weeks

Number of artists-in-residence in 2003: 12

Average number of artists-in-residence present at one time: 3

Selection process: Work samples are evaluated by two professionals in specific disciplines, and one staff member.

Artists Responsible for: Application fee—$25; residency fee—$40/day, due upon arrival; deposit—10 percent of residency fee; travel, materials, personal laundry, local transportation, and special dietary foods.

Organization Provides: Housing, studios, meals, and program administration.

Additional Support: Work/Study is available for those seeking general assistance. Reduced fees or waivers are available to those with demonstrated need.

Other Expectations & Opportunities:
Artcroft honors the needs of individuals to concentrate intensively on any given project. If residents wish to participate in gardening, collective activities, or community programming, these are available, if deemed mutually beneficial. Artists have the option of participating in public presentations/exhibitions both onsite and offsite, in studio tours, and in the donation of artwork.

Art Farm

"While at Art Farm, I was struck by the strength of the horizon—all blue sky above and green corn below. Nothing to stop all of the amazing dramatic weather! Whatever you envision can become a reality at Art Farm. There is an abundance of space, tools, technical assistance, and moral support for your dream project. A very quiet time to truly focus on working through ideas." —VIRGINIA SHEPLEY

1306 West 21st Road
Marquette, NE 68854-2112
Phone: (402) 854-3120
E-mail: *artfarm@hamilton.net*
Web: *www.artfarmnebraska.org*

Mission: To offer worksite, resources, and support to artists, giving them time to experiment with new ideas, concepts, or projects while working and living in a rural environment.

Founded: Organization and Residency, 1993.

Location: On a working farm with over-a-century-old buildings, two miles from the clay bluffs of the Platte River in South Central Nebraska, eighty miles west of Lincoln.

Past Residents: Deborah Sigel, Theresa Handy, Samantha Fields, Brian McArthur, Sung Jae Choi, Ian McDonald, Sandra Westley, Sonja Hinrichsen, Potter-Belmar Labs, The Top Hat Shine.

From the Director: "Art Farm's physical presence is its buildings and land, but more elusive to describe is the ambiance: the subtle influence of the environment's impact on time and space. Time is measured by sun and night sky, not by clock or calendar. Space finds its borders by proximity to sound and silence. The sky and your ears are full of sounds and shapes of birds and bugs. And, like it or not, the weather will be your collaborator in all undertakings." —ED DADEY

Eligibility: Visual artists: painters, sculptors, ceramicists; installation, environmental, video, and performance artists.

Studios & Special Equipment Available: Ceramics/pottery studio (one gas and two electric kilns, pug mill, electric wheel), digital media studio (access to computers and related equipment), fully equipped metal and wood-shops, tractors/earth movers, etc., for outdoor projects.

Housing, Meals, Other Facilities & Services:
Housing: Over-a-century-old, three-bedroom farmhouse with shared kitchen, bathroom, and sitting room; furnishings and linens provided. *Meals:* Cooking/kitchen facilities available for residents to prepare their own

meals. *Other facilities/services:* Common room and garden available for use; laundry facilities onsite; smoking permitted outdoors only; computer with Internet connection in common area; car available for rental for artists who come without a vehicle (Art Farm is ten miles from the nearest small town, and a car is essential). Spouses/partners allowed for short visits only with the agreement of other residents.

Accessibility: Artists in wheelchairs cannot be accommodated at this time. Art Farm has long-term plans to remedy this.

Application & Residency Information:

Application available online

Application deadline(s): April 1 (arrival date)

Resident season(s): June 1–November 1

Average length of residencies: 2–3 months

Number of artists-in-residence in 2003: 6

Average number of artists-in-residence present at one time: 3

Selection process: Internal selection (staff, board, and/or advisory board).

Artists Responsible for: Food, travel, materials (some onsite materials available for artists' use).

Organization Provides: Housing, some onsite materials, program administration.

Other Expectations & Opportunities:
Slide presentation and participation in the Art Harvest public event with open studio tours and/or a special project are expected. Occasional school, college, and art group studio tours expected. Artists are also expected to donate one piece of artwork. In addition, Art Farm's work-exchange program gives artists accommodation and barn studio space in exchange for fifteen hours of assistance to Art Farm each week in helping to run, build, and maintain the residency.

The Artist House at St. Mary's College of Maryland

"The perfect combination of privacy, resources, and fellowship! I feel strongly that my time here was beneficial to me and my work on many different levels—and this experience will sustain and continue to further my paintings throughout the next year."— MOLLY RAUSCH

c/o Sue Johnson and
Michael S. Glaser
Montgomery Hall
St. Mary's City, MD 20686
Phone: (240) 895-4225
E-mail: *artisthouse@smcm.edu*
Web: *www.smcm.edu/art/artist_house*

Mission: The Artist House has two interrelated program goals: (1) to support creative artists by offering them the time and space to create new work, and (2) to develop programming in which artists-in-residence share their work with the campus and local communities.

Founded: Organization and Residency, 2003.

Location: Seventy miles southeast of Washington, D.C., and ninety-five miles south of Baltimore, in historic St. Mary's County, Maryland, near the St. Mary's River and the campus of St. Mary's College of Maryland.

Past Residents: Charles Burmeister, Garrett Byrnes, Laurie Elrick, Reni Gower, Deborah Grant, Judith Hall, James Huckenpahler, Molly Rausch, Marlys West, April Vollmer, Teresa Whittaker.

From the Director: "It is our hope that we have created and thus are able to provide an environment that can help awaken the extraordinary. Our desire is to provide a place that is both supportive and nurturing, one that encourages creativity, collaboration, and experimentation. Beyond respect for other artists and the physical space and environment of the Artist House, we ask only for one public presentation and an opportunity for students and community members to interact with the artist as artist."— SUE JOHNSON, CO-DIRECTOR

Eligibility: Writers, visual artists, composers, media artists, filmmakers, performing artists, and interdisciplinary artists. The program strives for a mix of emerging and established artists, especially artists with the ability and interest to interact with our students and community as part of a residency. Currently the Artist House is only accepting applications that are in response to our invitation.

Studios & Special Equipment Available: Private studio space (320 square feet) with good natural light provided for fiber artists, painters, and sculptors (artists must bring own equipment; no welding or heavy power equipment allowed). Private studio space for writers provided on the first floor of the

Artist House. Limited access to music studio (piano only), digital media facilities (including large-format digital printers), dance studio, filmmaking facilities (artists should bring own equipment), exhibition space, woodworking facilities, nontoxic intaglio print shop (two etching presses, vacuum-frame exposure unit, and related digital equipment), and photography facilities at St. Mary's College.

Housing, Meals, Other Facilities & Services:
Housing: Private room and private bathroom in a shared facility; furnishings and linens provided. *Meals:* Residents purchase own food and prepare own meals in a shared kitchen. *Other facilities/services:* Common room or meeting space for residents' use; laundry facilities onsite; computer station with Internet access provided in the house, and residents also have access to computer labs at the college. Smoking is not permitted on premises. The Artist House is adjacent to the college campus where residents can easily make use of dining hall, snack bar, coffee shop, library, post office, and campus bookstore. Residents are encouraged to bring a car, and we suggest a bicycle is a nice way to tour the peaceful countryside and reach the heart of the campus. The campus is about eight miles from Lexington Park, MD, where most grocery shopping, supply stores, and restaurants are located. Spouses/partners allowed for visits only (arrangements must be made in advance and with agreement of other artists sharing the house).

Accessibility: The Artist House is currently studying ways to make this facility more accessible and searching for grant money to do so, but as of now there is no wheelchair accessibility.

Application & Residency Information:

Application available online

Application deadline(s): Rolling admission, usually 6–12 months ahead of planned residency

Resident season(s): Year-round

Average length of residencies: 2 weeks–2 months

Number of artists-in-residence in 2003: 18

Average number of artists-in-residence present at one time: 2

Selection process: Internal selection—proposals for residencies are solicited by invitation only.

Artists Responsible for: Food, travel, materials.

Organization Provides: Housing, studio space, access to college facilities. Occasional, limited travel assistance and general stipends available.

Other Expectations & Opportunities: Artists-in-residence are expected to provide one public lecture/demonstration and one workshop/class visitation for students and community members (usually at the college, but could take place in the Artist House studio). Participation in studio tours and the donation of artwork are optional. In some cases resident artists may be offered the opportunity to teach a seminar course or extended workshop/short course in exchange for a stipend. Beyond that we ask only that the artist take as full advantage as possible of this opportunity to create.

Artists' Enclave at I-Park

428 Hopyard Road
P.O. Box 124
East Haddam, CT 06423
Phone: (860) 873-2468
Fax: (877) 276-1306
E-mail: *ipark2002@ureach.com*
Web: *www.i-park.org*

Mission: To provide a physical and intellectual environment that is conducive to the creative process; to encourage greater seriousness and a higher level of commitment to quality in the fine arts; and to conserve and enhance a beautiful piece of property—all with a creative and contemporary twist.

Founded: Organization, 1998; Residency, 2001.

Location: I-Park is located in rural East Haddam, Connecticut, about a two-hour drive to Boston and a two-and-a-half hour drive to New York City. The I-Park property consists of 450 acres of forestland, fields, ponds, streams, and natural wetlands—with stone outcroppings, hills, walking trails, and a diverse selection of fauna and flora. The land is bisected by the Eight Mile River and its neighbors include a state park, the Nature Conservancy, the local land trust, as well as a large parcel owned by the East Haddam Fishing and Game Club.

From the Director: "The work's the thing."
—RALPH CRISPINO, JR., FOUNDER AND CREATIVE DIRECTOR

Eligibility: U.S. and international artists over twenty-one years old. Artists are eligible to return the following year but must take minimum two-year breaks between subsequent returns.

Studios & Special Equipment Available: Ceramics/pottery (electric kiln provided), painting, sculpture, and writing studios; digital media equipment (some computers, software provided), piano music studio (with Digital Performer and Mac hardware), Korg midi music recording studio.

Housing, Meals, Other Facilities & Services: *Housing:* Private room in a shared facility; furnishings and linens provided. *Meals:* Cooking/kitchen facilities available for residents to prepare own meals. *Other facilities/services:* Common room or meeting space for residents' use; laundry facilities onsite; computer with Internet connection available in common area and private area. Smoking permitted outdoors only. Organization provides a weekly shopping trip into town, and pickups at airport or train station upon arrival. Minimal provision for visits by spouses/partners and children.

Accessibility: Contact organization for details.

Application & Residency Information:

Application available online

Application deadline(s): December/January (varies)

Resident season(s): May–October

Average length of residencies: 1 month

Number of artists-in-residence in 2003: 43

Average number of artists-in-residence present at one time: 5

Selection process: Internal selection (staff, board, and/or advisory board).

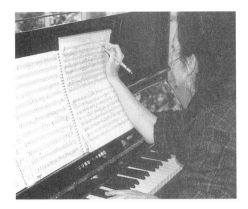

Artists Responsible for: Application fee—$20; food, travel, and materials.

Organization Provides: Housing, studio space, equipment, program administration.

Other Expectations & Opportunities:
Artists are asked to contribute a work of art to the project archives, if possible. Optional participation in studio tours. Individual photos are taken at some point during the residency and there is an end-of-session questionnaire. It is also hoped that artists will contribute their ideas and perhaps some of their energy to the I-Park vision.

Art Omi International Arts Center

55 Fifth Avenue
15th Floor
New York, NY 10003
Phone: (212) 206-6060
Fax: (212) 206-6114
E-mail: *artomi55@aol.com*
Web: *www.artomi.org*

Mission: To foster an environment of international artistic exchange while providing a rich working experience balanced with opportunities to meet with arts professionals.

Founded: Organization and Residency, 1992.

Location: Two hours north of New York City by car or train, in rural Columbia County.

Past Residents: Toshihiro Yashiro, Cecily Brown, Dumisani Mabaso, Joana Prezybyla, Karsten Wittke, Elena Beriolo, Cheryl Donegan, Ad Jong Park, Atsushi Yamaguchi, Michael Bramwell, Wenda Gu, Diego Toledo, Ryszard Wasko Geng Jianyi

From the Director: "At the Artists' Colony and Ledig House International Writers' Colony, artists, musicians, writers, and literary translators from around the world are provided with living/working space and the opportunity for meaningful cultural exchange. Musicians participate collaboratively throughout the residency, composing for one another and performing the works of colleagues in residence. New York City curators, critics, and gallery owners visit the artists' studios, providing artists the opportunity to meet professionals in their field."

Eligibility: Serious, professional visual artists, writers, and performing/composing musicians in any media.

Studios & Special Equipment Available: Music/piano, photography, printmaking, sculpture, and writing studios.

Housing, Meals, Other Facilities & Services: *Housing:* Private room in a shared facility for writers and musicians; shared rooms for visual artists. Furnishings and linens provided. *Meals:* All meals are provided; vegetarian meals are available; cooking/kitchen facilities are available to residents. *Other facilities/ services:* Common room or meeting space for residents' use; computer with Internet connection in common area; local transportation provided by Art Omi; smoking permitted outdoors only.

Accessibility: Facilities are fully accessible.

Application & Residency Information:

Application available online

Application deadline(s): Visual artists–February 1; Musicians–April 1; Writers–November 30

Resident season(s): Year-round

Average length of residencies: Visual artists–3 weeks; Musicians–18 days; Writers–2–8 weeks

Number of artists-in-residence in 2003: N/A

Average number of artists-in-residence present at one time: Varies (6–30)

Selection process: Combination of outside jury and internal selection.

Artists Responsible for: Travel and materials.

Organization Provides: Housing, meals, studio space, program administration.

Other Expectations & Opportunities: Artists-in-residence are expected to participate in public presentations (visual artists host open studios, musicians give group recitals, writers give readings); visual artists are also asked to contribute a print or other artwork.

ArtPace

> "My ArtPace residency was one of the most catalyzing experiences I have had as an artist. The generous resources—studios, living spaces, workshops, etc.—provided a rich, fertile ground to realize my project. The staff showed continuous, valuable, and ongoing support for the development of my work with their technical expertise and critical insight." — MICHAEL VELLIQUETTE

445 North Main Avenue
San Antonio, TX 78205
Phone: (210) 212-4900
Fax: (210) 212-4990
E-mail: *info@artpace.org*
Web: *www.artpace.org*

Mission: ArtPace serves as an advocate for contemporary art and as a catalyst for the creation of significant art projects. We seek to nurture emerging and established artists and to provide opportunities for inspiration, experimentation, and education. Our programs support the evolution of new ideas in contemporary art and cultivate diverse audiences while providing a forum for ongoing dialogue.

Founded: Organization, 1993; Residency, 1994.

Location: ArtPace's home is an 18,000-square-foot facility renovated by Lake/Flato Architects, winner of the American Institute of Architects' coveted Architecture Firm Award for 2004. The 1920s building, once a Hudson automobile dealership, is located in the vibrant downtown cultural district, one block from San Antonio's famous Riverwalk. ArtPace contributes to the city's vital cultural life by providing a facility with easy access, challenging exhibitions, and a diverse array of programs for artists, students, and adults.

Past Residents: Xu Bing, Maurizio Cattelan, Teresita Fernández, Felix Gonzalez-Torres, Isaac Julien, Tracey Moffatt, Franco Mondini-Ruiz, Robyn O'Neil, Dario Robleto, Nancy Rubins.

From the Director: "ArtPace is a site of invention and exchange. By inviting artists from Texas, the United States, and around the globe, ArtPace simultaneously focuses on the particularities of this place—South Texas—while engaging in an international art dialogue and enriching our community with the infusion of new ideas." — KATHRYN KANJO, EXECUTIVE DIRECTOR

Eligibility: ArtPace invites respected guest curators to select contemporary visual artists for the International Artist-in-Residence Program. Each residency is composed of three artists—one from Texas, one from elsewhere in the United States, and one from abroad. Unsolicited applications are not considered.

Studios & Special Equipment Available: Digital media, film/digital editing, painting, photography, sculpture, woodworking studios; metal shop; exhibition/installation space.

Housing, Meals, Other Facilities & Services:
Housing: Individual apartment for each resident; furnishings and linens provided.
Meals: Residents responsible for own meals; cooking/kitchen facilities in each apartment.
Other facilities/services: Common room or meeting space for residents' use; laundry facilities onsite; computer with Internet connection in living area; public transportation available; vehicle for residents' use may be available from organization; smoking permitted outdoors only. Spouses/partners, children, and pets allowed for full stay.

Accessibility: Facilities are fully accessible.

Application & Residency Information:

Residencies by invitation only

Average length of residencies: 2 months, followed by 2-month exhibition

Number of artists-in-residence in 2003: 9

Average number of artists-in-residence present at one time: 3

Selection process: Outside guest curators.

Artists Responsible for: Food, personal living expenses.

Organization Provides: Housing, studio space, materials stipend, general stipend for living expenses.

Other Expectations & Opportunities:
Each residency is followed by a two-month exhibition at ArtPace. While in residence, artists are encouraged to share their ideas and become involved with the San Antonio and Texas arts communities. They participate in a slide talk at the beginning of the residency to introduce their work to the community and engage in a public dialogue with the guest curator as the exhibition commences. Resident artists also participate in educational outreach activities in the local community, including slide lectures, studio visits, and workshops.

The Art Studio Changdong and Goyang

"This is the place where I realized the fact that I, truly, am an artist!" — WON-JOO PARK

601-107 Chang-dong Dobong-gu
Seoul, Korea 132-040
Phone: +82 2 995 0995
Fax: +82 2 995 2638
E-mail: *artgoam@hanmail.net*
Web: *www.artstudio.or.kr*

Mission: The Changdong and Goyang Art Studios are designed to provide support for promising artists who are working in every genre of visual art. They are sponsored by the Ministry of Culture and Tourism, and run by The National Museum of Contemporary Art, Korea.

Founded: Organization and Residency, 2002.

Location: The Art Studio has two locations: Changdong, in Seoul, and Goyang, about an hour outside of Seoul.

Past Residents: Jong-Hak Kim, Inhwan Oh, Eun-Sun Park, Kyung-Won Moon, Seoyoung Chung.

From the Director: "The Art Studio Changdong and Goyang is the most adequate place to understand and experience the vivid Asian contemporary art scene. Through this special and interdisciplinary environment, artists are able to exchange their originality and creativity in art." — YOON-SOO KIM

Eligibility: Professional artists from both Korea and overseas working in studio art, design, craft arts, photography, multimedia, architecture, animation, fashion, and other newly developing genres are eligible to apply for the residency.

Studios & Special Equipment Available: Exhibition/installation gallery and live/work studios.

Housing, Meals, Other Facilities & Services: *Housing:* Live/work studios with private bed-room, bath, and kitchen. *Meals:* Residents are responsible for their own meals and have a private kitchen in each live/work studio. *Other facilities/services:* Common room or meeting space available for residents' use; computer with Internet connection in common area; smoking permitted outdoors only. Spouses/partners and children allowed for visits only.

Accessibility: Contact organization for details.

Application & Residency Information:

Application available online

Application deadline(s): Ongoing

Resident season(s): Year-round

Average length of residencies: 1 year or 3–4 months

Number of artists-in-residence in 2003: 14

Average number of artists-in-residence present at one time: 14 at Changdong; 23 at Goyang

Selection process: Jury includes 4 outside professionals and 3 internal staff/board members.

Artists Responsible for: Food, travel, materials, and personal living expenses.

Organization Provides: Housing and studio space, exhibition space, program administration.

Other Expectations & Opportunities:
The Art Studio expects residents to attend at least one-third of the programs taking place at the Art Studio (such as seminars, exhibitions, open studios, and education outreach programs), but the residents' participation in these programs is purely optional.

Atlantic Center for the Arts

"A mixture of solitude and collegiality, up-to-date facilities and a natural setting. The time and space to have an intensive and extended exchange with talented artists from around the world provided me with an unparalleled experience enriched by cross-fertilization with other disciplines." — MARTHA ROSLER

1414 Art Center Avenue
New Smyrna Beach, FL 32168
Phone: (386) 427-6975 / (800) 393-6975
Fax: (386) 427-5669
E-mail: *program@ atlanticcenterforthearts.org*
Web: *www.atlanticcenterforthearts.org*

Mission: To promote artistic excellence by providing talented artists an opportunity to work and collaborate with some of the world's most distinguished artists in the fields of composing, and visual, literary, and performing arts, while coordinating community interaction through onsite and outreach presentations, workshops, and exhibitions.

Founded: Organization, 1977; Residency, 1982.

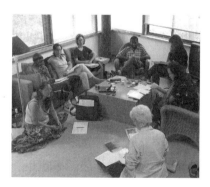

Location: Central east coast of Florida, six miles from the Atlantic Ocean. Modern studios on sixty-nine acres of lush palmetto and pine forest in the midst of 2,000 acres of an ecological preserve, on the richest tidal estuary in North America.

Past residents: Edward Albee, Allen Ginsberg, Ntozake Shange, Merce Cunningham, John Corigliano, Pauline Oliveros, Cecil Taylor, Nan Goldin, Gillian Wearing, Robert Rauschenberg.

From the Director: "ACA provides an environment that nourishes, enriches, and challenges some of the most talented artists working today; it serves as a cultural hotbed for experimentation, provides ongoing opportunities for collaboration, and builds new audiences for contemporary art through community programming." — ANN BRADY, EXECUTIVE DIRECTOR

Eligibility: Visual, media, literary, and performing artists; repeat residencies permitted.

Studios & Special Equipment Available: Studios for dance/choreography, digital media, film/digital editing, music (both piano studio and recording studio), painting, photography, sculpture, and writing. Exhibition/installation space and performance theater.

Housing, Meals, Other Facilities & Services: *Housing:* Private room and private bath in a shared facility; furnishings and linens provided. *Meals:* All meals served during the week; on weekends, meals are not prepared for residents but food is provided; cooking/ kitchen facilities available to residents; vegetarian meals available. *Other facilities/services:* Common room or meeting space for residents' use; laundry facilities onsite; computers with Internet connection in common area and in

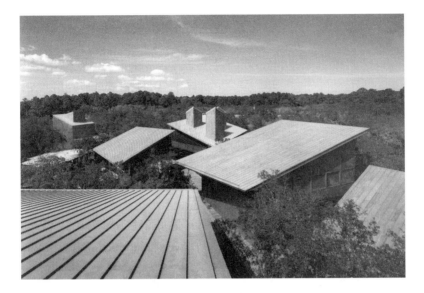

designated studios; van service to local markets provided two to three days/week during residencies; smoking permitted outdoors only. Spouses/partners allowed for visits only in special cases (please inquire).

Accessibility: Facilities are fully accessible.

Application & Residency Information:

Application available online

Application deadline(s): Varies—approximately 3 months prior to residency start date

Resident season(s): Year-round

Average length of residencies: 3 weeks

Number of artists-in-residence in 2003: 130

Average number of artists-in-residence present at one time: 25

Selection process: Master Artists set criteria and select 6–10 Associate Artists with whom to work.

Artists Responsible for: Application fee— $25; Residency fee—$850; travel and specialized materials.

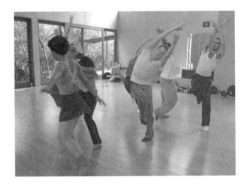

Organization Provides: Housing, studios, meals, and program administration.

Additional Support: Artists eligible for full and partial scholarships.

Other Expectations & Opportunities: Artists are given the option of participating in public exhibitions/presentations, as well as open studio for a public, works-in-progress presentation on the final evening of residency.

Aurora Project

RR1, Box 224, US Route 50
Aurora, WV 26705
Phone: (304) 735-3620
Fax: (304) 735-6643
E-mail: *ap@gcnetmail.net*
Web: *www.auroraproject.org*

Mission: To provide the gift of time and space within a creative, respectful environment designed to make all participants and visitors feel welcome.

Founded: Organization, 2001; Residency, 2005.

Location: The historic buildings that comprise the main residency site are located along a winding two-lane stretch of U.S. Route 50, across the road from a protected 132-acre, old growth forest. Surrounded by high plateau farmland and forested hills, the studios are located in several buildings, some onsite and others within two miles.

Past Residents: First residencies will begin in Spring 2005.

From the Director: "While here in these ancient Allegheny Mountains, resident artists have the opportunity to transcend the everyday and concentrate on the physical and conceptual realization of their creative energy. When we began to develop the Aurora Project, we looked to our community's history as a nineteenth-century resort destination and as the location of a Depression Era artists' colony. The historic cottages have been restored and our rural but not isolated location—ideal for a colony in the 1930s—continues to offer a timelessness and peacefulness. It is within this setting that we are able to provide artists with the time to think critically and the space to create freely, to explore and exchange new and diverse ideas and to be responsible only to themselves and their work."
—MICHELE MOURE, EXECUTIVE DIRECTOR

Eligibility: Artists working in visual arts, music, writing, film and video. Architects and historic preservationist will be considered for exploration of new ideas, research, and writing residencies. Repeat residencies every three years.

Studios & Special Equipment Available: Digital media studio (large-format digital printer; artist must bring all other equipment); piano/music studio (soundproof building with two rooms); two studios for painting or small-scale sculpture (325-square-foot, one-and-a-half story space with upper and lower windows on three sides); a large painting studio (located at the General Store about one-and-a-half miles away; 675 square feet with eleven-foot ceilings and large windows on three sides); photography studio suite (fully equipped black-and-white darkroom with 4 x 5-inch enlarger, digital or production space, and 250 square-foot studio; artists must

bring their own chemistry and paper); three writing studios (two adjoining guestrooms, and one rustic studio is about two miles from main campus). All studios are very basic; artists must bring all specialized studio equipment and tools. When facilities are completed, equipped sculpture, printmaking and book, fiber, and glass arts studios will also be available.

Housing, Meals, Other Facilities & Services:

Housing: Two nineteenth-century restored cottages—one three-story with nine bedrooms and four bathrooms, and one two-story with five bedrooms and two bathrooms. Bedrooms fully furnished; linens and towels provided and laundered weekly. *Meals:* All weekday meals are provided—breakfast and dinner are family style and lunch packed to take to the studio. Vegetarian meals available. Weekend meals are not prepared—local restaurants are open nearby; residents may use main kitchen, which is stocked with basic staples, and prepackaged meals will be available to heat in the microwave. *Other facilities/services:* Cottages include a library, two common areas, and an Internet connection (residents must bring own computers); laundry onsite for a small fee; residents may arrange to accompany staff to town for shopping, etc. There is a strict no-smoking policy in the living areas and studios; smoking is permitted outdoors only. Pets not allowed except seeing-eye dogs. To maintain the working atmosphere of the center, no spouses/partners (unless juried in) or children are permitted to stay or visit during the residency period. Closest train station is in Cumberland, Maryland, and closest airport is in Morgantown, West Virginia; both are one-and-a-half-hours away. Transportation from these locations to Aurora may be available if arranged in advance. Having personal transportation would be very beneficial.

Accessibility: Living quarters, studios, and public areas are accessible. Living quarters include three accessible bedrooms with one private and one shared bathroom, each with a roll-in shower. Pathways are designed for easy access between buildings and parking is available for one van near lodging buildings. (Please note exception to studio accessibility: one general studio and the photography studio are not accessible at this time.) Facilities are specially equipped with safety lighting for the hearing impaired, and an audible warning system for the visually impaired.

Application & Residency Information:

Application available online

Application deadline(s): September 1 for January–June; March 1 for July–December

Resident season(s): Year-round (closed mid-December—mid-January)

Average length of residencies: 3–6 weeks

Number of artists-in-residence in 2003: N/A

Average number of artists-in-residence present at one time: 7–14

Selection process: Peer review panels consider applications twice annually; staff reviews recommendations and makes final selections. A waiting list is maintained.

Artists Responsible for: Application fee—$20; residency fee—$25/day suggested voluntary fee (no one will be turned down due to inability to pay); travel and materials (there is no nearby art store—it is recommended that you bring what you need; mail-order delivery is an option).

Organization Provides: Housing, studios, meals, program administration.

Other Expectations & Opportunities:

Community involvement is completely optional. If you desire to participate, it is suggested that you work with staff to schedule activities in advance. Outreach opportunities include readings, PowerPoint/slide shows, and/or workshops in local colleges, elementary, middle and high schools, seniors' groups, and/or informal community gatherings. Space is available onsite for artists to do evening presentations for other residents. If the artist's residency results in a publication, a copy is requested for the Aurora Project Library. While the focus of the residency is your art work, we request that the responsibility for one chore be accepted each week. A list is posted and includes chores such as sweeping porches, shoveling snow, shelving books, washing dishes, etc. These tasks are completely optional and provide an opportunity to give back to the Aurora Project.

The Banff Centre/Leighton Studios

"I've never worked so well in my entire life as I have in the Leighton Studios."—TIMOTHY FINDLEY

107 Tunnel Mountain Drive
Banff, AB T1L 1H5
Canada
Phone: (403) 762-6180 / (800) 565-9989
Fax: (403) 762-6345
E-mail: *arts_info@banffcentre.ca*
Web: *www.banffcentre.ca*

Mission: The Leighton Studios offer a concentrated retreat environment to professional artists engaged in the creation of new work.

Founded: Organization, 1933; Residency, 1985.

Location: The Banff Centre is located in the town of Banff, Alberta, Canada, 130 km (80 miles) west of the city of Calgary. It lies within Banff National Park, which was the first national park to be established in Canada and is part of a World Heritage Site.

Past Residents: Timothy Findley, Julian Grater, Helen Cross, Gloria Sawai, Jane Urquhart, Diana McIntosh.

From the Director: "In a setting that is as magnificent in nature as it is rich in complexity, the Banff Centre is nestled amidst the majestic Rocky Mountains in Banff National Park. The retreat environment of the Leighton Studios offers an ideal working space for professional artists of various disciplines engaged in the creation of new work. These eight unique studios, each designed by a distinguished Canadian architect, awaken the senses to a sanctuary of inspiration."

Eligibility: Applications are accepted from artists in a variety of disciplines. Established artists of all nationalities are encouraged to apply.

Studios & Special Equipment Available: The Leighton Studios consist of three basic studio types: music/composition, writing, and visual arts. These studios are also suitable for a variety of other disciplines, and the Banff Centre as a whole can accommodate a wide range of artists. Each studio has a private view of the forest and is equipped with G4 Macintosh computer with printer and Internet access, a CD/cassette player, kitchenette and bath, and comfortable furnishings.

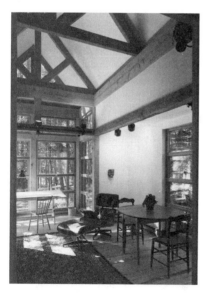

Housing, Meals, Other Facilities & Services: *Housing:* Private room with bath, phone, TV, and housekeeping in a shared facility; furnishings and linens provided. *Meals:* A meal plan is available if requested; vegetarian meals available; cooking/kitchen facilities available to residents. *Other facilities/services:*

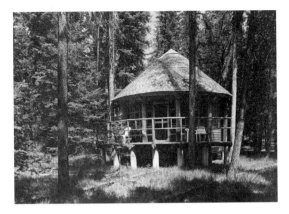

Common room or meeting space for residents' use; laundry facilities onsite; computer and Internet connection available in common area and in living or studio area; smoking permitted outdoors only; pets not allowed except service dogs. Residents have full access to the library and archives, dining room, café, and fitness and recreation facilities. Spouses/partners and children allowed for full stay, provided that space is available.

Accessibility: The Banff Centre and the Leighton Studios are located on the side of a mountain and therefore present challenges to people with limited mobility. The Leighton Studios are committed to improving accessibility and welcome questions about access or special needs.

Application & Residency Information:

Application available online

Application deadline(s): Ongoing

Resident season(s): Year-round

Average length of residencies: 1 week–3 months

Number of artists-in-residence in 2003: 75

Average number of artists-in-residence present at one time: Up to 8

Selection process: Outside professional jury/panel and internal selection.

Artists Responsible for: Residency fee— $53/day for studio, $51/day for accommodation (required with residency; artists are not permitted to sleep in their studios); deposit— $100; food—$14–$25/day (optional); materials (as required); equipment rentals and/or additional technical needs. All fees are in Canadian dollars.

Organization Provides: Studio, housing, and meal subsidy; facilities; program administration.

Additional Support: Discounted studio fees are available.

Other Expectations & Opportunities: The Leighton Studios are dedicated to providing a solitary retreat environment; however, there is a larger artistic community at the Banff Centre in which Leighton residents are welcome, but not required, to participate.

Bemis Center for Contemporary Arts

"Bemis is a fantastic thing out in the middle of America. It was a real meeting place away from the usual art-centered group. Working at Bemis was certainly different. I'm still trying to digest what happened there." — MANUEL NERI

724 South 12th Street
Omaha, NE 68102
Phone: (402) 341-7130
Fax: (402) 341-9791
E-mail: *bemis@novia.net*
Web: *www.bemiscenter.org*

Mission: To support exceptional talent by providing well-equipped studios, living accommodations, and a monthly stipend to visual artists.

Founded: Organization, 1981; Residency, 1985.

Location: In warehouses and a half-block of open urban property on the fringe of downtown Omaha, Nebraska.

Past residents: Manuel Neri, David Nash, Matt Lynch, Alice Aycock, Ian Harvey, Michael Todd, Miriam Bloom, Andreas Grunert, Christian Rothmann, Micki Watanabe.

From the Director: "The Bemis Center was established on the conviction that exceptional talent deserves to be supported. Our vision remains true through our practical commitment to providing artists with supported time for residencies, large studios, and well-equipped work facilities. The Bemis Center is a place where artists are granted the opportunity to be productive in a supportive environment conductive to self-challenge and experimentation." — MARK MASUOKA, EXECUTIVE DIRECTOR

Eligibility: Open to all visual media including video, installation, and performance art.

Studios & Special Equipment Available: Facilities include woodshop, darkroom, video editing, gallery and installation space, as well as multi-use studios.

Housing, Meals, Other Facilities & Services: *Housing:* Individual apartment for each resident; furnishings and linens provided. *Meals:* Residents are responsible for their own meals; apartments include a kitchen. *Other facilities/services:* Laundry facilities onsite; computer and Internet available in common area; public transportation available; access to extensive art library; smoking permitted in private living areas. Spouses/partners and children allowed for visits only.

Accessibility: Facilities are fully accessible.

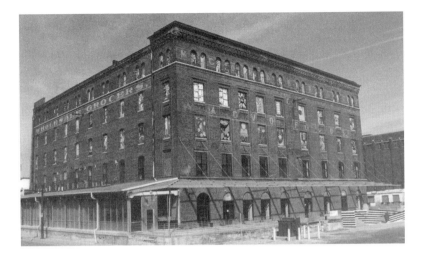

Application & Residency Information:

Application available online

Application deadline(s): February 28 and September 30

Resident season(s): Year-round

Average length of residencies: 3 months

Number of artists-in-residence in 2003: 24

Average number of artists-in-residence present at one time: 7

Selection process: Two separate independent juries, each composed of four artists and one curator, select from the applicants.

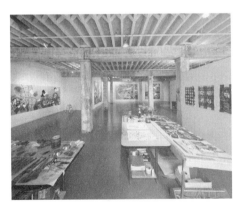

Artists Responsible for: Application fee— $35; deposit—$150; food, travel, materials, personal living expenses.

Organization Provides: Housing, studios, program administration, and general stipend ($500–$1,000/month).

Other Expectations & Opportunities: Artists are expected to give at least one informal public slide presentation about their work during their stay at Bemis and to leave one piece of work made during their residency as a donation to the Bemis Center. The donated piece is decided upon by the artist and the executive director.

Bogliasco Foundation

"I know that physical environment has a tremendous influence on my work, and the setting at the center was hauntingly beautiful. I can still see the great bowl of the sea outside my window, the layered terraces of flowers and trees. I have memories of waking at night to the full moon creating a circle of light on the sea with absolute darkness looming beyond, to the beads of light formed by fishing boats strung out across the horizon. And always in my mind is the soft and penetrating light of Italy that makes poets of us all."—ESMÉ THOMPSON

U.S. Office:
10 Rockefeller Plaza, 16th Floor
New York, NY 10020-1903
Phone: (212) 713-7628
Fax: (212) 489-0787
E-mail: *info@bfny.org*
Web: *www.liguriastudycenter.org*

Mission: To support and promote the arts and humanities. The Bogliasco Foundation was established in 1991 as a nonprofit entity devoted to the support of the arts and humanities through its operation of the Liguria Study Center for the Arts and Humanities. The study center offers residential fellowships to persons from around the world doing advanced creative work or scholarly research in the traditional disciplines of the arts and humanities.

Founded: Organization and Residency, 1991.

Location: Located on the Italian Riviera, in the small town of Bogliasco.

Past Residents: Chester Biscardi, Yves Dana, Susan Gubar, John Harbison, Richard Kenney, Ann Patchett, Mary Jo Salter.

Eligibility: Fellowships are granted to qualified persons engaged in advanced creative work or scholarly research in archaeology, architecture, classics, dance, film/video, history, landscape architecture, literature, music, philosophy, theater, and visual arts. Spouses or partners who intend to pursue a project in one of the disciplines, and who wish to be designated as Bogliasco fellows, must submit separate and complete applications; the Bogliasco Foundation encourages such joint applications.

Studios & Special Equipment Available: Fellows are assigned separate private studios; please inquire as to specific workspace needs. When requested in advance, study facilities for spouses/partners may be made available, either in one of the studios or within their living quarters.

Housing, Meals, Other Facilities & Services: *Housing:* Bedroom with private bath provided to all fellows (and spouse/partner, if accompanying the fellow). *Meals:* All meals are provided to fellows (and spouse/partner, if accompanying the fellow). Children and pets are not permitted. Visits by friends or family members are not allowed except by special prior arrangement.

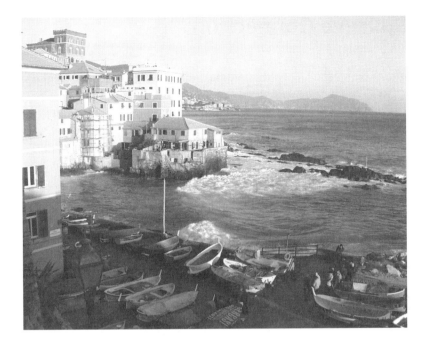

Accessibility: The buildings are old and there is no wheelchair accessibility. Persons who have difficulty walking would not be able to take advantage of the special setting the center offers.

Application & Residency Information:

See Web site or contact Foundation for application information.

Application deadline(s): January 15 for Fall–Winter; April 15 for Winter–Spring

Resident season(s): Fall–Winter, and Winter–Spring

Average length of residencies: 32 days

Number of artists-in-residence in 2003: 50

Number of artists-in-residence present at one time: Maximum of 16

Selection process: Twice a year by the selection committees

Artists Responsible for: The cost of transportation to and from Genoa is the responsibility of fellows and their accompanying spouses/partners; all other personal expenses incurred during the fellowship period, including the purchase of materials and equipment.

Organization Provides: Housing and meals, studios, and program administration.

The Bullseye Connection

"My approach to materials is not technical. I am not a glass fanatic, but I have chosen this material to realize the majority of my works. Being an artist-in-residence at Bullseye signaled a leap forward in the quality of work, not only from a technical point of view, but a conceptual one as well. While at Bullseye, I had the feeling that I could realize almost everything that I could imagine. It was as if the limits had been removed."
— SILVIA LEVENSON

3610 SE 21st Avenue
Portland, OR 97202
Phone: (503) 227-2797
Fax: (503) 227-3130
E-mail: *TedSawyer@bullseyeglass.com*
Web: *www.bullseyeconnection.com*

Mission: To encourage aesthetic and technical development in the field of kiln-formed glass for art, architecture, and design.

Founded: Organization, 1995; Residency, 1992 (under the auspices of Bullseye Glass Co.).

Location: Southeast quadrant of Portland, Oregon (next to Bullseye Glass factory).

Past Residents: Klaus Moje, Giles Bettison, Silvia Levenson, Anna Skibska, Claudia Borella, Jessica Loughlin, Rafael Cauduro, Narcissus Quagliata, Jun Kaneko, Judy Cooke.

From the Director: "The artist exchange program at the Bullseye Connection is run under the auspices of our research and education department. Artists come from all over the world to pursue this research, with assistance from staff, from both an aesthetic and technical perspective. It is our hope that these explorations will build one on top of the other, ever raising the standards in the execution and the content of work in the medium of kiln glass, and that in so doing, will create a platform from which future artists will be able to work. It is often artists from outside of the medium of glass that break significant ground in both respects, and we encourage these artists to apply."

Eligibility: Open to emerging and mid-career visual artists from all disciplines who are interested in working in glass. Returning applicants welcome. Bullseye studio residency program consists of Factory-Artist Exchanges that can range in duration from four hours to one year. Many have culminated in exhibitions and some in catalogs. The proposed project must require the use of Bullseye's glass product; be strongly technically based; the working method must be related to the kiln, the torch, or coldwork; and the artist must be willing to share the knowledge gained during the project. In order to support

technical advancements within the international glass art community, we give preference to working with artists who teach or who have no objections to our publishing or otherwise disseminating the discoveries made during their project (with credit given, of course, to the artist).

Studios & Special Equipment Available: Large, versatile studio in a factory setting with access to kiln glass equipment, including more than sixteen kilns ranging in size from 24" x 24" x 15" to 96" x 48" x 15". Limited coldworking equipment.

Housing, Meals, Other Facilities & Services: Housing and meals not provided. Public transportation available throughout Portland area.

Accessibility: Facilities are not wheelchair-accessible.

Application & Residency Information:

Please contact Ted Sawyer for application information.

Number of artists-in-residence in 2003: 4

Average number of artists-in-residence present at one time: Varies

Selection process: Internal selection.

Artists Responsible for: Food, travel, and housing.

Organization Provides: Facilities and equipment, program administration, materials stipend (Bullseye glasses appropriate to the scope of the project provided).

Other Expectations & Opportunities: Possible representation of works by the Bullseye Connection Gallery (terms to be agreed upon in advance of exchange project). Artists expected to participate in studio tours.

Byrdcliffe Colony / Woodstock Guild

"Byrdcliffe is magical. Just waking up there, in its beauty, surrounded by art and nature—you couldn't ask for a better environment to create in." — BARI K.

34 Tinker Street
Woodstock, NY 12498
Phone: (845) 679-2079
Fax: (845) 679-4529
E-mail: *franne@woodstockguild.org*
Web: *www.woodstockguild.org*

Mission: To provide the opportunity for people to discover and develop their creative and artistic spirit; and to preserve the Byrdcliffe Colony as an arts haven, natural environment, and historic site.

Founded: Organization, 1902; Residency, 1988.

Location: Three hundred acres of mountains, pines, meadows, forests, and streams in the Catskill Mountains on the slopes of Mt. Guardian, close to the village of Woodstock, and two hours from New York City.

Past Residents: Eve Hesse, Milton Avery, Wallace Stevens, Will and Arie Durant, John Dewey, Bob Dylan, Ava Watson Schuetze, Zulma Steele, Sapphire, Gina Gionfriddo.

From the Director: "Byrdcliffe's natural setting, its proximity to Woodstock, and its legacy of a rich arts and crafts heritage continue to be a creative stimulus for today's many artistic disciplines."

Eligibility: Poets, playwrights, fiction and nonfiction writers, painters, sculptors, composers.

Studios & Special Equipment Available: Ceramics/pottery studio and kiln, painting, and writing studios.

Housing, Meals, Other Facilities & Services: *Housing:* Private bedroom in a shared facility; furnishings and linens provided. *Meals:* Meals are the responsibility of the residents; cooking/kitchen facilities available for residents' use. Every artist has a private studio. *Other facilities/services:* Common room with computer and Internet connection for residents' use; laundry facilities onsite. Smoking not permitted onsite.

Accessibility: Facilities are not accessible.

Application & Residency Information:
Application available online
Application deadline(s): April 1
Resident season(s): June–September
Average length of residencies: 4 weeks

Number of artists-in-residence in 2004: 40

Average number of artists-in-residence
present at one time: 10

Selection process: Outside professional
jury/panel selection.

Artists Responsible For: Application fee—
$10; residency fee—$600; food, travel, and
materials.

Organization Provides: Housing, studios,
program administration.

Additional Support: Writers under the age
of thirty-five who need financial assistance
may apply for a $100 scholarship from the
Patterson Fund.

Other Expectations & Opportunities:
Artists are invited to participate in end-of-
session Open Studios and Readings open to
Woodstock's artistic community.

Caldera

"Like a traveler in a foreign land, I could happily amble without a map. Await the unknown; receive the special mystery of the place. Discovery is transformation. Hidden passages were revealed, making the creative journey long and deep."
— PATRICE SILVERSTEIN

224 NW 13th Avenue
Portland, OR 97209
Phone: (503) 937-7594
Fax: (503) 937-8594
E-mail: *marna.stalcup@wk.com*
Web: *www.calderaarts.org*

Mission: Caldera is a nonprofit interdisciplinary arts organization committed to fostering creativity, provoking experimentation, and stimulating a deeper appreciation for the environment.

Founded: Organization, 1996; Residency, 2001.

Location: Caldera is located on the shore of a cerulean blue lake formed in the cindercone of an extinct volcano in the Central Cascades. Our site is located at an altitude of 3,500 feet and set amid ninety acres of Douglas Fir and Ponderosa Pine surrounded by the Deschutes National Forest, seventeen miles west of Sisters, Oregon.

Past Residents: Judith Barrington, John Callahan, Stacey D'erasmo, Dorianne Laux, Joseph Millar, Joanne Mulcahy, Michael Stirling, Anthony Swofford, Edie Tsong, Akil Wingate.

From the Director: "As we nurture the child who loves dance, writing, or painting, we must be ready to support the choreographer, novelist, or artist that this child might one day become. At Caldera, the quiet, natural surroundings offer inspiration and solitude to create without obligation." — MARNA STALCUP

Eligibility: Visual artists, writers, and performance artists (see Indices for more specifics) selected by peer review panel. Expanding opportunities with addition of equipment. Repeat residencies permitted after one year.

Studios & Special Equipment Available: Ceramics/pottery, dance/choreography, metalworking, painting, sculpture, woodworking, and writing studios; exhibition/installation space and performance theater.

Housing, Meals, Other Facilities & Services: *Housing:* Individual cabin/house for each resident; furnishings and linens provided. *Meals:* Residents responsible for own meals; kitchen for residents' use. *Other facilities/ services:* Common room with computer and Internet access for residents' use; laundry

facilities onsite; some local transportation available with advance notice; smoking not permitted onsite.

Accessibility: Studios and common building (including bathrooms) are wheelchair-accessible. Sleeping area in living quarters is accessible, but not bathroom.

Application & Residency Information:

Application available online

Application deadline(s): June 1

Resident season(s): December–March

Average length of residencies: 2–4 weeks

Number of artists-in-residence in 2003: 38

Average number of artists-in-residence present at one time: 5

Selection process: Outside professional jury/panel selection.

Artists Responsible for: Application fee—$15; food, travel, materials, and specialized equipment.

Organization Provides: Housing, studios, and program administration.

Other Expectations & Opportunities: Workshops with students and/or adults or other outreach activities in the local community are suggested for artists with residencies of more than two weeks.

The Carving Studio and Sculpture Center

636 Marble Street, P.O. Box 495
West Rutland, VT 05777-0495
Phone: (802) 438-2097
Fax: (802) 438-2020
E-mail: *carving@vermontel.net*
Web: *www.carvingstudio.org*

Mission: The Carving Studio and Sculpture Center is a nonprofit educational organization dedicated to the creation and presentation of sculpture. Our studio environment integrates workshops, artist residencies, and exhibitions to foster sculptural investigation and cultural exchange.

Founded: Organization, 1987; Residency, 1989.

Location: Situated among the Green Mountains of central Vermont, adjacent to two hundred acres of former marble quarrying and manufacturing facilities. The former company store of the Vermont Marble Company serves as the center for workshops, lectures, communal dinners, and special events. We maintain a gallery in the historic West Rutland business district to showcase contemporary sculpture.

Past Residents: Margaret Otieno, Peter von Tiesenhausen, Masaharu Suzuki, Ayushiin Ulziibataar, Tony Birks-Hay, Carlos Dorrien, Mary Cooke.

From the Director: "The Artist-in-Residency Program at the CSSC offers a unique environment conducive to the particular needs of sculptors. The summer workshops attract an appreciative audience and talented instructors who enrich the experience of each artist's residency." — CAROL DRISCOLL, DIRECTOR

Eligibility: Sculptors in all media are eligible for one- to eight-week residencies; U.S. and international artists.

Studios & Special Equipment Available: Variety of indoor and outdoor spaces for sculpture, including stonecarving facilities.

Housing, Meals, Other Facilities & Services: *Housing:* Private bedroom in a shared facility; furnishings and linens provided. *Meals:* Dinner served daily; vegetarian meals available; cooking/kitchen facilities available to residents. *Other facilities/services:* Common room/meeting space for residents' use with computer and Internet connection; smoking permitted outdoors only.

Accessibility: Studios and public areas are accessible.

Application & Residency Information:

Application deadline(s): Ongoing

Resident season(s): May–September

Average length of residencies: 1 month

Number of artists-in-residence in 2003: 9

Average number of artists-in-residence present at one time: 2

Selection process: Outside professional jury/panel selection and internal selection.

Artists Responsible for: Some food, some travel, some materials.

Organization Provides: Housing, evening meals, some travel, some materials, and general stipend of $1,000.

Other Expectations & Opportunities: Artists-in-residence are expected to participate in public exhibitions/presentations; participation in studio tours and donation of artwork is optional.

Center for Contemporary Printmaking

"It was difficult to find my feet again after [losing all my work in a] fire, but this creative haven has allowed me to find my phoenix in the ashes." — PAUL FURNEAUX

Mathews Park, 299 West Avenue
Norwalk, CT 06850
Phone: (203) 899-7999
Fax: (203) 899-7997
E-mail: *contemprints@conversent.net*
Web: *www.centerforcontemporary printmaking.org*

Mission: Center for Contemporary Printmaking is a nonprofit studio and gallery dedicated to exhibiting, creating, and preserving art on paper, and educating artists and the general public about the art of the print. It is the only center of its kind between New York and Boston.

Founded: Organization, 1995; Residency, 2003.

Location: Less than one hour from New York City, near Long Island Sound and in the artistic community of southwestern Fairfield County, Connecticut. Our facilities are housed in two fully updated nineteenth-century buildings in Mathews Park, the setting for the historic Lockwood Mathews Mansion Museum and Stepping Stones Museum for Children.

Past Residents: Paul Furneaux, Nancy Friese.

From the Director: "The Artist-in-Residence Program provides artists with the necessary seclusion of an Artist's Cottage, enables interaction with other artists and printers in the main building, gives access to the Center's multimedia resources, and affords opportunities to share ideas, insights, and produced work with the general public."
— ANTHONY KIRK, ARTISTIC DIRECTOR

Eligibility: Artists from any geographic location, working in any printmaking mediums, paper arts, book arts, and related disciplines.

Studios & Special Equipment Available: Fully equipped printmaking studios for intaglio, woodcut, and silkscreen; paper mill; darkroom; computers for digital prepress.

Housing, Meals, Other Facilities & Services: *Housing:* Private bedroom in a shared facility; furnishings and linens provided. *Meals:* Meals are the responsibility of residents; cooking/ kitchen facilities available to residents. *Other facilities/services:* Common room or meeting space for residents' use; laundry facilities onsite; smoking permitted outdoors only. Spouses/partners allowed for full stay.

Accessibility: Facilities are fully accessible.

Application & Residency Information:

Application available online

Application deadline(s): Varies

Resident season(s): Ongoing

Average length of residencies: 1 or more weeks

Number of artists-in-residence in 2003: 1

Average number of artists-in-residence
present at one time: 1

Selection process: Internal selection (staff,
board, and/or advisory board).

Artists Responsible for: Application fee —
$25; residency fee — $600/week; food, travel,
and materials.

Organization Provides: Housing, studios,
equipment, program administration.

Additional Support: The Center is in the
process of establishing continuing fellowships.

Other Expectations & Opportunities:
Artists-in-residence are expected to participate
in onsite public exhibitions/presentations and
to donate a piece of artwork to the Center;
participation in studio tours is optional.

Civitella Ranieri Foundation

"I came at a time of bigger than usual doubt and uncertainty about my work. Here I was able to forget everything for a few weeks and reconnect with the pleasure of working. I was able to reconnect with beauty: the beauty of the castle and of Umbria, of people and things."

U.S. Office:
28 Hubert Street
New York, NY 10013
Phone: (212) 226-2002
Fax: (212) 226-3113
E-mail: *civitella@civitella.org*
Web: *www.civitella.org*

Mission: To bring together visual artists, writers, and musicians from around the world who demonstrate talent and an enduring commitment to their disciplines. To support the dissemination of ideas and to foster a collaborative spirit among the fellows at the Civitella Ranieri Center.

Founded: Organization, 1993; Residency, 1995.

Location: In the fifteenth-century Civitella Ranieri castle near the city of Umbertide in the Umbria region of Italy.

Past Residents: Past fellows are listed on the Civitella Ranieri Web site.

From the Director: "The mixture of disciplines and cultural backgrounds in each group of Civitella fellows is what makes the residency experience a rewarding one. The beauty of the surrounding Umbrian countryside plays an unpredictable but lasting role in each fellow's work."—ALEXANDER CRARY, EXECUTIVE DIRECTOR

Eligibility: The Civitella Ranieri Foundation invites individual visual artists, writers, and composers (see Indices for specific categories) to apply for fellowships. A rotating group of nominators submits the names of candidates who are then invited to apply. An international jury of peers makes the final selection of fellows.

Studios & Special Equipment Available: Digital media, music/piano, music recording, painting, sculpture, and writing studios.

Housing, Meals, Other Facilities & Services: *Housing:* Individual apartment for each resident; furnishings and linens provided. *Meals:* All meals are provided. *Other facilities/ services:* Common room or meeting space for residents' use; computers (without Internet) are available for fellows' projects; Internet connection (without computer) available in common area; local transportation provided; smoking permitted in studios and outdoors only. Spouses/partners are encouraged to visit for no more then two weeks during a residency session.

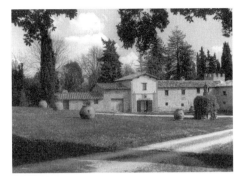

Accessibility: Most studio, living, and public spaces are not accessible to wheelchairs.

Application & Residency Information:

Residencies awarded by invitation only; unsolicited applications not accepted.

Selection process: Outside professional jury/panel selection.

Artists Responsible for: Personal expenses.

Organization Provides: All travel, lodging, and meals. There is no additional stipend.

Other Expectations & Opportunities: Artists-in-residence are given the options of participating in public exhibitions/presentations and studio tours, and donating artwork.

The Cooper Union School of Art Summer Residency Program

"I wanted to work in Manhattan for a few weeks. My studio is small and I wanted to have a large studio. I have a full-time job and it was good to get away. Interacting with other artists and the visiting professionals really helped make it a productive three weeks for me."—BRIAN WENDLER

30 Cooper Square
New York, NY 10003
Phone: (212) 353-4200
Fax: (212) 353-4345
E-mail: *pecora@cooper.edu*
Web: *www.cooper.edu/artsummer*

Mission: To foster the creative and professional development of emerging and mid-career visual artists.

Founded: Organization, 1859; Residency, 2003.

Location: The Cooper Union for the Advancement of Science and Art is a distinguished private college of art, architecture, and engineering founded in 1859 by Peter Cooper, an inventor, industrialist, and philanthropist. Located in New York City's East Village, the Cooper Union Foundation building is a National Historic Landmark and contains a rich, storied history.

Past Residents: Dore Ashton, Louisa Chase, Jim Dine, Jacqueline Humphries, Lyle Ashton Harris, David Row, Jerry Saltz, Peter Schjeldahl, Gary Schneider, Terry Winters.

From the Director: "The Cooper Union School of Art Summer Residency Program presents artists with the possibility to situate themselves within the heart of New York City's art world to interact with a community of dynamic and renowned visual artists, critics, and scholars and to enjoy a devoted, focused time in which to create their artwork. The studios are spacious and sky-lit, and the facilities are state-of-the-art. The experience is intense and unparalleled anywhere else in the world."—ROBERT RINDLER, DIRECTOR

Eligibility: The program is international. It is ideally suited to emerging and mid-career artists who seek an intensely focused period of time with their ongoing artwork and an outlet for interaction with other artists and critical feedback. Artists working in the fields of painting, drawing, photography, and printmaking are eligible.

Studios & Special Equipment Available: Painting/drawing (each participant is provided with a semi-private studio, easel, work table, chair, materials cabinet, glass palette, shatterproof jars, paint rags, and nonlatex gloves;

additional equipment is available for checkout, such as tools, lights, slide projector, opaque projector, hotplates, and large-size stretcher bars; technical support available); photography (black-and-white and color darkrooms, medium- and large-format printing, digital lab, additional equipment available for checkout; artists must bring their own camera; technical support available); printmaking (etching, lithography, silkscreen; access to hydraulic press; fully equipped facilities with well-ventilated acid room; technical support available).

Housing, Meals, Other Facilities & Services:
Housing: Artists share two-bedroom apartments conveniently located on campus. The facilities are modern, clean, with wonderful views of the city. Each apartment is a self-contained, air-conditioned unit with its own bathroom and kitchenette, and each artist has his/her own bedroom with a twin bed, linens, desk, wardrobe, and bookshelf.
Meals: Some meals are provided; each apartment has a kitchen for residents to prepare their own meals; in addition, the East Village is an extremely exciting area full of a wide variety of ethnically diverse restaurants and charming boutiques. There are many places to eat cheaply and shop for groceries, and the Union Square Greenmarket is a five-minute walk from campus. *Other facilities/services:* The Menschel Room is a wonderful gathering space for artists-in-residence, with a balcony overlooking the city; laundry facilities onsite; computers with Internet access are available in the college library or by bringing your own laptop (additional accommodations may be made available, as necessary). There is a full-time Manager, a Facilities Manager, and seven Resident Assistants, all of whom live in the building. A particular Resident Assistant will be your primary contact for all housing concerns. There are several colleges nearby, which creates a vibrant and well-patrolled neighborhood. No smoking onsite; ample public transportation. Spouses/partners and children allowed for visits only, dependent upon living accommodations and number of visits. Guests and visitors will not be permitted into the residence unless a resident signs them in and escorts them. Advance authorization from roommates and the Resident Manager and/or the Program Coordinator is required to have overnight guests.

Accessibility: Living quarters and studios are fully accessible; ramps and handicapped lifts provide access to those in wheelchairs.

Application & Residency Information:
Application available online
Application deadline(s): March 1 (please check Web site for updated deadlines.)
Resident season(s): Summer
Average length of residencies: 3 weeks
Number of artists-in-residence in 2003: 9
Average number of artists-in-residence present at one time: 30
Selection process: Internal selection (staff, board, and/or advisory board).

Artists Responsible for: Application fee—$25; residency fee—$2,500; deposit—$1,250; food, travel, and materials.

Organization Provides: Facilities, studios, and equipment; technical assistance; program administration.

Other Expectations & Opportunities:
Residents are provided with the opportunity for a group exhibit at the Cooper Union and the chance to give a slide lecture on their work for fellow residents. Various events, including exhibits, seminars, critiques, and tours are scheduled; all are optional. The residents are asked to participate in a program survey that helps the school evaluate the program. They are also asked to permit the use of candid photographs for program promotion.

Djerassi Resident Artists Program

"I don't know if it was the redwood trees or the ebb and flow of sea fog that triggered many of my poems. The poet Anne Carson, a former Djerassi resident, wrote, 'Fog invents the imagination.' Now I understand what she meant." — EUGENE GLORIA

2325 Bear Gulch Road
Woodside, CA 94062-4405
Phone: (650) 747-1250
Fax: (650) 747-0105
E-mail: *drap@djerassi.org*
Web: *www.djerassi.org*

Mission: To support and enhance the creativity of artists by providing uninterrupted time for work, reflection, and collegial interaction in a setting of great natural beauty, and to preserve the land on which the program is situated.

Founded: Organization and Residency, 1979.

Location: On a 580-acre former cattle ranch in the Santa Cruz Mountains, forty miles south of San Francisco. The secluded property encompasses vast grasslands with spectacular views of the Pacific Ocean, cascading creeks, and woodlands thick with towering redwoods, ageless Coastal Oaks, and twisting madrone. Miles of hiking trails lead artists-in-residence to more than forty site-specific sculptures created on the land by former residents. The Artists' House and Artists' Barn provide housing and studios for groups of eight to ten artists who share a residency period and work in a genuine retreat atmosphere.

Past Residents: In its twenty-five years of operation, more than 1,300 artists from locations worldwide have been in residence at the Djerassi Program, including many of international renown.

From the Director: "In the rugged California coastal range, small communities of artists gather to work in solitude and share in a life that is, for one uninterrupted month, art-centered. During each session at Djerassi, a diverse group of writers, visual and media artists, composers, and choreographers comes together in this remote and spectacular setting. Djerassi residencies provide a dedicated time and private place for artistic renewal and release, when the creative process is allowed to evolve freely. Artists explore and advance new ideas free from the confines of everyday life—and residents consistently speak of the extraordinary quantity and quality of new work they produce. Beyond these personal achieve-ments, at Djerassi artists engage in collegial fellowship seldom realized in the outside world. Communal evening meals, artistic presenta-tions, extended conversations, walks, and studio visits frequently lead to spontaneous interdisciplinary collaborations and long-lasting professional associations."
— DENNIS O'LEARY, EXECUTIVE DIRECTOR

Eligibility: Artists of all disciplines worldwide are welcome to apply for a residency at the Djerassi Program. The program panels artist applications in literature (mainly prose, poetry, and playwriting), the visual arts (painting, sculpture, drawing, photography, mixed-media, etc.), music composition, and choreography. The program strives for a wide range of applicants and invites artists of diverse backgrounds, career stages, ages, and geographical origin. Repeat residencies are allowed after a three-year hiatus. Project-based winter residencies are available for alumni.

Studios & Special Equipment Available:
Facilities for ceramics/pottery (small electric kiln only); dance/choreography (1,000-square-foot sprung dance floor, mirrors, sound system, video); digital media (Mac G4 and HP Kayak computers with software and large-format printers); film/digital editing; metal shop (basic welding equipment); music studio (six-foot studio grand and Alesis QS8 Midi pianos and sound system); painting; photography (black-and-white processing); performance theater; sculpture (basic woodworking tools); and writing (studios include a large desk, work space, and outdoor deck).

Housing, Meals, Other Facilities & Services:
Housing: Writers are given a private room in the Artists' House; visual and performing artists are given private live/work space in the Artists' Barn (heated with wood-burning stoves)—barn studios include a sleeping loft. Only the composer's studio has a private bathroom. Furnishings and linens provided (residents do their own laundry). *Meals:* Weeknight meals are prepared by program chef; the kitchen is stocked for other meals, which residents prepare for themselves. Vegetarian meals available; kitchens in both buildings available for residents' use. *Other facilities/services:* Common room or meeting space for residents' use; laundry facilities onsite. Shared iMacs available for e-mail and Internet access in common areas; some studios also have Internet access. Transportation to/from San Francisco and San Jose airports

and weekly town trip provided. Smoking permitted outdoors only. Guests (including children) are welcome as day visitors—no overnight stays.

Accessibility: Living quarters, studios, and public areas are accessible; however, the Djerassi landscape is generally steep and rugged and trails are not easily accessible.

Application & Residency Information:
Application available online
Application deadline(s): February 15
Resident season(s): March–November regular season; winter residencies available to former residents
Average length of residencies: 1 month
Number of artists-in-residence in 2003: 60
Average number of artists-in-residence present at one time: 9
Selection process: Outside professional jury/panel selection (panelists change each year).

Artists Responsible for: Application fee—$25; travel to and from San Francisco Bay Area; all artist materials; personal amenities.

Organization Provides: Housing, meals, studios, some local transportation, and program administration.

Additional Support: Fellowship opportunities (see Web site for details).

Other Expectations & Opportunities:
One session per year, artists participate in our Open House; participating artists stay one week longer. Artists are asked to create an "Artist's Page" commemorating Djerassi residency; these artworks are periodically exhibited in Bay Area shows and at Djerassi events.

Dorland Mountain Arts Colony

"Dorland is attractive in a way no other artists' colony in my experience can rival: verdant mountains in the midst of desert-ranch country, with a fascinating population of birds, animals, wildflowers, ponds, orchards, abundant sunlight, clear air. I will always remember with pleasure my stay there as one of the first colonists." — MAY SWENSON

P.O. Box 6
Temecula, CA 92593
Phone: (951) 302-3837
E-mail: *dorland@ez2.net*
Web: *www.dorlandartscolony.org*

Mission: To provide composers, writers, and visual artists with simple living and working facilities so that creative work may be accomplished within a setting of natural beauty. The unspoiled environment and undisturbed solitude foster creativity.

Founded: Organization and Residency, 1979.

Location: This three-hundred-acre preserve is located in the foothills of Palomar Mountain, overlooking the Temecula Valley. It is sixty miles north of San Diego and approximately one hundred miles southeast of Los Angeles.

Past Residents: Morten Lauridsen, Ray Adams, Donald Rubenstein, Ed Cansino, Jane Culp, Joel Sokolov, Gilah Hirsch, Alice Sebold, May Swenson, Penelope Moffet, James Reiss.

From the Director: "Residents find that the benefits of Dorland normally exceed their preconceptions. Once they settle in (and this can take up to a week) to the lack of noise and interruptions, the natural rhythm of their day can lead them into their innermost selves, that which is frequently forgotten or set aside in their busy daily lives. This provides an opportunity to expand their talents in new and exciting directions. Dorland offers a chance for change, not only at an artistic level, but also on a deeper spiritual level."

Eligibility: Writers, visual artists, and composers. Repeat residencies are available.

Note: Dorland was destroyed in a fire in May 2004. Please visit the organization's Web site to determine current programs. Information on studios & special equipment; housing, meals, other facilities & services; accessibility; and application & residency are not available at this time.

Artists Responsible for: In the past, artists have been responsible for a residency fee. Please contact organization for current information.

Organization Provides: In the past, the organization provided housing, studios, and program administration. Please contact organization for current information.

Other Expectations & Opportunities: In the past, artists-in-residence have been expected to participate in once-a-month open studios that include audiences from the local communities. Please contact organization for current information.

Willard R. Espy Literary Foundation

"When quiet out the window sheds quiet in the head, when sunrise lights up the brain as well as the beaches, then the Espy residency program is working well. In Oysterville, it does so with more tender attention to whatís needed than anywhere else Iíve been. It was all a gift: the small village, the villagers, the staff, the fellow writers, the weather, the sky, the sounds of water on sand and wind in shingles." — ELEANOR MUNRO

P.O. Box 614
Oysterville, WA 98641
Phone: (360) 665-5220
Fax: (360) 665-5224
E-mail: *wrelf@willapabay.org*
Web: *www.espyfoundation.org*

Mission: To provide time and place for artists to create new work.

Founded: Organization, 1998; Residency, 1999.

Location: In Oysterville, a National Historic District on Willapa Bay near the northern tip of Washington State's Long Beach Peninsula.

Past Residents: Faith Adiele, Annie Callan, Charles Cross, Michael Morse, Eleanor Munro, Marc Nieson, Kary Wayson, Moon Unit Zappa.

From the Director: "The Espy residency program is both about purpose—activating the creative process—and place—a village on a magnificent estuary. The tides sweeping in and out across the bay, the incredible light, and the quietude all create a perfect atmosphere in which artists can discover pathways to new work." — POLLY FRIEDLANDER, FOUNDER AND PRESIDENT, BOARD OF TRUSTEES

Eligibility: Open to writers, photographers, media artists, and scholars from all countries. No restrictions on repeat residencies.

Studios & Special Equipment Available: Writers' workspace.

Housing, Meals, Other Facilities & Services: *Housing:* Two two-resident houses are the principle residency units; occasionally, the single-occupant Red Cottage is available. Furnishings and linens are provided. *Meals:* Dinner is provided the first evening and occasionally during the residency. Residents are responsible for all other meals; each house has a complete kitchen. Residents receive a weekly stipend for food. *Other facilities/services:* Common room or meeting space for residents' use; laundry facilities onsite; computer with Internet connection in common area; public transportation available; transportation to/from Oysterville and Seattle-Tacoma International

Airport is usually provided. Smoking permitted outdoors only. Spouses/partners and children allowed for visits only; must stay in local B&B/hotel.

Accessibility: Facilities are not accessible.

Application & Residency Information:

Application available online

Application deadline(s): December 1, March 1, July 1

Resident season(s): March, June, October

Average length of residencies: 1 month

Number of artists-in-residence in 2003: 9

Average number of artists-in-residence present at one time: 3–5

Selection process: Internal selection (2–3 board members plus 1 former resident).

Artists Responsible for: Application fee— $15; travel and materials.

Organization Provides: Housing, meals, general stipend—$400.

Other Expectations & Opportunities: Artists-in-residence are expected to partici- pate in onsite public presentations.

Evergreen House, Johns Hopkins University

"Being the only artist in residence, I thought I may be a bit lonesome, but the staff and interns at the house, not to mention the docents who give tours and the grounds manager, the Shakespeareans on the lawn, the students from the university and the Baltimore community in general were so friendly and welcoming that I forgot all of my anxieties and quickly began work in the most amazing studio ever. In addition to the beautiful studio, I was transported into a lush English garden, an Italianate mansion, and had the use of a rare book collection to feed my work. This was a dream residency, one I never wanted to leave." — MICKI WATANABE

4545 North Charles Street
Baltimore, MD 21210
Phone: (410) 516-0341
Fax: (410) 516-0864
E-mail: *joregan@jhu.edu*
Web: *www.jhu.edu/historichouses*

Mission: The mission of Evergreen is two-fold: first, to preserve, document, and care for Evergreen, the home of the Garrett family, and its collection of fine and decorative arts; second, to honor and continue the Garrett family legacy of arts patronage in Baltimore by producing innovative exhibitions of contemporary art, offering an annual artist's residency, hosting educational and public programs and musical and performing arts events, and granting scholarships to students of music and art.

Founded: Evergreen House Foundation, 1952; historic house museum, 1990; Residency, 2001.

Location: On twenty-six landscaped acres fifteen minutes from downtown Baltimore; the historic house is centrally located on a major north-south thoroughfare between two college campuses.

Past Residents: Randy Bolton, Maggie Thomas, Micki Watanabe, Mehmet Dogu.

From the Director: "During 1922–1923, Leon Bakst—the Russian avant-garde set and costume designer—was an artist-in-residence at Evergreen house. As a six-month guest of the Garretts' (who lived here until 1952) he found a book on Russian peasant art in the vast family library and proceeded to design a fantastic private theater at Evergreen with bold Russian folk-art motifs taken directly from the book. Thirty thousand books, Chinese porcelains, modern paintings, and Dutch marquetry furniture are among the many resources artists may respond to during their residency. Temporary art exhibitions in the historic house, the gallery, and outdoors allow installations with mediums ranging from landscape painting, digital prints, live sheep, a forty-foot flatbed truck, and a sculpture made entirely out of cardboard. We invite artists to come to Evergreen and connect with the past and practice in place."
—JACKIE O'REGAN, DIRECTOR

Eligibility: Visual artists living outside of Maryland; future plans to host writers.

Studios & Special Equipment Available:
Facilities for exhibition/installation and painting.

Housing, Meals, Other Facilities & Services:
Housing: One-bedroom cottage apartment for each resident; furnishings and linens provided. The artist is expected to keep the cottage apartment clean and in good condition. Half of the stipend will be held until the residency is completed. *Meals:* Residents must purchase and prepare meals; kitchen in each apartment. *Other facilities/services:* Laundry facilities onsite; access to computer and Internet in the Evergreen House museum offices; bicycle for residents' use; smoking permitted outdoors only. Spouses/ partners and children allowed for full stay.

Accessibility: Only public areas are accessible.

Application & Residency Information:
Application deadline(s): November 1 (postmark)

Resident season(s): June and July

Average length of residencies: 8–9 weeks

Number of artists-in-residence in 2003: 1

Average number of artists-in-residence present at one time: 1

Selection process: Outside professional jury/panel selection.

Artists Responsible for: Food, travel, and materials.

Organization Provides: Housing, studios, and facilities; general stipend of $2,000 (to cover all transportation and shipping of art to and from exhibition, one return visit for an opening, and program expenses).

Other Expectations & Opportunities:
The artist will have an exhibition the year following the residency; artists must participate in an open studio for one evening during the residency. Donation of artwork is optional.

The Exploratorium

"Working as an artist-in-residence at the Exploratorium has been the best collaborative experience that I have had in more than twenty-five years as an artist." — GEORGE GESSERT

3601 Lyon Street
San Francisco, CA 94123
Phone: (415) 563-7337
Fax: (415) 561-0370
E-mail: *pamw@exploratorium.edu*
Web: *www.exploratorium.edu/arts*

Mission: The Exploratorium is a museum of science, art, and human perception, with a mission to create a culture of learning through innovative environments, programs, and tools that help nurture their curiosity about the world around them. We invite artists to explore the natural world in new ways. From the beginning, the museum has used the observations made by scientists and artists as a means of expanding visitors' understanding of nature, culture, and natural phenomena.

Founded: Organization, 1969; Residency, 1979.

Location: In the northern part of San Francisco near the Golden Gate Bridge and the San Francisco Bay. Housed in the Palace of Fine Arts, a beaux-arts building constructed during the Panama Exhibition of 1915.

Past Residents: Eduardo Kac, Philip Ross, Heather Ackroyd, Dan Harvey, Rhodessa Jones, Barabara Damashek, Hector Fernandez Pena.

From the Director: "We are intrigued by artists who are interested in developing new insights and understandings by incorporating the artistic process with other investigative processes. We hope that the resulting artworks will initiate internal and public discourse about the relationships among art, science, human activities, and topics related to multidiscipli-nary and multicultural activities. Artists should be interested in dialogue and interaction, and view art as a key to understanding and com-municating their excitement about the world."

Eligibility: There are no restrictions in terms of region, etc. Many artists from a variety of disciplines have been featured; however, installation artists, phenomena artists, exhibit artists, filmmakers, media artists, performers, and sound artists make up the majority of our roster.

Studios & Special Equipment Available: A large warehouse-like building with few white walls, a small, 130-seat theater, and a flexible exhibition floor. The museum floor features hundreds of interactive exhibits that explore seeing, sound, and hearing, the physical world, mind and learning, and the life sciences. The atmosphere on the floor is generally noisy, although special spaces for artworks that require control over light and sound have been built. There is a fully equipped machine shop and woodworking shop as well as media and electronic labs. Graphic production facilities are also available.

Housing, Meals, Other Facilities & Services:
Housing: Hotels and other external residencies. If the artist requests it, accommodations with a kitchen can be found. *Meals:* Residents are responsible for own meals; per diem provided by organization. *Other facilities/services:* Computer and Internet connection in studio area; public transportation available; smoking permitted outdoors only. Pets allowed (there are a lot of dogs). Spouses/partners and children allowed for full stay (at artists' own expense).

Accessibility: Facilities are fully accessible.

Application & Residency Information:

Application available online

Application deadline(s): Ongoing

Resident season(s): Year-round

Average length of residencies: 1 week–1 year

Number of artists-in-residence in 2003: 6

Average number of artists-in-residence present at one time: 4

Selection process: Internal selection (staff, board, and/or advisory board).

Artists Responsible for: Nothing—if accepted, the Exploratorium pays for everything.

Organization Provides: Housing, meals, travel assistance, materials stipend, housing stipend, and general stipend.

Other Expectations & Opportunities:
Two levels of residencies: Exploratory and Full Residencies. Exploratory Residencies usually last approximately one week, and there is no expectation of completed artwork. These residencies are used to begin a dialogue between the artist and the Exploratorium; we expect the artist to be onsite and ready for conversation. During Full Residencies, the outcome is an artwork that will become a permanent part of our collection or function as a temporary work of art. We frequently organize public opportunities for the artist.

Fine Arts Museums of San Francisco

"The whole experience of the residency was really great for me. It was nice to be connected to the community with my art in a way that has not been possible before—the act of creating art while engaging with the public. I am very grateful for the opportunity to participate."—MARK FAIGENBAUM

Legion of Honor Museum
100 34th Avenue
San Francisco, CA 94121
Phone: (415) 750-7634
Fax: (415) 750-3656
E-mail: *rbaldocchi@famsf.org*
Web: *www.thinker.org*

Mission: Bringing working artists into the museum setting, and giving the community access to the artistic process.

Founded: Organization, 1924; Residency, 1998.

Location: The Legion of Honor is located in San Francisco in Lincoln Park, overlooking the San Francisco Bay. The new de Young Museum is scheduled to re-open in summer 2005 and is located in Golden Gate Park, San Francisco.

Past Residents Include: Ray Beldner, Geoffry Nwogu, Silva Poloto, Cynthia Tom, Rick Rodrigues, Mike Arcega, Robert Gutierrez, Ted Vasin, Lynne-Rachel Altman, Tatiana Lyskova.

From the Director: "The artist-in-residency program began at the de Young Museum in 1998 and was relocated to the Legion of Honor and the de Young Art Center during the rebuilding of the de Young Museum. During this time the program has evolved from a weeklong residency to a month-long residency, which has afforded our artists the opportunity to experiment with new ideas and techniques while focusing on the creation of a new series/body of work. Often times, the artists will begin their residency with pre-conceived ideas of their projects and discover that a few days into the residency they are taking a new turn with their work. This is extremely satisfying to our staff as it is our goal to witness an artist taking risks and thus developing their work. It does take courage on the artist's behalf, as they are working in a bubble. However, this bubble of constantly being on view tends to provide inspiration as each artist interacts with the public and receives enthusiastic responses."

Eligibility: Focus is on local artists and may occasionally choose an artist outside the Bay Area. The residency is specifically designed for visual artists of all media including film. Metal work/blacksmithing is not an option due to the lack of facilities.

Studios & Special Equipment Available:
A basic space for an artist to work and the
artist must bring all equipment.

Accessibility: Facilities are fully accessible.

Application & Residency Information:

Application deadline(s): Ongoing

Resident season(s): Year-round

Average length of residencies: 1 month

Number of artists-in-residence in 2003: 12

Average number of artists-in-residence
present at one time: 1

Selection process: Internal selection (staff,
board, and/or advisory board).

Artists Responsible for: Housing, meals,
travel, materials, and equipment.

Organization Provides: Studio space,
materials stipend—$10/day; general stipend—
$50+/day.

Other Expectations & Opportunities:
The artist is expected to be onsite working
at least four hours a day, five days a week.
The artist has an option to give a lecture,
slide-show, and workshop. The residency
provides the artist with a reception at the
end of the residency. Studio tours and dona-
tion of artwork are optional.

Fine Arts Work Center

"A Fine Arts Work Center Fellowship means freedom and community. It allows me the freedom to explore, play, and grow as a creative individual without constraints and expectations, to fall in love again with my craft, to rigorously challenge myself, to unfurl, to free-fall. And I savor the camaraderie formed by the writing and visual arts fellows and the extended community of Provincetown and Cape Cod, the three-mile stretch of sand, shacks, and quirky souls edging the gleaming ocean, boundless and open."—VIET LE

24 Pearl Street
Provincetown, MA 02657
Phone: (508) 487-9960
Fax: (508) 487-8873
E-mail: *General@FAWC.org*
Web: *www.FAWC.org*

Mission: The Fine Arts Work Center in Provincetown is dedicated to providing emerging writers and visual artists with time and space in which to pursue independent work in a community of peers.

Founded: Organization and Residency, 1968.

Location: FAWC is housed in a converted lumberyard in Provincetown, Massachusetts, America's oldest arts colony, located at the end of Cape Cod.

Past Residents: Adam Haslett, Portia Munson, Yun-fei Ji, Lisa Yuskavage, Denis Johnson, Yusuf Komunyakaa, Louise Glück, Michael Cunningham, Nick Flynn, Jack Pierson, Jhumpa Lahiri, Ellen Gallagher.

From the Director: "The Fine Arts Work Center, designed in 1968 by a group of concerned artists and writers, has been dedicated to the effort of attracting emerging visual artists and writers to Provincetown, and supporting them with space to live and work and a modest stipend. This annual infusion of fresh creative talent and ideas serves as a dynamic wellspring from which the entire community thrives. The plan is to encourage younger artists and writers in the early 'emerging' stage of their careers with seven months of uninterrupted time to devote exclusively to their art in a community of like-minded peers. To date, the Work Center has provided support for over 700 writers and visual artists, many of whom have gone on to win the most prestigious prizes in arts and letters, making a profound contribution to, and impact on, contemporary art and literature in America and indeed the world."
— HUNTER O'HANIAN, EXECUTIVE DIRECTOR

Eligibility: Emerging creative writers (poetry and fiction) and visual artists (all forms) from all nations in the critical early stages of their careers.

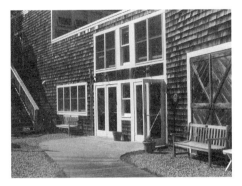
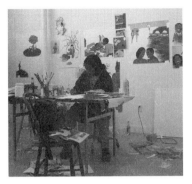

Studios & Special Equipment Available:
Studios can accommodate painting, photography, sculpture, woodworking, and writing. Exhibition/installation space onsite.

Housing, Meals, Other Facilities & Services:
Housing: All fellows are provided with private furnished apartments with kitchens and baths. *Meals:* Fellows are responsible for their own meals. *Other facilities/services:* Common room or meeting space for residents' use; laundry facilities onsite; computer with Internet connection in common area; smoking permitted outdoors only. Pets allowed in three units, available on a first come, first served basis ($100 nonrefundable deposit). Spouses/partners and children allowed for full stay.

Accessibility: First-floor living quarters and studios are accessible; public areas are accessible.

Application & Residency Information:

Application available online

Application deadline(s): December 1 for creative writers; February 1 for visual artists

Resident season(s): October 1–May 1

Average length of residencies: 7 months

Number of artists-in-residence in 2003: 20 (chosen from 1,200 applications)

Average number of artists-in-residence present at one time: 20

Selection process: Outside professional jury/panel selection (different jury each year).

Artists Responsible for: Application fee—$35; pet deposit (if applicable)—$100 (nonrefundable); food, travel, and materials.

Organization Provides: Housing, studios, and program administration; general stipend—$650/month.

Other Expectations & Opportunities:
Once selected for a fellowship, artists and writers are asked to do nothing except to focus on their work. FAWC offers former fellows opportunities beyond their fellowship through the Returning Residency and Long-Term Residency Programs. In addition to the Winter Fellowship Program, FAWC also partners with other nonprofits who select artists and writers to be in residence during other times of the year. FAWC also offers weekend and week-long workshops in creative writing and visual arts in the summer and fall. More than 10,000 people attend FAWC's public events each year.

Isabella Stewart Gardner Museum

"As usually I don't spend more than an hour inside any museum or gallery, staying at the Isabella Stewart Gardner for a month has been a challenging and rewarding experience. The museum itself is an unfinished architectural fairy tale where words and sentences are colors, lights, shadows, reflections, textures, paths, patterns, carvings...scattered around, often disconnected, waiting for the visitor to put them together, give them meaning, sense, ending...finding her or his own way out." — DANIJEL ZEZELJ

2 Palace Road
Boston, MA 02115
Phone: (617) 278-5100
E-mail: *contemporary@isgm.org*
Web: *www.isgm.org*

Mission: Isabella Stewart Gardner founded her museum in 1903 for the "education and enjoyment of the public forever." Today, the museum exercises cultural and civic leadership by nurturing a new generation of talent in the arts and humanities; by delivering the works of creators and performers to the public; and by reaching out to involve and serve its community. The collection is at the center of this effort as an inspiring encounter with beauty and art.

Founded: Organization, 1903; Residency, 1992.

Location: On the Fenway in Boston. Three floors of galleries surround a garden courtyard blooming with life in all seasons. The galleries are filled with paintings, sculpture, tapestries, furniture, and decorative arts from cultures spanning centuries.

Past Residents: Liz Lerman, Doris Cypit, Juan Muñoz, Jennifer Tipton, Abelardo Morell, Lee Mingwei, Laura Owens, Elaine Reichek, Steffon Harris, Dayanita Singh, Nari Ward.

From the Director: "In 1992, the Isabella Stewart Gardner Museum reached out to the artist community in the search for renovation. Rarely are artists given an active role in the reshaping and rethinking of an institution. Here, though, through the Artist-in-Residence Program, a celebrated museum has undertaken to support the imaginative through creativity and learning, and in so doing has strengthened the founder's legacy."

Eligibility: All are welcome to apply.

Studios & Special Equipment Available: Individual workspace.

Housing, Meals, Other Facilities & Services: *Housing:* Individual apartment for artist-in-residence. *Meals:* Residents responsible for own meals; kitchen in apartment. *Other facilities/ services:* Laundry facilities onsite; computer with Internet connection in residents' area; local transportation throughout the Boston area. Smoking permitted outdoors only. Spouses/partners and children allowed for visits only.

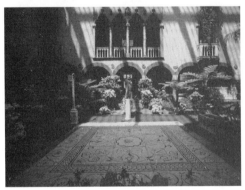

Accessibility: The museum and the collection are fully accessible to wheelchairs; however, the artist apartment is not.

Application & Residency Information:

Application deadline(s): September 29

Resident season(s): Year-round

Average length of residencies: 1 month

Number of artists-in-residence in 2003: 5

Average number of artists-in-residence present at one time: 1

Selection process: Internal selection by Curator of Contemporary Art.

Artists Responsible for: Food.

Organization Provides: Travel assistance (two round-trip airplane tickets between Boston and your permanent residence at a discounted coach fare); housing stipend—$50/day; general stipend—$7,000.

Other Expectations & Opportunities:
If their schedule permits, the artists-in-residence will agree to work with the Museum's Education Department in conjunction with partnership schools and teachers to effect ISGM programs with area schoolchildren. This commitment will be a minimum of twelve hours during the residency term but may be expanded upon mutual written agreement.

Hall Farm Center for Arts and Education

"My residency at the Hall Farm in June 2002 was the catalyst for a body of work based on light interactions on water. The atmosphere from the moment you arrive at the Farm is one that encourages the artist to use the time as he or she sees fit— an environment that takes the idea of a 'retreat' seriously. At the Hall Farm I found a walk through forest trails, a visit with another artist, or a cup of coffee with staff had as much to offer to my work as hours of studio isolation. In my brief time at the Farm I found myself able to focus again on the artistic experimentation that has since allowed my work to progress."
— JEFF MARSHALL

392 Hall Drive
Townshend, VT 05353
Phone: (802) 365-4483
E-mail: *info@hallfarm.org*
Web: *www.hallfarm.org*

Mission: The Hall Farm Center for Arts and Education is a nonprofit organization dedicated to promoting the processes of artistic creation and their integration into school and society. Central to our mission is the Hall Farm, which provides an environment for artists, educators, and students to investigate, experiment, collaborate, and create. Direct support for working artists is provided through summer residencies at Hall Farm, where they can devote sustained attention to their creative endeavors. During the school year, we offer workshops for educators on the integration of the arts into school curricula, as well as space, instruction, and resources to young and emerging artists. (Educational programming never overlaps with residencies.)

Founded: Organization, 1999; Residency, 2000.

Location: Rolling hills, pastures, forest, and a pond on 221 acres in southeastern Vermont, twenty miles northwest of Brattleboro, about two and a half hours from Boston, and about four hours from New York City. Hall Farm offers modern amenities while retaining the spirit of a nineteenth-century farm.

Past Residents: Rebecca Chace, Joanna Fuhrman, Rebecca Gates, Elijah Gowen, Lisa Lerner, Mary Mazziotti, Brooke Stephens, Susan Thames, Timothy A. Westmoreland, Penny Wolfson.

From the Director: "Time at the Hall Farm is an opportunity to work, relax, reflect, and be inspired by the quiet refuge of the Vermont countryside. The rolling pastures and woods, the pond, and the farm buildings themselves offer the perfect embodiment of a life of quiet contemplation and creative possibility. Or, to quote Shakespeare, 'And this our life, exempt from public haunt, finds tongues in trees, books in the running brooks, sermons in stones, and good in everything.'"
— SCOTT BROWNING

Eligibility: Artist residencies are offered at no cost to artists at all stages of their careers working in a variety of mediums. Residents are from the United States and abroad.

Studios & Special Equipment Available: Studios are appropriate for painting, sculpture, woodworking, and writing.

Housing, Meals, Other Facilities & Services:
Housing: Private bedroom in a shared facility; furnishings and linens provided. *Meals:* All meals are provided; vegetarian meals available; kitchen in main building available for residents' use. *Other facilities/services:* Common room for residents' use with book and music library; laundry facilities onsite; computer with Internet in common area; some local transportation provided by organization. Smoking permitted outdoors only. Pets allowed on a case-by-case basis.

Accessibility: Studios are accessible. Please discuss needs with directors.

Application & Residency Information:

Application available online

Application deadline(s): First week of February (see Web site for details)

Resident season(s): June–October

Average length of residencies: 1–6 weeks

Number of artists-in-residence in 2003: 25

Average number of artists-in-residence present at one time: 4

Selection process: Outside selection by committees of working artists from each discipline.

Artists Responsible for: Application fee — $20; travel and materials.

Organization Provides: Housing, meals, studios, and program administration.

Hambidge Center for Creative Arts and Sciences

"I've been coming to Hambidge since 1984, and this I know: the Hambidge experience is a special experience. At Hambidge, time is slower, richer, and multilayered; Hambidge time is not lock-stepped clock time. Time at Hambidge is going nowhere in time, but rather is time coming into the light of the present. Time at Hambidge is not used, but is time embraced. Hambidge time is permeable—woods and hopes, clouds and dreams, seasons and desires all mix together here in a spirit of shared community. Above all, Hambidge time is a gift. It can't be bought, sold, or rented. It can only be shared. And in this sense it's sacramental . . . So, of course, it's priceless."

105 Hambidge Court
Rabun Gap, GA 30568
Phone: (706) 746-5718
Fax: (706) 746-9933
E-mail: *center@hambidge.org*
Web: *www.hambidge.org*

Mission: To nurture the creative process that exists in artists of all mediums. With a rich history in life sciences, the Center works to maintain the delicate balance between land, resources, and the creative spirit.

Founded: Organization, 1934; Residency, 1973.

Location: In northeastern Georgia where the Blue Ridge and Nantahala Mountain ranges meet. The Center is 120 miles from Atlanta, and ninety miles from Asheville, North Carolina. The Center sits on six hundred pristine acres and is listed on the National Register of Historic Places.

Past Residents: Kathryn Stripling Byer, Tom Benjamin, Olive Ann Burns, Lucinda Bunnen, Tracey Lane, Gregory Maguire, Andy Newman, Chester Olds, Suzanne Stryk, Mark Winegardener.

From the Director: "A residency at the Hambidge Center is unique because of our live-in studios, and evening fellowship and exchange between the residents. The studios provide the quiet and uninterrupted time required for the creative process to evolve; our setting provides the inspiration of nature on a secluded six-hundred-acre wooded property laced with hiking trails, streams, and waterfalls. Each fully equipped, private studio is adapted to the medium in which the artist is working and is tucked away in the woods, giving privacy and independence to the artist."
—DIMMIE WELLER ZEIGLER, EXECUTIVE DIRECTOR

Eligibility: U.S. and international artists working in all areas of the creative arts and sciences, including writing, poetry, ceramics, visual arts, music composition, performance and dance, environmental arts, and mixed media (see Indices for more specific types of

Resident season(s): February–December

Average length of residencies: 2 weeks–2 months

Number of artists-in-residence in 2003: N/A

Average number of artists-in-residence present at one time: 8

Selection process: Outside professional jury/panel selection.

artists served). Repeat residencies permitted, but limited.

Studios & Special Equipment Available: Facilities for ceramics/pottery (large, electric kiln, raku, wood, cone ten reduction; soda kiln under construction; electric and kick wheels, slab roller and extruder); dance/choreography (limited space); exhibition/installation (limited space); fiber arts; music studio (with Steinway grand piano); spacious painting studios with wall space and great lighting; photography (small darkroom available—chemicals not provided); sculpture; and writing (spacious, scenic, secluded studios with private screened-in porches).

Housing, Meals, Other Facilities & Services: *Housing:* Individual cabin/house for each resident with fully equipped kitchens, twenty-four-hour computer and telephone access for residents; furnishings and linens provided. *Meals:* Dinner provided; vegetarian meals available; kitchen available for residents' use. *Other facilities/services:* Common room for residents' use with fireplace, magazines, CD player, and screened porch; laundry facilities onsite; computer with Internet and printer in common area. Smoking permitted outdoors only. Spouses/partners allowed for visits only.

Accessibility: Living quarters, public areas, and some studios are accessible.

Application & Residency Information:

Application available online

Application deadline(s): May 1 for September–December; October 1 for February–August

Artists Responsible for: Application fee—$20; residency fee—$125/week; refundable cleaning deposit—$50; food (Four meals provided weekly by organization); travel and materials.

Organization Provides: Housing, studios, and four meals a week.

Additional Support: Artists are eligible for the Nellie Mae Rowe Fellowship; Fulton County Arts Council Fellowship; Rabun Gap-Nacoochee School Teaching Fellowship; Rabun County Teaching Fellowship; Individual Benefactor's Fellowships.

Other Expectations & Opportunities: Artists-in-residence have opportunities to give back to Hambidge in a variety of ways, including teaching at local schools, giving slide lectures/presentations, hosting a Hambidge event in their own community, recruiting artists of like-caliber to Hambidge, donating artwork to Hambidge's major fundraising event, hosting open studios, and serving as workshop instructors. Participation in these is optional, though artists are strongly encouraged to support Hambidge's major fundraising event with the donation of artwork.

Headlands Center for the Arts

"The spirit of exploration—the openness to new ideas, new ways of seeing and being in the world—is one of the strongest lessons and greatest gifts Headlands has given visiting artists, and through these artists, to the world." — THÚY LÊ THI DIEM

944 Fort Barry
Sausalito, CA 94965
Phone: (415) 331-2787
Fax: (415) 331-2787
E-mail: *air@headlands.org*
Web: *www.headlands.org*

Mission: Headlands Center for the Arts (HCA) provides an unparalleled environment for the creative process and the development of new work and ideas. Through artists' residencies and public programs, we offer opportunities for reflection, dialogue, and exchange that build understanding and appreciation for the role of society.

Founded: Organization, 1982; Residency, 1986.

Location: On 13,000 coastal acres in Marin County, just ten minutes north of San Francisco, across the Golden Gate Bridge. HCA is housed in historic, former military buildings in a National Park, surrounded by low coastal hills and scenic Pacific Ocean bluffs at the northern edge of the entrance to the San Francisco Bay.

Past Residents: Laylah Ali, Polly Apfelbaum, Mark Dion, Guillermo Gómez-Peña, Joe Goode, Ann Hamilton, Lewis Hyde, Ned Kahn, Julie Mehretu, Shahzia Sikander.

From the Director: "Headlands is based in the importance and transformative power of the creative process. Our community hosts a diverse, international mix of people, disciplines, and approaches, challenging us all to think and work in new ways. Residencies are designed to free artists to take risks and explore new ideas. We are committed to cross-cultural, cross-disciplinary exchange as essential to growth and understanding, in today's interdependent and globalized world." — KATHRYN REASONER

Eligibility: Open to artists working in a range of disciplines—visual, literary, film/video, dance, performance, and music—from the United States and abroad through application and nomination.

Studios & Special Equipment Available: Facilities for dance/choreography, music/piano, painting, photography, sculpture, woodworking, and writing; exhibition/installation space and performance theatre.

Housing, Meals, Other Facilities & Services: *Housing:* Private bedroom in a shared facility; furnishings and linens provided. *Meals:* Dinners provided; vegetarian meals available; houses have fully equipped kitchens. *Other facilities/services:* Common room for residents' use; laundry facilities onsite; computer with Internet connection available in library/office

for artists' exclusive use; limited Internet connection available in some studios; cars provided by organization for shared use. Smoking permitted outdoors only. Spouses/partners allowed for visits only up to two weeks; families and children allowed by special arrangement.

Accessibility: Living quarters are accessible, as well as most studios and public areas.

Application & Residency Information:

Application available online

Application deadline(s): First Friday in June

Resident season(s): March 1–November 30

Average length of residencies: 6 weeks–3 months, live-in; up to 6 months for non-live-in

Number of artists-in-residence in 2003: 38

Average number of artists-in-residence present at one time: 12

Selection process: Outside professional jury/panel selection.

Artists Responsible for: Application fee— $15; deposits—$100 car, $10 keys; travel, some meals, and materials.

Organization Provides: Housing, some meals, stipend—$500/month, program administration.

Other Expectations & Opportunities: Artists-in-residence are given the option of participating in public exhibitions/presentations. Artists are expected to participate in HCA's Open House, held three times a year (April, July, and October). Donations of artwork are occasionally accepted for benefit auction.

Hedgebrook

"The craft and courage that went into creating Hedgebrook has seeped into my bones and I leave charged and changed, to write and live and pass it on. This blessed place is a blueprint of a community of love and support that we will carry out, in our writing and in our hearts, to our world."— ALEIDA RODRIGUEZ

2197 Millman Road
Langley, WA 98260
Phone: (360) 321-4786
Fax: (360) 321-2171
E-mail: *info@hedgebrook.org*
Web: *www.hedgebrook.org*

Mission: Hedgebrook invests in women who write by providing them with space and time to create significant work in solitude and community, and by developing an international network to connect writers and audiences.

Founded: Organization and Residency, 1988.

Location: On Whidbey Island, northwest of Seattle, Washington, on fifty acres of woods and meadows overlooking Puget Sound. Six writers' cottages are noted for their craftsmanship of wood, glass, and stone.

Past Residents: Ursula LeGuin, Gloria Steinem, Julia Cho, Farida Karodia, Adrian LeBlanc, and more than eight hundred others from more than forty states and a dozen countries.

From the Director: "Hedgebrook quietly makes a world of difference, one woman writer at a time. Our value—to the women who participate and to everyone they touch—is that we put the individual creator first and foremost in everything we do. I think of Hedgebrook as a potent antidote to a global trend that seems to increasingly value quantity over quality, and decisions by committee instead of vision through personal leadership."— BETH BRADLEY

Eligibility: Women writers only, working in all genres. No repeat residencies except by special invitation.

Studios & Special Equipment Available: Writing workspace.

Housing, Meals, Other Facilities & Services: *Housing:* Individual cabin for each resident; furnishings and linens provided. *Meals:* All meals are provided; vegetarian meals available; cooking/kitchen facilities available to residents. *Other facilities/services:* Common room or meeting space for residents' use; laundry facilities onsite; computer and Internet connection available in common area; local transportation provided by organization, public transit also available. Smoking permitted outdoors only.

Accessibility: Only public areas are accessible; however, we will do our best to accommodate special needs in the cottages.

Application & Residency Information:

Application available online

Application deadline(s): October 15

Resident season(s): February–November

Average length of residencies: 2 weeks–2 months

Number of artists-in-residence in 2003: 0

Average number of artists-in-residence present at one time: 6

Selection process: Outside professional jury/panel selection.

Artists Responsible for: Application fee— $15; travel.

Organization Provides: Housing, meals, studios, and travel assistance (limited availability).

Other Expectations & Opportunities:
Artists-in-residence are given the option of participating in public exhibitions/presentations, studio tours, and the donation of artwork.

Hermitage Artists Retreat

"It was great to see how the various buildings with all their sense of history had been so lovingly restored and transformed into an inspiring and extremely comfortable modern facility that had its own particular rustic charm coupled with a contemporary feel. To say that the Hermitage is an inspiring place to live and be creative is an understatement—the place is magical and peaceful."— MALCOLM ROBERTSON

6650 Manasota Key Road
Englewood, FL 34223
Phone: (941) 475-2098
E-mail: *info@hermitage-fl.org*
Web: *www.hermitage-fl.org*

Mission: The Hermitage is dedicated to using its unique historic property and inspiring tropical setting to release the creativity of local, national, and international artists. We provide each guest with an experience conducive for making his or her best work. By sharing our passion for art with members of the community, we strive to inspire them. Through our commitment to individual creativity, we encourage humanity to achieve its highest potential.

Founded: Organization and Residency, 2004.

Location: A restored, eight-acre 1907 homestead directly between the Gulf of Mexico and Englewood Bay, Florida, featuring a seemingly endless beach for walking and perfect tropical weather.

Past Residents: Malcolm Robertson, Gwyneth Walker, Daphne Cummings, Douglas Langworthy, Monika Teal, Xue Di.

From the Director: "Artists have been escaping to the tropics for centuries to pursue their art. This new residency, with a limited number of accomplished artists working alone and living together on the tropical shores of the Gulf of Mexico, provides the ideal environment for inspiration and artistic achievement."

Eligibility: Mid-career artists working in poetry, prose, script forms, visual media, musical composition, design, scholarship, and creative endeavors.

Studios/Special Equipment Available: Dance/choreography, digital media, film/digital editing, and digital photography facilities to be developed in the future; music studio with Clavinova, sculpture studio (depending on media), and writing studio available.

Housing, Meals, Other Facilities & Services: *Housing:* Private room and bath in a shared facility; furnishings and linens provided. *Meals:* All meals are provided; cooking/kitchen facilities available to residents. *Other facilities/ services:* Common room or meeting space for residents' use; laundry facilities onsite; computer with Internet connection in common area; Internet connection only available in

common area and in living or studio area; local transportation provided by organization. Smoking permitted outdoors only.

Accessibility: Facilities are fully accessible.

Application & Residency Information:

Application available online

Application deadline(s): Twice a year

Resident season(s): Year-round

Average length of residencies: 5 weeks

Number of artists-in-residence in 2003: 10

Average number of artists-in-residence present at one time: 5

Selection process: Outside professional jury/panel selection.

Artists Responsible for: Application fee—$20; voluntary residency fee; travel and materials.

Organization Provides: Housing, meals, and studios; housing stipend and general stipend.

Other Expectations & Opportunities: Artists are requested to give two services to the community in the form of a class, workshop, lecture, open studio, performance, or reading at the choice of the artist. Artists are also asked to credit the Hermitage upon publication or performance for work developed during the residency.

HOME, Inc.

"This has been a wonderful supportive environment where I have been able to develop and focus on my work. The space is great!" — BEBE BEARD

731 Harrison Avenue
Boston, MA 02118
Phone: (617) 266-1386
Fax: (617) 266-8514
E-mail: *alanmichel@homeinc.org*
Web: *www.homeinc.org*

Mission: Our mission is to help develop and sustain creative, multidisciplinary arts and education projects. For HOME, the arts are a vital means of self-expression and a fundamental tool for stimulating lifelong learning.

Founded: Organization, 1974; Residency, restarted in 2002.

Location: HOME, Inc. is located in the historic Bates Art Center in the South End—Boston's largest arts community.

Past Residents: Adam Schatten, Bebe Beard.

From the Director: "Whether you are looking for contemplative moments or are working through some tough technical problems, the environment is supportive and inventive. New ideas are welcome and particular interest in video and media make really great opportunities to meet the larger media arts community in Boston." — ALAN MICHEL

Eligibility: Artists working in the media arts: video, digital photography, and multimedia.

Studios & Special Equipment Available: Digital media and film/digital editing studios; exhibition/installation space and performance theater.

Housing, Meals, Other Facilities & Services: Housing and meals not provided. Computer with Internet connection available in common area; public transportation throughout Boston area. Smoking permitted outdoors only.

Accessibility: Only the theater is accessible.

Application & Residency Information:
Application available online
Application deadline(s): Ongoing
Resident season(s): Year-round
Average length of residencies: 3 months
Number of artists-in-residence in 2003: 2
Average number of artists-in-residence present at one time: 1
Selection process: Internal selection (staff, board, and/or advisory board).

Artists Responsible for: Housing, meals, and living expenses.

Organization Provides: Studios and facilities, program administration.

Other Expectations & Opportunities:
In the spirit of HOME's mission, the artist-in-residency program shall also require that the artist-in-residence provide educational and support services for a total of five events. These services shall include providing video footage for public presentations or to help promote the artists' work, participation in technical and artistic workshops in schools or health centers, and/or other presentations consistent with HOME's education and arts programs and its mission.

Hopscotch House/Kentucky Foundation for Women

"This oasis in a busy world has been of inestimable value to me. I've been able to do substantial work there, and I never have a clearer mind than I have at Hopscotch House. It is so easy and natural to settle in and start work right away."
— MARY ANN TAYLOR-HALL

8221 Wolf Pen Branch Road
Prospect, KY 40059
Phone: (502) 228-4875
Fax: (502) 561-0420
E-mail: *sherry@kfw.org*
Web: *www.kfw.org*

Mission: A program of the Kentucky Foundation for Women, the mission of the Hopscotch House is to provide a supportive setting for feminist artists and activists to create, connect, and convene. Kentucky Foundation for Women's mission is to promote positive social change through varied feminist expression in the arts.

Founded: Organization, 1985; Residency, 1987.

Location: Thirteen miles east of downtown Louisville; a classic Kentucky farmstead on ten acres, with outbuildings converted to studios. Additional access to founder's four hundred acres of surrounding woodlands, rolling fields, and water sheds.

Past Residents: Lorna Littleway/Juneteenth Legacy Theatre, Lynn Pruett, Crystal Wilkinson, Susan E. King, Mary Ann Taylor-Hall, Ellen Hagan, Penny Sisto, Rebekka Seigel.

From the Director: "In a world where women juggle so many roles and responsibilities, Hopscotch House offers its residents the gift of time and solitude for the creation of art that promotes positive social change."
— SHERRY HURLEY

Eligibility: Kentucky women artists whose art focuses on positive social change; writing in all genres, visual arts, media arts, performing arts. Out-of-state artists by invitation only.

Studios & Special Equipment Available: Ceramics/pottery, painting, and writing studios.

Housing, Meals, Other Facilities & Services:
Housing: Private room and bath in a shared facility; furnishings and linens provided. *Meals:* Residents are responsible for their own food and beverages; cooking/kitchen facilities available to residents. *Other facilities/ services:* Common room with computer and Internet for residents' use; laundry facilities onsite; smoking permitted outdoors only.

Accessibility: One downstairs bedroom/ bathroom is accessible.

Application & Residency Information:

Application available online

Application deadline(s): Ongoing

Resident season(s): Year-round

Average length of residencies: 1 week

Number of artists-in-residence in 2003: 34

Average number of artists-in-residence present at one time: 3 with a maximum of 5 at any one time

Selection process: Internal selection (outside panel selection to begin in 2005).

Artists Responsible for: Food, travel, and materials.

Organization Provides: Housing and studio space/facilities.

Additional Support: Limited travel funds and general stipends available for those in financial need.

Other Expectations & Opportunities:
Artists-in-residence are given the opportunity of participating in public exhibitions/presentations on- and offsite; artists may donate artwork if they wish.

International School of Drawing, Painting, and Sculpture

*"Seriously the best experience of my life
(both for my life and art)."*—M.E.

Via Regina Margherita 6
Montecastello di Vibio
Perugia 06057
Italy
Phone: +39 075 8780072
Fax: (in U.S.) (866) 449-3604
E-mail: *mservin@giotto.us*
Web: *www.giotto.us*

Mission: The International School is an ideal environment in which artists can completely devote themselves to working and learning, building to a high level of productivity and, for many, a breakthrough.

Founded: Organization, 1998; Residency, 2001.

Location: Overlooking the lush Tiber River Valley, Montecastello in Umbria, Italy, is a medieval hill town in the province of Perugia, two hours north of Rome and south of Florence. A beautifully preserved medieval borgo, Montecastello looks much like it did five hundred years ago. A fortress wall surrounds the tiny heart-shaped town, with vast panoramas all around and a tranquil little park at one edge. This delightful village is our campus, with the facilities based in a complex of historic buildings.

From the Director: "The Artist's Residence Program in Montecastello provides the ideal combination of seclusion and community in a setting of truly inspirational beauty. Artists can work intensively and independently for four or more weeks in a supportive and intimate environment. The Residence Program also enables students to continue to work and progress independently. Our weekly trips to Italy's cities of art inspire and inform the work in the studio. And in the dining room, residents enjoy meals prepared with care by our local cooks, and develop a close sense of community."—MARC SERVIN

Eligibility: Open to visual artists (please see Indices for specific artists served).

Studios & Special Equipment Available: Painting and sculpture studios.

Housing, Meals, Other Facilities & Services: *Housing:* Private room(s) in a shared facility; furnishings and linens provided. *Meals:* All meals are provided; vegetarian meals available. *Other facilities/services:* Common room or meeting space for residents' use; laundry facilities onsite; computer and Internet connection in common area; art book library and art supply store onsite; VCR and video library; day trips to Rome, Assisi, Perugia,

and Florence; car available for local trips. Smoking permitted outdoors only.

Accessibility: Facilities are not accessible.

Application & Residency Information:

Application available online

Application deadline(s): Ongoing

Resident season(s): May, September

Average length of residencies: 4 weeks

Number of artists-in-residence in 2003: 16

Average number of artists-in-residence present at one time: 8

Selection process: Internal selection (staff, board, and/or advisory board).

Artists Responsible for: Application fee— $40 (USD), residency fee—€700, deposit, materials.

Organization Provides: Housing, meals, and studios.

Additional Support: Artists eligible for some special grants/fellowships for former students and faculty of the school.

Other Expectations & Opportunities: Artists-in-residence are given the option of participating in onsite public exhibitions/ presentations and studio tours, and of donating artwork.

Jacob's Pillow Dance Festival

"[Being at the Pillow] was such a wonderful combination of beauty, creativity, intense work, and fun." — JANE COMFORT

P.O. Box 287
Lee, MA 01238
Phone: (413) 327-1234
Fax: (413) 243-4744
E-mail: *info@jacobspillow.org*
Web: *www.jacobspillow.org*

Mission: To support dance creation, presentation, education, and preservation; and to engage and deepen public appreciation and support for dance.

Founded: Organization, 1933; Residency, 1983.

Location: The Pillow is located in the Berkshires in western Massachusetts, three hours from New York City and two and a half hours from Boston, on 161 acres. The site is a National Historic Landmark and it has a rich, storied history.

Past Residents: Big Dance Theatre, Felix Ruckert, Tiffany Mills, Pilobolus, Bill T. Jones, Mark Morris, Trisha Brown, Limon Dance Company, Jane Comfort & Company.

From the Director: "The Pillow offers a retreat-like setting deep in the woods of the Berkshires, steeped in dance history for more than seven decades. Resident artists may enjoy access to the extensive collection of dance videos, literature, and other memorabilia in the Pillow Archives. There is no requirement or pressure to create work in this supportive, stress-free environment."

Eligibility: Dancers/choreographers— individuals as well as companies.

Studios & Special Equipment Available: Dance/choreography studios and perform- ance theater.

Housing, Meals, Other Facilities & Services: *Housing:* Some private and some shared rooms in a shared facility; furnishings and linens provided. *Meals:* Residents are responsible for their own meals; kitchen facilities onsite. *Other facilities/services:* Common room or meeting space for residents' use; computer with Internet connection in office area only; smoking permitted outdoors only. Some pets allowed—applicants should call to discuss. Spouses/partners and children allowed for full stay.

Accessibility: Studios and public areas are accessible.

Application & Residency Information:

Application deadline(s): Ongoing

Resident season(s): Spring, Summer, Fall

Average length of residencies: 1–2 weeks

Number of artists-in-residence in 2003: 13

Average number of artists-in-residence present at one time: 6

Selection process: Internal selection (staff, board, and/or advisory board).

Artists Responsible for: Food, travel, and materials.

Organization Provides: Housing and facilities.

Other Expectations & Opportunities: Artists-in-residence present an informal work-in-progress showing (not ticketed), and Jacob's Pillow expects to be given commissioning credit for works created while in residence.

Jentel Artist Residency Program

> *"I had the space to re-envision my work, to take the time to let it be what it needed to become, and to ride out the feelings of panic, excitement, and fear that the transition created. I was able to go deep."* —JACKIE GRAVES

130 Lower Piney Creek Road
Banner, WY 82832
Phone: (307) 737-2311
Fax: (307) 737-2305
E-mail: *jentel@jentelarts.org*
Web: *www.jentelarts.org*

Mission: The Jentel Foundation offers dedicated artists and writers a supportive environment in which to further their creative development.

Founded: Organization and Residency, 2001.

Location: Located on a working cattle ranch in the Lower Piney Creek Valley, twenty miles southeast of Sheridan, Wyoming, with spectacular views over scoria-topped hills to the majestic Bighorn Mountains. The new and renovated structures reflect the historical and agricultural heritage of the setting and echo the richness and incredible beauty of the landscape.

Past Residents: Millicent Borges Accardi, Jan Beatty, Jon Billman, Rebecca Carroll, Ann Chwatsky, Jessica Dunne, Evan Holloway, Tucker Nichols, Ken Steinken, Jay Sullivan.

From the Director: "At Jentel artists and writers are valued and respected for who they are and what they do. This spirit is preserved in the attention to detail throughout the facilities and in communication with the applicants/residents, interaction with staff, and engagement with people in the surrounding communities. Jentel is limited only by the imagination of the residents who seek unfettered time and an expansive space to further their creative process. Jentel also offers an opportunity to shape and experience a community. And Jentel is a landscape; yes, an incredible, healing, and restorative landscape." —MARY JANE EDWARDS

Eligibility: Visual artists working in all media and writers working in all genre, U.S. citizens or members of the international arts community currently living in the United States, non-students twenty-five years and older. Repeat residencies after two years.

Studios & Special Equipment Available: While Jentel is a low-tech and non-equipment-based residency, a Takach Garfield press for monotypes with 32" x 48" bed and a drying rack are located in one of the studios and are reserved for one resident per session. The two writers' studios include high-speed Internet access.

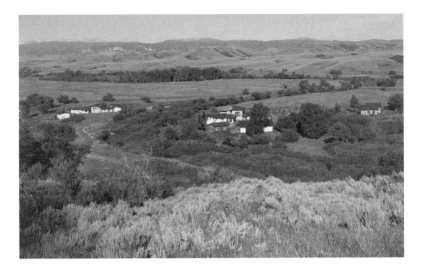

Housing, Meals, Other Facilities & Services:
Housing: A large, private bedroom for each of the six residents with four individual shared bathrooms; linens are provided. American primitive furnishings and a variety of textiles give warmth to a contemporary living space. The grounds are landscaped with native and non-native shrubs, trees, grasses, and flowers planted as though nature left them to be discovered. This all creates a home and workspace that cultivates, supports, and honors the creative spirit. *Meals:* A welcoming dinner for residents and a farewell dinner with staff are served. All other meals are the responsibility of residents. Staff drives residents to town for a weekly grocery and errand run. Residents share a spacious, fully equipped kitchen and dining room for food prep and meals. *Other facilities/services:* The residence includes a great room for living and dining; a large eat-in kitchen; a library with computer, printer, and Internet access; a lounge and a recreation room; and a washer and dryer onsite for linens and personal laundry needs. Local transportation is the responsibility of artists; however, auto rentals are reasonable and the companies will deliver and pick up vehicles. Smoking permitted outdoors only. Spouses/partners and children allowed for visits only—the surrounding area has numerous motels and B&Bs.

Accessibility: Facilities are not accessible.

Application & Residency Information:
Application available online
Application deadline(s): September 15 and January 15
Resident season(s): January 15–May 13 and May 15–December 13
Average length of residencies: 1 month
Number of artists-in-residence in 2003: 66
Average number of artists-in-residence present at one time: 6
Selection process: Outside professional jury/panel reviews applications and makes recommendations to the director.

Artists Responsible for: Application fee—$20; deposit—$100; travel, materials, and personal items.

Organization Provides: Housing and studios/facilities; general stipend—$400 to help defray the cost of food and travel.

Other Expectations & Opportunities:
Some visual artists and writers who are invited to Jentel may come with an interest or commitment to engage with a larger creative arts community during their residency. Although no services are expected of the residents during their session, community outreach is encouraged and supported through the monthly Jentel Presents program, an evening of slide presentations and readings in one of the nearby communities.

Kala Art Institute

"Kala has had a profound effect on me as an artist and teacher. A chance to interact with truly outstanding, creative, and important artists who have and will continue to shape the nature of printmaking and print media, a chance to think, work, stretch, and celebrate about issues and process." — BARBARA FOSTER

1060 Heinz Avenue
Berkeley, CA 94710
Phone: (510) 549-2977
Fax: (510) 540-6914
E-mail: *kala@kala.org*
Web: *www.kala.org*

Mission: To help artists sustain their creative efforts over time through our artist-in-residence and fellowship programs, and to encourage innovative artwork of the highest quality.

Founded: Organization and Residency, 1974.

Location: Kala Art Institute is situated in the East Bay Area, directly across the Bay Bridge from San Francisco. Inhabiting the historic Heinz Ketchup factory, Kala is nestled in a light industrial area that borders Emeryville, Oakland, and Berkeley.

Past Residents: Kazuko Watanabe, Sandra Gibson, Taro Hattori, Endi Poskovic, Joan Truckenbrod, Barbara Robertson, May Chan, Jessica Dunne, Unai San Martin, Takahiko Iimura.

From the Director: "The physical production of art in a shared facility such as Kala naturally leads to an exchange of ideas among artists, and presentations of their work in Kala's gallery allows us to share these ideas with the greater public." — ARCHANA HORSTING

Eligibility: Residency program is open to all printmaking, book arts, and digital media artists locally, nationally, and internationally. In addition, Kala Fellowships are awarded annually to eight artists working in the realms of printmaking, book arts, and digital media. Previous Kala Fellowship winners may not apply for award.

Studios & Special Equipment Available: Digital media center (includes G4 Macs, a high-quality Imacon scanner, a 24" Epson printer and a 54" Roland printer; both are wide-format digital printers with archival inks and papers); electronic media center (includes high-quality digital still cameras, video cameras, video editing deck and sound equipment, plus extensive array of software; film editing and projection are not available); photography darkroom (black-and-white); 8,500-square-foot print studio (includes three American French tool etching presses: one 48" x 78" and two 40" x 70", two Griffin etching presses: 44" x 21.5" and 32" x 18"; Griffin manual litho

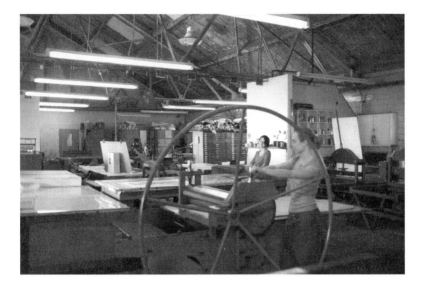

press: 56" x 32"; Takach-Garfield motorized litho press: 56" x 32"; Bumpodo litho press: 45" x 34"; two Vandercook letterpresses; a Vreeland Orbital A-2 polymer platemaker; an aquatint box; a plate cutter; and a Challenge book cutter); and exhibition gallery.

Housing, Meals, Other Facilities & Services:

Housing and meals not provided. Kitchen onsite available to residents. Common room/meeting space for residents' use; computer with Internet connection in common area and studio space; public transportation readily available. Smoking permitted outdoors only.

Accessibility: Most of Kala's facility, including studios and public areas, is wheelchair accessible.

Application & Residency Information:

Application available online

Application deadline(s): May 4 for fellowship award; no deadline for residency program

Resident season(s): Year-round

Average length of residencies: 1–6 months

Number of artists-in-residence in 2003: Eight fellowship awardees; about 50 artists-in-residence

Average number of artists-in-residence present at one time: 1–4 fellowship artists, plus artist-in-residence

Selection process: Internal selection (staff,

board, and/or advisory board).

Artists Responsible for: Deposit—$100; housing, food, travel, and materials. Non-fellowship artists-in-residence pay a monthly fee for studio usage ($125–$340/month).

Organization Provides: Studios/facilities, exhibition space, and program administration. Fellowship artists receive a $2,000 stipend; they may choose to use it for travel, housing, food, or art-making expenses.

Other Expectations & Opportunities:

Fellowship artists are included in one of two fellowship group exhibitions. Both fellowship artists and non-fellowship artists-in-residence are included in the Kala Gallery exhibitions. Kala's offsite exhibition program includes venues ranging from gallery and museum exhibitions to international exchange presentations. Fellowship artists working in the printmaking studio are expected to donate three sample prints to the Kala Archives. Artists working in digital media are requested to give video or DVD work samples. Artists-in-residence are expected to donate one print per each six-month period.

KHN Center for the Arts

"I especially enjoyed the very warm environment within the center and the equally gracious reception I received everywhere in the city. The apartment was absolutely lovely and so conducive to 'stretching out' mentally. There was ample privacy, and yet I enjoyed meeting and getting to know others, too, not only within the center, but in Nebraska City as well." — ERIKA DREIFUS

801 3rd Corso
Nebraska City, NE 68410
Phone: (402) 874-9600
Fax: (402) 874-9600
E-mail: *kathy@KHNCenterfortheArts.org*
Web: *www.KHNCenterfortheArts.org*

Mission: The mission of the KHN Center for the Arts is to encourage and support established and emerging writers and visual and performing artists by providing working and living environments that allow for uninterrupted time for work, reflection, and creative growth and development. Accompanying the strong commitment to our residency program is the dedication to inspire and expand the arts throughout the state of Nebraska. Residents are enthusiastically asked to join with the center to provide onsite and outreach performances, presentations, classes, and exhibitions.

Founded: Organization and Residency, 2001.

Location: The facility is a renovated luxury triplex located in the center of historic Nebraska City, settled during the Civil War on the western bank of the Missouri River, approximately 130 miles north of Kansas City. The community of over 6,500 is surrounded by apple orchards and is the home of the national tree-planting holiday, Arbor Day.

Past Residents: Blair Tindall, Paddy Woodworth, Rob Scheps, Maung Swan Yi, Christopher Cartmill, Nancy Duncan, Anna Hepler, Erika Dreifus, Rick Dula, Chunsoo Park.

From the Director: "A very supportive and welcoming environment exists at the KHN Center for the Arts. This nurturing spirit expands beyond the doors of the center and can be experienced throughout the community. With working conditions such as these, great things happen."

Eligibility: Writers and visual and performing artists from across the U.S. and beyond are welcome to apply. Repeat residencies after two years.

Studios & Special Equipment Available: Music/piano studio, painting studio, writing studio, Vandercook book press, and exhibition space.

Housing, Meals, Other Facilities & Services: *Housing:* Private room and bath in a shared facility; furnishings and linens provided. *Meals:* Meals are the responsibility of residents; cookware, dishes, utensils, etc., provided. *Other facilities/services:* Common room or meeting space for residents' use; laundry facilities onsite (residents responsible for their own detergent); computer with Internet connection in common area and Internet connection only

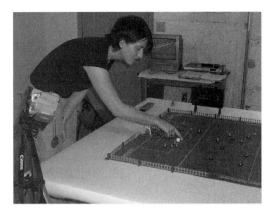

in living or studio area. Smoking permitted outdoors only. Spouses/partners and children allowed for visits only—no overnight stays.

Accessibility: Facilities are fully accessible (with the exception of one upstairs apartment).

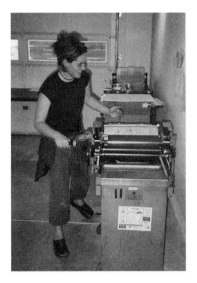

Application & Residency Information:

Application available online

Application deadline(s): March 1, May 15, October 1

Resident season(s): Summer (June–July), Fall (August–early December), Winter (February–early June)

Average length of residencies: 2–8 weeks

Number of artists-in-residence in 2003: 18

Average number of artists-in-residence present at one time: 4

Selection process: Outside professional jury/panel selection.

Artists Responsible for: Application fee—$25; food.

Organization Provides: Housing, studios, and program administration.

Other Expectations & Opportunities:

Artists-in-residence are given the option of participating in public exhibitions/presentations—onsite and offsite—and studio tours. The donation of artwork is strongly encouraged.

John Michael Kohler Arts Center

"What is unique about this residency is that it is not of the artist's world. The factory challenges everything sensitive, intellectual, and dear. It is a thrill to see ideas take root and grow in such an environment. The power of art is confirmed. The selfless support of the artists by the workers makes it happen. This residency... brought my life's work together into a singularity for the first time ever. The resolution this experience represented will resonate in my work for years." — TOM SPLET

608 New York Avenue
P.O. Box 489
Sheboygan, WI 53082-0489
Phone: (920) 458-6144
Fax: (920) 458-4473
E-mail: *info@jmkac.org*
Web: *www.jmkac.org*

Mission: To encourage and support innovative explorations in the arts and to foster an exchange between a national community of artists and a broad public that will help realize the power of the arts to inspire and transform our world.

Founded: Organization, 1967; Residency, 1974.

Location: The residency takes place within the nation's leading plumbingware manufacturer, Kohler Co., in Kohler, Wisconsin, approximately four miles west of the lakeside city of Sheboygan, and 120 miles north of Chicago.

Past Residents: Ann Agee, Jack Earl, Marek Cecula, Martha Heavenston, Tom Joyce, Ken Little, Juan Logan, Melissa McGill, Carolyn Ottmers, Christine Tarkowski.

From the Director: "Working side by side with industrial staff who are producing plumbingware and engines, the artists use the materials and technologies to create sculpture, installations, murals, and public commissions not otherwise possible. For many years the Arts/Industry residency has been hailed as one of the most unusual and fruitful collaborations between the arts and industry in twentieth-century America, and has been featured in media from Japan to Chicago." — RUTH DEYOUNG KOHLER

Eligibility: Open to all visual artists. Repeat residencies permitted.

Studios & Special Equipment Available: The program takes place within the Kohler Co. manufacturing facility, with studios in both the iron foundry and the pottery buildings. Artists have access to cast iron, cast brass, enameled cast iron, metal plating, sprayed metals, and vitreous china, as well as wood facilities and an extensive metal fabrication shop. Access to other areas such as the patternmaking shop, block and case, and painting facilities are provided on a case-by-case basis. The John Michael Kohler Arts Center, located four miles

east of the factory, is a one-acre site with a newly expanded 100,000-square-foot facility including nine galleries, a multi-arts performance space and intimate theater, four classrooms/studios, a resource center, gallery shop, and café. Specific equipment includes limited blacksmithing facilities; ceramics/pottery (extensive slip-casting facilities with slip piped into studio; extensive glaze chemistry—stains only, no oxides; tunnel and shuttle gas kilns, small electric kilns); metal shop (extensive metal fabrication facility); sculpture (extensive iron and brass sand-mold casting facilities); and enameling kilns and materials for enameling on iron.

Housing, Meals, Other Facilities & Services:

Housing: Private room(s) in a four-bedroom furnished house with laundry facilities. *Meals:* Artists responsible for own meals; kitchen in housing facility. *Other facilities/services:* Common room for residents' use with computer and Internet connection; laundry facilities onsite. Artists may bring their own vehicles if they wish; however, everything is very close and having a car is not necessary. Smoking permitted outdoors only. Spouses/partners and children allowed for visits only.

Accessibility: It would be very difficult to navigate the site in a wheelchair; however, the Arts Center will consider each individual according to his/her needs and the extent of his/her disability. No special facilities for artists with vision or hearing impairment.

Application & Residency Information:

Application available online

Application deadline(s): August 1 (postmark)

Resident season(s): Year-round

Average length of residencies: 14 weeks

Number of artists-in-residence in 2003: 16

Average number of artists-in-residence present at one time: 4

Selection process: Applications are reviewed by staff, former artists-in-residence, and others. In some cases, proposals are reviewed by Kohler Co. ceramic or metallurgical personnel.

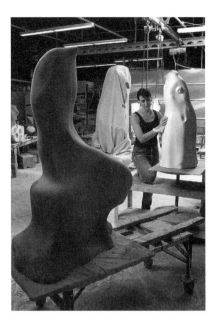

Artists Responsible for: Food.

Organization Provides: Housing; twenty-four-hour access to studios and facilities; materials; technical assistance; travel assistance (round-trip travel within the continental United States); free safety equipment and photographic services; and general stipend—$140/week.

Other Expectations & Opportunities:

Each artist is asked to spend approximately eight hours per month of his/her stay participating in educational outreach opportunities, which may include slide lectures, workshops, studio tours, video interviews, and other activities in the region. Each artist is also requested to gift two works of art: one to the John Michael Kohler Arts Center and one to Kohler Co.

Lighton International Artists Exchange Program / Kansas City Artists Coalition

"I found the month in Hungary to be life-altering. I had no firsthand knowledge of Eastern Europe and learned so much about the art, architecture, landscape, and people of that region. The opportunity to work directly with Hungarian and other European artists in the studio at the International Artists Center was an invaluable experience. Living with artists, rather than simply traveling through and visiting a country, allowed me and the other artists there to exchange knowledge and to grow artistically to an extent that is unparalleled in my experience."

— CARY ESSER

201 Wyandotte
Kansas City, MO 64105
Phone: (816) 421-5222
Fax: (816) 421-0656
E-mail: *JanetSimpson@ KansasCityArtistsCoalition.org*
Web: *www.KansasCityArtistsCoalition.org*

Mission: The Kansas City Artists Coalition (KCAC) is a nonprofit organization that promotes visual arts awareness in Kansas City and the surrounding region, and supports the professional growth of artists. KCAC's Lighton International Artists Exchange Program (LIAEP) works to make the world a smaller place by giving artists of different cultures the opportunity to work together in the hope that lasting friendship and understanding will develop.

Founded: Organization, 1976; Residency, 2002.

Location: The Lighton International Artists Exchange Program grant provides support for Kansas City and other regional visual artists to travel to international residencies and artists' communities, and for foreign visual artists to travel to and work in Kansas City.

Past Residents: Peteris Martinsons, Elek Anita, Dobány Sánor, Cary Esser, Lynn Smiser Bowers, Laura DeAngelis, Anna Calluori Holcombe, Hesse Laurence McGraw, Wade Eldean, Isadora Gabrielle Leidenfrost, Eric von Robertson.

From the Director: "The LIAEP grant is a unique and valuable resource; it provides support for dedicated artists whose work is of exceptional quality and whose work and career is at a level to benefit from international exchange with peers. This initiative is designed to nurture artists, promote the exchange of ideas and expertise between peers in different parts of the world, expand our horizons, and shrink our world."

Eligibility: Applications are accepted from visual artists from Kansas City and the surrounding region. Foreign visual artists are by invitation only.

Studios & Special Equipment Available: Facilities vary according to the residency program in which artists are placed.

Housing, Meals, Other Facilities & Services:
Facilities vary according to the residency
program in which artists are placed.

Accessibility: Facilities vary according to the
residency program in which artists are placed.

Application & Residency Information:

Application available online

Application deadline(s): March 1

Selection process: Outside professional
jury/panel and internal selection (staff, board,
and/or advisory board).

Artists Responsible for: Contact organization
for information on what funding covers.

Organization Provides: LIAEP funds inter-
national residencies and travel/research for
visual artists.

Other Expectations & Opportunities:
Artists must complete a final report in addition
to a presentation in Kansas City of their project.

Louisiana ArtWorks

"It was an incredible joy to be part of the Helen Escobedo Master Artist Residency Program. Creating art is usually a solitary pursuit, so it was especially affirming to have an opportunity to be part of a collaborative art making process."

725 Howard Avenue
New Orleans, LA 70130
Phone: (504) 523-1465
Fax: (504) 529-2430
E-mail: *mail@artscouncilofneworleans.org*
Web: *www.artscouncilofneworleans.org*

Mission: To nurture artistic growth, enhance technical skills, and provide marketing and economic development for Louisiana artists in a unique environment, while offering the public opportunities to see, enjoy, and understand the process involved in the creation of art.

Founded: Organization and Residency, 2004.

Location: Louisiana ArtWorks, a project of the Arts Council of New Orleans, is located in New Orleans' historic Warehouse Arts District on approximately two blocks of prime multiuse and historic real estate, encompassing 90,000 square feet directly on two stops along the St. Charles streetcar line near Lee Circle.

Past Residents: John T. Scott, Helen Escobedo.

From the Director: "Designed to be both dynamic state-of-the-art working shops in glass, metal, printmaking, and ceramics, and a visual arts cultural destination, Louisiana ArtWorks is slated to be a vital epicenter where professional artists, Louisiana residents, community school groups, and visitors from around the world can explore the creative process and develop an increased understanding of the meaning and value of art in everyday life. Louisiana ArtWorks is poised to become a gateway to the historic Warehouse Arts District, helping to solidify New Orleans' prominence as a progressive, thriving arts community and cultural destination."

Eligibility: Louisiana artists working in glassblowing, metal, ceramics, and printmaking. National and international artists will be accommodated through an invitational process.

Studios & Special Equipment Available: Facilities for blacksmithing, ceramics/pottery (woodfiring kiln), glass blowing, metal shop/foundry, sculpture, and printmaking; exhibition/installation space.

Housing, Meals, Other Facilities & Services: Housing and meals not provided. Common room or meeting space for residents' use. Public transportation available.

Accessibility: Facilities are fully accessible.

Application & Residency Information:

Application information not available at this time; please check Web site for details.

Selection process: Outside professional jury/panel, and internal selection (staff, board, and/or advisory board).

Artists Responsible for: Not yet determined; please check Web site for details.

Organization Provides: Not yet determined; please check Web site for details.

Other Expectations & Opportunities:
The public visibility and accessibility of artists-in-residence will be promoted through the architectural feature of viewing catwalks situated nine feet above all four shop floors, as well as through opportunities to sell completed works of art at Artful Objects, the store at Louisiana ArtWorks. Artists-in-residence are expected to participate in exhibitions/presentation, studio tours, and the donation of artwork.

The MacDowell Colony

"To enter one's assigned studio in the morning in expectation of a whole day with no distractions to intrude on the project in hand, and to look forward to a succession of such days for the continuity that is so hard to obtain elsewhere, is to feel oneself in the possession of a kingdom. Cheney, my studio in the woods, was a kingdom of happiness where I completed more work than I have ever before in a comparable period. I know of no other place that so perfectly fulfills its purpose as does MacDowell." — BARBARA TUCHMAN

100 High Street
Peterborough, NH 03458
Phone: (603) 924-3886
Fax: (603) 924-9142
E-mail: *info@macdowellcolony.org*
Web: *www.macdowellcolony.org*

Mission: To provide an ideal environment in which creative artists are free to pursue their work without interruption.

Founded: Organization and Residency, 1907.

Location: Four hundred and fifty acres of woodlands and fields near Mt. Monadnock in the southern New Hampshire town of Peterborough, two hours from Boston.

Past Residents: Milton Avery, James Baldwin, Leonard Bernstein, Michael Chabon, Barbara Ess, Spalding Gray, Meredith Monk, Susan Lori Parks, Alice Walker, Thornton Wilder, Jessica Yu.

From the Director: "The MacDowell Colony is probably best known as the first and oldest multidisciplinary artist residency program in America. We are proudest, however, of the reputation we have for being a great place to work. The simple formula that Edward and Marian MacDowell developed has changed little since its founding in 1907. The spirit of the place is refreshed each year by the variety and vitality of the artists themselves. The solitude, uninterrupted time, and an appropriate workspace, all within a supportive community of other creative people, make for the perfect environment." — CHERYL YOUNG

Eligibility: U.S. and international artists encouraged to apply (see Indices for specific artists served); one application per artist per year.

Studios & Special Equipment Available: Digital media and film/digital editing facilities; metal shop; music/piano studios; painting, photography, sculpture, woodworking, and writing studios; exhibition/installation space.

Housing, Meals, Other Facilities & Services:
Housing: Individual cabin or private room in a shared facility for each resident; furnishings and linens provided. *Meals:* All meals are provided; vegetarian meals available. *Other facilities/services:* Common room for residents' use; laundry facilities onsite; computer and Internet connections in common area; some local transportation provided by the organization. Smoking permitted outdoors only. Spouses/partners and children allowed for visits only.

Accessibility: Public areas, living quarters, and some studios are accessible.

Application & Residency Information:

Application available online

Application deadline(s): January 15 for Summer residencies; April 15 for Fall; September 15 for Winter/Spring

Resident season(s): Summer, Fall, Winter/Spring

Average length of residencies: 4 weeks, with a maximum stay of 8 weeks

Number of artists-in-residence in 2003: 237

Average number of artists-in-residence present at one time: 32 in summer, 22 during other seasons

Selection process: Outside professional jury/panel selection.

Artists Responsible for: Application fee— $20; travel and materials.

Organization Provides: Housing, meals, studios/facilities.

Additional Support: Travel grants available as needed; writers' aid, based on need.

Other Expectations & Opportunities:
Artists-in-residence are provided with the opportunity to volunteer for community activities through two programs, including outreach in the schools program. Artists may also contribute a sample of their work to the MacDowell collection, which is made available to artists-in-residence in the library. Donations may also be made to the local public library.

Robert M. MacNamara Foundation

"It has taken me two solid weeks to get my feet on the ground after returning from the residency. I was just flying high on that creative energy. It still amazes me how much work I was able to accomplish. The outcome of my experience and exploration into new work will be far-reaching." — LYNN TRAVIS

241 East Shore Road
Westport Island, ME 04578
Phone: (207) 882-1254
Fax: (207) 882-4722
E-mail: *rmmf241@midcoast.com*

Mission: To provide professional-level artists uninterrupted time for experimentation, exploration, and personal growth.

Founded: Organization, 1987; Residency, 2002.

Location: Located in an island community (a three-hour drive from Boston and one hour from Portland, Maine), the program is centered in a vintage structure situated on three acres fronted by the Sheepscot River and backed by a tidal, saltwater marsh. A nearby family-owned compound of more than 250 acres provides additional accommodations and studio space for visiting artists.

Past Residents: Mike Stiler, Frank Pitcher, Nelleke Beltjens, J. Fred Woell, Peter Zokosky, Pasha Rafat, F. Scott Hess, Chris Wilson, Judy Dubrawski, JoAnn Schnabel.

From the Director: "Whether it's the intimate size of the program, the talented people who come together here, or our spectacular coastal Maine location, each session has been a life-changing experience for visiting artists. A MacNamara Foundation residency gives you a chance to push your limits—a chance to meet, live, and share space with a small group of incredibly creative people."
— MAUREEN M. BARRETT, PRESIDENT

Eligibility: Open to professional-level artists from around the world working in a variety of mediums. Repeat residencies will be considered.

Studios & Special Equipment Available: Ceramics/pottery facilities (two kilns, potter's wheel, slab roller, etc.); digital media center (all Macintosh computers, variety of printers, etc.); fiber arts, film/digital editing, painting, photography, sculpture, woodworking, and writing studios; exhibition/installation space.

Housing, Meals, Other Facilities & Services: *Housing:* Private room and bath in a shared facility; furnishings and linens provided. *Meals:* All meals are provided; vegetarian meals available. *Other facilities/services:* Common room or meeting space for residents' use;

computer and Internet connection in common area and in living or studio area; local transportation provided by the organization. Designated smoking areas based on the comfort of all residents. Spouses/partners and children allowed for daytime visits only (no overnight stays).

Accessibility: The main building is fully accessible; elevator access to living quarters, studio, and workshop; ramp access; wheel-chair-accessible shower. Every effort will be made to accommodate artists with hearing/visual impairments.

Application & Residency Information:

Application deadline(s): September

Resident season(s): Winter/Spring/Summer/Fall

Average length of residencies: 6 weeks

Number of artists-in-residence in 2003: 25

Average number of artists-in-residence present at one time: 7

Selection process: Internal selection (advisory board and one staff member).

Artists Responsible for: Travel and some materials (resident makes own travel arrangements; stipend may be used to cover costs of travel and additional materials, beyond what the Foundation provides).

Organization Provides: Housing, food, and studios/facilities; travel/materials stipend provided to all artists-in-residence (Foundation materials on hand may be used free of charge); field trips and restaurant meals paid for by the Foundation.

Other Expectations & Opportunities:
The Foundation hosts special-needs students (grades 3–12) once each session for a day-long outing. Resident participation is optional. In addition, residents are given the option of participating in onsite public exhibitions/presentations and gallery tours, and donating artwork.

The Mattress Factory

"I appreciated all that Mattress Factory made possible in Pittsburgh. I came worried about the project and a bit road weary with too much travel...but the help, generosity, caring, humor, support of process made it feel more like home and community than being on the road, and created an allowing atmosphere that makes making possible." — ANN HAMILTON

500 Sampsonia Way
Pittsburgh, PA 15212
Phone: (412) 231-3169
Fax: (412) 322-2231
E-mail: *info@mattress.org*
Web: *www.mattress.org*

Mission: The Mattress Factory is a research and development lab for artists. As a museum of contemporary art, it commissions new site-specific works, presents them to the widest possible audience, and maintains selected individual installations in a growing and distinctive permanent collection.

Founded: Organization, 1977; Residency, 1982.

Location: The Mattress Factory was founded in 1977 in a vacant Stearns and Foster warehouse located in a residential neighborhood on Pittsburgh's North Side. Artists rehabilitated the six-story industrial building for studio/living space, a co-op restaurant, and an experimental theater. In 1982, programming began to focus on installations that engage the architecture of the site and, in many cases, the community and the region. The Mattress Factory is a unique hybrid in that it functions as an optimal artist's residency where the artist's creative process is entirely supported by the institution, and also as a museum with an exhibition program, a permanent collection, and a full-range of educational, interpretive, and promotional programs.

Past Residents: James Turrell, Kiki Smith, John Cage, Ann Hamilton, Yayoi Kusama, Winifred Lutz, John Latham, Rolf Julius, and William Anastazi.

From the Director: "The Mattress Factory's physical and organizational environments have grown out of and in response to a central focus on creativity."

Eligibility: Installation artists, and visual and sound artists.

Studios & Special Equipment Available: Multiple studio/exhibition/installation spaces.

Housing, Meals, Other Facilities & Services: *Housing:* Private room(s) in a shared facility; furnishings and linens provided. *Meals:* Residents prepare own meals; cooking/kitchen facilities available to residents. *Other facilities/ services:* Common area with computer and Internet connection for residents' use; public transportation available. Smoking permitted outdoors only.

Accessibility: Housing areas are not accessible.

Application & Residency Information:

Application available online

Application deadline(s): Ongoing

Resident season(s): Year-round

Average length of residencies: 2–8 weeks

Number of artists-in-residence in 2003: 10

Average number of artists-in-residence present at one time: 5

Selection process: Internal selection (staff, board, and/or advisory board).

Artists Responsible for: Food.

Organization Provides: Air transportation to and from Pittsburgh; housing, per diem, and local transportation; all materials and equipment; curatorial support to identify and secure all materials; skilled and unskilled labor during the installation process; marketing and publicity; documentation (4" x 5" transparencies, color slides, digital images); an opening reception to present the exhibition to the public; and honorarium.

Other Expectations & Opportunities: Artists-in-residence are given the option of participating in public exhibitions/presentations.

McColl Center for Visual Art
(formerly Tryon Center for Visual Art)

"For the last five years, I have traveled throughout the world peddling my wares and ideas with many major institutions. By far, my experience with McColl Center for Visual Art has been the most dynamic, interesting, and rewarding. I hope I can come back." — FRANCO MONDINI-RUIZ

721 North Tryon Street
Charlotte, NC 28202
Phone: (704) 332-5535
Fax: (704) 377-9808
Web: *www.mccollcenter.org*

Mission: To catapult artists to the vanguard of contemporary art by providing a state-of-the-art facility, a challenging and dynamic environment, collaboration among artists and the community, bold exhibitions, and strong affiliation with arts organizations worldwide.

Founded: Organization, 1997; Residency, 1999.

Location: McColl Center's artist-in-residency program facility is a historic, neo-Gothic church built of brick and stone in uptown Charlotte, North Carolina. The structure burned in a fire in 1985 and was renovated for the residency program in 1998.

Past Residents: Marcus Shubert, Ann Chamberlain, Willie Little, Franco Mondini-Ruiz, Liz Canner, Juan Logan, Todd McKie, Nick Cave, Judy McKie.

From the Director: "McColl Center for Visual Art provides visual artists, as well as creative thinkers from other fields, opportunities to immerse themselves in their work for periods of three months. McColl Center offers an atmosphere that encourages collaboration, formal and informal forums for exchanging ideas, and interaction between artists of this region and artists from other places and other cultures. The Center is located in a vital, progressive, and growing city that is excited to host this urban laboratory."
— SUZANNE FETSCHER

Eligibility: Sculpture, painting, technology/media, photography, ceramics, installation, and community art (see Indices for more specific types of artists served). Emerging, mid-career, and senior/mature artists; local, national, and international artists are selected through a jurying process. Repeat residencies permitted.

Studios & Special Equipment Available: Facilities for blacksmithing, ceramics/pottery, digital media, fiber arts, film/digital editing, metal shop, painting, photography, sculpture, and woodworking; exhibition/installation space.

Housing, Meals, Other Facilities & Services:
Housing: Individual apartment for each resident; furnishings and linens provided. *Meals:* Residents responsible for their own meals. *Other facilities/services:* Laundry facilities in individual apartments; computer with Internet connection in the media lab; Internet connections in living or studio area; public transportation available (cars available for residency functions only). Smoking permitted outdoors only. Spouses/partners and children allowed for full stay (no special accommodations).

Accessibility: Facilities are fully wheelchair-accessible, and are specially equipped for the visually impaired.

Application & Residency Information:

Application available online

Application deadline(s): May 1

Resident season(s): Fall (September–November) and Winter (January–March)

Average length of residencies: 3 months

Number of artists-in-residence in 2003: 12

Average number of artists-in-residence present at one time: 6

Selection process: Outside professional jury/panel and internal selection.

Artists Responsible for: Deposit—$200 (refundable), food, and travel (fully refundable upon arrival).

Organization Provides: Housing, studios/facilities, and program administration; travel assistance (fully refundable upon arrival); materials stipend—$2,000; and general stipend—$3,300.

Other Expectations & Opportunities:
We have an open-door policy—when visitors are in the facility and an artist's studio door is open, they are allowed to enter and dialogue with the artist. Occasionally, there are tours of the facility and artists are encouraged to be available. In addition, each artist is required to do two outreaches in the community. This can be in the form of lectures at the area universities; workshops in the local school system; other area arts organizations, etc.

The Mesa

"Being at The Mesa reminded me afresh how rich and abundant our nation is. Being in Springdale profoundly transformed my way of looking at the world. At creativity. The landscape is beyond description. Awe-inspiring. Beyond possession. It fed my soul. Thank you for a happy stay and years of inspired material and experiences. I commend The Mesa for this glorious place where art will flourish." — JOHN DUFFY

145 Red Rock Trail
P.O. Box 145
Springdale, UT 84767
Phone: (435) 772-0300
Fax: (435) 772-0303
E-mail: *admin@themesa.org*
Web: *www.themesa.org*

Mission: The Mesa is a non-profit arts and humanities residency center; our mission is to provide facilities and support for creative work in an environment rich in stimulation and fellowship.

Founded: Organization, 1993; Residency, 2002.

Location: The Mesa owns a twenty-nine-acre site along Lion Boulevard in Springdale adjacent to the entrance of Zion National Park; a complex of structures will be built on two and a half acres of the red-rock tabletop overlooking Zion Canyon, one of the country's most magnificent settings, in southwest Utah.

Past Residents: Syl Cheney-Coker, Stephen Savage, Teresa Jordan, Elizabeth Zimmer, Chris Aiken, Raine Bedsole, Maremi Hooff, Kevin Martini-Fuller, Suzanne Carbonneau, Stanley Crouch.

From the Director: "As a new residency center, The Mesa doesn't have a body of creative work to look back on…But in listening to the positive experiences that our residents share, we can see the direct effect that the time, space, and support we can provide has on the creative process. We create a community among our local residents, provide rich interactions with the public, and let the majestic beauty of Zion Canyon inspire each artist's stay." — KIM KONIKOW

Eligibility: Currently, artists are invited one at a time through a curatorial process until the facilities are built. Invitations are extended to a variety of writers and artists to bring a diverse balance to the program in terms of discipline, gender, geography, and point of career (established, mid-career, emerging). Eventually, twelve artists and scholars will be in residence at one time, selected through an application and panel review process.

Studios & Special Equipment Available: At this time, studio space and equipment is provided for the following, as required by the selected artist and that are readily available

in the community: dance/choreography, exhibition/installation, fiber arts, music/piano, painting, performance/theater, photography, sculpture, woodworking, and writing. Eventually there will be five studio spaces with a variety of specialized equipment.

Housing, Meals, Other Facilities & Services:
Housing: Individual cabin/house for each resident; furnishings and linens provided. *Meals:* Residents are responsible for preparing own meals; per diem provided for food, and organization provides transportation to the grocery store. *Other facilities/services:* Laundry facilities onsite; Internet access at local library or in several coffee shops. Local shuttle service in Springdale (April through October), as well as bike rentals; staff assists with transportation needs for pre-arranged activities. Smoking not permitted. Spouses/partners and children allowed for visits only, depending on the length of each resident's stay.

Accessibility: Currently, public activities are held in accessible spaces. As for lodging, arrangements are made to accommodate all residents. Eventually, two of the twelve live-work spaces, all the studios, and the Main Lodge will be accessible; the remainder of the live-work spaces and much of the site are being built using universal design.

Application & Residency Information:
Average length of residencies: 2–4 weeks

Number of artists-in-residence in 2003: 6

Average number of artists-in-residence present at one time: 1

Selection process: Currently an internal selection.

Artists Responsible for: Local travel, shipping of materials and supplies, long-distance telephone service, and Internet service at locales other than the library.

Organization Provides: Travel assistance (long-distance travel only), materials stipend (for public activities only), housing, and general stipend; small fee for participation in public activities; per diem for groceries and transportation to the grocery store.

Other Expectations & Opportunities:
The Mesa concentrates on supporting the rather solitary creative process; in doing so, we must utilize our resident artists to engage with the public and our community. Residents are asked to participate in one to two activities, depending on the length of their stay. We design quality arts programs that are appropriate for the artist as well as the public and seek out the right organizations or individuals for collaboration. All activities are free or low-cost, and are held in accessible spaces; they include a variety of workshops, exhibitions, readings, lectures, panel discussions, performances, etc.

Millay Colony for the Arts

"The world was beating at me. I needed to lose myself from it, immerse myself in the fictional realm. That brief stay at Steepletop was just enough to get my bearings, take some walks, make some headway in my new novel. The place was haunted, it seemed to me, by Edna St. Vincent Millay's presence; the pool, thick with algae, weird and gothic. I found footpaths through the blackberries, the simplicity of my room, the communal gathering for meals, all of it strange and yet somehow liberating."
— DAVID MORSE

454 East Hill Road
P.O. Box 3
Austerlitz, NY 12017
Phone: (518) 392-3103
Fax: (518) 392-4144
E-mail: *application@millaycolony.org*
Web: *www.millaycolony.org*

Mission: To support and nourish artists of all ages and at all points in their careers through the unique gift of uninterrupted time, personal solitude, and extraordinary natural beauty.

Founded: Organization, 1973; Residency, 1974.

Location: The Millay Colony is located at Steepletop, the country estate that belonged to the poet Edna St. Vincent Millay in Austerlitz, New York. The Colony is located about two and a half hours north of New York City and two and a half hours west of Boston.

From the Director: "Quality of experience is our focus here: Millay's extraordinary estate, Steepletop, seems to offer itself up as muse and catalyst. Artists frequently talk about their residencies as coinciding with significant turning points in their careers. With only six residents each month, this experience is deepened by a temporary but powerful community that supports and nurtures each resident in just the way she or he needs. Our facilities and our mission are simple and straightforward: subtlety or celebration develops according to who comes."
— DRAKE PATTEN

Eligibility: Millay welcomes writers, visual artists, and composers of all ages and at all points in their careers. International artists encouraged to apply. Repeat residencies after one year.

Studios & Special Equipment Available: Music/piano studio; painting, photography, sculpture, and writing studios.

Housing, Meals, Other Facilities & Services:
Housing: Private room in a shared facility; some private, some shared baths; furnishings and linens provided. *Meals:* The chef prepares dinner weeknights; residents prepare all other meals, with food provided by Millay.

Vegetarian meals available; cooking/kitchen facilities available to residents. *Other facilities/ services:* Common room or meeting space for residents' use; laundry facilities onsite; Internet connection only (no computer) in common area (residents must have their own Internet provider accounts); limited transportation provided by the organization, mostly for arrival to and departure from the Colony. Smoking permitted outdoors only. Spouses/ partners allowed for visits only—no facilities for overnight guests at the Colony.

Accessibility: Facilities are fully accessible. The main building is a universal design; please contact Millay for details regarding special accessibility features for the visually and hearing-impaired.

Application & Residency Information:

Application available online

Application deadline(s): October 1 for the following year

Resident season(s): April–November

Average length of residencies: 1 month

Number of artists-in-residence in 2003: 48

Average number of artists-in-residence present at one time: 6

Selection process: Outside professional jury/panel selection.

Artists Responsible for: Application fee—$20; travel and materials.

Organization Provides: Housing, food, studios/facilities, and program administration.

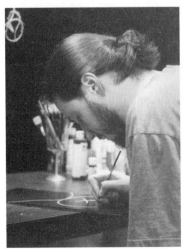

Montalvo

15400 Montalvo Road
P.O. Box 158
Saratoga, CA 95071
Phone: (408) 961-5819
Fax: (408) 961-5850
E-mail: *kwallerstein@
villamontalvo.org*
Web: *www.villamontalvo.org*

Mission: Our mission is to promote the development and circulation of aesthetic, critical, and thoughtful reflections on the world by creative and talented individuals who have committed themselves to professional art practices. We see the residency community as an opportunity for discourse and a global exchange of perspectives between artists and thinkers from different disciplines and different parts of the globe, and between the residents and members of larger communities.

Founded: Organization, 1930; Residency, 1939 (re-opened in Fall 2004).

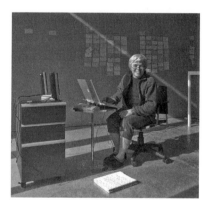

Location: Montalvo is located in Saratoga, California, on a 175-acre park in the foothills of the Santa Cruz Mountains; forty-five miles south of San Francisco, twenty miles north of Santa Cruz, and ten miles west of San Jose.

From the Director: "Residency programs support the process of cultural production, that 99 percent of artistic effort that precedes the moment where 'art' meets the 'audience.' These temporary communities invigorate and encourage that aspect that separates art from decoration or entertainment—and that is, the exchange of ideas that provide a critical perspective. Montalvo's international residency program energetically supports these benefits and offers additional possibilities through the intentional advancement of collaborations, including those that often arise spontaneously among residents as well as through opportunities designed to utilize Montalvo's exhibition and performance venues, its educational and outreach programs, and through partnerships with the local communities—particularly the technicians exploring the edge of the envelop in the digital and biotech industries."
—GORDON KNOX

Eligibility: Artists from all disciplines and countries are eligible (see Indices for specific artistic categories); however, open applications are not accepted.

Studios & Special Equipment Available: Dance/choreography, digital media, film/digital editing, music/piano, music/recording, painting, photography, sculpture, and writing studios; exhibition/installation and performance theater space.

Housing, Meals, Other Facilities & Services: *Housing:* The Orchard at Montalvo consists of ten state-of-the art live/work studios, built by six teams of architects and artists; and the Commons building for meals and socializing. Furnishings and linens provided. *Meals:* Gourmet dinners five nights a week will be prepared in the Commons building; the evening meal is seen as a key component of the residency experience. Vegetarian meals

available. Food for breakfast and lunch provided, for residents to prepare themselves. In addition, each studio has a kitchenette. *Other facilities/services:* The Commons building houses not only a large dining room and kitchen, but also a lounge/media center for socializing, reading, watching movies, and so on. Both Mac and PC computer equipment will be available in each studio and in the Commons area, with high-speed (T1) connection; the entire hillside will be Wi-Fi equipped for wireless-enabled laptops. Laundry facilities onsite. A van, a couple of cars, and several bicycles available for use by residents. Smoking permitted outdoors only. Spouses/partners allowed for full stay; children allowed for visits only.

Accessibility: Four out of ten studios and living quarters are fully accessible, as is the public area.

Application & Residency Information:

Applications by invitation only: A two-tiered recommendation/invitational system, whereby an international panel for each major discipline nominates three mid-career artists. The nominated individuals will then each be invited to submit an application, which in turn will be reviewed by a jury of internationally recognized artists and professionals. It is Montalvo's expectation and hope that this approach will ensure the participation of talented and committed artists from around the world who would not normally find their way to a residency program.

Artists Responsible for: Cost of travel for spouse and/or children, if applicable.

Organization Provides: All residency costs.

Other Expectations & Opportunities:
Residents are welcome and encouraged to use their time here for reflection, research, and experimentation with new ideas. The focus of our program is on the process of creation rather than the final product; however, a residency can also be used to complete a project, and in that case exhibition/presentation venues, both on campus and off, can be arranged.

The Montana Artists Refuge

"The Montana Artists Refuge houses all the goodies an artist could ever desire: lots of space, time, support, friends, beauty, and individuality. My time there was one of the soundest times in my life...all things working. I was challenged spiritually, intellectually, artistically, and received nothing but encouragement in return. My only regret is that I could not have stayed longer." — MARY CAROTHERS

101 & 103 Basin Street
P.O. Box 8
Basin, MT 59631
Phone: (406) 225-3500
Fax: (406) 225-3500
E-mail: *mar@mt.net*
Web: *www.montanarefuge.org*

Mission: The Montana Artists Refuge is organized to further the creative work of artists, to create residencies for artists, and to provide arts programs and arts education for both artists and community members.

Founded: Organization and Residency, 1993.

Location: The Montana Artists Refuge is located in the historic mining community of Basin, Montana, high in the Rocky Mountains about fifteen miles east of the Continental Divide. Studio and living spaces are housed in two historic brick buildings on the main street of town. The Refuge is surrounded by unparalleled beauty and natural wonders, wildlife, and inspiration.

Past Residents: Pamela Alexander, Lloyd Van Brunt, Eric Moe, Debra Earling, Bently Spang, William Big Day, Michael Haykin, Lori Novak, Jan Beatty, Margaret Baldwin.

From the Director: "Artists have the opportunity to spend their residency in quiet, contemplative solitude and immerse themselves in their work. They can also opt to collaborate with other artists at the Refuge or make the trip into Helena or Butte and participate in a lively arts community in both towns." — CINDY LABLUE

Eligibility: The Montana Artists Refuge is a multidisciplinary residency program, open to all national and international artists, writers and musicians.

Studios & Special Equipment Available: Ceramics/pottery (kick wheel and an electric wheel but no kilns; can arrange firing with local potter in town); dance/choreography; other general-use studios.

Housing, Meals, Other Facilities & Services: *Housing:* Individual furnished apartment with kitchen for each resident (includes private phone line; use calling card for long distance);

linens generally provided, check with coordinator. *Meals:* Residents are responsible for own meals. *Other facilities/services:* No computers but there is a phone line available in each apartment for artists to hook up with their Internet server; access to the Internet is also available in the public library nine miles away in Boulder. Artists who come to the Refuge without transportation are encouraged to make their own travel arrangements with current Refuge artists, board members, or local community members. Smoking permitted outdoors only. Spouses/partners and children allowed for full stay.

Accessibility: Public areas are accessible; ramp to one apartment is available, and one studio has ground-floor accessibility; the Refuge is working on better ADA accessibility.

Application & Residency Information:

Application available online

Application deadline(s): January 15 for May–August; May 15 for September–December.; August 15 for January–April

Resident season(s): Winter/Spring, Summer, Fall

Average length of residencies: 1–3 months

Number of artists-in-residence in 2003: 21

Average number of artists-in-residence present at one time: 2–3

Selection process: Residency Committee consisting of board members, and outside professional artists.

Artists Responsible for: Residency fee— $450–550 (check Web site for current fees); deposit—$200; food, travel, and materials.

Organization Provides: Housing, studios, and program administration.

Additional Support: Artists eligible for full scholarships available to Montana American-Indian artists. In addition, two one-month fully paid scholarships available (covers the residency fee). Also available: The Carol Davis Scholarship and the Owens Family Scholarship. Contact organization for details.

Other Expectations & Opportunities: Residents are encouraged to give a public presentation/exhibition if they wish; however, they are not required to do so. For residents only staying for a month, they must make arrangements with the residency coordinator within the first week of arrival. The Refuge encourages artists-in-residence to provide community outreach. If you are interested in discussing your work or providing other community contact during your stay, we can assist with arrangements either prior to or upon your arrival; however, we do mean "refuge" literally and if, in your short stay, your preference is time alone to work or just gather your resources, you are certainly under no obligation.

Nantucket Island School of Design and the Arts

"The associations that I made with other artists in residence at the NISDA cottages enhanced the experience. There are few opportunities in the visual arts—which makes NISDA even more important." — KEVIN LEE MILLIGAN

P.O. Box 958
Nantucket, MA 02554
Phone: (508) 228-9248
Fax: (508) 228-3648
E-mail: *nisda@nantucket.net*
Web: *www.nisda.org*

Mission: To provide the isolation for focus, the inspiration to create, and artists' dialogue; to explore the interrelationship of arts, sciences, humanities, and the environment; to realize the innate power of the arts as social voice, conveyor of human spirit, and medium toward peace; to encourage artists as educational leaders.

Founded: Organization, 1973; Residency, 1982.

Location: On Nantucket Island, thirty miles to sea off the coast of Cape Cod, with eighty miles of varied shoreline. Sea View Farm Art Center Studios are located across from conservation land and Polpis Harbor; Harbor Cottages are near Nantucket Harbor and historic towns with museums, galleries, library, theater, and island-wide land and seascape sites.

Past Residents: Robert Rindler, James Pierce, Brenda Miller, Michelle Stewart, Kevin Lee Milligan, Tom Holden, Corinne Loeh, Buckminster Fuller, Roman Vishniac, Michael James.

From the Director: "We welcome emerging and professional artists. In our residency, artists focus independently and wholly on personal work, cradled in a cottage in an intimate island environment of dawn and dusk lights, winds, and weather—nature's cycles for inspiration and respite." — KATHY KELM

Eligibility: National and international, emerging and professional artists and educators (see Indices for specific artists eligible).

Studios & Special Equipment Available: Includes open 2D, 3D, and performance studio, ceramics studio (skutt electronic and raku kiln, electric wheels, pit-firing equipment), black-and-white darkrooms, textile studio, and outdoor studio. Often artists elect to work in their cottage with sojourns out into the natural landscape. Presentation/exhibition space includes Silo Gallery at the Farm, Harbor Gallery in town, and open-air site installations island-wide. Seaview Farm Art Center, Studios in Dairy Barn and Long Shed, and pavilion in meadow available for outdoor work and performance.

Housing, Meals, Other Facilities & Services:
Housing: Simple, heated cottages (private or shared), with full kitchenette and bath, located on Waterfront Street, near library, museums, theaters, and galleries. *Meals:* Artists purchase food and prepare meals in own cottage; seafood, bakery, and whole-food store nearby. *Other facilities/services:* Internet access can be set up by residents in cottages via phone or cable. Town shuttle operates June to October; personal car, scooter, or bike recommended— great bike paths across island. Pets allowed only in off-season, and with space limitations— residents must make special request and be approved; additional pet companion fee. No smoking onsite. Spouses/partners allowed for full stay if also an artist-in-residence; otherwise, allowed for visits only (artist may apply for partner or friend to share cottage, dependent on space and programs). Children allowed for visits only; it's important to schedule visit with consideration for other artists and the work's process in the community.

Accessibility: Cottages are low to the ground. Bathrooms/kitchens are on same level; doors are regular size.

Application & Residency Information:
Application deadline: Ongoing

Resident season(s): September–December; January–June; July–August

Average length of residencies: 1–3 weeks in summer; 1–6 months rest of year

Average number of artists-in-residence present at one time: 6–10 (cottages can accommodate collaborative gathering of up to 32)

Selection process: Interdisciplinary artists/ faculty panel.

Artists Responsible for: Application fee— $30; travel, food, personal needs, materials, computer; pet companion fee, if applicable. Residency fees vary according to season, length of stay, cottage size, and studio needs (for September–June—studio workspace: $75/week or $250/month; 1-BR cottage with loft: $350/week or $850/month; 1-BR cottage: $300/week or $750/month; studio cottage: $250/week or $650/month); plus $50/week to $100/month utilities. (Please call for weekly summer fees.)

Organization Provides: Studio/workspace, housing subsidy, program administration.

Additional Support: Projects may be available for partial work-exchange, dependent on season; please inquire for more information.

Other Expectations & Opportunities: We appreciate artists taking time to share their work and ideas through readings, lectures, slide presentations and workshops, being judges in the annual Sand Sculpture Event, and installing site works in the environment or at our Silo Gallery or Harbor Gallery in town. Occasionally there is an opportunity to mentor/present to island organizations and public/private school children. A donation of work to sell at the gallery assists in the support of the facilities.

Northwood University Alden B. Dow Creativity Center

"I'm sold on the concept of the creativity residency. I've begun investigating other such opportunities, but thus far I've found none that compare to what I was offered at the Creativity Center."

4000 Whiting Drive
Midland, MI 48640
Phone: (989) 837-4478
Fax: (989) 837-4468
E-mail: *creativity@northwood.edu*
Web: *www.northwood.edu/abd*

Mission: To encourage the creativity in individuals and to preserve the architectural philosophy of Alden B. Dow.

Founded: Organization, 1978; Residency, 1979.

Location: One hundred and twenty miles north of Detroit, Michigan, on the wooded campus of Northwood University.

Past Residents: Weston Agor, Pamela Becker, Ruth H. Jacobs, Caroll Michels, Karin Muller, Jessika Satori, Ben Shedd, Robert Waite.

From the Director: "The Northwood University Alden B. Dow Creativity Center offers a gift of time for individuals to spend ten weeks pursuing their creative projects. What makes our residency unique is that it is open to all fields of endeavor—the arts, humanities, and the sciences."

Eligibility: Open to all U.S. citizens working in the arts, humanities, and sciences.

Studios & Special Equipment Available: Residents use their large apartments as workspace, when applicable. The Creativity Center will try to accommodate, from within the community, special needs whenever possible.

Housing, Meals, Other Facilities & Services: *Housing:* Individual apartment for each resident; furnishings and linens provided. *Meals:* Lunch is provided; residents responsible for all other meals; cooking/kitchen facilities available to residents. *Other facilities/services:* Common room or meeting space for residents' use; laundry facilities onsite; computer with Internet connection in live/work space; public transportation available. Smoking permitted outdoors only. Spouses/partners allowed for visits only.

Accessibility: Facilities are fully accessible.

Application & Residency Information:

Application deadline(s): December 31 (postmarked)

Resident season(s): Mid-June–mid-August

Average length of residencies: 10 weeks

Number of artists-in-residence in 2003: 3

Average number of artists-in-residence present at one time: 3–4

Selection process: Applications initially viewed by peers having expertise in area of project subject; finalists reviewed by Creativity Center board, with their selection of awardees.

Artists Responsible for: Application fee— $10; breakfast and dinner.

Organization Provides: Housing and work-space; lunch; travel stipend—$500; materials stipend—$750; general stipend—$1,750 for ten-week residency.

Other Expectations & Opportunities:
The Creativity Center Fellow's primary focus is to make significant progress on achieving the goals of his/her project. If time allows, fellows are encouraged to interface with the community, by participating in optional public exhibitions/presentations and studio tours. The donation of artwork is optional.

Oregon College of Art and Craft

"Having the chance to work outside of my own studio and in such a good facility allowed me to think 'outside the box' and both get reacquainted with techniques I haven't used in a long time, as well as dream up some really ambitious projects for the future. Having the time and space was invaluable and having the companionship of the other residents made the experience even more exciting." — JULIE CHEN

8245 SW Barnes Road
Portland, OR 97225
Phone: (503) 297-5544
Fax: (503) 297-3155
Web: *www.ocac.edu*

Mission: Oregon College of Art and Craft is dedicated to excellence in teaching art through craft, contributing significantly to the continuity of contemporary craft as an artistic expression.

Founded: Organization, 1907; Residency, 1979.

Location: Oregon College of Art and Craft's eleven-acre garden and orchard—sitting high in the West Hills of Portland—overlooks Oregon's coastal mountains, yet it is minutes from downtown Portland's cultural resources.

Past Residents: Adrian Arleo, Robert Ebendorf, Sarah Perkins, Phillip Baldwin, Layne Goldsmith, Marcia MacDonald, Julie Chen, Marna Goldstein-Brauner, John McQueen, Patrick Hall.

From the Director: "Residents make art while they are here, but they also make friends with other residents, with students, with faculty and staff, and with artists they meet in Oregon. We are a community committed to the pursuit of art with all that entails: invigorating challenges, bursts of creativity, the occasional dry spell, the rewards of cama-raderie, and the pleasure of a time to work. Residents contribute immeasurably to the College. We offer them a space, the incentive to work and a place in our community."

Eligibility: The Junior Residency for emerging artists is open to U.S. nationals or permanent residents. The College defines emerging artists as post-graduates (post-MFA preferred) with less than five years' experience as an exhibiting artist. The Senior Residency for mid-career artists is open to U.S. nationals or permanent residents. The College defines mid-career artists as artists with more than five years' experience in a medium with a substantial exhibition record.

Studios & Special Equipment Available: Ceramics/pottery facilities (with electric and kick wheels, indoor and outdoor kilns including salt, wood, soda, and an experimental firings

area); weaving studio (a variety of looms, a construction studio with sewing machines and sergers, and a surface design studio for printing, batik, and dying); jewelry-making/fine metals construction (equipment for casting, soldering, annealing, raising and forming, plating, enameling, stonecutting and a variety of saws, grinders, and shears); photography studio (black-and-white and color capabilities with enlarging capacity from 35mm to 4" x 5" as well as process camera and non-silver capabilities; Macintosh computers equipped with Photoshop available for digital work); and woodworking tools (a variety of hand and machine tools including bandsaws, miter saws, lathes, planers, joiners, sanders, and spray booth).

Housing, Meals, Other Facilities & Services:

Housing: The residents live in the on-campus resident house, a private fully furnished house with kitchen, private bedrooms, and a shared bath; linens provided. *Meals:* Residents are responsible for own meals. *Other facilities/services:* Common room or meeting space for residents' use; laundry facilities located in the resident house and free of charge; Macintosh computers with Internet access available for use in the student computer lab; public transportation available throughout the Portland area (the College is located on a main bus line just minutes from downtown Portland). Smoking permitted outdoors only. Spouses/partners and children allowed for visits only (visits should be limited to long weekends).

Accessibility: Only public areas are accessible.

Application & Residency Information

Application available online

Application deadline(s): April 1

Resident season(s): Jr. Residency—Spring and Fall; Sr. Residency—Summer of odd-numbered years

Average length of residencies: Jr. Residency—16 weeks; Sr. Residency—6 weeks

Number of artists-in-residence in 2003: 10

Average number of artists-in-residence present at one time: 2 (Spring and Fall), 3 (Summer)

Selection process: Internal selection (staff, board, and/or advisory board).

Artists Responsible for: Food.

Organization Provides: Housing, studios/facilities, and program administration; travel assistance—$500; materials stipend—$500 (Jr. Residency), $200 (Sr. Residency); general stipend—$1,200 (Jr. Residency), $750 (Sr. Residency).

Other Expectations & Opportunities: Residents make informal entrance and exit presentations as well as participate in the artists-in-residence show in our Hoffman Gallery in the fall following their residency. Studio tours and the donation of artwork are optional. Junior Residents are asked to work a maximum of ten hours per week for the College working in the studios or at the reception desk.

Penland School of Crafts

"Everything at Penland is for the art.
Everything supports it and points back to it."
— ANDREW SAFTEL

P.O. Box 37
Penland, NC 28765
Phone: (828) 765-2359
Fax: (828) 765-7389
E-mail: *office@penland.org*
Web: *www.penland.org*

Mission: The mission of Penland School of Crafts is individual and artistic growth through craft. Penland enriches the lives of individuals by teaching skills, stimulating ideas, and promoting the value of craft in the world. Everyone is welcome, from beginning and advanced craft practitioners to the general public. Penland offers a learning environment that is beautiful, stimulating, and egalitarian. It is a place where people love to work, feel free to experiment, and frequently exceed their own expectations. Penland's programs encompass traditional and contemporary craft, and seek to acknowledge the human spirit that is universally expressed through craft.

Founded: Organization, 1926; Residency, 1963.

Location: Forty miles northeast of Asheville, in the western North Carolina mountains.

Past Residents: Randy Shull, Hoss Haley, Deborah Groover, Carmen Grier, Cynthia Bringle, Christina Shmigel, Bill Boysen, Adela Akers, Mark Peiser, Junichiro Baba.

From the Director: "Penland's resident artists have the remarkable opportunity to spend three years making their work in close proximity to other residents and within a stone's throw of one of the liveliest educational environments anywhere. In addition to nurturing the careers of many creative people this program has helped build Penland's amazing community of artists."

Eligibility: The program welcomes self-motivated, focused individuals working in traditional and nontraditional studio crafts.

Studios & Special Equipment Available: A variety of multi-use studios appropriate for ironwork, clay (wood kiln on site), fiber arts, glass, metalworking, photography (darkroom space available), and woodworking (ventilation in place). Residents build or supply additional equipment and supplies.

Housing, Meals, Other Facilities & Services: *Housing:* Individual apartment with kitchen for each resident. Meals: Residents responsible for own meals. *Other facilities/services:* Common room or meeting space for residents' use; laundry facilities onsite. Smoking not permitted. Pets allowed with prior permission; dogs must be leashed in public areas. Spouses/partners and children allowed for full stay, when housing permits (may be an additional housing charge).

Accessibility: Four ground-floor studios are accessible; three upstairs studios are currently not accessible.

Application & Residency Information:

Application deadline(s): October 30 (call for information about which studios are available)

Resident season(s): Year-round

Average length of residencies: 3 years

Number of artists-in-residence in 2003: 7

Average number of artists-in-residence present at one time: 7

Selection process: An advisory committee (artist/boardmember, past resident, current resident, and program director) recommends residents to the director.

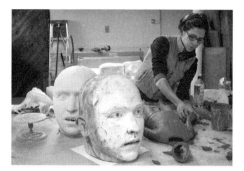

Artists Responsible for: Application fee— $25; deposit—$100 on housing and on studio; food, equipment, and travel.

Organization Provides: Housing, studio facilities, and program administration.

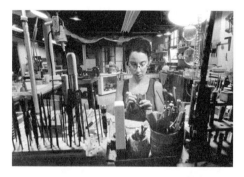

Other Expectations & Opportunities:

Residents are offered the opportunity to exhibit their work in the Penland Gallery every two years; in addition, there are numerous opportunities for the group to exhibit nationally. Residents are asked to host an open house during each Penland session and to maintain an open-door policy in their studios; Penland offers tours of campus and hosts arts-related groups interested in the school programs and local studios. Penland encourages interaction between residents and its other programs; this may include demonstrations in classes, class visits to resident studios, and personal contact with students. Residents also participate in the annual benefit auction and are encouraged to participate in other events as they arise. Residents are invited to leave a piece of their work for the school when they leave the program; objects are displayed in the common area of the resident's studio.

Pilchuck Glass School

"My experience at Pilchuck was absolutely wonderful and extraordinarily gratifying on every level. I can't imagine another situation where I could have learned so much in such a brief amount of time. The spirit of sharing, both information and hands-on help, permeates the place and makes it an outstanding laboratory for experimentation and learning. The physical plant provides excellent facilities in a gorgeous setting." — ARLENE SHECHET

430 Yale Avenue North
Seattle, WA 98109-5431
Phone: (206) 621-8422
Fax: (206) 621-0713
E-mail: *info@pilchuck.com*
Web: *www.pilchuck.com*

Mission: Our mission is to be the premier international learning center for artists who create with glass, and to further awareness and understanding of glass as a visual arts medium.

Founded: Organization, 1971.

Location: Pilchuck's campus is located fifty miles north of Seattle, on fifty-four acres of wooded land set amidst a 2,000-acre tree farm located in the foothills of the Cascade Mountain Range. The contemporary timber construction of the lodge, various studio buildings, and all housing facilities highlight the campus's natural beauty and provide superlative working and living spaces.

Past Residents: Xu Bing, Judy Chicago, Fred Wilson, Margo Sawyer, Richard Marquis, Achy Obejas, Steve Klein, Fay Jones, Dick Weiss, Hanae Uechi Mills.

From the Director: "Everyone at Pilchuck becomes a part of a lively and supportive community that encourages artistic collaboration and respects personal achievement. Almost everyone on campus is a practicing artist. Many come from around the world to teach, to learn, or to work at Pilchuck. They discover that the school's experimental attitude, international character, and commitment to excellence are as strong as ever. Most important, they find at Pilchuck the personal growth they are seeking."— PATRICIA WATKINSON

Eligibility: *Summer Artists-in-Residence Program:* Visual artists working in any medium, typically not glass; by invitation only. *Visiting Artists:* Artists working in any medium; by invitation only. *Fall Emerging Artists-in-Residence Program:* Artists in the early stages of their careers who need financial support, time, and a creative environment in which to develop individual bodies with glass as a focus; by application. *Winter-Spring Professional Artists-in-Residence Program:* Experienced and mature professional artists who wish to engage in creative projects using glass, at their own

expense and relying on their own expertise; by application. *Spring John H. Hauberg Fellowship Program:* Twelve-day residency offering visual artists in all media as well as writers, poets, art critics, and curators the opportunity to create work that responds to Pilchuck's environment and/or utilizes Pilchuck's glassmaking facilities.

Studios & Special Equipment Available:
Glass blowing hot shop with five work stations, hot-casting studio, kiln-casting studio, glass printmaking studio, flat shop (neon, mosaic, stained glass, flameworking), and cold shop (engraving, sandblasting, and finishing); limited metal shop; limited woodworking equipment; and vitreography studio (glass-plate printmaking).

Housing, Meals, Other Facilities & Services:
Housing: A variety of shared and private housing, depending on residency type; furnishings and linens provided. *Meals:* For Summer Artists-in-Residence, Summer Visiting Artists, and Hauberg Fellows only, all meals provided; vegetarian meals available. For Emerging and Professional Artists-in-Residence, residents responsible for own meals; cooking/kitchen facilities provided. *Other facilities/services:* Common room with computer and Internet connections for residents' use; laundry facilities onsite; local transportation provided to and from regional airport and some weekend excursions. Smoking permitted outdoors only. Spouses/partners and children allowed for visits only—must pay for all meals.

Accessibility: Call or e-mail for details.

Application & Residency Information:

Application available online

Application deadline(s): Emerging Artists: April 1; Winter/Spring Professional Artists: September 1; Spring Hauberg Fellowship: September 1. (Those interested in the invitation-only programs should send letters of interest and supporting materials to Pilchuck's artistic director at any time.)

Resident season(s): Summer (late-May–early-September in 5 consecutive 17-day sessions), Fall (mid-September–mid-November),

Winter/Spring; Hauberg Fellowship Program (mid-May–late September).

Average length of residencies: 17 days

Number of artists-in-residence in 2003: 30

Average number of artists-in-residence present at one time: 4

Selection process: Outside professional jury/panel selection for Emerging Artists-in-Residence and Hauberg Fellows; all others by internal selection (staff, board, and/or advisory board).

Artists Responsible for: For all applicants: application fee—$35. For Professional Artists-in-Residence: residency fee (varies), deposit (varies), food, travel, and materials. For Emerging Artists-in-Residence: food, travel, and materials. For Hauberg Fellows: travel and materials.

Organization Provides: For all residents: housing, facilities, and program administration. In addition, the organization provides: For Summer Artists-in-Residence and Summer Visiting Artists—all meals and travel assistance; for Emerging Artists-in-Residence—materials stipend and general stipend; for Hauberg Fellows—all meals.

Other Expectations & Opportunities:
Summer Artists-in-Residence are asked to give a slide lecture during the session, to work in Pilchuck's vitreography studio and leave one or two prints for the school's permanent collection, to provide critiques to willing students, and to host an open-studio tour (along with the rest of the campus community) at the end of each session. Summer Visiting Artists may be asked to give demonstrations or slide talks, depending upon the purpose for which they were invited. Pilchuck conducts an annual fundraising auction consisting of work donated by students, instructors, artists-in-residence, and affiliated artists. These donations are optional.

Prairie Center of the Arts

"This residency gave me the opportunity to work with new industrial technology that I otherwise would not have had access to." — FISHER STOLZ

1412 SW Washington Street
Peoria, IL 61602
Phone: (309) 673-5589
Fax: (309) 673-5592
E-mail: *mjr@tricitymachine.com*

Mission: To provide time, space, and equipment for artists to create and collaborate.

Founded: Organization, 2003; Residency, 2004.

Location: The Center is housed in a large mill-constructed warehouse located in Peoria, Illinois, near the Illinois River. The century-old building is listed on the National Historic Register and was formerly a rope manufacturer known as the Peoria Cordage. It is located at the intersection of routes 29 and 116 at the foot of the Cedar Street Bridge. Chicago and St. Louis are a three-hour drive in either direction. Also housed in the building is a functioning machine shop.

Past Residents: Fisher Stolz (first artist-in-resident, 2004)

From the Director: "Emphasis will be placed on collaborations with other arts organizations and universities and colleges to enhance the experience of the artists."
— RICHELE RICHEY

Eligibility: Artists working in the areas of drawing, painting, and sculpture.

Studios & Special Equipment Available: Small metal fabrication equipment, including welding—500 pound max weight; acrylic and watercolor painting and drawing workspace; metal and 3D sculpture done on ABS plastic rapid prototyping machine.

Housing, Meals, Other Facilities & Services: Housing and meals not provided. Common room with computer and Internet connection for residents' use; public transportation available (building is along local bus line). Smoking not permitted.

Accessibility: Facilities are not accessible.

Application & Residency Information:

Application available online, beginning fall 2005

Application deadline(s) and residency statistics: Please contact organization for more information.

Selection process: Internal selection (staff, board, and/or advisory board).

Artists Responsible for: Application fee—$35; deposit—$100; some housing and travel costs; food and materials.

Organization Provides: Studio facilities/ equipment and program administration; travel assistance, housing stipend, and general stipend (amounts not yet determined).

Other Expectations & Opportunities: Artists-in-residence are expected to participate in public exhibitions/presentations, on- or offsite, and studio tours; artists are also asked to donate a piece of artwork to the Prairie Center.

Ragdale Foundation

"Ragdale's strength is more than its buildings or grounds. The real heart and soul of Ragdale is its ability and willingness to bring people together." — MIRIAN KINNEY

1260 N.Green Bay Road
Lake Forest, IL 60045
Phone: (847) 234-1063
Fax: (847) 234-1063
E-mail: *mosher@ragdale.org*
Web: *www.ragdale.org*

Mission: The mission of the Ragdale Foundation is to support writers and artists in a retreat setting and to make the arts more accessible to the public. This is accomplished through three core program areas: the artists' residency program, community programs, and preservation of the historic site.

Founded: Organization and Residency, 1976.

Location: Ragdale is located on the grounds of noted architect Howard Van Doren Shaw's summer retreat, thirty miles north of Chicago and easily accessible via public transportation. The house and gardens, listed on the National Register of Historic Places, are among the few surviving intact examples of the arts and crafts movement in the country. Residency facilities are adjacent to fifty-five acres of preserved prairie, yet Chicago is only an hour away.

Past Residents: Lawrence Block, Scott Eyerly, Jane Hamilton, Lynda Lowe, Jacquelyn Mitchard, Audrey Niffenegger, Alex Kotlowitz, Gail Tsukiyama, Mark Winegardner, Alice Sebold.

From the Director: "The thing which I believe distinguishes Ragdale among artist communities is the feeling of being 'at home.' For more than a hundred years, this beautiful retreat has provided artists of all kinds with a sense of security and support that allows them to do their best work." — SUSAN TILLETT

Studios & Special Equipment Available: Facilities can accommodate dance/ choreography, composition (piano studio), painting, woodworking, writing, and exhibition/installation.

Housing, Meals, Other Facilities & Services: *Housing:* Private room in a shared facility; some private bathrooms; furnishings and linens provided. *Meals:* All meals are provided; vegetarian meals available; kitchen facilities available for residents' use. *Other facilities/ services:* Common room for residents' use; laundry facilities onsite; computer and Internet connection in common area; public transportation available. Smoking permitted outdoors only.

Accessibility: Accessible studio opened in January 2005. Accommodations for hearing- and visually impaired made upon request.

Application & Residency Information:

Application available online

Application deadline(s): January 15 and June 1

Resident season(s): January–April; June–mid-December

Average length of residencies: 2–4 weeks

Number of artists-in-residence in 2003: 200

Average number of artists-in-residence present at one time: 12

Selection process: Outside professional jury/panel selection; work samples are judged anonymously by qualified professionals in each discipline.

Artists Responsible for: Application fee—$30; residency fee—$25/day; deposit—$100 for each two-week period; travel and materials (including printers and computers).

Organization Provides: Housing, meals, studio space, and program administration.

Additional Support: Frances Shaw Fellowship, Friends Fellowship, Gary Goberville Memorial Fellowship for a Wisconsin visual artist.

Other Expectations & Opportunities:
Artists and writers are frequently invited to share their work with the public once during their stay, but this is completely optional, as are studio tours and the donation of artwork.

Red Cinder Creativity Center

"Red Cinder provided for me a place of incredible beauty, peace, and sanctuary that greatly facilitated the making of my paintings. It has just the right balance of solace and community for serious work and connection with other artists."
— PHYLLIS TROWBRIDGE

P.O. Box 527
Na'alehu, HI 96772
Phone: (808) 929-9600
E-mail: *hchellin@red-cinder.com*
Web: *www.red-cinder.com*

Mission: The Big Island of Hawaii has a tradition of artistic creativity, which is no surprise in a place that is literally still creating itself. Red Cinder is a residency program where working artists in many disciplines can focus on their work for short-term stays—not in retreat, but in balance with nature and culture.

Founded: Organization and Residency, 2001.

Location: A ten-acre, rural, upland site near towns of Na'alehu and Oceanview on the Big Island. Red Cinder property borders Kahukuâ, Hawaii Volcanoes National Parks' recent 116,000-acre parkland addition.

Past Residents: Susan Middleton, David Liittschwager, Victoria McOmie, Noriko Senshu, Rachel Suntop, Phyllis Trowbridge, Sandy Walker, Sarah Johnson, Peter Harris, Jeff Crandall.

From the Director: "It has long been my dream to create a place where artists could be granted the space, time, and encouragement to pursue their work free of outside distractions. That's the basic principle of all artists' residencies; however, most require a stay of at least four weeks. This excludes many serious artists who, for whatever reason, also have to earn a living doing other work, or the care of young children makes a month too long a time gone from home. The stay for an artist at Red Cinder is two weeks—enough time to complete a short-term project or get a longer one well started. It is also time enough to find one's place in Red Cinder's community of residency artists. Red Cinder's primary focus is its group residency program. We do, however, offer a non-group residency stay (no more than two weeks). This is our educational guest stay program."— HELEN CHELLIN

Eligibility: Open to all serious artists for short-term stays of two weeks. Artists are selected by a panel of peers designated by the Red Cinder Director.

Studios & Special Equipment Available: Facilities can accommodate ceramics/pottery (hand building only), dance/choreography, digital media, exhibition/installation, fiber arts, painting and sculpture (625-square-foot

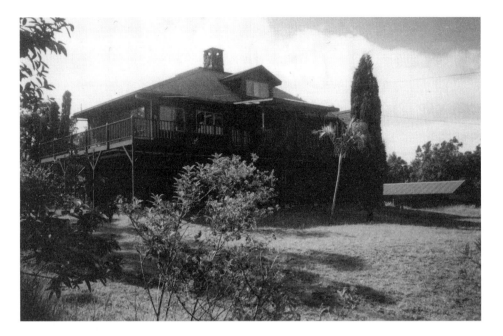

studio in barn), and writing (in live/work spaces). Please see Web site for photos, facility descriptions, and floor plan.

Housing, Meals, Other Facilities & Services: *Housing:* Private room in a shared facility; furnishings and linens provided. *Meals:* All meals are provided; cooking/kitchen facilities also available to residents. *Other facilities/ services:* Common room or meeting space for residents' use; laundry facilities onsite; computer with Internet connection in common area (one phone line for Internet connection, shared by all). Transportation provided to and from Kona airport only; it is the responsibility of artists to provide transportation to the island of Hawaii—there is no public transportation. No smoking in any indoor facility.

Accessibility: Facilities are not accessible.

Application & Residency Information:
Application available online
Application deadline(s): Ongoing
Resident season(s): Year-round

Average length of residencies: 2 weeks

Number of artists-in-residence in 2003: 10

Average number of artists-in-residence present at one time: 4–6

Selection process: Outside professional jury/panel selection.

Artists Responsible for: Application fee—$25; residency fee—$20/day; food—$20/day; travel, materials, GET, and TAT Hawaiian taxes on food and lodging as applies.

Organization Provides: Housing, meals, studio/workspace, program administration.

Other Expectations & Opportunities: Informal presentations of one's work to other onsite residents are encouraged but not required. Making a page to be added to the artists' book—a residents' history of those at Red Cinder—is encouraged but not required. We would always welcome artists' support in donations of time, money, works, or goodwill.

Rockmirth EcoArts School, Atelier, and Residential Artists' Retreat

"Wind and stars, the butterscotch smell of ponderosa, spectacular Hermit Peak and Truchas Mountain hovering at the head of the canyon, light-filled studio space, and incredible gourmet food combine with the wild, radically joyful and brilliant inspiration of Director Judyth Hill to make this my favorite place for writing and dreaming in the whole world."
—ELEANOR MARKS

HC 69 Box 20H
Sapello, NM 87745
Phone: (505) 454-9628
Fax: (208) 474-8286
E-mail:*rockmirth@cybermesa.com*
Web: *www.rockmirth.com*

Mission: Rockmirth is a magnificent rural setting for arts and eco-creation, education (classes and workshops), and residencies, and the delights of playful work; devoted to pollinating creativity and inspiring community, ecological, and cultural transformations deeply rooted in tending and attending nature and our earth.

Founded: Organization and Residency, 2004.

Location: On the east side of the Sangre de Christo mountains on 111 acres in a high canyon, surrounded by lush ponderosa pine forests, midway between Santa Fe and Taos.

From the Director: "Rockmirth is unique because of these mountains, this Ponderosa-pined canyon, these wild animals and birds, this refuge of peace and deep, ecological connection, all animate and alive, all holding us in a nest of creativity, brooding, fledgling and ecstatic flight. Work and joy, silence and hilarity go hand in hand here. The folks who love this place the most are those who delight in hard, playful work, good hard hand and heart work; those who have a natural instinct to tend and honor nature, those who love silence and beauty and bird song—leading to the bliss of stretching yourself into doing your finest work in your medium of choice, followed by the great good evening times after a long, satisfying day, when we gather to eat delectable food, schmooze, dance, make music, perform, hot tub, and study the stars in one of the dark sky capitals of the world."—JUDYTH HILL

Eligibility: There are no eligibility requirements other than the artist's passionate commitment to his or her art form and a passionate, natural ability to live both respectfully and generously with nature and incredibly diverse co-workers.

Studios & Special Equipment Available: General-purpose space is available; artists-in-residence must bring their own equipment and tools. All musicians are welcome, though there is no piano onsite.

Housing, Meals, Other Facilities & Services:
Housing: Two guesthouse spaces are available, and there are up to six small rooming places attached to a huge, shared studio. There are also three private rooms in the main house. Furnishings and linens provided. *Meals:* Some meals are provided; vegetarian meals available; two large kitchens available for residents' use. Director Judyth Hill is a poet, gourmet chef, baker, caterer, food guide and cookbook author, in addition to her lifelong calling as a nomadic performance poet/poetry teacher extraordinaire; depending upon her schedule, she will be orchestrating gourmet dinner feasts on a negotiable basis. *Other facilities/services:* Common room for residents' use with Internet connection (no computer); smoking permitted outdoors only. Spouses/partners allowed for visits only (please inquire; will work individually with each artist to meet specific needs). Children may be allowed for visits (please inquire; occasionally there are programs specifically for children).

Accessibility: Studio areas are accessible; living areas attached to studio and common area in main house are also accessible.

Application & Residency Information:

Application available online

Application and residency statistics not yet available; please contact organization for more information.

Selection process: Internal selection (staff, board, and/or advisory board).

Artists Responsible For: Application fee— $20; residency fee—$500–800/month (sliding scale); deposit—$250; food, travel, and materials.

Organization Provides: Housing, some meals, facilities, and program administration.

Additional Support: Currently developing our guidelines for sliding scale residency fees, and for caretaker/building repair and maintenance work-study exchanges. Please call for more information.

Other Expectations & Opportunities:
The artists are expected, of course, to be patient—to be, in fact, profoundly patient and supernaturally easy-going in this, our first year of birth. Furthermore, we trust that the artists who come to live and work here will treat the mountains and the land here with the tenderness and awed delight of a new lover—then and only then we will know that we can trust this kind of naturally sensitive person to be profoundly respectful of the ancient, cultural mix of this canyon: Hispanic, Native American, Anglo, horse and cow people, hard-working, down-to-earth, brilliant and incredibly generous folks, who regardless of schooling are the most schooled in this gorgeous yet often drought-challenged ecosystem. In sum, the artists must be excellent neighbors to our excellent neighbors here. Artists-in-residence are welcome to conduct readings, presentations, workshops, etc., studio tours, and to contribute artwork to Rockmirth, though all are entirely optional.

Roswell Artist-in-Residence Program

"The Roswell grant gave me the opportunity for a pure focus on my work, telescoping in a single year what might have taken three—and I suspect the questions asked here will sustain my work for years."—JULIA COUZENS

1404 West Berrendo Road
Roswell, NM 88202
Phone: (505) 622-6037
Fax: (505) 623-5603
E-mail: *rswelair@dfn.com*
Web: *www.rair.org*

Mission: The mission of the Roswell Artist-in-Residence Program is to provide studio-based visual artists of outstanding merit an extended "gift of time" without any obligations or demands.

Founded: Organization and Residency, 1967.

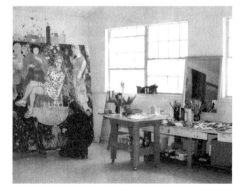

Location: Located on eleven acres just outside the town of Roswell, New Mexico. The residency is purpose-built, practical, and reasonably spacious. Studios average about six hundred square feet.

Past Residents: David Reed, Milton Resnick, Luis Jimenez, Robert Colescot, Alison Saar, James McGarrell, Robert ParkeHarrison, Al Souza, Anne Harris, Kumi Yamashita.

From the Director: "Disconnecting from the outside world and its implied expectations is part of the Roswell residency experience. In a certain way the community of Roswell itself helps serve this goal. The city of Roswell is about as far off the cultural map as you can get. The artists at our program find themselves 'decontextualized' and must reevaluate why they are artists and what their art is about. The whole year of the residency is a crucial element in this process. It can take that long for the individual to adjust to the different pace of life in Roswell. The long reach of time is as important to the residency as its remote location. The 'gift of time' is primarily what the Roswell Artist-in-Residence Program has to offer and its defining feature."

Eligibility: Adult professional visual artists, both from the United States and international, not concurrently enrolled as students. No production crafts or performance art.

Studios & Special Equipment Available: Printmaking, etching, litho, 23" electric kiln, arc welder, and modest wood shop.

Housing, Meals, Other Facilities & Services: *Housing:* Residents provided with two- or three-bedroom in 1970s-era furnished homes; overseas artists will be provided linens if needed. *Meals:* Residents are responsible for own meals. *Other facilities/services:* Laundry facilities onsite; personal transportation and

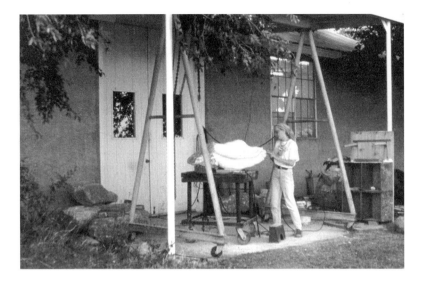

valid driver's license strongly recommended; smoking permitted outdoors, in private living areas and in studios; indoor cats permitted. Spouses/partners and children allowed for full stay (stipend increased $100 per month for each dependent living with artist).

Accessibility: Any needed modifications will be made if and when necessary.

Application & Residency Information:

Application available online

Application deadline(s): Varies

Resident season(s): Year-round

Average length of residencies: 12 months

Number of artists-in-residence in 2003: 10

Average number of artists-in-residence present at one time: 5

Selection process: Outside professional jury/ panel selection plus Program Director and Director of Roswell Museum and Art Center.

Artists Responsible for: Application fee— $25; food, travel, and materials.

Organization Provides: Housing, studios, and program administration; materials stipend (possible $1,200/year available); general stipend—$500/month.

Other Expectations & Opportunities:

The "gift of time" makes no demands of any kind on its residents except to respect the privacy of the other residents and follow the Golden Rule. Residents are required to be in residence—unarranged absence from the program facilities for more that two weeks results in diminished stipend. Travel for professional, cultural, and creative purposes is encouraged. Residents have the opportunity to participate in public exhibitions/presentations, studio tours, and the donation of artwork, but all are optional.

Sacatar Foundation

*"How do you thank someone for changing your life?
I'm sure I don't know how, but this gift you have given
me will be treasured forever."* — MELANIE BAKER

U.S. Office:
P.O. Box 2612
Pasadena, CA 91102-2612
Phone: (626) 440-9688
Fax: (626) 449-1557
E-mail: *info@sacatar.org*
Web: *www.sacatar.org*

Mission: To provide artists a place to live and create; to generate opportunities for artists to interact and collaborate with the local and regional community; to enhance the visibility and cultural impact of the host city and nation; to encourage art that returns us to where art began— to a wordless silence before all of creation.

Founded: Organization, 2000; Residency, 2001.

Location: A courtyard house surrounded by two and a half acres of gardens on a calm beach on the island of Itaparica, across the bay from Salvador, Bahia—the first capital of Brazil.

Past Residents: Diana Blok, Patricia Chao, Carlos Estevez, Jane Ingram Allen, Sook Jin Jo, Eduardo Kac, Joe Sam, Tim Whiten.

From the Director: "For five hundred years, the spontaneity and inclusiveness of the culture of Bahia has been characterized by the strong fusion of native, Portuguese, and African influences. At the Sacatar Foundation, we try to make this richness available to all fellows by creating appropriate liaisons to the local culture."

Eligibility: Creative individuals in all disciplines.

Studios & Special Equipment Available: General-use workspace, including two large rooms in the main house, the smaller of which has a sink, and a very simple wood-working facility with basic tools. In general, there are no special facilities, but each fellow is provided with a place to work and special needs can be arranged by locating additional facilities (dance schools, theaters, galleries, etc.) in Salvador or on the island of Itaparica. This is a low-tech environment, and artists are urged to work directly and simply with available materials and methods.

Housing, Meals, Other Facilities & Services: *Housing:* Private room and bath in a shared facility; furnishings and linens provided. *Meals:* Almost all meals are provided; vegetarian meals available. No prepared meals provided Saturday evening or all day Sunday, when residents may use the kitchen and/or raid the refrigerator. *Other facilities/services:* Common room or meeting space for residents' use; laundry facilities onsite; Internet connection (no computer) is available every evening and

on the weekends; initial transportation from the airport to the island provided. Smoking permitted outdoors only. Spouses/partners and children allowed for visits only (visits may be arranged on the weekends or by special request).

Accessibility: We schedule artists with wheelchairs during the dry season (September–February). While the Foundation is reasonably accessible, neither Itaparica nor Salvador is particularly easy to manage in a wheelchair, and this is compounded by the rainy season (May–August).

Application & Residency Information:

Application available online

Application deadline(s): April 10 (postmarked); confirm at Web site

Resident season(s): May–February

Average length of residencies: 8 weeks

Number of artists-in-residence in 2003: 20

Average number of artists-in-residence present at one time: 5

Selection process: Outside professional jury/panel selection.

Artists Responsible for: Application fee—$35; materials, and visa fees.

Organization Provides: Housing, meals, workspace, and program administration; travel (round-trip airfare from closest regional airport to Salvador, Brazil).

Additional Support: UNESCO/Aschberg bursaries to the Sacatar Foundation provide artists in specific disciplines and from specific regions of the world $200 USD per month for materials and/or personal expenses, in addition to the above. Please see *www.unesco.org/culture/ifpc* for more information.

Other Expectations & Opportunities: We have arranged for exhibitions and presentations, as requested by residents, both on the island and in Salvador, at galleries, theaters, schools, universities, libraries, museums, and even at abandoned military forts. Studio tours are optional, and very rarely does the general public have access to the residential estate. Sacatar asks artists to bring a book of their own work or of general interest for the Foundation's library. Artists are requested but not required to donate a work at the conclusion of their stay.

Santa Fe Art Institute

"When I stepped into my studio I was stunned—it was a magnificent working space. My soul expanded to fill the space and I experienced one of the most intense and productive creative periods I've ever had." — LORNA BIEBER

P.O. Box 24044
Santa Fe, NM 87502
Phone: (505) 424-5050
Fax: (505) 424-5050
E-mail: *info@sfai.org*
Web: *www.sfai.org*

Mission: Exploring the intersections of contemporary art and society through residencies, lectures, workshops, publications, exhibitions, and educational and outreach programming.

Founded: Organization, 1985; Residency, 1999.

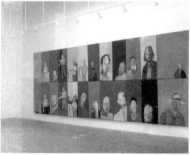

Location: Santa Fe, New Mexico, is a welcoming, culturally minded community fifty miles north of Albuquerque with vast resources for residents, including art galleries, museums, libraries, and other artistic and literary organizations. SFAI's location on the College of Santa Fe campus permits easy access to the college's library facilities, among them the art and slide library in the Visual Arts Center. In Santa Fe proper, there are professional photographic services, kilns, specialists, and art suppliers for all mediums, bookstores, and literary activities and resources. Pueblos, historical sites, and a wealth of cultural and recreational experiences are located within, or a short distance from, Santa Fe.

Past Residents: Monica Bravo, Harmony Hammond, Basia Irland, Sonya Sklaroff, Margaret Evangeline, Elinor Milchan, Joseph Girandola, Joan Perlman, Abby Donovan, Tatiana Maria Lund.

From the Director: "The Institute offers the time and space needed for concentrated creativity—a real opportunity to conceive, construct, and communicate ideas often thought about but rarely attempted. The window of possibility is always open at the Santa Fe Art Institute." — DIANE KARP

Eligibility: Creative artists in all fields.

Studios & Special Equipment Available: Use of the College of Santa Fe's ceramics, performance, moving-image arts, music/piano, metalworking, photography, sculpture, and woodworking facilities can be arranged prior to arrival for residency. SFAI also has Mac G3s available for digital media, workspace for painting (SFAI has a nontoxic work environment policy; there is an outdoor courtyard for toxic paints and resins), writing studios, and exhibition/installation space.

Housing, Meals, Other Facilities & Services:
Housing: Individual apartment for each resident; furnishings and linens provided. *Meals:* Residents are responsible for own meals; cooking/kitchen facilities provided. *Other facilities/services:* Common room and meeting space for residents' use; laundry facilities onsite; computer with Internet connection in common area and T1 Internet connection available in each apartment; vehicle available for residents' use and public transportation available. Smoking permitted outdoors only. Spouses/partners allowed for visits only; children allowed in special circumstances.

Accessibility: Facilities are fully accessible; facilities are specially equipped for the visually impaired.

Application & Residency Information:
Application available online
Application deadline(s): January 5 and July 5
Resident season(s): Year-round
Average length of residencies: 1–3 months
Number of artists-in-residence in 2003: 20

Average number of artists-in-residence present at one time: 3–6

Selection process: Residency Selection Committee changes yearly.

Artists Responsible for: Application fee—$25; residency fee—$1,000/month; refundable key deposit—$150; food, travel, and materials.

Organization Provides: Housing, studios/facilities, and program administration.

Additional Support: Sliding scale residency fee waivers available; 90 percent of accepted artists receive some form of financial support.

Other Expectations & Opportunities:
Artists- and Writers-in-Residence have the opportunity to engage in the Santa Fe Art Institute's Educational Outreach program. This includes public presentations of their work, workshops, and individual critiques with students in and around the Santa Fe community. The residents also have access to the many public events and workshop programs offered at SFAI. Studio tours are optional.

Sculpture Space

"I arrived at Sculpture Space and was overjoyed to find a huge facility equipped with all the necessary machinery, a friendly staff, and only a few other artists to share it with; my kind of heaven." — KELLIE MURPHY

12 Gates Street
Utica, NY 13502
Phone: (315) 724-8382
Fax: (315) 797-6639
E-mail: *info@sculpturespace.org*
Web: *www.sculpturespace.org*

Mission: Sculpture Space is an international residency program that provides emerging, mid-career and established artists with the physical space, technical assistance, specialized equipment and financial support to create new work. Interaction between the artists, their work, and the public is promoted through exhibition, lecture, and educational opportunities.

Founded: Organization and Residency, 1975.

Location: Sculpture Space thrives in upstate New York, in the Mohawk Valley, adjacent to a highway where the Erie Canal once flowed. Located in the city of Utica (pop. 60,000), a booming mill town in the nineteenth century, which is now a small post-industrial city that boasts many resources for sculptors. Situated on a 3/4-acre site in an area of light industry in the former Utica Steam Engine and Boilerworks plant. Colleges and universities within an hour include Colgate and Syracuse Universities, Hamilton and Utica Colleges.

Past Residents: Garth Amundson, Roberly Bell, Emilie Brzezinski, Maica Evers, Christy Rupp, Takashi Soga, William Tucker, Marion Wilson, Issac Witkin, Lynne Yamamoto.

From the Director: "The intimate scale of our program—never more than four artists at a time—helps guarantee that our residents have adequate space for experimentation during their two-month work stays; and a handful of colleagues with whom to network. Our specialized open studio offers the support of a studio manager and equipment to which artists might not otherwise have access."
—SYDNEY WALLER

Eligibility: Professional artists eighteen years of age or older: emerging, mid-career, or established. Focus may be sculpture, installation, metalwork, woodwork; conceptual, environmental, performance, or multidisciplinary arts. One repeat residency is permitted, but the second residency is not funded. Working knowledge of English is required.

Studios & Special Equipment Available: Exhibition/installation space (one four-hundred-square-foot installation room); 5,500-square-foot, well-equipped shared open space (metalworking, sculpture, woodworking). A list of equipment is available on the Web site.

Housing, Meals, Other Facilities & Services:
Housing: Private room in a shared facility—shared bathroom; furnishings provided; artists recommended to bring their own linens if possible. Housing is a ten-minute walk from the studio. *Meals:* Residents are responsible for own meals; both the apartment and the studio have fully equipped kitchens. *Other facilities/ services:* G3 computer available for residents' use; Internet connection in common area; DSL available in the enclosed artists' office. Limited public transport available; Sculpture Space provides bicycles. There is no smoking in the studio or apartment. Spouses/partners allowed for visits only.

Accessibility: Studio and public areas are accessible. Housing and artists' office are not accessible.

Application & Residency Information:

Application deadline(s): November 1

Resident season(s): Year-round

Average length of residencies: 2 months

Number of artists-in-residence in 2003: 20

Average number of artists-in-residence present at one time: 3–4

Selection process: Professional artists who are board members, plus one guest panelist who is an established arts professional on panel selection.

Artists Responsible for: Food, travel, and materials.

Organization Provides: Housing, studio, and program administration; travel assistance for New York State artists only—$100; general stipend—$2,000, to be applied toward materials and living expenses.

Additional Support: From time to time a special demographic or culture-specific grant may be available.

Other Expectations & Opportunities:
Informal talks onsite during works-in-progress receptions; lecture opportunities offsite at neighboring colleges. Monday night open studio in the summer. Studio tours are optional—college and high school art students may visit. Artists-in-residence are required to provide five to ten images of the new work they create at Sculpture Space, for the Sculpture Space archives and to share with funders. Artists are invited to contribute works of art to Sculpture Space's October annual auction, CHAIRity; however, this is entirely optional.

Scuola Internazionale di Grafica

"I found Venice to be a delightful and inspiring place to be an artist, full of visual wonder to stir my senses. Having this great printshop as a focal location in my Venetian day helped to center my artistic intentions." — MARISHA SIMONS

San Marcuola, Cannaregio
Calle Seconda del Cristo, 1798
30121 Venice
Italy
Phone: +39 041 721 950
Fax: +39 041 524 2374
E-mail: *info@scuolagrafica.it*
Web: *www.scuolagrafica.it*
and *www.artsinvenice.it*

Mission: The Scuola Internazionale di Grafica offers the possibility for every person to come and deepen their skills and creativity.

Founded: Organization, 1969; Residency, 2000.

Location: Located in the city of Venice, Italy, in the historical area of Cannaregio, near the Grand Canal.

Past Residents: Sandi Rigby, Mary Baranowski Lowden, Gabriela Galindo, Delia Jurek, Rosalie Frankel, Tessa Holmes, Marisha Simons.

From the Director: "The Scuola Internazionale di Grafica offers the opportunity to work in the unique city of Venice and with many artists of all nationalities and ages in a stimulating environment. Residents immediately translate this exposure into new and exciting work." — LORENZO DE CASTRO

Eligibility: Printmakers, painters (June 1– Sept. 30 only), mixed media, and graphic designers. Repeat residencies permitted.

Studios & Special Equipment Available: Facilities for digital media (iMacs, scanners, printers, CD burners); painting; print workshop with presses for etching, lithography, off-set lithography and letterpress; darkroom for non-silver photography and water-based screen printing; library. Residents are provided with workspace within the shared studios.

Housing, Meals, Other Facilities & Services: *Housing:* Residents share furnished apartments, with private bedroom; linens provided. *Meals:* Residents are responsible for own meals; kitchen in apartment. *Other facilities/services:* Laundry facilities onsite; computers with Internet connection in the library at the Scuola. Transportation within Venice is only by waterbus or by foot; transportation from the airport is by autobus or waterbus. Smoking permitted outdoors only.

Accessibility: Studios and public areas are accessible; living quarters are not wheelchair accessible. The city of Venice can be a challenge for people with physical disabilities.

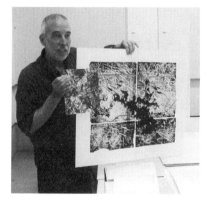

Application & Residency Information:

Application available online

Application deadline(s): Ongoing

Resident season(s): Painting: June 1–
September 30; printmaking, drawing, mixed
media, graphic design: year-round

Average length of residencies: 4 weeks

Number of artists-in-residence in 2003: 10
(20 applicants)

Average number of artists-in-residence present
at one time: Maximum 3 printmaking,
4 painting

Selection process: Internal selection (staff,
board, and/or advisory board).

Artists Responsible for: Residency fee—
€3,100 for four weeks; deposit—€700 (part
of the total residency fee); food, travel, and
materials (basic materials provided by the
Scuola).

Organization Provides: Housing, work-
space facilities, basic materials, and program
administration.

Additional Support: Partial fellowships
available based on merit and need, and may
cover up to half of the residency fee from
November to March, and up to a quarter of
the residency fee from April through October.
Applicants for a partial fellowship must submit
an income tax return or other appropriate
documents when applying.

Other Expectations & Opportunities:
It is beneficial to the students for the resident
to show their work at the end of their
residency. The Scuola hosts an exhibition of
every student, resident, and visiting artist
once a year. All residents are asked to partici-
pate with one piece of work. A catalog is
published each year and mailed to the
resident. Donation of artwork is optional.

Sea Change Residencies / Gaea Foundation

"Where else can you work on a chapter in the morning, bike through the dunes in the afternoon, and go to a drag show at night? Sea Change whisked me out of the trenches for a breath of fresh air and I've come back to activism reinvigorated and renewed."
— JULIA SUDBURY

Gaea Foundation
1611 Connecticut Avenue, NW
Washington, DC 20009
Phone: (202) 232-0304
Fax: (202) 232-1651
E-mail: *info@gaeafoundation.org*
Web: *www.gaeafoundation.org*

Mission: Sea Change Residencies provide time, space, and funding to outstanding artists and activists making critical headway in bringing forward alternative paths to social change.

Founded: Organization, 1992; Residency, 2001.

Location: Nestled in the far west end of Provincetown, Massachusetts, on the farthest tip of the Cape Cod peninsula, Sea Change's antique cottage sits across from Cape Cod Bay, within walking distance to Provincetown's many shops, performance venues, and restaurants, and a short bike ride to the National Seashore.

Past Residents: Will Power, Alice Tuan, Tchaiko Omawale, Michelle Parkerson, Alison Cornyn, Dread Scott, Paula Gunn Allen, Danny Hoch, Helen Zia, Margo Okazawa-Rey.

From the Director: "Sea Change's values are simple: support artists and activists whose stunning work is recreating the definitions of 'margins' and 'center,' whose commitment stems from a determination to shift structures of power that are as common as air, and lethal to the core."

Eligibility: Sea Change Residencies support artists whose work is creating fundamental shifts in public perceptions of reality and possibility, and activists who employ creative and artistic tools in the struggle for change.

Studios & Special Equipment Available: The need for studio space and other support can be accommodated.

Housing, Meals, Other Facilities & Services: *Housing:* Individual cottage for each resident. *Meals:* Residents responsible for own meals; kitchen in resident's cottage. *Other facilities/ services:* Laundry facilities onsite; computer with Internet connection in living area; smoking permitted outdoors only. Spouses/ partners and children may be allowed for full stay, on a case-by-case basis.

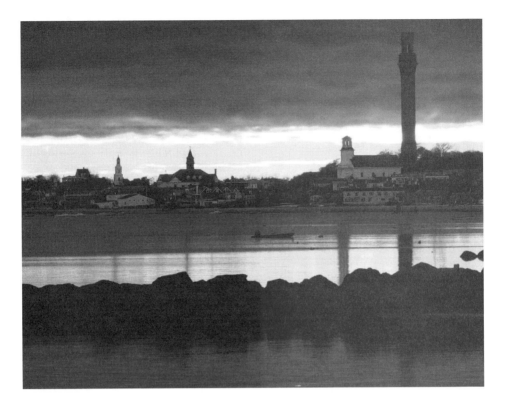

Accessibility: We make every effort to accommodate wheelchair users. Deaf and blind residents can be accommodated.

Application & Residency Information:

Application by nomination only

Selection process: A nominations committee provides nominees, then staff and board select from nominee pool.

Artists Responsible for: Food.

Organization Provides: Housing, workspace, and program administration; round-trip air or rail travel, or mileage reimbursement; and general stipend—$600/week.

Other Expectations & Opportunities: Sea Change Residents are connected to the local community of artists through Provincetown's Fine Arts Work Center, which has played a central role in developing artists and the Provincetown arts community since 1968.

Sitka Center for Art and Ecology

"The walls are warm with the good work that has happened in this place." — VLADIMIR TSIVIN

P.O. Box 65
Otis, OR 97368
Phone: (541) 994-5485
Fax: (541) 994-8024
E-mail: *info@sitkacenter.org*
Web: *www.sitkacenter.org*

Mission: The Sitka Center for Art and Ecology is dedicated to expanding the relationships between art, nature, and humanity through workshops, presentations, and individual research projects; and to maintaining a facility appropriate to its needs that are in harmony with the inspirational coastal environment of Cascade Head.

Founded: Organization, 1971; Residency, 1983.

Location: Sitka Center is located in the Cascade Head National Scenic Research Area in Oregon, overlooking the Salmon River estuary and Pacific Ocean, one hundred miles down the coast from Astoria.

Past Residents: Vladimir Tsivin, Jindra Vikova, Pavel Banka, Krzysztof Czyewski, Ferida Durakovic, Don Reitz, Larry Thomas, Kim Stafford, Alison Hawthorne Deming, Roy DeForest.

From the Director: "Sitka Center is about this place in nature and about the residents finding a way to make this place their own. There is an openness to new ideas that the setting and the studios engender, that we simply facilitate. Primarily the time spent is to experience nature, focus on your work, then share that work with others doing their work and ultimately with the public. Something significant happens when a resident experiences our trust in their abilities and a setting that stimulates their perceptions." — RANDALL KOCH

Eligibility: Emerging and mid-career visual artists, writers, designers, scholars, naturalists, and others are eligible to apply.

Studios & Special Equipment Available: Facilities for ceramics/pottery (two skutt kilns, one wheel, one raku kiln), dance/choreography, fiber arts (spinning equipment), film/digital editing (artists bring own equipment), painting, printmaking (two presses—36" x 72" and 24" x 48"), sculpture, woodworking, and writing.

Housing, Meals, Other Facilities & Services: *Housing:* One individual apartment, two individual cabins; furnishings and linens provided. *Meals:* Residents responsible for own meals; kitchen facilities provided. *Other facilities/services:* Laundry facilities onsite; computer with cable Internet, as well as Internet connection for laptops in the library; one common vehicle available for residents. No smoking on campus. Spouses/partners allowed for full stay (only one

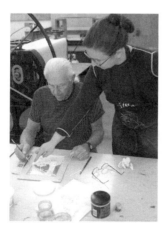

residence can accommodate two adults for longer than visit); children allowed for visits only (exceptions case-by-case; only one residence would accommodate).

Accessibility: Studios, public areas, and office are accessible. One residence can be made wheelchair-accessible.

Application & Residency Information:

Application available online

Application deadline(s): April 21

Resident season(s): October–May

Average length of residencies: 3–4 months

Number of artists-in-residence in 2003: 18

Average number of artists-in-residence present at one time: 3

Selection process: Combination of outside committee and staff, with additional expertise required based on applicant's range of mediums.

Artists Responsible for: Deposit—$50–$100 for cleaning/repairs may be assessed depending on the nature of the resident's medium or project; each resident's situation will be discussed before assessing fee. Food, travel, and materials.

Organization Provides: Housing, studios, and program administration.

Additional Support: Programs for Recorder players/composers have support.

Other Expectations & Opportunities:
Artists-in-residence are expected to participate in public onsite exhibitions/presentations and studio tours (weekend availability for visits in general, exceptions made). In addition, a percentage of sales of work made at Sitka donated to Sitka Center may be requested depending on financial position of artist. The artists-in-residence are requested to give back to the program in two ways: 1) by participating in educational outreach activities in the local community for a total of up to sixteen hours over a four-month period (this may include slide lectures or workshops); 2) writers are asked to contribute a book of their authorship to the library at Sitka Center.

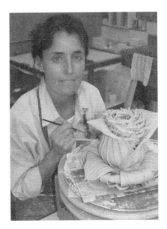

Lillian E. Smith Center for Creative Arts

"It's a gorgeous setting and the history of the place is very inspirational. In one week I do more writing and thinking and dreaming than I'd ever thought possible."
— ELIZABETH STUCKEY-FRENCH

June 1–August 15:
P.O. Box 467
Clayton, GA 30525
Phone: (706) 782-7846

August 15–June 1:
710 Waverly Road
Tallahassee, FL 32312
Phone: (850) 385-5763
E-mail*: nfichter@mailer.fsu.edu*
Web: *www.lilliansmith.org*

Mission: The mission is to offer a place where gifted creative artists and scholars in various disciplines may find the conditions of quiet solitude and privacy in which to pursue their work. The Lillian E. Smith Foundation, Inc., was established to honor the memory of Lillian E. Smith, one of this country's eminent writers. The first project of the Foundation has been to create an artists' retreat, located in the mountain community of Clayton, Georgia. Lillian E. Smith, acknowledged as a significant writer and humanitarian, held at the center of her being her function as a creative artist. She also deeply valued the power of the arts to transform the lives of all human beings. For most of her life she pursued her own creative destiny at her home in the mountains of North Georgia. In that same place she also for many years directed the Laurel Falls Camp for Girls, which served as a place where the life of the mind and the spirit of creative activity were honored and nurtured. It was her expressed wish that such opportunity and activity would have future life. It was with her vision in mind that the concept of an artists' retreat on her home-site was developed.

Founded: Organization and Residency, 2000.

Location: Two miles east of Clayton, Georgia, on 120 acres of woodland forest, in the northeast corner of the state. The property is on Screamer Mountain in the heart of the Blue Ridge Mountains, near the Chattooga River. All buildings are on the estate of the late Lillian E. Smith, the site of her home and library, and the Laurel Falls Camp for Girls that she directed.

Past Residents: Elizabeth Stuckey-French, Ned Stuckey-French, John Gregory Brown, Ellen Elmes, Darryl Curran, Nick Potter, Allison Jester, Alan Finch, Gabriele Stauf, Rita Mae Reese.

From the Director: "The LES Center honors the belief that an atmosphere of protected solitude and quiet is a rare and valuable gift to the creative spirit and that all art disciplines and scholarly pursuits welcome such an environment. Space and time in a beautiful natural setting are offered and the director's home is often open for refreshments, conversation, and the occasional meal in the evenings."

Eligibility: Artists and scholars in all disciplines are eligible to apply.

Studios & Special Equipment Available: Proposals for environmental installations and outdoor sculpture in keeping with the natural environment will be considered; a site-specific sculpture project is also being planned; 20' x 24' painting studio.

Housing, Meals, Other Facilities & Services: *Housing:* Individual cabin/house for each resident; furnishings and linens provided. *Meals:* The Director often invites participants in for refreshments and the occasional meal in the evening; otherwise, meals are the responsibility of residents and kitchen facilities are provided. *Other facilities/services:* Common room or meeting space for residents' use;

laundry facilities onsite. Smoking permitted outdoors only. Residents may negotiate with organization to be accompanied by spouses/partners or pets; children allowed for visits only.

Accessibility: There is limited accessibility to living quarters.

Application & Residency Information:

Application available online

Application deadline(s): May 1

Resident season(s): June–August

Average length of residencies: 1–3 weeks

Number of artists-in-residence in 2003: 7

Average number of artists-in-residence present at one time: 1–3

Selection process: Internal selection (staff, board, and/or advisory board).

Artists Responsible for: Residency fee—$100/week; food, travel, materials, and long-distance telephone costs.

Organization Provides: Housing, studios, and program administration.

Other Expectations & Opportunities: Artists-in-residence are given the option of participating in public exhibitions/presentations and studio tours. Some artists and writers have donated artwork and books of their authorship to the Center's library.

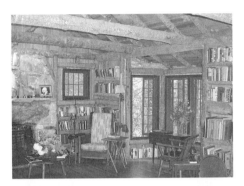

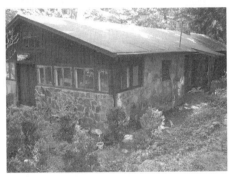

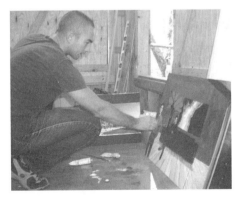

Snug Harbor Cultural Center, Newhouse Center for Contemporary Art

"Snug Harbor is a wonderful place. It's quiet enough to concentrate on your work; on the other hand, if you need stimulation, you can go to Manhattan. The staff is small and helpful, and I felt like I received a lot of personalized attention." — KYOKO SERA

1000 Richmond Terrace
Staten Island, NY 10301
Phone: (718) 448-2500, ext. 260
Fax: (718) 442-8534
E-mail: *newhouse@snug-harbor.org*
Web: *www.snug-harbor.org*

Mission: In the context of a regional art center, Snug Harbor Cultural Center's residency program seeks to foster the exchange of ideas and to further the public's interest in artists' work by facilitating interaction between international, national, and regional artists and arts professionals. Efforts are made to link the residencies with the Newhouse Center for Contemporary Art's ongoing exhibitions and multidisciplinary programs and to utilize New York City's critical forum for the promotion of new work. Snug Harbor Cultural Center encourages resident artists or arts professionals to participate in exhibitions as well as in educational programs and performance projects that are developed according to their particular areas of concentration.

Founded: Organization, 1976; Residency, 1988.

Location: The Newhouse Center for Contemporary Art is set in the historically significant Snug Harbor Cultural Center—eighty-three acres of parkland, twenty-eight buildings preserved for the visual and performing arts—located on Staten Island, New York. Snug Harbor Cultural Center, once a retirement home for sailors, is located five minutes from the Staten Island Ferry Terminal, which offers a free, twenty-two-minute ferry ride to Manhattan.

Past Residents: Kyoko Sera, Ellen Driscoll, Toshihiro Sakuma, Marja Kanervo, Jussi Heikkilä, Perry Bard, Kaisu Koivisto, Miyuki Yokomizo, Tserang Dhundrup, Long-Bin Chen.

From the Director: "A residency at Snug Harbor Cultural Center balances exposure to New York City's contemporary art scene with a retreat from its intensity. The eighty-three-acre parkland provides an environment well-suited for artists to develop their work and the opportunity for a solo exhibition. More importantly, it affords time and space to exchange and explore ideas with other onsite artists." — JENNIFER POOLE

Eligibility: National and international artists, with the exception of artists living in New York, New Jersey, and Connecticut (see Indices for more specific types of artists served). Repeat residences permitted.

Studios & Special Equipment Available: Facilities for dance/choreography, exhibition/installation, film/digital editing, painting, photography, performance theater, sculpture, and writing.

Housing, Meals, Other Facilities & Services: *Housing:* Two private cottages, each with bath and fully equipped kitchen; also shared

housing (with private room and bath) in the Governor's House. Furnishings and linens provided; housecleaning provided once a week. *Meals:* Residents responsible for own meals; kitchen facilities provided. *Other facilities/ services:* Common room or meeting space for residents' use; laundry facilities onsite; computer with Internet connection in Snug Harbor's administrative offices and Internet connection only in residents' area; public transportation available. Smoking permitted outdoors only. Spouses/partners allowed for full stay; children allowed for visits only.

Accessibility: Facilities are fully accessible.

Application & Residency Information:

Application available online

Application deadline(s): Ongoing

Resident season(s): Year-round

Average length of residencies: 6 months–1 year

Number of artists-in-residence in 2003: 5

Average number of artists-in-residence present at one time: 2–3

Selection process: Internal selection (staff, board, and/or advisory board).

Artists Responsible for: Application fee— $15. For other expenses, all artist residencies require outside funding. Once an artist is

approved, Snug Harbor Cultural Center will work with the artist to seek funds and will provide the necessary letters of invitation as well as prepare an individualized budget.

Organization Provides: Studio space, program administration, housing stipend, and general stipend ($200 to cover shipping of artwork). In addition, the organization works with accepted artists to seek funds for other residency expenses.

Other Expectations & Opportunities: Snug Harbor Cultural Center offers interpretive programs that have been created to develop a relationship between the artist and the Staten Island and regional community. *Conversations about Art*, an informal dinner gathering, creates a forum for exchange between featured artists and local artists, those in other regional residency programs, arts managers, and members of the cultural community. *Food for Thought* includes a gallery talk, slide presentation, and a welcoming reception and introduces the artists-in-residence to members of the Staten Island community and the New York City contemporary art world. Participation in such public presentations is expected of artists-in-residence, while conducting studio tours and donating artwork are optional.

Stonehouse Residency for the Contemporary Arts

"I spent one month at Stonehouse Residency, surrounded by the natural beauty of the Sierra, plied with delicious meals and companionship. I was given the time, privacy, and studio accommodations I needed to restore myself, and to develop my work. The time since my Stonehouse residency has been extremely productive. It was better than any heaven I could imagine." — KAREN BROWN

47694 Dunlap Road
Miramonte, CA 93641
Phone: (509) 336-9985
E-mail: *stonehouse@spiralcomm.net*
Web: *www.stonehouseresidency.org*

Mission: The mission of the Stonehouse Residency for the Contemporary Arts is to advantage visual and writing arts faculty with uninterrupted creative time.

Founded: Organization and Residency, 2001.

Location: Stonehouse Residency is located one mile east of Miramonte, California, on 173 acres of open land next to Kings Canyon and Sequoia National Parks. At an elevation of 3,600 feet, the ranch includes Burn's Flat, an oak flat with Mill Creek meandering through it. The residence is situated on a knoll with magnificent views of the high Sierra Mountains to the east and the San Joaquin Valley and foothills to the west.

Past Residents: Rachel Simmons, Heather Wilcoxon, Frederick Horstman, Ian Davis, Karen Brown, Gretchen Mintzer, Gina Greene, Marilyn Collins, Adam Longatti, Molly Cranch.

From the Director: "The Stonehouse Residency experience is structured to provide artists-in-residence the opportunity to fully engage in a supportive, creative community. The high-mountain ranch setting and the close proximity to outstanding national parks afford the context for the quiet reflection that nurtures and renews the soul of each artist."

Eligibility: All visual artists and writers. Visual and writing arts faculty are given preference for two out of three residencies.

Studios & Special Equipment Available: Painting, sculpture, and writing studios.

Housing, Meals, Other Facilities & Services: *Housing:* Private room in a shared facility; furnishings and linens provided. *Meals:* All meals are provided; vegetarian meals available; cooking/kitchen facilities available to residents. *Other facilities/services:* Common room or meeting space for residents' use; laundry facilities onsite; Internet connection only (no

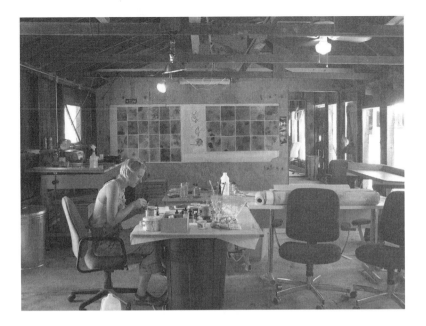

computer) in common area; local transportation provided by organization. Smoking permitted outdoors only. Visits/stays by spouses/partners and children negotiable.

Accessibility: Facilities are not accessible.

Application & Residency Information:

Application available online

Application deadline(s): February 1

Resident season(s): Summer

Average length of residencies: 4 weeks

Number of artists-in-residence in 2003: 6

Average number of artists-in-residence present at one time: 3

Selection process: Internal selection (staff, board, and/or advisory board).

Artists Responsible for: Deposit—$150 (applied to contribution); $300 contribution toward food and consumables.

Organization Provides: Housing, meals, studios, and program administration.

Other Expectations & Opportunities: Artists-in-residence are expected to participate in offsite public exhibitions/presentations, and in open house studio tours. In addition, residents are free to share cooking and maintenance chores. A cooperative work, generally on paper, combining the talents of all artists-in-residence is requested.

A Studio in the Woods

"I was able to draw upon the Studio's rich natural environment: the woods, the pond, peace and quiet, curious animals, and the Mississippi River to listen to music, concentrate, practice, meditate; and out of that experience came a newfound musical awareness and my most productive creative period to date."

— DR. MICHAEL WHITE

13401 River Road
New Orleans, LA 70131
Phone: (504) 392-5359
Fax: (504) 394-5977
E-mail: *info@astudiointhewoods.org*
Web: *www.astudiointhewoods.org*

Mission: A Studio in the Woods is dedicated to preserving eight acres of pristine bottomland hardwood forest on the Mississippi River and providing within it a peaceful retreat where visual, literary, and performing artists can work uninterrupted and reconnect with universal creative energy.

Founded: Organization, 2002; Residency, 2001.

Location: On the west bank of the Mississippi River in the last remaining wetland forest within the city limits of New Orleans and its rich multicultural offerings. All buildings made using recycled materials and with environmental sensitivity. The site is eight miles from the nearest grocery store, pharmacy, etc., so residents are encouraged to have their own transportation.

Past Residents: Hannibal Lokumbe, Yuki Fukushima, Daniel Winkert, Jane Marshall, Wendy Taylor Carlisle, Dr. Michael White, Deedra Ludwig, Krista Franklin, Alexis Wreden, New Orleans Public High School students.

From the Director: "A Studio in the Woods honors both the artist and the natural environment. We also treasure the time, tranquility, and resources the artist requires to reconnect with Nature's processes as a grounding, regenerating, and revisioning experience. Here there is no hierarchy of beings or art forms. The brilliant spider web illumined with dew is treated with the same respect as the potter's vessel or the composer's melody. Each arises from the rhythms of the day, the sounds of the night, the images, smells, and gestures of the woods and waters, and the natural elements of the earth. Each is equally precious."

—LUCIANNE AND JOE CARMICHAEL, FOUNDERS

Eligibility: Visual, literary, and performing artists, especially those whose work is in harmony with our mission and reveals the oneness and interdependence of all life.

Studios & Special Equipment Available: Potter's wheel and electric kilns; piano studio; painting and writing studios; dancers/choreographers and performers use outdoor meadows spaces and the river levee (limited audience

options onsite); sculptors use outdoor space in harmony with ASITW's mission to protect the small bottomland hardwood forest.

Housing, Meals, Other Facilities & Services:
Housing: Private room and bathroom located on the ground floor of the founders' rustic home, with private outside access; furnishings and linens are provided. *Meals:* Lunch and dinner are provided; vegetarian meals are available; cooking/kitchen facilities are available to residents to prepare breakfast and some lunches. *Other facilities/services:* Laundry facilities onsite; computer with Internet connection in office area and available only after-hours; smoking permitted outdoors only. Spouses/partners and children allowed for visits only.

Accessibility: Only public areas are accessible.

Application & Residency Information:
Application available online
Application deadline(s): Varies
Resident season(s): September–May
Average length of residencies: 3–4 weeks
Number of artists-in-residence in 2003: 4

Average number of artists-in-residence present at one time: 1

Selection process: Jury may include individuals from staff, board, and/or advisory board.

Artists Responsible for: Application fee— $20; residency fee—$20/day to cover food costs; deposit—$100; travel and materials.

Organization Provides: Housing, meal preparation, studios, and program administration. In addition, artists may collaborate with the staff by proposing and assisting in the preparation of grant applications to outside sources toward funding their residencies and stipends.

Other Expectations & Opportunities:
One public presentation is required during the residency (could be onsite or offsite); participation in studio tours is optional. Artists are requested to leave evidence of their experience at ASITW for future residents by leaving an artistic product for the archive. Artists are also expected to write a brief statement on how the residency influenced them personally and artistically.

STUDIO for Creative Inquiry

"Access to Carnegie Mellon's research environment has drastically changed the course of my artwork. Through the STUDIO for Creative Inquiry and Carnegie Mellon University, I have started numerous projects that were previously unthinkable and out of range as an individual artist working in New York. Affiliation with the STUDIO has provided me with a credible platform from which to launch my most imaginative and ambitious projects, drawing from the knowledge of people from a wide range of disciplines...The STUDIO also provided me with a new model of collaborative art-making which is little-practiced in the traditional art world: the artist as entrepreneur, artists as collective members, the artist as community diplomat."
— HEIDI KUMAO

College of Fine Arts Building, Room 111
Carnegie Mellon
5000 Forbes Avenue
Pittsburgh, PA 15213-3890
Phone: (412) 268-3454
Fax: (412) 268-2829
E-mail: *studio-info@andrew.cmu.edu*
Web: *www.cmu.edu/studio*

Mission: The STUDIO for Creative Inquiry was founded in 1989 to support experimental and cross-disciplinary work in the arts through yearlong residencies. The STUDIO has designed a model for an artist community within a research environment that builds upon the techno-logical excellence of Carnegie Mellon and provides access to new knowledge and highly skilled collaborators. The STUDIO proposes that artists working collaboratively with other professionals can lead complex processes in both imaginative and useful directions and have a profound impact on the most pressing issues and concerns of our times.

Founded: Organization, 1989; Residency, 1990.

Location: On the campus of a prominent research university, in an urban neighborhood of Pittsburgh, Pennsylvania.

Past Residents: Rob Fisher, SK Woodall, Agnes Denes, Seth Riskin, Patricia Villalobos, Tim Collins, Stephanie Flom, Portia Cobb.

From the Director: "The STUDIO for Creative Inquiry serves as a home to artists whose practices encompass a developing interdisciplinary approach—artists who imagine the future, who question the direction of humanity, who are able to synthesize the constantly changing technology, viewpoints and culture into their artistic vision. Artists who are STUDIO fellows frequently are risk-takers, challenging commonly held beliefs. With the support of the STUDIO, these artists are able to pursue their vision, communicate with targeted audiences, and impact the global community...Beyond fulfilling its mission, the STUDIO has clearly established itself as a vibrant model organization for incubating and nourishing the artist-entrepreneur."
— MARGARET MYERS, ASSOCIATE DIRECTOR

Eligibility: Open to all those conducting creative work.

Studios & Special Equipment Available:
Facilities include digital media, film/digital editing, photography, sculpture, and writing workspaces; music recording studio; exhibition/installation space and performance theater.

Housing, Meals, Other Facilities & Services:
Housing and meals not provided (affordable rentals available nearby). Common room or meeting space for residents' use; computer with Internet connection in studio area; public transportation available. Spouses/partners and children allowed for full stay.

Accessibility: Public areas and some workspaces are accessible.

Application & Residency Information:
Application available online

Application deadline(s): Ongoing

Resident season(s): Year-round

Average length of residencies: 1 year

Number of artists-in-residence in 2003: 6

Average number of artists-in-residence present at one time: 6

Selection process: Combination of staff and outside panel.

Artists Responsible for: Housing, food, travel, and materials.

Organization Provides: Artists are paid a salary and usually given a project fund; travel assistance and materials stipend, workspace, facilities, and program administration also provided.

Other Expectations & Opportunities:
Artists-in-residence are expected to participate in onsite public exhibitions/presentations and studio tours.

Taipei Artist Village

"The facility, location, and staff resources of the Taipei Artist Village have exceeded my expectations. As an international residency program, it is rich with opportunities to meet and engage with artists of all disciplines and backgrounds. It is a self-contained creative pocket alive within the incredibly fascinating world of downtown Taipei." — ANTHONY LUENSMAN

N.7 Peiping East Road
Taipei, Taiwan ROC
Phone: 886 2 33937377
Fax: 886 2 33937389
E-mail: *bt-tav@mail.tcg.gov.tw*
Web: *www.artistvillage.org*

Mission: The Taipei Artist Village was created to provide Taipei with a base where local and international artists would be brought together to facilitate creative intercultural encounters and collaboration.

Founded: Organization and Residency, 2001.

Location: The Taipei Artist Village is conveniently located at the hub of Taipei's business and government districts. The 1,650-square-meter site and four-story building are in the heart of Taipei City.

Past Residents: Bum-Su Kim, Anthony Luensman, Lisa Milroy, Miyuki Yokomiz, Jannicke Laker, Myli Thi, Andreas Constantinou, Daniel Saul, Jeroen Speak, Stephen Eastauph.

From the Director: "The Taipei Artist Village provides an artist-led space where pioneering artists in all disciplines—visual, literary, musical, film/video/photography, performing and interdisciplinary—from throughout Taiwan and the world are brought together. The artists drawn to TAV share what is unique from their cultures and experiences, playing a crucial role in enhancing the beauty and grandeur of Taipei city."

Eligibility: Based on exchange program with many countries, and involvement in creative art projects across different fields.

Studios & Special Equipment Available: Facilities for blacksmithing, dance/choreography, digital media, exhibition/installation, film/digital editing, music (piano studio), painting, photography, sculpture, woodworking, and writing.

Housing, Meals, Other Facilities & Services: *Housing:* Individual apartment for residents with private room and bath; furnishings and linens provided. *Meals:* Residents responsible for own meals; kitchen facilities provided. *Other facilities/services:* Common room or meeting space for residents' use; laundry facilities onsite; computer with Internet available in common area and Internet connection

also available in residents' area; public transportation available. Smoking permitted outdoors only. Spouses/partners and children allowed for visits only (for no more than one-third of residency).

Accessibility: Living quarters, studios, and public areas are accessible.

Application & Residency Information:

Application available online

Application deadline(s): End of every year

Resident season(s): Year-round

Average length of residencies: 3 months

Number of artists-in-residence in 2003: 32

Average number of artists-in-residence present at one time: 10

Selection process: Outside professional jury/panel and internal selection; selection also by exchange program with other organizations.

Artists Responsible for: Meals and materials.

Organization Provides: Housing, studios, program administration, travel assistance, materials stipend—$600/month; general stipend—$35/day.

Other Expectations & Opportunities: Artists-in-residence are given the opportunity to participate in public exhibitions/presentations, studio tours, and the donation of artwork to TAV.

Ucross Foundation Residency Program

"I write about land and human history in America, the way they are tangled and enmeshed. The sky, the light, the cattle, the blowing snow, the magpies, the bare trees of Ucross worked themselves into every sentence I composed. I am grateful for that—the chorus of an American place. I will keep it with me always."—ALYSON HAGY

30 Big Red Lane
Clearmont, WY 82835
Phone: (307) 737-2291
Fax: (307) 737-2322
E-mail: *info@ucross.org*
Web: *www.ucrossfoundation.org*

Mission: The Ucross Foundation is where stewardship of the land and the creative spirit are fostered together as one. The Residency Program seeks to encourage fresh, innovative work by serious artists, writers, composers, and scientists, by providing the uninterrupted time, private space, and supportive environment necessary for all creative thought.

Founded: Organization, 1981; Residency, 1983.

Location: On a 22,000-acre working cattle ranch on the High Plains of northeast Wyoming, near the Bighorn Mountains, thirty miles southeast of Sheridan.

Past Residents: Francisco Goldman, Ricky Ian Gordon, Adam Guettel, Jessica Hagedorn, Ha Jin, Byron Kim, Karen Kitchel, Doug Wright, Ann Patchett, Annie Proulx.

From the Director: "The vast open space of Wyoming—its landscape and skyscape—produces a creative alchemy that transforms all who encounter it. For most artists and writers, the outer geography of Ucross has a profound impact on what happens inside their studios, and leaves a lasting impression for years to come."—SHARON DYNAK

Eligibility: Writers, visual artists, composers, scholars, and scientists working in all disciplines. Repeat residencies after three years.

Studios & Special Equipment Available: Facilities for dance/choreography (performance space available in spacious, renovated barn loft), music studio (composer's cabin features an upright piano and electronic keyboard; loft space has a grand piano available for composer use), painting (4 visual arts studios each have over 450 square feet of space), photography (no darkroom), printmaking (studio features an Elephant etching press), and writing (four writer's studios—two in a renovated train depot, two in the Kocur Writer's Retreat on the banks of Clear Creek).

Housing, Meals, Other Facilities & Services: *Housing:* Residents have a private bedroom in a shared house (four bedrooms in the School House, four bedrooms in the Depot, a renovated train depot); furnishings and linens

provided. *Meals:* Lunch and dinner are prepared by a professional chef, Monday–Friday; residents prepare own meals for breakfast and on weekends; vegetarian meals available. *Other facilities/services:* Common room with computer and Internet access for residents' use; laundry facilities onsite. Limited local transportation—residents are picked up in Sheridan and Buffalo, and are provided weekly town trips; residents wanting to explore the area rent their own cars; bicycles are also available for resident use. Smoking is permitted outdoors only. Facilities are for the use of invited residents only; staff provides suggestions for nearby guest rooms and hotels for possible spouse/partner visits.

Accessibility: Facilities are fully accessible.

Application & Residency Information:

Application available online

Application deadline(s): March 1 for Fall; October 1 for Spring

Resident season(s): Spring (February 1–mid-June); Fall (August 1–mid-December)

Average length of residencies: 4 weeks

Number of artists-in-residence in 2003: 80

Average number of artists-in-residence present at one time: 8

Selection process: Outside professional jury/panel selection.

Artists Responsible for: Application fee— $20; refundable deposit—$50 (returned after residency is completed); and travel to Sheridan, Wyoming.

Organization Provides: Housing, food, studios, some local transportation, and program administration.

Other Expectations & Opportunities: There are no expectations placed on artists-in-residence; though always appreciated, all presentations and contributions are voluntary. While the Foundation seeks to protect the autonomy, privacy, and uninterrupted time of its artists-in-residence, interaction with the local community is encouraged if residents are interested.

University of Saskatchewan, Emma Lake Kenderdine Campus

Room 133, Kirk Hall
117 Science Place
Saskatoon, SK S7N 5C8
Canada
Phone: (306) 966-8675
Fax: (306) 966-5567
E-mail: *emma.lake@usask.ca*
Web: *www.emmalake.usask.ca*

Mission: To promote lifelong learning in the arts and culture.

Founded: Organization, 1935; Residency, 2001.

Location: Emma Lake Kenderdine Campus is situated approximately fifty kilometers (forty-five-minute drive) north of Prince Albert, Saskatchewan. It is on a small isolated peninsula in a lake-resort area. The campus has a communal dining lodge overlooking the lake, a shop with souvenirs, books, clothing, art supplies, and toiletry items, several private and shared cabins in rustic and modern architectural styles, laundry facilities, a large open studio with water and electricity, three classrooms and two outdoor covered work areas.

Past Residents: Greg Hardy, Peter von Tiesenhausen, Wynona Mulcaster, Courtney Milne, Louise Cook, Sandra Birdsell, Glen Sorestad, Sharon Butala, Grant McConnell.

From the Director: "The Emma Lake Kenderdine Campus offers a certain degree of isolation in a residential learning environment where artists can come together for a concentrated period of time, free from external interruptions and daily routines. The sharing of ideas, attitudes, and work processes takes place on a personal level. As the creative need dictates, participants can choose to work in close proximity to each other in a large studio facility—an environment that contributes to a dynamic and creative atmosphere, in the natural lakeside environment or in their private spaces. Communal dining and social times allow for interchange and discussion."

Eligibility: Visual artists, performance artists, musicians, composers, critics, curators, arts administrators, designers, and writers are invited to apply to the Residency Program. The program has been designed to provide workspace, accommodations, and meals in a retreat environment where participants can work independently on their own project(s) for a time period of one to two weeks depending on availability. The Program also features an invited artist-in-residence whenever possible. The artist-in-residence is invited to work independently and is not required to provide formal instruction to residency

participants. There are opportunities for creative interaction during social and serendipitous occasions. The Residency Program is offered in June and August/September.

Studios & Special Equipment Available: Large and small multipurpose spaces are available—easels, tables, and chairs are supplied; can make wheels and kilns available. Otherwise, the artist must be self-sufficient.

Housing, Meals, Other Facilities & Services: *Housing:* A variety of furnished facilities that are assigned according to availability and/or need—some private, some shared; some units have private bathrooms, and there is a central bathroom facility. *Meals:* All meals are provided; vegetarian meals available. *Other facilities/services:* Common room or meeting space with Internet connection for residents' use with own laptops (Internet connection is through dial-up only and charges apply for use); laundry facilities onsite. Public transportation available (airport into Saskatoon and bus transit to Christopher Lake; organization can pick residents up at bus depot—fifteen minutes from campus—with prior arrangements). Smoking permitted outdoors and in designated private cabins. Spouses/ partners allowed for full stay—required to pay full meal and accommodation rates.

Accessibility: Facilities are fully accessible, though wheelchair accessibility is being upgraded. This is a woodland retreat and pathways and forested areas are left in as natural a state as possible. Boardwalks or concrete paths have not been provided; however, most areas are easily accessed.

Application & Residency Information: Application available online
Application deadline(s): Ongoing
Resident season(s): June and September
Average length of residencies: 2 weeks
Number of artists-in-residence in 2003: 20
Average number of artists-in-residence present at one time: 20
Selection process: Internal selection (staff, board, and/or advisory board).

Artists Responsible for: Residency fee— $300 (CAD); travel, materials, and equipment (some equipment may be able to be provided, such as potter's wheel and kiln).

Organization Provides: Housing, meals, studios, and program administration.

Other Expectations & Opportunities: Optional slide shows and readings are often held on an impromptu basis. Artists are welcome to donate a piece of artwork, but this is optional.

Vermont Studio Center

*"They spoil us here. I have never had so much time
in my life to paint, paint, paint."*

P.O. Box 613
Johnson, VT 05656
Phone: (802) 635-2727
Fax: (802) 635-2730
E-mail: *info@vermontstudiocenter.org*
Web: *www.vermontstudiocenter.org*

Mission: To support dedicated
artists, by offering distraction-free
working time and space, the
companionship of creative peers,
and the inspiration of distinguished
mentors in a noncompetitive,
international community
that honors the making of art
as a communication of spirit
through form.

Founded: Organization and
Residency, 1984.

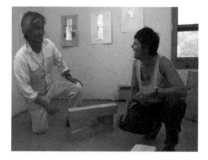

Location: Forty miles east of Burlington in
Johnson (pop. 2,500), a traditional Vermont
village in the heart of the Green Mountains.
The Center's award-winning studio campus is
composed of thirty historic buildings on the
banks of the Gihon River, all within walking
distance of each other.

Past Residents: Carole Robb, Bill Jensen,
Lois Dodd, Stuart Shils, John Walker, Marilyn
Nelson, Jane Hamilton, Michael Ryan,
Galway Kinnel, Wolf Kahn.

From the Director: "As the country's largest
international artists' and writers' community,
the Vermont Studio Center offers a broad
range of creative encounters and a focused,
noncompetitive working environment in a
community founded on the principles of
awareness, compassion, and mutual support."

Eligibility: Serious, emerging, or mid-career
visual artists and writers from all over the
United States and the world.

Studios & Special Equipment Available:
Exhibition/installation space; painting,
photography, printmaking, sculpture, and
writing workspace.

Housing, Meals, Other Facilities & Services:
Housing: Private room(s) in a shared facility;
furnishings and linens provided. *Meals:* All
meals are provided; vegetarian meals available.
Other facilities/services: Common room or
meeting space for residents' use; computer
with Internet connection in common area;
local transportation provided by organization.
Smoking permitted outdoors only. Spouses/
partners allowed for visits only.

Accessibility: The main building, the Red
Mill, is fully accessible, and some studios and
living areas are also accessible.

Application & Residency Information:

Application available online

Application deadline(s): Feb. 15, April 1, June 15, October 1

Resident season(s): Year-round (closed between Christmas and New Year's)

Average length of residencies: 4–12 weeks

Number of artists-in-residence in 2003: 600

Average number of artists-in-residence present at one time: 65

Selection process: Outside professional jury/panel and internal selection (staff, board, and/or advisory board).

Artists Responsible For: Application fee— $25; residency fee—$3,500/month (fellowships available).

Organization Provides: Housing, meals, studios, and program administration.

Additional Support: Artists are eligible for two hundred Full Fellowship Awards and three hundred Partial Fellowship Awards to national and international artists and writers, as well as Work-Exchange Fellowships; some awards offer travel expenses and materials stipend.

Other Expectations & Opportunities:
There are many lectures, readings, art openings, studio visits, yoga classes, and other community events that residents may participate in if they choose; however, participation is entirely voluntary, and residents may pick and choose among the events offered.

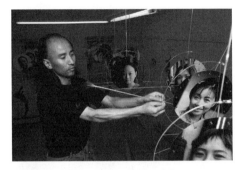

Virginia Center for the Creative Arts

"It might seem an overstatement to say that my experience at the VCCA has been the most important event in my literary life, but I assure you that is not hyperbole. The facilities were marvelous and staff magnificent in their attentiveness. I am absolutely astounded at how productive I was during working hours, and I believe that my interaction with other fellows at meals and during the evenings stimulated this productivity. I wrote a substantial amount of new work with an intensity and clarity of concentration that I rarely (if ever) have experienced. I attribute that to the VCCA—the nurturing character of both the place and the people."—MARGARET INGRAHAM

154 San Angelo Drive
Amherst, VA 24521
Phone: (434) 946-7236
Fax: (434) 946-7239
E-mail: *vcca@vcca.com*
Web: *www.vcca.com*

Mission: The Virginia Center for the Creative Arts is a year-round community that provides a supportive environment for superior national and international visual artists, writers, and composers of all cultural and economic backgrounds to pursue their creative work without distraction in a pastoral residential setting.

Founded: Organization and Residency, 1971.

Location: Four hundred and fifty acres in the foothills of the Blue Ridge Mountains of central Virginia, 160 miles southwest of Washington, D.C.

Past Residents: David Del Tredici, John Casey, Naomi Wolf, Ha Jin, Manil Suri, Alice McDermott, Jacque Hnizdovsky, Cy Twombly, Yuriko Uamaguchi, Nathan Currier.

From the Director: "The Virginia Center for the Creative Arts is an egalitarian, international community intent on providing fellows-in-residence ideal conditions in which to work. Our fellows determine for themselves the perfect mix of privacy and community by balancing their time of solitude and work with opportunities for lively interaction with others at mealtime and during performances, readings, and studio visits. From the emerging visual artist to the cutting-edge composer to the established author, our fellows tell us time and time again that coming to the VCCA is akin to returning home. Everything we offer—from our peaceful bucolic setting to our allegiance to service to our growing international exchange program—is fine-tuned to create the environment that yields unparalleled productivity."—SUNY MONK

Eligibility: Painters, sculptors, printmakers, poets, fiction writers, screenwriters, playwrights, writers of creative nonfiction, composers, performance artists, video artists, choreographers (see Indices for more specific types of artists served). Repeat residencies permitted.

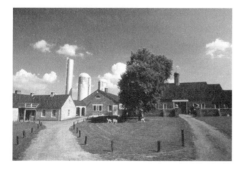

Studios & Special Equipment Available:
Facilities for dance/choreography (can accommodate choreographers in large visual artists' studios), music studio (piano only), painting, photography, printmaking (Dickerson electric press), sculpture, and writing.

Housing, Meals, Other Facilities & Services:
Housing: Private room in a shared facility (bathroom shared with one other fellow); furnishings and linens provided. *Meals:* All meals provided—breakfast and dinner served in dining room; lunches delivered to studios. Vegetarian meals available; cooking/kitchen facilities available to residents. *Other facilities/services:* Common room with computer and Internet connection for residents' use; laundry facilities onsite; transportation to town and Sweet Briar College provided twice weekly. Smoking is permitted outdoors and in some writing studios. Spouses/partners and children allowed for visits only; two bedrooms will accommodate double-occupancy if both partners are accepted for residency.

Accessibility: Artists in wheelchairs or with vision or hearing impairment can be accommodated. Housing, housing bathrooms, studios, and public bathrooms are wheelchair-accessible. Wheelchair-friendly bath facilities in the residence include a roll-in shower.

Application & Residency Information:

Application available online

Application deadline(s): January 15, May 15, September 15

Resident season(s): Year-round

Average length of residencies: 4 weeks

Number of artists-in-residence in 2003: 331

Average number of artists-in-residence present at one time: 22

Selection process: Outside professional jury/panel selection.

Artists Responsible for: Application fee—$25; residency fee—$30/day (suggested contribution); deposit—$50; travel and materials.

Organization Provides: Housing, meals, studios, and program administration.

Additional Support: Occasional fully funded residencies are available. The Geraldine R. Dodge Foundation has funded residencies for artists from New Jersey and the Heinz Foundation has funded residencies for artists from southwestern Pennsylvania. Call for details of possible upcoming opportunities.

Other Expectations & Opportunities:
There are no artists' duties. Open studios, readings, and concerts are optional. A few artists are paid an honorarium to make presentations to students at Sweet Briar College. Formal international exchange program established with organizations in France, Austria, Germany, and Ireland.

Weir Farm Trust

"The great opportunity of a workplace free from distractions has been a life-altering experience. I have never painted so much, read so much, walked so much, written so much, or thought so much as I have in this short time."— ANN HUEY

735 Nod Hill Road
Wilton, CT 06897
Phone: (203) 761-9945
Fax: (203) 761-9116
E-mail: *evanswft@optonline.net* or *allenwft@optonline.net*
Web: *www.nps.gov/wefa*

Mission: The Weir Farm Trust, a private, nonprofit organization, works in partnership with the National Park Service in the operation and development of Weir Farm National Historic Site. Through innovative programs, the Trust brings artists and audiences to Weir Farm and builds community and financial support to ensure its success as a vital creative and educational center. Our mission is to promote public awareness of the Farm's history and artistic tradition, facilitate its use by contemporary artists, provide educational opportunities, and preserve the Farm's unique environment.

Founded: Organization, 1989; Residency, 1998.

Location: Weir Farm National Historic Site is Connecticut's first National Park Site and the only one in the country devoted to American painting. Weir Farm, with its rolling fields, stone walls, woods, pond, and historic structures, is considered the finest remaining landscape associated with American Impressionism. Located in Fairfield County about fifty miles north of New York City in the towns of Wilton and Ridgefield, the Farm includes the sixty-acre historic core and is surrounded by another 110 acres of protected land known as the Weir Preserve.

Past Residents: Matt Franks, Donna Sharrett, Emna Zghal, Julia Mandle, Leonard Ragouzeous, Martha Burgess, Claudia Schmacke, Roberly Bell, Eugenio Espinosa, Ann Huey.

From the Director: "Weir Farm is the former home of noted American painter J. Alden Weir (1852–1919). Weir's outgoing nature and welcoming home encouraged and comforted hundreds of aspiring artists whose needs and talents he discovered long before they were recognized by the world. His positive impact on the lives of fellow artists, his concern for humanity, and his great affection for family and friends are the basis for the vision and values that underlie the spirit of our residency program."

Eligibility: Advanced visual artists of all backgrounds who have reached a level of maturity in their work and have strong records of artistic achievement or the promise of this achievement, are encouraged to apply for admission. The Weir Farm Trust does not discriminate on the basis of race, creed, color, religion, national origin, age, gender, or sexual orientation.

Studios & Special Equipment Available: Facilities for exhibition/installation, painting

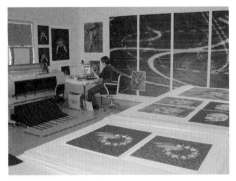

(large easel, large tables), photography (darkroom facilities are available nearby at the Center for Contemporary Printmaking), sculpture (heavy-duty air compressor and small hand tools provided in studio), and woodworking.

Housing, Meals, Other Facilities & Services:

Housing: Individual cabin/house for each resident; furnishings and linens provided. *Meals:* Residents responsible for own meals; kitchen facilities provided. *Other facilities/services:* Laundry facilities onsite; dial-up Internet connection (no computer) in residents' area. Public transportation available; very limited travel for special circumstances provided by organization. Smoking permitted outdoors only. Spouses/partners allowed for visits only.

Accessibility: At the present time, facilities are not wheelchair accessible. (Future new facilities will be accessible.)

Application & Residency Information:

Application available online

Application deadline(s): January 15 for May–October; July 15 for November–April

Resident season(s): Year-round

Average length of residencies: 2 weeks–1 month

Number of artists-in-residence in 2003: 19

Average number of artists-in-residence present at one time: 1 (2 artists may apply as a collaborative team or to participate in the program at the same time doing independent work)

Selection process: Outside professional jury/panel selection.

Artists Responsible for: Application fee—$25; deposit—$75 (returned when artist comes for residency); food, travel, and materials.

Organization Provides: Housing/utilities, studio, and program administration; general stipend—$500/month.

Other Expectations & Opportunities: The primary purpose of the residency is for artists to spend uninterrupted time creating their work. A ranger-led tour of Weir Farm National Historic Site and a visit to the Weir Farm archives are the only additional requirements. Artists may give a lecture/slide presentation if they request. Onsite gallery exhibitions are extended to many artists, but after the residency period. Artists are asked to participate in one open studio session.

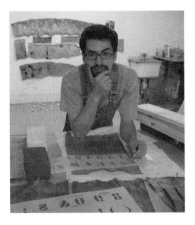

The Julia and David White Artists' Colony

"It is a wonderful thing the Colony is doing. Along with the other artists, it enables composers to dream in sound and to share with others what it feels like to be alive, through music."
— BRIAN CURRENT

U.S. Address:
Interlink 232
P.O. Box 526770
Miami, FL 33152

Apdo. 102-6100
Ciudad Colón
Costa Rica

Phone: + 506-249-1414
Fax: + 506-249-1831
E-mail: *info@forjuliaanddavid.org*
Web: *www.forjuliaanddavid.org*

Mission: Providing year-round residencies in Costa Rica to dedicated artists from around the world.

Founded: Organization and Residency, 1998.

Location: On a seventeen-acre farm within walking distance from Ciudad Colón, and less than forty-five minutes by bus from the capital of Costa Rica, San Jose.

Past Residents: Former residents, photos, and bios listed on Web site.

From the Director: "The Julia and David White Artists' Colony is committed to providing today's visionaries and innovators the opportunity to explore their creativity in the peaceful culture of Costa Rica."

Eligibility: Our primary focus is to provide residencies for writers, visual artists, and composers from anywhere in the world. All other artists, including those working, for example, in media arts and performing arts, are encouraged to inquire, as they can often be well accommodated at the Colony. Repeat residencies are welcomed, to foster artist-to-artist camaraderie, connectedness of artists to the work of the Colony, and a fuller immersion of artists into the culture of Costa Rica.

Studios & Special Equipment Available: General-use studios can accommodate a variety of arts, and much equipment is available locally; music studio has piano and electronic keyboard. Please contact organization for specific information.

Housing, Meals, Other Facilities & Services:
Housing: Four individual apartments with private bath and full kitchen; three cabins with private bath and full kitchen. Furnishings and linens provided. *Meals:* Dinner on Fridays and breakfast on Sundays are served in the home of Dr. White; vegetarian meals available. Artists cook other meals themselves, either individually in their studios or communally in the Nine Muses. *Other facilities/services:* The Nine Muses—the Colony's common building—

contains a full kitchen and dining room, small library and exhibition space, cable TV with VCR, a group telephone with answering machine, and a Windows desktop PC with printer and Internet connection. Free laundry facilities onsite. Reliable and inexpensive bus and taxi service to all of Costa Rica are readily available from the village of Ciudad Colón, within walking distance of the Colony; weekly grocery runs and transportation to some scheduled events are provided by the Colony. Smoking permitted outdoors only. Non-artist spouses/partners are allowed for visits; couples who wish to share a residency must apply individually or as a collaborative team.

Accessibility: Facilities are not accessible.

Application & Residency Information:

Application available online

Application deadline(s): Ongoing (notification usually provided within 4 weeks)

Resident season(s): Year-round

Average length of residencies: 1–2 months

Number of artists-in-residence in 2003: 60

Average number of artists-in-residence present at one time: 6

Selection process: Separate committee for each category of writers, visual artists, and composers.

Artists Responsible For: Application fee—$40; residency fee—$550/month; deposit—$275 (due at time of scheduling residency); food—about $150/month; travel and materials.

Organization Provides: Subsidized housing, workspace, and program administration. (The approximate cost per artist, for each month of residency, is $1,100. The residency fee, $550, covers half this cost. The Colony provides the rest as a scholarship to each successful applicant.)

Other Expectations & Opportunities:

A monthly open studio, reading, and performance time is scheduled onsite; when such events are scheduled offsite, artists are encouraged to participate—friends of the Colony are invited to attend. Artists-in-residence are asked to contribute a work of art or work of their authorship to the Colony; these donations are greatly appreciated and exhibited.

Wildacres Retreat

"It's a wonderful thing, to pluck painters, musicians, scholars, poets, and playwrights out of the everyday world, and deposit us in a context of beauty and meaning that corresponds with our inner urges to create something with meaning and beauty. You're doing a great service."— JOHN B. JUSTICE

P.O. Box 280
Little Switzerland, NC 28749
Phone: (828) 756-4573
Fax: (828) 756-4586
E-mail: *wildacres@wildacres.org*
Web: *www.wildacres.org*

Mission: The mission of Wildacres is to improve human relations, increase common understanding, and build a sense of community among all people.

Founded: Organization, 1946; Residency, 1999.

Location: Situated on 1,600 acres atop Pompey Ridge, about one hour from Asheville, North Carolina, and adjacent to the Blue Ridge Parkway near Little Switzerland.

Past Residents: Sam Watson, Scott Jagow, John Kessell, Amy Rogers, Doug Robarchek, Michael White, Leslie Takahashi-Morris, Bruce Hoch, New Century Saxophone Quartet.

From the Director: "Wildacres Retreat gives residency participants a place where artists of all kinds can leave their everyday obligations behind and work uninterrupted in an environment where creativity grows and flourishes. The Residency Program affords Wildacres the opportunity to open its facilities to individuals that need a space where they can create new work."— PHILIP BLUMENTHAL

Eligibility: Writers, visual artists, musicians (see Indices for more specific types of artists served). Repeat residencies permitted.

Studios & Special Equipment Available: Facilities for ceramics/pottery, music/piano studio, and painting.

Housing, Meals, Other Facilities & Services: *Housing:* Individual cabin for each resident; furnishings and linens provided. *Meals:* Meals are provided; vegetarian meals available; cooking/kitchen facilities available to residents. *Other facilities/services:* Common room or meeting space for residents' use; laundry facilities onsite; Internet connection only (no computer) in residents' area. Smoking permitted outdoors only.

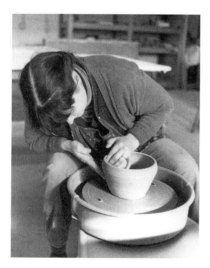

Accessibility: Facilities are not accessible.

Application & Residency Information:

Application available online
(*www.wildacres.org/residency.htm*)

Application deadline(s): February 15

Resident season(s): May–October

Average length of residencies: 1 week

Number of artists-in-residence in 2003: 26

Average number of artists-in-residence
present at one time: 1

Selection process: Outside professional
jury/panel selection.

Artists Responsible for: Travel and materials.

Organization Provides: Housing, meals.

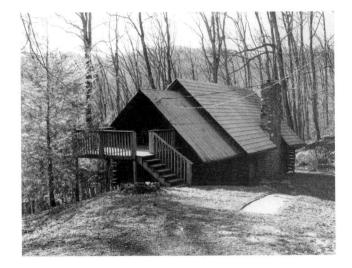

Women's Studio Workshop

"In contrast to my usual feeling of working in isolation, my residency at WSW was the first time I ever felt that someone else really cared whether my project got done or not. To witness and participate in the mutually supportive environment of WSW artists gave me hope and inspiration." — INDIGO SOM

722 Binnewater Lane
P.O. Box 489
Rosendale, NY 12472
Phone: (845) 658-9133
Fax: (845) 658-9031
E-mail: *info@wsworkshop.org*
Web: *www.wsworkshop.org*

Mission: The mission of Women's Studio Workshop is to operate and maintain an artists' workspace that encourages the voice and vision of women artists; to provide professional opportunities and employment for artists at various stages of their careers; and to promote programs designed to stimulate public involvement, awareness, and support for the visual arts.

Founded: Organization, 1974; Residency, 1979.

Location: Among marsh and woodland in the rolling Shawangunk Mountains of the mid-Hudson River Valley, ninety miles north of New York City.

Past Residents: Tomie Arai, Wei Jane Chir, Maureen Cummins, Cheri Gaulke, Mei Ling Hom, Susan King, Susan Mills, Rochelle Rubenstein, Clarissa Sligh, Elizabeth Zanis.

From the Director: "Women's Studio Workshop's facilities are unparalleled in the breadth and range of equipment available. The staff provides technical support and problem-solving expertise. As an artists' workspace, we actively engage with artists by providing them with space, technical assistance, stipends, and resources. WSW's semi-private studio environment encourages the cross-fertilization of ideas and aesthetics among the diverse population of artists served by our programs." — TATANA KELLNER

Eligibility: Women artists working in book arts, ceramics, papermaking, photography, and printmaking. Repeat residencies permitted.

Studios & Special Equipment Available: Facilities for ceramics/pottery (two electric kilns, wheels, slab roller, glaze lab), papermaking (two hollander beaters, 30" x 40" hydraulic press, vats, vacuum table, variety of molds and deckles), photography (four enlargers, dry mount facilities, Photostat processor, 20" x 24" copy camera), and printmaking (facilities for etching, silkscreen, and letterpress; presses include two 30" x 50" Charles Brand intaglio presses, 11" x 18" Chandler and Price Platen Press, and 14" x 20" Vandercook Proof Press).

Housing, Meals, Other Facilities & Services:
Housing: Private room in a shared facility; furnishings and linens provided. *Meals:* Residents are responsible for own meals; residents are invited to join staff for potluck lunch on weekdays. *Other facilities/services:* Computer with Internet connection available to residents before 9 A.M. and after 6 P.M. No smoking onsite.

Accessibility: One room with bathroom is fully wheelchair accessible.

Application & Residency Information:

Application available online

Application deadline(s): March 15 and November 1 for Fellowships; November 15 for Artist's Book Residency; April 1 for all other studio residencies

Resident season(s): October–July

Average length of residencies: 2–6 weeks

Number of artists-in-residence in 2003: N/A

Average number of artists-in-residence present at one time: 3 residents, 3 local artists, 8 staff

Selection process: Outside professional jury/panel selection.

Artists Responsible for: Personal materials, phone, groceries. Fellowships—$200/week residency fee.

Organization Provides: WSW supports up to ten artists annually with fully funded Studio Residencies, which include a $2,000 stipend, housing, studio, and support toward travel and materials expenses. WSW hosts approximately twenty artists annually in partially supported Fellowships; Fellowship artists pay $200/week and receive housing and studio access.

Other Expectations & Opportunities:
Artists-in-residence are expected to participate in onsite public exhibitions/presentations (reading, lecture, slide show, workshop, gallery show, etc.).

Workspace for Choreographers

"The week I spent at the Workspace was one of those rare times when one's artistic expression and daily living are inseparable— from waking in the morning to the sounds of cows in the pasture, to eating fresh-picked blackberries, to being in the studio and having the time to take the time to truly warm up: warm-up in spirit, mind, emotions, and muscles. During the two weeks after I left Sperryville, I created a solo based on some personal experiences and family history I had been speaking and dancing about while at the studio. The piece slid right out of me." —AMY DOWLING

567 Woodward Road
Sperryville, VA 22740
Phone: (540) 987-9234, ext.1
E-mail: *wfcsandra@yahoo.com*

Mission: A rural retreat for choreographers seeking to develop work that is explorative from their standpoint.

Founded: Organization, 1991; Residency, 1989.

Location: Nestled in the foothills of the Blue Ridge Mountains, an hour and a half south-west of Washington, D.C., on twenty-two acres of woodland bordering the Shenandoah National Park.

Past Residents: Sharon Wyrrick, Hannah Dennison, Nancy Stark-Smith, Stephanie Skura, K.J. Holmes, Liz Lerman, Fiona Marcotty, Mollie O'Brien, Andrea Woods, Ausdruckstanz Dance Theater.

From the Director: "Thriving on the same mix of caution, tenderness, and respect that every living thing seeks, choreographers are invited to explore the relation between their own creative nature and the nature in which we live. Surrounded by wilderness, they often find more trust in process, respect for its timing and direction, and curiosity about where it might take them." —SALLY NASH

Eligibility: Choreographers, alone or with dancers, who are free of immediate perform-ance deadlines.

Studios & Special Equipment Available: Dance/choreography studio is 50' x 34', accessible 9:30 A.M. to 6:30 P.M. (not available Sundays).

Housing, Meals, Other Facilities & Services: *Housing:* Two private rooms and shared sleeping loft for groups up to six; furnishings provided. Meals: Residents responsible for own meals; kitchen facilities available to residents. *Other facilities/services:* Feldenkrais® lessons offered free of charge to residents if

desired (Feldenkrais® is a registered service mark of the Feldenkrais Guild®). Choreographic feedback available but optional—no pressure to produce. Common room in cabin for residents' use; laundry facilities onsite. Smoking permitted outdoors only. Spouses/partners and children allowed for visits only.

Accessibility: Living quarters and studio are accessible.

Application & Residency Information:

Application deadline(s): October 1 (for March–April); February 1 (for May–August); June 1 (for September–November)

Resident season(s): March–November

Average length of residencies: 2 weeks

Number of artists-in-residence in 2003: 12

Average number of artists-in-residence present at one time: 1 choreographer or group

Selection process: Chosen by director.

Artists Responsible for: Refundable deposit—$50 (to be returned after stay); food, travel, linens, towels, phone cards for long-distance calls.

Organization Provides: Housing, studio and program administration; travel assistance (only for car rental).

Other Expectations & Opportunities: Artists can show work to small groups or teach a workshop as part of their exploration; however, admission will not be charged. The Workspace offers a brief suspension from the connection between art and the market, in hopes of encouraging freedom to learn. For this reason, it is not available as a rental space in which to give workshops or performances. Artists are asked to share their process with Sally Nash, Artistic Director, through informal talk and her presence at one rehearsal of their choice; the amount and kind of feedback she gives is entirely up to them.

Writers and Books Gell Center of the Finger Lakes

"A beautiful place, all the more so in an April snow."
— WILLIAM LEAST HEAT-MOON

740 University Avenue
Rochester, NY 14607
Phone: (585) 473-2590, ext. 103
Fax: (585) 442-9333
E-mail: *kathyp@wab.org*
Web: *www.wab.org/gell*

Mission: To promote reading and writing as lifelong opportunities for people of all ages and backgrounds.

Founded: Organization, 1980; Residency, 1990.

Location: Forty-five minutes south of Rochester, New York, in the beautiful Bristol Hills in the Finger Lakes Region of New York state. Located on twenty-three acres of rolling hills. Consists of the Gell House and the Gleason Lodge.

Past Residents: Richard Forester, Anne LaBastille, William Least Heat-Moon, Janine Pommy-Vega, Allan Ginsberg, Anne Waldman, Bob Holman, Kim Addonizio, Gary Snyder.

From the Director: "The Gell Center offers writers an opportunity and a setting in which to focus upon their writing away from the distractions of their everyday lives. We are especially interested in providing opportunities to emerging or mid-career writers."
— JOE FLAHERTY

Eligibility: No geographical restrictions to writers and scholars working in all genres of literature. Emerging and mid-career writers encouraged to apply.

Studios & Special Equipment Available: Writing studios and letterpress print shop.

Housing, Meals, Other Facilities & Services: *Housing:* Private room and bath in a shared facility; furnishings and linens provided. *Meals:* Residents responsible for own meals; kitchen facilities available to residents. *Other facilities/services:* Common room or meeting space for residents' use; laundry facilities onsite; Internet connection only (no computer) in residents' area. Smoking permitted outdoors only. Spouses/partners allowed for full stay; children allowed for visits only.

Accessibility: Only public areas are accessible.

Application & Residency Information:

Application available online

Application deadline(s): Ongoing

Resident season(s): Year-round

Average length of residencies: 1 week

Number of artists-in-residence in 2003: 10

Average number of artists-in-residence present at one time: 1

Selection process: Internal selection (staff, board, and/or advisory board).

Artists Responsible for: Residency fee—$35/day; deposit—$100; food, travel, and materials.

Organization Provides: Housing, workspace, and program administration.

Other Expectations & Opportunities: None. Writers are welcome to donate a work of their authorship to the program if they wish.

Writers' Colony at Dairy Hollow

"This is my third August at Dairy Hollow, and once again the magic of being here is pervading my spirit, indeed my very pores, allowing my creativity to surface in a way that is difficult in any other circumstance. I could add all the usual stuff about the uniqueness, the quirkiness, how wonderful the staff and environment are, and how hard they work to create this opportunity for us. And all that is true, but the most important thing is the chance to do one's work unimpeded."

515 Spring Street
Eureka Springs, AR 72632
Phone: (479) 253-7444
Fax: (479) 253-9859
E-mail: *director@writerscolony.org*
Web: *www.writerscolony.org*

Mission: Writers' Colony at Dairy Hollow (WCDH) provides uninterrupted residency time for writers and interacts with the wider community to stimulate new thinking and energize creative expression.

Founded: Organization, 1999; Residency, 2000.

Location: Located in the Ozark Mountain city of Eureka Springs, Arizona, the entirety of which is on the National Historic Register. Though within the city limits, the Colony is nestled in a private wooded hollow, adjacent to a park and near wooded walking and biking paths, a few miles from Beaver Lake and the White River.

Past Residents: Linda Mannheim, Pat Schneider, Rosemary Daniell, Rhoda Stamell, Kathryn Watterson, John T. Edge, Terri Wuerthner, Laura Parker, Agymah Kamau, Sam Pickering.

From the Director: "WCDH—at home in a town where over three hundred writers, artists, and musicians live and work—nurtures, nudges, and fosters the creative spirit. The natural world and the inner world weave an atmosphere of exploration, spurring the discovery, deepening, and full expression of a writer's individual voice."

Eligibility: Emerging, experienced, and/or published authors of all genres and songwriters are encouraged to apply.

Studios & Special Equipment Available: Writing studios.

Housing, Meals, Other Facilities & Services:
Housing: Private room and bath in a shared facility; furnishings and linens provided.
Meals: Dinner is prepared five nights per week; vegetarian meals available; a stocked kitchen is available for residents to prepare

their own breakfast and lunch. *Other facilities/services:* Common room or meeting space for residents' use; laundry facilities onsite; Internet connection only (no computer) in residents' area; public transportation (trolley system) available. Smoking permitted outdoors only.

Accessibility: Only public areas are accessible.

Application & Residency Information:

Application available online

Application deadline(s): Ongoing

Resident season(s): February–November

Average length of residencies: 2 weeks– 2 months

Number of artists-in-residence in 2003: 40

Average number of artists-in-residence present at one time: 5

Selection process: Outside professional jury/panel selection.

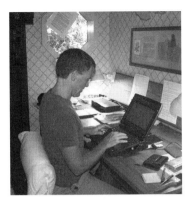

Artists Responsible for: Application fee— $35; residency fee—$20/day minimum donation; deposit—$100; travel and materials.

Organization Provides: Housing, food, studios, and program administration. Artists eligible for dedicated fellowships; details on Web site.

Other Expectations & Opportunities: For each thirty days of residency, writers commit to a minimum of one day of community service. This can be workshops, seminars, readings, or other forms of interaction. All writers, regardless of length of stay, are welcome and encouraged to do so. Staff actively assists in organizing public events. Books by WCDH resident writers are always welcome as a donation.

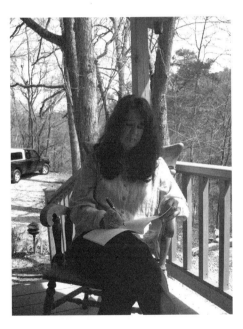

Yaddo

"I was able to work in a focused way that I never have before...there's not a ripple on the horizon, nothing to interfere with a perfect environment to work, rest, and enjoy."
— MARCIA TUCKER

P.O. Box 395
Saratoga Springs, NY 12866
Phone: (518) 584-0746
Fax: (518) 584-1312
E-mail: *yaddo@yaddo.org*
Web: *www.yaddo.org*

Mission: To support professional working artists, chosen by panels of their peers, by providing them with the space, uninterrupted time, and supportive community they need to work at their best.

Founded: Organization, 1900; Residency, 1926.

Location: In Saratoga Springs, New York, three hours from New York City, on four hundred acres of wooded and open areas, lake, and gardens. A fifty-five-room mansion and sixteen outbuildings serve as working and living facilities.

Past Residents: Milton Avery, Leonard Bernstein, Marc Blitzstein, Truman Copote, Aaron Copland, Philip Guston, Langston Huges, Sylvia Plath, Virgil Thomson, William Carlos Williams.

Eligibility: Creative artists working at a professional level in their field. Repeat residencies permitted.

Studios & Special Equipment Available: Facilities for dance/choreography, exhibition/installation, metal shop, music/piano studio, painting, performance art, photography, sculpture, and writing.

Housing, Meals, Other Facilities & Services: *Housing:* Private room and bath in a shared facility; furnishings and linens provided. *Meals:* All meals are provided; vegetarian meals available. *Other facilities/services:* Common room and meeting space for residents' use; laundry facilities onsite; computer with Internet connection in common area; recreational facilities for residents' use. Local transportation provided by organization, by public transit, or by artists (up to the artists' preference). Smoking permitted outdoors, in living areas, and in studios; however, there are designated nonsmoking areas.

Accessibility: Facilities are fully accessible, though some accessibility is seasonal (winter dining facilities are not accessible). Accommodations can be made for artists with hearing or vision impairments.

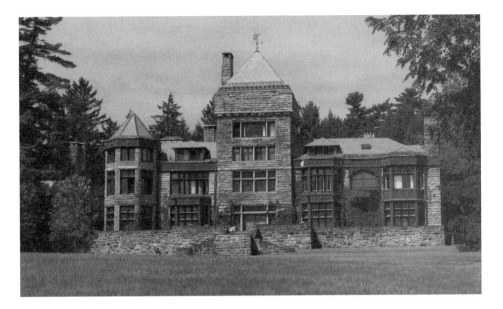

Application & Residency Information:

Application available online

Application deadline(s): January 1 and August 1

Resident season(s): Year-round

Average length of residencies: 5 weeks

Number of artists-in-residence in 2003: 207

Average number of artists-in-residence present at one time: 35 during the summer, 15 during other seasons

Selection process: 5 separate panels of professionals: literature, music composition, visual arts, film/video, and media/performance.

Artists Responsible for: Application fee—$20; materials.

Organization Provides: Housing, meals, studios, and program administration; travel assistance and materials stipend.

The Yard

"The Yard is a fertile, lush environment for the creative spirit, as well as for the body, where dancers and choreographers can meet and make work without the dulling constraints of jobs, lack of studio space, and funding. Here, work is made free from obligation, judgment, and mundane hassles. The Yard is truly a liberated time and space of paradise for the artists, like no other on earth. For accuracy, it should be renamed 'Artist's Eden.' That's how close to perfection the Yard is. Long may it thrive."
— ANNIE B. PARSONS

P.O. Box 405
Chilmark, MA 02535
Phone: (508) 645-9662
Fax: (508) 645-3176
E-mail: *admin@dancetheyard.org*
Web: *www.dancetheyard.org*

Mission: To promote growth and experimentation in dance by giving artists time and space to create and premiere their new work.

Founded: Organization and Residency, 1973.

Location: The Yard is tucked between hills and meadows in Chilmark, on the island of Martha's Vineyard. Its setting is simple — three houses and a barn, now converted to a studio and theater, surrounded by grass, woods, and stone walls.

Past Residents: Susan Marshall, David Dorfman, Doug Elkins, Gus Solomons Jr., Doug Varone, Dan Shapiro and Joanie Smith, Jawole Willa Jo Zoller, Annie B. Parsons, Nicholas Leichter.

From the Director: "There are many opportunities for established companies to have residencies, but the Yard's Bessie Schonberg Residency is the only program of its kind that provides young choreographers with a company, studios, and production support for a month each summer. It is an important rung in the career ladder for emerging choreographers."
— LOIS WELK

Eligibility: Dancers/choreographers, individuals, and companies.

Studios & Special Equipment Available: Fully equipped theater that seats around 110, featuring a 35' x 28' sprung dance floor. Lighting, sound, and video equipment. Dance studio, 24' x 28', adjacent to the theater.

Housing, Meals, Other Facilities & Services: *Housing:* The Yard provides shared housing for choreographers and dancers; baths are shared and some bedrooms are shared as well. *Meals:* Residents are responsible for own meals; cooking/kitchen facilities available.

Artists Responsible for: Application fee—
$20; food.

Organization Provides: Housing, workspace,
technical and administrative support, concert
performances of new work at the Yard's
theater; general stipend—ranges from $1,200
for individuals to $4,000 for companies.

Other Expectations & Opportunities:
Artists are required to provide a number of
community services, and concert performances
of new work at the Yard's theater are available.

Other facilities/services: Theater-studio spaces
are available as well as living rooms of both
houses for residents' use. The Yard provides
a van for the shared use of the artists-in-
residence. Spouses may be allowed during
residencies dependent on individual situa-
tions—artists must make a request; as a
general rule guests are not allowed, but there
are nearby B&Bs, inns, and a hostel. Children
are allowed if there is adequate room and
childcare and this is not an imposition on
other residents.

Accessibility: Facilities are not accessible.

Application & Residency Information:

Application deadline(s): early November

Resident season(s): April–October

Average length of residencies: 4 weeks

Number of artists-in-residence in 2003: 50

Average number of artists-in-residence
present at one time: 16

Selection process: Outside professional
jury/panel selection.

Artistic Categories
Visual Arts

	Book Arts	Ceramics/Clay Arts/Pottery	Drawing	Glass Arts	Installation Arts	Jewelry Making/Fine Metals	Metalworking/Blacksmithing	Mixed Media	Painting	Paper Arts	Photography	Printmaking	Sculpture	Textile & Fiber Arts	Weaving	Wood
18th Street Arts Center	■	■	■	■	■	■	■	■	■	■	■	■	■	■		■
Abrons Art Center/ Henry Street Settlement	■	■	■		■			■	■							
Edward F. Albee Foundation/ William Flanagan Memorial Creative Persons Center	■	■	■	■	■	■	■	■	■	■	■	■	■	■		■
American Academy in Berlin	■	■	■	■	■	■	■	■	■	■	■	■	■	■	■	■
Anderson Center for Interdisciplinary Studies	■	■	■		■			■	■	■	■	■	■	■		■
Anderson Ranch Arts Center		■	■	■				■			■	■	■			■
Arrowmont School of Arts and Crafts	■	■	■	■		■	■	■	■	■	■	■	■	■		■
ArtCenter/South Florida			■		■			■	■	■	■	■	■			■
Artcroft Center for Arts and Humanities	■	■	■	■	■	■	■	■	■	■	■	■	■	■		■
Art Farm		■	■		■		■	■	■	■		■				■
The Artist House at St. Mary's College of Maryland	■		■		■			■	■		■		■			
Artists' Enclave at I-Park		■	■	■	■			■			■		■			
Art Omi International Arts Center	■	■	■	■	■	■	■	■	■	■	■	■	■	■		■
ArtPace	■	■	■	■	■	■	■	■	■	■	■	■	■	■		■
The Art Studio Changdong and Goyang	■	■	■	■	■	■	■	■	■	■	■	■	■	■		■
Atlantic Center for the Arts		■			■			■	■		■		■			■
Aurora Project	■		■	■				■	■		■	■	■			
The Banff Centre/ Leighton Studios	■	■	■	■	■	■	■	■	■	■	■	■	■	■	■	■
Bemis Center for Contemporary Arts	■	■	■	■	■	■	■	■	■	■	■	■	■	■		■
Bogliasco Foundation	■	■	■	■	■	■	■	■	■	■	■	■	■	■	■	■
Archie Bray Foundation		■											■			
The Bullseye Connection	■	■	■	■	■	■	■	■	■	■	■	■	■	■	■	■
Byrdcliffe Arts Colony/ Woodstock Guild		■	■					■	■	■	■					
Caldera	■	■	■					■	■	■	■		■			
Carving Studio and Sculpture Center													■			
Center for Contemporary Printmaking	■										■		■			

228

	Book Arts	Ceramics/Clay Arts/Pottery	Drawing	Glass Arts	Installation Arts	Jewelry Making/Fine Metals	Metalworking/Blacksmithing	Mixed Media	Painting	Paper Arts	Photography	Printmaking	Sculpture	Textile & Fiber Arts/Weaving	Woodworking
Civitella Ranieri Foundation			●		●			●	●	●		●	●		●
The Cooper Union School of Art			●					●	●		●		●		
Djerassi Resident Artists Program	●		●		●			●	●	●			●		●
Dorland Mountain Arts Colony	●	●	●		●	●		●	●	●	●	●	●	●	●
Willard R. Espy Literary Foundation			●					●		●		●			
Evergreen House	●		●					●	●	●			●		
The Exploratorium					●						●		●		
Fine Arts Museums of San Francisco	●	●	●	●	●			●	●	●	●	●	●	●	●
Fine Arts Work Center	●	●	●					●	●		●	●			●
Isabella Stewart Gardner Museum	●	●	●	●	●	●	●	●	●	●	●	●	●	●	●
Hall Farm Center for Arts and Education	●	●	●					●	●	●	●	●	●	●	●
Hambidge Center for Creative Arts and Sciences	●	●	●		●			●	●	●	●	●	●		●
Headlands Center for the Arts	●		●		●			●	●		●	●	●	●	●
Hermitage Artists Retreat	●		●						●				●		
Hopscotch House/Kentucky Foundation for Women	●	●	●	●	●	●	●	●	●	●	●	●	●		●
International School of Drawing, Painting and Sculpture	●		●					●	●	●	●		●		
Jentel Artist Residency Program	●	●	●	●	●	●	●	●	●	●	●	●	●	●	●
Kala Art Institute	●							●		●	●	●			
KHN Center for the Arts	●	●						●	●	●		●			
John Michael Kohler Arts Center	●	●	●	●	●	●	●	●	●	●	●	●	●	●	●
Lighton International Artists Exchange Program/Kansas City Artists Coalition	●	●	●	●	●	●	●	●	●	●	●	●	●		●
Louisiana ArtWorks		●		●	●		●	●		●		●	●		
The MacDowell Colony	●	●	●		●			●	●	●	●	●	●	●	●
Robert M. MacNamara Foundation	●	●	●		●	●	●	●	●	●	●	●	●		●

continued on next page

Artistic Categories
Visual Arts

continued from previous page

	Book Arts	Ceramics/Clay Arts/Pottery	Drawing	Glass Arts	Installation Arts	Jewelry Making/Fine Metals	Metalworking/Blacksmithing	Mixed Media	Painting	Paper Arts	Photography	Printmaking	Sculpture	Textile & Fiber Arts/Weaving	Woodworking
The Mattress Factory					■										
McColl Center for Visual Art	■	■	■		■	■	■	■	■	■	■	■	■	■	■
The Mesa	▨		▨	▨	▨	▨		▨	▨	▨			▨	▨	▨
Millay Colony for the Arts			■		■			■	■		■		■		
Montalvo	▨	▨	▨		▨			▨	▨	▨	▨	▨	▨	▨	
Montana Artists Refuge	■	■	■	■	■	■	■	■	■	■	■	■	■	■	■
Nantucket Island School of Design and the Arts	▨	▨	▨		▨			▨	▨	▨	▨	▨	▨	▨	▨
Northwood University Alden B. Dow Creativity Center	■	■	■	■	■	■	■	■	■	■	■	■	■	■	■
Oregon College of Art and Craft	▨	▨	▨			▨			▨		▨	▨		▨	▨
Penland School of Crafts	■	■	■	■	■	■	■	■	■	■	■	■	■	■	■
Pilchuck Glass School	▨	▨	▨	▨	▨	▨	▨	▨	▨	▨	▨	▨	▨	▨	▨
Prairie Center of the Arts			■					■				■			
Ragdale Foundation	▨	▨			▨				▨		▨	▨		▨	▨
Red Cinder Creativity Center	■	■	■	■	■	■	■	■	■	■	■	■	■	■	■
Rockmirth	▨	▨	▨		▨	▨		▨	▨	▨	▨	▨	▨	▨	▨
Roswell Artist-in-Residence Program		■	■		■		■	■	■	■	■	■	■	■	■
Sacatar Foundation	▨	▨	▨	▨	▨	▨	▨	▨	▨	▨	▨	▨	▨	▨	▨
Santa Fe Art Institute	■	■	■	■	■	■	■	■	■	■	■	■	■	■	■
Sculpture Space					▨		▨	▨					▨		▨
Scuola Internazionale di Grafica	■		■					■	■	■		■			
Sea Change Residencies/ Gaea Foundation	▨	▨	▨	▨	▨	▨	▨	▨	▨	▨	▨	▨	▨	▨	▨
Sitka Center for Art and Ecology	■	■	■	■	■	■	■	■	■	■	■	■	■	■	■
Lillian E. Smith Center for Creative Arts	▨	▨	▨	▨	▨	▨	▨	▨	▨	▨	▨	▨	▨	▨	▨
Snug Harbor Cultural Center, Newhouse Center for Contemporary Art	■		■		■			■	■	■	■	■			
Stonehouse Residency for the Contemporary Arts	▨		▨					▨	▨				▨		
A Studio in the Woods		■	■		■			■	■			■	■		
STUDIO for Creative Inquiry	▨	▨	▨	▨	▨	▨	▨	▨	▨	▨	▨	▨	▨	▨	▨
Taipei Artist Village	■		■		■			■	■	■	■	■			■

	Book Arts	Ceramics/Clay Arts/Pottery	Drawing	Glass Arts	Installation Arts	Jewelry Making/Fine Metals	Metalworking/Blacksmithing	Mixed Media	Painting	Paper Arts	Photography	Printmaking	Sculpture	Textile & Fiber Arts/Weaving	Woodworking
Ucross Foundation Residency Program	■		■		■			■	■	■	■	■			■
University of Saskatchewan, Emma Lake Kenderdine Campus	■	■	■	■	■	■	■	■	■	■	■	■	■	■	■
Vermont Studio Center			■					■	■		■	■	■		
Virginia Center for the Creative Arts	■	■	■		■			■	■	■	■	■	■		
Weir Farm Trust	■		■		■			■	■	■	■	■	■		■
The Julia and David White Artists' Colony	■	■	■	■	■	■	■	■	■	■	■	■	■	■	■
Wildacres Retreat	■	■	■			■		■	■		■	■	■		
Women's Studio Workshop	■	■							■	■	■				
Yaddo	■	■	■	■	■	■	■	■	■	■	■	■	■	■	■

Artistic Categories
Media Arts

	Electronic Arts	Film & Video	Multimedia	Sound Art	TV & Radio
18th Street Arts Center	■	■	■	■	■
American Academy in Berlin	■	■	■	■	■
Artcenter/South Florida	■		■	■	
Art Farm	■	■	■	■	
The Artist House at St. Mary's College of Maryland	■	■	■	■	■
Artists' Enclave at I-Park	■	■	■	■	
Art Omi International Arts Center	■	■	■	■	
Artpace	■	■	■	■	■
The Art Studio Changdong and Goyang	■	■	■	■	■
Atlantic Center for the Arts	■	■	■	■	
Aurora Project		■	■		
The Banff Centre/Leighton Studios	■	■	■	■	■
Bemis Center for Contemporary Arts	■	■	■	■	■
Djerassi Resident Artists Program	■	■	■	■	
Willard R. Espy Literary Foundation	■	■	■	■	■
The Exploratorium	■	■	■	■	
Fine Arts Museums of San Francisco		■	■	■	
Fine Arts Work Center		■	■		
Isabella Stewart Gardner Museum	■	■	■	■	■
Hall Farm Center for Arts and Education	■	■	■	■	■
Headlands Center for the Arts		■	■	■	
HOME, Inc.	■	■	■	■	■
Hopscotch House/Kentucky Foundation for Women	■	■	■	■	■
Kala Art Institute	■	■	■	■	
Lighton International Artists Exchange Program/Kansas City Artists Coalition	■	■	■		
The MacDowell Colony	■	■	■	■	■
Robert M. MacNamara Foundation	■				
The Mattress Factory	■		■		
McColl Center for Visual Art		■	■	■	
The Mesa	■	■	■	■	■
Millay Colony for the Arts		■	■		
Montalvo	■	■	■	■	■
Montana Artists Refuge	■	■	■	■	■
Nantucket Island School of Design and the Arts	■	■	■	■	

	Electronic Arts	Film & Video	Multimedia	Sound Art	TV & Radio
Northwood University Alden B. Dow Creativity Center	■	■	■	■	■
Pilchuck Glass School		■	■		
Ragdale Foundation	■	■	■	■	■
Red Cinder Creativity Center	■	■	■	■	■
Rockmirth	■	■	■	■	
Sacatar Foundation	■	■	■	■	■
Santa Fe Art Institute	■	■	■	■	■
Scuola Internazionale di Grafica	■				
Sea Change Residencies/Gaea Foundation	■	■	■	■	■
Lillian E. Smith Center for Creative Arts	■	■	■	■	■
Snug Harbor Cultural Center, Newhouse Center for Contemporary Art			■	■	
STUDIO for Creative Inquiry	■	■	■	■	■
Taipei Artist Village	■	■	■	■	■
Ucross Foundation Residency Program	■	■	■	■	
Virginia Center for the Creative Arts	■	■	■	■	■
Weir Farm Trust		■	■		
The Julia and David White Artists' Colony	■	■	■	■	■
Wildacres Retreat	■	■	■		
Writers' Colony at Dairy Hollow	■	■			
Yaddo	■	■	■	■	■

Artistic Categories
Writing

	Fiction	Journalism	Literary Nonfiction	Playwriting	Poetry	Screenwriting	Translating
18th Street Arts Center	▦	▦	▦	▦	▦	▦	▦
Edward F. Albee Foundation/William Flanagan Memorial Creative Persons Center	■	■	■	■	■	■	■
American Academy in Berlin	▦	▦	▦	▦	▦	▦	▦
Anderson Center for Interdisciplinary Studies	■	■	■	■	■	■	■
Artcroft Center for Arts and Humanities	▦	▦	▦	▦	▦	▦	▦
The Artist House at St. Mary's College of Maryland	■	■	■	■	■	■	■
Artists' Enclave at I-Park	▦		▦	▦			
Art Omi International Arts Center	■	■	■	■	■	■	■
Atlantic Center for the Arts	▦	▦	▦	▦	▦	▦	▦
Aurora Project	■		■	■	■	■	■
The Banff Centre/Leighton Studios	▦	▦	▦	▦	▦	▦	▦
Bogliasco Foundation	■	■	■	■	■	■	■
Byrdcliffe Arts Colony/Woodstock Guild	▦	▦	▦	▦	▦	▦	▦
Caldera	■	■	■	■	■	■	■
Civitella Ranieri Foundation	▦	▦	▦	▦	▦	▦	▦
Djerassi Resident Artists Program	■		■	■	■	■	
Dorland Mountain Arts Colony	▦	▦	▦	▦	▦	▦	▦
Willard R. Espy Literary Foundation	■	■	■	■	■	■	■
The Exploratorium			▦				
Fine Arts Work Center	■		■		■		
Isabella Stewart Gardner Museum	▦	▦	▦	▦	▦	▦	▦
Hall Farm Center for Arts and Education	■	■	■	■	■	■	■
Hambidge Center for Creative Arts and Sciences	▦	▦	▦	▦	▦	▦	▦
Headlands Center for the Arts	■	■	■	■	■	■	
Hedgebrook	▦	▦	▦	▦	▦	▦	▦
Hermitage Artists Retreat	■	■	■	■	■	■	■
Hopscotch House/Kentucky Foundation for Women	▦	▦	▦	▦	▦	▦	▦
Jentel Artist Residency Program	■	■	■	■	■	■	■
KHN Center for the Arts	▦	▦	▦	▦	▦	▦	▦
The MacDowell Colony	■	■	■	■	■	■	■
Robert M. MacNamara Foundation	▦	▦	▦	▦	▦	▦	▦
The Mesa	■	■	■	■	■	■	■
Millay Colony for the Arts	▦	▦	▦		▦	▦	
Montalvo	■	■	■	■	■	■	■

	Fiction	Journalism	Literary Nonfiction	Playwriting	Poetry	Screenwriting	Translating
Montana Artists Refuge	■	■	■	■	■	■	■
Nantucket Island School of Design and the Arts	■	■	■	■	■	■	■
Northwood University Alden B. Dow Creativity Center	■	■	■	■	■	■	
Ragdale Foundation	■	■	■	■	■	■	
Red Cinder Creativity Center	■	■	■	■	■	■	■
Rockmirth	■	■	■	■	■	■	■
Sacatar Foundation	■	■	■	■	■	■	■
Santa Fe Art Institute	■	■	■	■	■	■	■
Sea Change Residencies/Gaea Foundation	■	■	■	■	■	■	■
Sitka Center for Art and Ecology	■	■	■	■	■	■	■
Lillian E. Smith Center for Creative Arts	■	■	■	■	■	■	■
Snug Harbor Cultural Center, Newhouse Center for Contemporary Art				■	■		
Stonehouse Residency for the Contemporary Arts	■		■	■	■	■	
A Studio in the Woods	■	■	■	■	■	■	■
STUDIO for Creative Inquiry	■	■	■	■	■	■	■
Taipei Artist Village	■	■	■	■	■	■	■
Ucross Foundation Residency Program	■		■	■	■	■	■
University of Saskatchewan, Emma Lake Kenderdine Campus	■	■	■	■	■	■	■
Vermont Studio Center	■		■		■	■	
Virginia Center for the Creative Arts	■		■	■	■	■	
The Julia and David White Artists' Colony	■	■	■	■	■	■	■
Wildacres Retreat	■	■	■	■	■	■	■
Writers and Books Gell Center of the Finger Lakes	■	■	■	■	■	■	■
Writers' Colony at Dairy Hollow	■	■	■	■	■	■	■
Yaddo	■	■	■	■	■	■	■

Artistic Categories
Performing Arts

	Acting	Choreography/Dance	Composition/Music	Directing (film & theater)	Performance Art	Storytelling
18th Street Arts Center	■	■	■	■	■	■
Abrons Art Center/Henry Street Settlement						■
American Academy in Berlin	■	■	■	■	■	■
Anderson Center for Interdisciplinary Studies	■	■	■		■	■
ArtCenter/South Florida					■	
Artcroft Center for Arts and Humanities	■				■	■
Art Farm					■	
The Artist House at St. Mary's College of Maryland	■	■	■	■	■	■
Art Omi International Arts Center			■		■	
Atlantic Center for the Arts	■	■	■	■	■	■
Aurora Project			■			■
The Banff Centre/Leighton Studios	■	■	■		■	■
Bemis Center for Contemporary Arts					■	
Bogliasco Foundation	■	■	■	■	■	■
Byrdcliffe Arts Colony/Woodstock Guild			■			■
Caldera	■	■	■	■	■	■
Civitella Ranieri Foundation			■			
Djerassi Resident Artists Program		■	■		■	
Dorland Mountain Arts Colony	■	■	■	■	■	■
The Exploratorium	■	■	■	■	■	■
Isabella Stewart Gardner Museum	■	■	■	■	■	■
Hall Farm Center for Arts and Education	■		■	■	■	■
Hambidge Center for Creative Arts and Sciences	■	■	■	■	■	■
Hermitage Artists Retreat		■	■		■	■
Hopscotch House/Kentucky Foundation for Women	■	■	■	■	■	■
Jacob's Pillow Dance Festival		■				
KHN Center for the Arts			■			■
The MacDowell Colony		■	■		■	
Robert M. MacNamara Foundation			■		■	■
McColl Center for Visual Art					■	
The Mesa	■	■	■	■	■	■
Millay Colony for the Arts			■		■	
Montalvo	■	■	■	■	■	■
Montana Artists Refuge	■	■	■	■	■	■
Nantucket Island School of Design and the Arts	■	■	■	■	■	■

	Acting	Choreography/Dance	Composition/Music	Directing (film & theater)	Performance Art	Storytelling
Northwood University Alden B. Dow Creativity Center	■	■	■	■	■	■
Ragdale Foundation		■	■		■	
Red Cinder Creativity Center	■	■	■	■	■	■
Rockmirth	■	■	■	■	■	■
Sacatar Foundation	■	■	■	■	■	■
Santa Fe Art Institute	■	■	■	■	■	■
Sculpture Space					■	
Sea Change Residencies/Gaea Foundation	■	■	■	■	■	■
Lillian E. Smith Center for Creative Arts	■	■	■	■	■	■
Snug Harbor Cultural Center, Newhouse Center for Contemporary Art		■	■		■	
Stonehouse Residency for the Contemporary Arts						■
A Studio in the Woods		■	■		■	■
STUDIO for Creative Inquiry	■	■	■	■	■	■
Taipei Artist Village	■	■	■	■	■	■
Ucross Foundation Residency Program	■	■	■	■	■	■
University of Saskatchewan, Emma Lake Kenderdine Campus	■	■	■	■	■	■
Virginia Center for the Creative Arts		■	■		■	
The Julia and David White Artists' Colony	■	■	■	■	■	■
Wildacres Retreat	■	■	■		■	
Workspace for Choreographers		■			■	
Writers' Colony at Dairy Hollow						■
Yaddo	■	■	■	■	■	■
The Yard		■				

Artistic Categories
Design

	Architecture	Costume/Fashion Design	Graphic Design	Illustration	Industrial Design	Landscape Architecture	Set & Stage Design	Urban Planning
18th Street Arts Center	▫	▫	▫	▫	▫	▫	▫	▫
American Academy in Berlin	■	■	■	■	■	■	■	■
Anderson Center for Interdisciplinary Studies	▫	▫	▫	▫		▫	▫	▫
Art Farm	■				■			
The Artist House at St. Mary's College of Maryland		▫	▫	▫		▫	▫	
Artists' Enclave at I-Park	■		■	■	■			
The Art Studio Changdong and Goyang	▫	▫	▫	▫	▫	▫		▫
Atlantic Center for the Arts	■		■			■	■	
Aurora Project	▫				▫	▫	▫	▫
The Banff Centre/Leighton Studios	■	■	■	■			■	
Bogliasco Foundation	▫					▫		
The Bullseye Connection	■							
Caldera	▫	▫	▫	▫	▫	▫		▫
Djerassi Resident Artists Program	■					■	■	
Dorland Mountain Arts Colony	▫	▫	▫	▫	▫	▫	▫	▫
Fine Arts Museums of San Francisco			■					
Isabella Stewart Gardner Museum	▫	▫	▫	▫	▫	▫	▫	▫
Hall Farm Center for Arts and Education			■	■			■	
Hambidge Center for Creative Arts and Sciences	▫	▫	▫	▫	▫	▫	▫	▫
Hermitage Artists Retreat	■	■	■	■	■	■	■	■
The MacDowell Colony	▫		▫	▫	▫	▫	▫	▫
McColl Center for Visual Art	■							■
The Mesa	▫	▫	▫	▫	▫	▫	▫	▫
Montalvo	■	■	■	■	■	■	■	■
Montana Artists Refuge	▫	▫	▫	▫	▫	▫	▫	▫
Nantucket Island School of Design and the Arts	■	■	■	■	■	■	■	■
Northwood University Alden B. Dow Creativity Center	▫	▫	▫	▫	▫	▫	▫	▫
Pilchuck Glass School	■			■		■		
Ragdale Foundation		▫	▫		▫			
Red Cinder Creativity Center	■	■	■	■	■	■	■	■
Rockmirth	▫	▫	▫	▫	▫	▫	▫	▫
Sacatar Foundation	■	■	■	■	■	■	■	■
Santa Fe Art Institute	▫	▫	▫	▫	▫	▫	▫	▫
Scuola Internazionale di Grafica		■	■					

	Architecture	Costume/Fashion Design	Graphic Design	Illustration	Industrial Design	Landscape Architecture	Set & Stage Design	Urban Planning/Design
Sea Change Residencies/Gaea Foundation	■	■	■	■	■	■	■	■
Sitka Center for Art and Ecology	■	■	■	■	■	■	■	■
Lillian E. Smith Center for Creative Arts	■	■	■	■	■	■	■	■
Snug Harbor Cultural Center, Newhouse Center for Contemporary Art	■	■	■				■	
A Studio in the Woods	■					■		■
STUDIO for Creative Inquiry	■	■	■	■	■	■	■	■
Taipei Artist Village	■	■	■	■	■	■	■	■
University of Saskatchewan, Emma Lake Kenderdine Campus	■	■	■	■	■	■	■	■
Virginia Center for the Creative Arts	■				■			
The Julia and David White Artists' Colony	■	■	■	■	■	■	■	■
Wildacres Retreat	■	■	■	■	■	■	■	■
Writers' Colony at Dairy Hollow				■				

Artistic Categories
Scholarship

	Art Conservation	Art Education	Art History	Computer Science	Criticism	Environmentalism/Conservation	History	Linguistics	Mathematics	Philosophy	Preservation	Science
18th Street Arts Center	■	■	■	■								
American Academy in Berlin	■	■	■		■	■	■	■		■	■	
Anderson Center for Interdisciplinary Studies	■	■	■	■	■	■	■	■	■	■	■	■
Artcroft Center for Arts and Humanities	■	■	■	■	■	■	■	■	■	■	■	■
Art Omi International Arts Center					■							
Aurora Project	■	■	■	■	■	■	■	■	■	■	■	■
The Banff Centre/Leighton Studios	■	■	■		■							
Bogliasco Foundation	■	■	■	■	■	■	■	■	■	■	■	■
Caldera		■				■						
Djerassi Resident Artists Program		■			■							
Willard R. Espy Literary Foundation	■	■	■	■	■	■	■	■	■	■	■	■
Isabella Stewart Gardner Museum	■	■	■	■	■	■	■	■	■	■	■	■
Hall Farm Center for Arts and Education	■	■	■		■	■	■			■		
Hambidge Center for Creative Arts and Sciences	■	■	■	■	■	■	■	■	■	■	■	■
Headlands Center for the Arts		■			■	■						
Hermitage Artists Retreat	■	■	■	■	■	■	■	■	■	■	■	■
Hopscotch House/Kentucky Foundation for Women	■	■	■		■	■	■			■		
Jentel Artist Residency Program	■	■	■	■	■	■	■	■	■	■	■	■
KHN Center for the Arts		■	■									
Louisiana ArtWorks	■	■	■		■						■	
The Mesa	■	■	■	■	■	■	■	■	■	■	■	■
Montalvo	■	■	■	■	■	■	■	■	■	■	■	■
Montana Artists Refuge	■	■	■	■	■	■	■	■	■	■	■	■
Nantucket Island School of Design and the Arts	■	■	■		■	■	■	■	■	■	■	■
Northwood University Alden B. Dow Creativity Center	■	■	■	■	■	■	■	■	■	■	■	■
Pilchuck Glass School		■			■							
Ragdale Foundation						■	■			■		
Red Cinder Creativity Center	■	■	■	■	■	■	■	■	■	■	■	■
Rockmirth	■	■	■	■	■	■	■	■	■	■	■	■
Sacatar Foundation		■	■			■	■				■	
Santa Fe Art Institute	■	■	■		■	■						
Sea Change Residencies/Gaea Foundation	■	■	■	■	■	■	■	■	■	■	■	■

	Art Conservation	Art Education	Art History	Computer Science	Criticism	Environmentalism/Conservation	History	Linguistics	Mathematics	Philosophy	Preservation	Science
Sitka Center for Art and Ecology	■	■	■	■	■	■	■	■	■	■	■	■
Lillian E. Smith Center for Creative Arts	■	■	■	■	■	■	■	■	■	■	■	■
STUDIO for Creative Inquiry	■	■	■	■	■	■	■	■	■	■	■	■
Taipei Artist Village	■	■	■	■	■	■	■	■	■	■	■	■
Ucross Foundation Residency Program		■			■	■	■	■		■	■	■
University of Saskatchewan, Emma Lake Kenderdine Campus	■	■	■	■	■	■	■	■	■	■	■	■
The Julia and David White Artists' Colony	■	■	■	■	■	■	■	■	■	■	■	■
Wildacres Retreat	■	■	■	■	■	■	■	■	■	■	■	■
Writers and Books Gell Center of the Finger Lakes					■	■	■	■			■	■
Writers' Colony at Dairy Hollow							■					

Artistic Categories
Other

	Interdisciplinary Arts	Collaborative Teams (may apply as a team)	Collaborative Teams (must apply separately)	Conceptual Arts	Environmental Arts	Multimedia Arts	New Genres
18th Street Arts Center	■	■		■	■	■	■
Anderson Center for Interdisciplinary Studies	■	■		■	■		
ArtCenter/South Florida			■				
Artcroft Center for Arts and Humanities	■	■		■	■	■	■
Art Farm			■	■	■	■	
The Artist House at St. Mary's College of Maryland	■	■		■	■	■	■
Artists' Enclave at I-Park				■	■	■	■
Art Omi International Arts Center	■	■		■	■	■	■
ArtPace	■			■		■	■
The Art Studio Changdong and Goyang	■	■		■	■	■	■
Atlantic Center for the Arts	■		■	■	■	■	■
Aurora Project	■		■	■	■	■	■
The Banff Centre/Leighton Studios	■	■		■	■	■	■
Bemis Center for Contemporary Arts		■		■	■	■	■
Caldera	■			■	■	■	■
Center for Contemporary Printmaking		■					
Djerassi Resident Artists Program	■		■	■	■	■	■
Dorland Mountain Arts Colony	■			■	■		
Willard R. Espy Literary Foundation		■					
The Exploratorium	■	■		■	■	■	■
Fine Arts Museums of San Francisco		■		■	■	■	■
Fine Arts Work Center	■	■		■	■		■
Isabella Stewart Gardner Museum	■			■	■	■	■
Hall Farm Center for Arts and Education	■	■		■	■	■	■
Hambidge Center for Creative Arts and Sciences	■	■		■	■	■	■
Headlands Center for the Arts	■	■		■	■	■	■
Hermitage Artists Retreat	■	■		■	■	■	■
Hopscotch House/Kentucky Foundation for Women	■	■		■	■	■	
Jacob's Pillow Dance Festival		■					
Jentel Artist Residency Program	■		■	■	■	■	■
Kala Art Institute	■		■	■		■	■
KHN Center for the Arts	■	■					
John Michael Kohler Arts Center		■					
Lighton International Artists Exchange Program/Kansas City Artists Coalition				■	■	■	■
Louisiana ArtWorks	■	■					■
The MacDowell Colony	■		■	■	■	■	■

	Interdisciplinary Arts	Collaborative Teams (may apply as a team)	Collaborative Teams (must apply separately)	Conceptual Arts	Environmental Arts	Multimedia Arts	New Genres
Robert M. MacNamara Foundation		■		■		■	
McColl Center for Visual Art	■	■		■	■	■	■
The Mesa	■	■		■	■	■	
Millay Colony for the Arts			■	■		■	■
Montalvo	■	■		■	■	■	
Montana Artists Refuge	■	■		■	■	■	■
Nantucket Island School of Design and the Arts	■	■		■	■	■	
Northwood University Alden B. Dow Creativity Center	■	■		■	■	■	■
Pilchuck Glass School	■	■				■	
Ragdale Foundation	■	■					
Red Cinder Creativity Center	■	■		■	■		■
Rockmirth	■	■		■	■	■	■
Roswell Artist-in-Residence Program		■		■	■	■	■
Sacatar Foundation	■	■		■	■	■	■
Santa Fe Art Institute	■	■		■	■	■	■
Sculpture Space	■	■		■	■	■	■
Sea Change Residencies / Gaea Foundation	■	■		■	■	■	■
Sitka Center for Art and Ecology	■	■		■	■	■	■
Lillian E. Smith Center for Creative Arts	■	■		■	■	■	■
Snug Harbor Cultural Center, Newhouse Center for Contemporary Art	■	■			■	■	
Stonehouse Residency for the Contemporary Arts		■		■	■		■
A Studio in the Woods	■			■	■		
STUDIO for Creative Inquiry	■	■		■	■	■	■
Taipei Artist Village	■	■		■	■	■	■
Ucross Foundation Residency Program	■	■		■	■	■	■
University of Saskatchewan, Emma Lake Kenderdine Campus	■		■	■	■	■	■
Vermont Studio Center	■			■		■	
Virginia Center for the Creative Arts	■		■			■	■
Weir Farm Trust		■		■	■		
The Julia and David White Artists' Colony	■	■		■	■	■	■
Wildacres Retreat	■	■		■	■	■	■
Workspace for Choreographers			■				
Yaddo	■	■		■	■	■	■
The Yard		■					

Seasons and Deadlines

	Summer	Fall	Winter	Spring	Application Deadlines
18th Street Arts Center	■	■	■	■	Ongoing
Abrons Art Center/Henry Street Settlement	■	■	■	■	May 1
Edward F. Albee Foundation/ William Flanagan Memorial Creative Persons Center	■				April 1 (postmarked)
American Academy in Berlin		■		■	Visual Artists: December 1; all others: November 1
Anderson Center for Interdisciplinary Studies	■	■			February 1 (for Summer); March 1 (for Fall)
Anderson Ranch Arts Center		■	■		April 1
Arrowmont School of Arts and Crafts	■	■	■	■	February 15
ArtCenter/South Florida	■	■	■	■	Ongoing
Artcroft Center for Arts and Humanities	■	■	■	■	January 1 (for April–June); April 1 (for July–September); July 1 (for October–December): October 1 (for January–March)
Art Farm	■	■			April 1
The Artist House at St. Mary's College of Maryland	■	■	■	■	Ongoing (6–12 months prior to planned residency)
Artists' Enclave at I-Park	■	■		■	December/January
Art Omi International Arts Center	■	■	■	■	Visual Artists: February 1; Musicians: April 1; Writers: November 30
ArtPace	■	■	■	■	Ongoing
The Art Studio Changdong and Goyang	■	■	■	■	Ongoing
Atlantic Center for the Arts	■	■	■	■	~3 months prior to residency
Aurora Project	■	■	■	■	September 1 (for January–June); March 1 (for July–December)
The Banff Centre/Leighton Studios	■	■	■	■	Ongoing
Bemis Center for Contemporary Arts	■	■	■	■	February 28 and September 30
Bogliasco Foundation		■	■	■	January 15 (for Fall–Winter); April 15 (for Winter–Spring)
Archie Bray Foundation	■	■	■	■	Residencies: March 1; Fellowships: February 1
The Bullseye Connection	■	■	■	■	Ongoing
Byrdcliffe Arts Colony/Woodstock Guild	■				April 1
Caldera			■		June 1
Carving Studio and Sculpture Center	■				Ongoing
Center for Contemporary Printmaking	■	■	■	■	Ongoing

	Summer	Fall	Winter	Spring	Application Deadlines
Civitella Ranieri Foundation					By invitation only
The Cooper Union School of Art	■				March 1 (check Web site for updated deadlines)
Djerassi Resident Artists Program	■	■		■	February 15
Dorland Mountain Arts Colony					Check Web site for current information
Willard R. Espy Literary Foundation	■	■		■	December 1, March 1, July 1
Evergreen House	■				November 1 (postmarked)
The Exploratorium	■	■	■	■	Ongoing
Fine Arts Museums of San Francisco	■	■	■	■	Ongoing
Fine Arts Work Center		■	■	■	Creative Writers: December 1; Visual Artists: February 1
Isabella Stewart Gardner Museum	■	■	■	■	September 29
Hall Farm Center for Arts and Education	■	■			First week of February (check Web site for updates)
Hambidge Center for Creative Arts and Sciences	■	■	■	■	May 1 (for September–December); October 1 (for February–August)
Headlands Center for the Arts	■	■		■	1st Friday in June
Hedgebrook	■	■		■	October 15
Hermitage Artists Retreat	■	■	■	■	Twice annually (check Web site)
HOME, Inc.	■	■	■	■	Ongoing
Hopscotch House/Kentucky Foundation for Women	■	■	■	■	Ongoing
International School of Drawing, Painting and Sculpture		■		■	Ongoing
Jacob's Pillow Dance Festival	■	■		■	Ongoing
Jentel Artist Residency Program	■	■	■	■	September 15 and January 15
Kala Art Institute	■	■	■	■	Fellowship: May 4; Residency: Ongoing
KHN Center for the Arts	■	■	■		March 1, May 15, October 1
John Michael Kohler Arts Center	■	■	■	■	August 1 (postmarked)
Lighton International Artists Exchange Program/Kansas City Artists Coalition					March 1
Louisiana ArtWorks	■	■	■	■	Ongoing
The MacDowell Colony	■	■	■	■	January 15 (for Summer); April 15 (for Fall); September 15 (for Winter/Spring)
Robert M. MacNamara Foundation	■	■	■	■	September
The Mattress Factory	■	■	■	■	Ongoing

continued on next page

Seasons and Deadlines

continued from previous page

	Summer	Fall	Winter	Spring	Application Deadlines
McColl Center for Visual Art		■	■		May 1
The Mesa					Ongoing
Millay Colony for the Arts	■	■		■	October 1
Montalvo	■	■	■	■	By invitation only
Montana Artists Refuge	■	■	■	■	January 15 (for May–August); May 15 (for September–December); August 15 (for January–April); received-by deadlines
Nantucket Island School of Design and the Arts	■	■	■	■	Ongoing
Northwood University Alden B. Dow Creativity Center	■				December 31 (postmarked)
Oregon College of Art and Craft	■	■		■	April 1
Penland School of Crafts	■	■	■	■	October 30
Pilchuck Glass School	■	■	■	■	Varies
Prairie Center of the Arts					Contact organization for information
Ragdale Foundation	■	■	■	■	January 15 and June 1
Red Cinder Creativity Center	■	■	■	■	Ongoing
Rockmirth					Ongoing
Roswell Artist-in-Residence Program	■	■	■	■	Varies
Sacatar Foundation		■	■	■	April 10 (postmarked) (confirm on Web site)
Santa Fe Art Institute	■	■	■	■	January 5 and July 5
Sculpture Space	■	■	■	■	November 1 (received-by deadline)
Scuola Internazionale di Grafica	■	■	■	■	Ongoing
Sea Change Residencies/Gaea Foundation					By nomination only
Sitka Center for Art and Ecology		■	■	■	April 21
Lillian E. Smith Center for Creative Arts	■				May 1
Snug Harbor Cultural Center, Newhouse Center for Contemporary Art	■	■	■	■	Ongoing
Stonehouse Residency for the Contemporary Arts	■				February 1
A Studio in the Woods		■	■	■	Varies
STUDIO for Creative Inquiry	■	■	■	■	Ongoing
Taipei Artist Village	■	■	■	■	End of the year
Ucross Foundation Residency Program		■		■	March 1 (for Fall); October 1 (for Spring)
University of Saskatchewan, Emma Lake Kenderdine Campus	■	■			Ongoing

	Summer	Fall	Winter	Spring	Application Deadlines
Vermont Studio Center	■	■	■	■	February 15, April 1, June 15, October 1
Virginia Center for the Creative Arts	■	■	■	■	January 15, May 15, September 15
Weir Farm Trust	■	■	■	■	January 15 (for May–October); July 15 (for November–April)
The Julia and David White Artists' Colony	■	■	■	■	Ongoing
Wildacres Retreat	■	■			February 15
Women's Studio Workshop	■	■	■	■	Fellowship residencies: March 15 and November 1; Studio residencies: April 1; Artist's Book residencies: November 15
Workspace for Choreographers	■	■		■	October 1 (for March–April); February 1 (for May–August); June 1 (for September–November)
Writers and Books Gell Center of the Finger Lakes	■	■	■	■	Ongoing
Writers' Colony at Dairy Hollow	■	■	■	■	Ongoing
Yaddo	■	■	■	■	January 1 and August 1
The Yard	■	■		■	Early November

Fees and Stipends

	ARTIST RESPONSIBLE FOR					
	Application Fee	Residency Fee	Food	Materials	Travel	Other
18th Street Arts Center			All	■	■	Studio rent for local artists and organization
Abrons Art Center/Henry Street Settlement				*	
Edward F. Albee Foundation/William Flanagan Memorial Creative Persons Center			All	■	■
American Academy in Berlin			Some	■		
Anderson Center for Interdisciplinary Studies				■	■
Anderson Ranch Arts Center	$10	$875/month	Some	■	■	$250/monthly studio fee
Arrowmont School of Arts and Crafts	$25		Some	■		$175 refundable damage security deposit.
ArtCenter/South Florida			All	■		Studio rent: $8.50–$11.50
Artcroft Center for Arts and Humanities	$25	$40/daily		■	■	Deposit: 10% of residency fee. Special dietary needs
Art Farm			All	■	■
The Artist House at St. Mary's College of Maryland			All	■	■
Artists' Enclave at I-Park	$20		All	■	■
Art Omi International Arts Center				■	■
ArtPace			*		
The Art Studio Changdong and Goyang			All	■	■
Atlantic Center for the Arts	$25	$850	Some	■	■	Specialized materials.
Aurora Project	$20	$25/day (suggested)	Some	■	■	Applicants won't be turned away due to an inability to pay.
The Banff Centre/Leighton Studios		$51 CAD /day	Some	■	■	Studio fee $53 CAD/day. Deposit $100 CAD. Equipment rental and/or additional tech needs.
Bemis Center for Contemporary Arts	$35		All	■	■	Deposit: $150.
Bogliasco Foundation				■	■
Archie Bray Foundation	$20		All	■	■	Application fee is for residencies. No fellowship application fee. Responsible for firing cost

Stipends	Fellowships & Grants	Housing
Varies according to sponsorship.	Varies.	Varies.
Materials stipend.	
.	▪
Round-trip to/from Berlin provided. General stipend: $3,000–$5,000.	■
.	Available to emerging artists and writers from NYC and MN during July.	▪
.	Joseph Fellowship for U.S. citizens of racial minority.	■
General stipend: $300/month. Travel assistance: $900, dependent on proposal submission/approval.	Trabue Family Scholarship for Women; $1,500 awarded based on need.	▪
.	
.	Work study for general assistance; reduced fees/waivers available to those of demonstrated needs.	▪
.	■
Limited general stipend. Limited travel assistance.	▪
.	■
.	▪
Materials stipend. General stipend for living expenses.	■
.	▪
.	Full and partial scholarships available.	■
.	▪
.	Discount studio fee available.	■
General stipend.	▪
.	■
.	

Fees and Stipends

continued from previous page

	ARTIST RESPONSIBLE FOR					
	Application Fee	Residency Fee	Food	Materials	Travel	Other
The Bullseye Connection			All		■
Byrdcliffe Arts Colony/Woodstock Guild	$5	$600	All	■	■
Caldera	$15		All	■	■	Specialized equipment.
Carving Studio and Sculpture Center			Some	■	■	
Center for Contemporary Printmaking	$25	$600/week	All	■	■
Civitella Ranieri Foundation					
The Cooper Union School of Art	$25	$2,500	Some	■	■	Deposit: $1,250.
Djerassi Resident Artists Program	$25			■	■	Personal amenities.
Dorland Mountain Arts Colony						Contact organization for current information.
Willard R. Espy Literary Foundation	$15		Some	■	■
Evergreen House			All	■	■
The Exploratorium			*		
Fine Arts Museums of San Francisco			All	■	■	Equipment.
Fine Arts Work Center	$35		All	■	■	Deposit for pets only: $100, nonrefundable.
Isabella Stewart Gardner Museum			All		
Hall Farm Center for Arts and Education	$20			■	■	
Hambidge Center for Creative Arts and Sciences	$20	$125/week	Some	■	■
Headlands Center for the Arts	$15		Some	■	■	Deposit: $10 keys, $100 car.
Hedgebrook	$15				■
Hermitage Artists Retreat	$20	Voluntary		■	■
HOME, Inc.			All		
Hopscotch House/Kentucky Foundation for Women			All	■	■
International School of Drawing, Painting and Sculpture	$40 (USA)	€700/week		■		Deposit.
Jacob's Pillow Dance Festival			All	■	■
Jentel Artist Residency Program	$20		Some*	■	*	Deposit: $100.

*Artist responsible for obtaining; stipend provided to subsidize costs.

Stipends	Fellowships & Grants	Housing
Materials stipend.	
.	Writers under the age of 35 in need of financial assistance may apply for $100 scholarship from Patterson Fund.	▪
.	▪
General stipend.	▪
.	▪
All travel, lodging, and meals provided.	▪
.	▪
.	Check Web site.	▪
.	Current info N/A; see Web site for more information.	▪
General stipend: $400.		▪
General stipend: $2,000 (see profile for more information).	▪
Stipends available to cover all costs.	▪
Materials stipend: $10/day. General stipend: $50/day.	
Housing stipend available. General stipend: $650/month.	▪
Travel assistance to/from Boston. Housing stipend: $50/day. General stipend: $7,000.	▪
.	▪
.	See profile for more information.	▪
General stipend: $500/month.	▪
Limited travel assistance available.	▪
Housing and general stipend available.	▪
.	
Limited travel assistance and general stipend available based on financial need.	▪
.	Available to former students and faculty of the school.	▪
.	▪
General stipend: $400.	▪

Fees and Stipends

continued from previous page

ARTIST RESPONSIBLE FOR	Application Fee	Residency Fee	Food	Materials	Travel	Other
Kala Art Institute			All	■	■	Deposit: $100. Studio fee for non-fellowship artists: $125-$340/month
KHN Center for the Arts	$25		All		
John Michael Kohler Arts Center			All		
Lighton International Artists Exchange Program/Kansas City Artists Coalition						Varies according to program.
Louisiana ArtWorks			All			Please check Web site regarding associated cost
The MacDowell Colony	$20			■	■
Robert M. MacNamara Foundation				*	*
The Mattress Factory			*		
McColl Center for Visual Art					*	Deposit: $200 refundable
The Mesa			*	■	■	Shipping of materials/supplies, long distance telephone, and Internet service.
Millay Colony for the Arts	$20		Some	■	■
Montalvo						Costs of travel for spouse/partner and children.
Montana Artists Refuge		$450-$550	All	■	■	Check Web site for current residency fee. Deposit: $200.
Nantucket Island School of Design and the Arts	$30	Varies	All	■	■	See profile for housing fees and additional costs.
Northwood University Alden B. Dow Creativity Center	$10		Some	*	*
Oregon College of Art and Craft			All	*	*
Penland School of Crafts	$25		All			Deposit: $100 on housing and on studio.
Pilchuck Glass School	$35	Varies	■	■	■	Deposit: Varies. See profile.
Prairie Center of the Arts	$35		All	■	■	Deposit: $100.
Ragdale Foundation	$30	$25/day		■	■	Deposit: $100 for 2-week period.

Organization Provides: Stipends	Fellowships & Grants	Housing
	Fellowship stipend: $2,000.	
		■
General stipend: $140/week. Travel, housing, and materials provided.		■
	Varies according to program.	■
Please check Web site for stipend and fellowship availabilities.		
Travel assistance available as needed.	Writers' aid based on need.	■
Travel/materials stipend provided.		■
Organization supports all costs.		■
Travel is fully refundable upon arrival. Materials stipend $2,000. Housing stipend provided. General stipend $3,300.		■
Materials stipend available for public activities only. Travel assistance available. General stipend is limited. Per diem for food.	Small fee for participation in public activities.	■
		■
		■
	See profile for list.	■
Seasonal work-exchange may be available; please check with organization.		■
Travel assistance: $500. Materials stipend: $750. General stipend: up to total of $1,750 for 10-week residency.		■
Travel assistance: $500. Materials stipend: Junior Residency—$500; Senior Residency—Residency—$200. General stipend: Junior Residency—$1,200; Senior Residency—$750.		■
		■
Limited stipends available.		■
Stipends to be determined. Please contact organization.		
Housing stipend available.	See profile for more info.	■

Fees and Stipends

continued from previous page

	Application Fee	Residency Fee	Food	Materials	Travel	Other
Red Cinder Creativity Center	$25	$20/day	$20/day	■	■	Hawaiian taxes on food and lodging as applicable.
Rockmirth	$20	$500–$800/month	Some	■	■	Deposit: $250. Residency fee based on a sliding scale.
Roswell Artist-in-Residence Program	$25		All	■	■
Sacatar Foundation	$35			■		Visa fees.
Santa Fe Art Institute	$25	$1,000/month	All	■	■	Refundable key deposit: $150.
Sculpture Space			All	■	■
Scuola Internazionale di Grafica		€3,100/4 weeks	All	■	■	Deposit: €700.
Sea Change Residencies/Gaea Foundation			All		
Sitka Center for Art and Ecology			All	■	■	Deposit: $50–$100 for cleaning/repairs.
Lillian E. Smith Center for Creative Arts		$100/week	Some	■	■	Long-distance telephone costs.
Snug Harbor Cultural Center, Newhouse Center for Contemporary Art	$15		All	■	■	All residencies require outside funding. Assistance in seeking funds is provided.
Stonehouse Residency for the Contemporary Arts						Deposit: $150 applied to contribution. Contribution toward food and consumables: $300.
A Studio in the Woods	$20	$20/day	Some	■	■	Deposit $100.
STUDIO for Creative Inquiry			All	*	■
Taipei Artist Village			All		
Ucross Foundation Residency Program	$20		Some	■	■	Refundable deposit: $50.
University of Saskatchewan, Emma Lake Kenderdine Campus		$300 CAD		■	■	Specialized equipment.

Column headers: ARTIST RESPONSIBLE FOR

*Artist responsible for obtaining; stipend provided to subsidize costs.

Stipends	Fellowships & Grants	Housing
		■
	Please contact organization for more info.	■
General stipend: $500/month (additional $100/month for each dependent living with artist). Materials grant: $1,200/year possible.		■
Travel assistance provided.	UNESCO/Aschberg provides $200/month to artists in specific disciplines and specific international regions for materials/expenses.	■
Sliding-scale residency fee waivers available (90% of accepted artists receive some form of financial support).		■
Travel assistance/stipend: $100 for NYS artists only. General stipend: $2,000 to be applied toward materials and living expenses.	Special demographic or culture specific-grants may be available.	■
	Partial fellowships available based on merit and need and may cover 1/4–1/2 of the residency fee depending on the season.	■
Travel assistance: round-trip air, rail, or mileage reimbursement. General stipend: $600/week.		■
	Support for composers/performers on the recorder.	■
		■
Housing stipend. General stipend: $200 to cover shipping of artwork.		■
		■
	Organization will collaborate with artists for grants.	■
Travel assistance. Materials stipend.	Artists are paid a salary and usually given a project fund.	
Travel assistance. Materials stipend: $600/month. General stipend: $35/day.		■
		■
		■

Fees and Stipends

continued from previous page

	Application Fee	Residency Fee	Food	Materials	Travel	Other
Vermont Studio Center	$25	$3,500/month			
Virginia Center for the Creative Arts	$25	$30/day (suggested)		■	■	Deposit: $50.
Weir Farm Trust	$25		All	■	■	Refundable deposit: $75.
The Julia and David White Artists' Colony	$40	$550/month	Some	■	■	Deposit: $275 (due at the time residency is scheduled). Food: ~$150/month.
Wildacres Retreat			Some	■	■
Women's Studio Workshop			All	■		Fellowships: $200/week.
Workspace for Choreographers			All		■	Refundable deposit: $50 refundable.
Writers and Books Gell Center of the Finger Lakes		$35/day	All	■	■	Deposit: $100.
Writers' Colony at Dairy Hollow	$35	$20/day minimum donation		■	■	Deposit: $100.
Yaddo	$20			*	
The Yard	$20		All		

Stipends	Fellowships & Grants	Housing
Some awards offer travel expenses and materials.	Full and partial fellowships as well as work-exchange fellowships available.	■
.	Fully funded residencies occasionally available. Call for details on possible opportunities.	■
General stipend: $500/month.	■
.	■
.	■
Travel assistance. Materials stipend. General stipend. Housing stipend.	Studio residency and Artist's Book residency receive stipend for travel and materials and a $2,000 general stipend.	■
Travel assistance for car rental only.	■
.	■
.	Details on Web site.	■
Travel assistance. Materials stipend.	■
General stipend: $1,200, individuals; $4,000, companies.	■

Accessibility

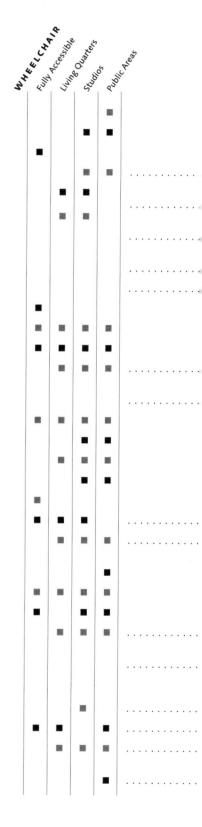

	Fully Accessible	Living Quarters	Studios	Public Areas
18th Street Arts Center				■
Abrons Art Center / Henry Street Settlement			■	■
American Academy in Berlin	■			
Anderson Center for Interdisciplinary Studies			■	■
Anderson Ranch Arts Center		■	■	
Arrowmont School of Arts and Crafts		■	■	
Artcroft Center for Arts and Humanities				
Art Farm				
The Artist House at St. Mary's College of Maryland				
Art Omi International Arts Center	■			
ArtPace	■	■	■	■
Atlantic Center for the Arts	■	■	■	■
Aurora Project		■	■	■
The Banff Centre / Leighton Studios				
Bemis Center for Contemporary Arts	■	■	■	■
Archie Bray Foundation			■	■
Caldera		■	■	■
Carving Studio and Sculpture Center			■	■
Center for Contemporary Printmaking	■			
The Cooper Union School of Art	■	■	■	
Djerassi Resident Artists Program		■	■	■
Evergreen House				■
The Exploratorium	■	■	■	■
Fine Arts Museums of San Francisco	■		■	■
Fine Arts Work Center		■	■	■
Isabella Stewart Gardner Museum				
Hall Farm Center for Arts and Education			■	
Hambidge Center for Creative Arts and Sciences	■	■		■
Headlands Center for the Arts		■	■	■
Hedgebrook			■	

continued on next page

Comments	Accessibility for the Visually Impaired	Accessibility for the Hearing Impaired
Main floor of residence only.		
Avg. 150" of snow/year; outside paths difficult to maneuver in wheelchair.		
Will work to accommodate individuals with special needs with prior notice.		
Working to expand accessibility.		
Working to expand accessibility.		
One general studio and the photography studio are not accessible at this time.	■	■
Working to expand accessibility.		
Ramps and handicapped lifts.		
Landscape is steep and rugged; trails are not easily accessible.		
Studio and living quarters' accessibility limited to first floor access.		
The Museum and the collections are fully accessible to wheelchairs; the artist apartment is not.		
Discuss needs with director.		
Some studios have limited access.		
Limited accessibility in some studio and public areas.		
Will do best to accommodate special needs in cottages.		

Accessibility

continued from previous page

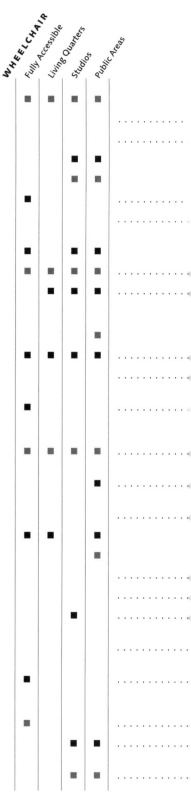

Accessibility — WHEELCHAIR

	Fully Accessible	Living Quarters	Studios	Public Areas
Hermitage Artists Retreat	■	■	■	■
HOME, Inc.				
Hopscotch House/Kentucky Foundation for Women				
Jacob's Pillow Dance Festival			■	■
Kala Art Institute			■	■
KHN Center for the Arts	■			
Lighton International Artists Exchange Program/Kansas City Artists Coalition				
Louisiana ArtWorks	■		■	■
The MacDowell Colony	■	■	■	
Robert M. MacNamara Foundation		■	■	■
The Mattress Factory			■	
McColl Center for Visual Art	■	■	■	■
The Mesa				
Millay Colony for the Arts	■			
Montalvo	■	■	■	■
Montana Artists Refuge				■
Nantucket Island School of Design and the Arts				
Northwood University Alden B. Dow Creativity Center	■	■		■
Oregon College of Art and Craft				■
Penland School of Crafts				
Ragdale Foundation				
Rockmirth			■	
Roswell Artist-in-Residence Program				
Sacatar Foundation	■			
Santa Fe Art Institute	■			
Sculpture Space			■	■
Scuola Internazionale di Grafica			■	■

 continued on next page

Comments	Accessibility for the Visually Impaired	Accessibility for the Hearing Impaired	Comments
Theater is accessible.			
One downstairs bedroom/bathroom is accessible.			
One upstairs apartment is inaccessible.			
Accessibility varies per residency location.			
Not all studios are accessible.			
Main building fully accessible. Elevator access to living quarters, studio, and workshop. Wheelchair-accessible shower.			Will make every effort to accommodate hearing- and visually-impaired artists.
. .	■		
Working to expand accessibility. Public activities held in accessible spaces.			
Facility is a universal design.	■	■	Please contact organization for details regarding facilities for the hearing- and visually-impaired.
Four out of ten studios and living quarters are fully accessible.	■	■	
Working to expand accessibility. One apartment and studio are accessible.			
Partial accessibility in studios and living quarters.			
Four ground-floor studios are accessible.			
New fully accessible live/work studio.			Accommodations made upon request.
Living areas attached to studio and common areas are accessible.			
Needed modifications will be made when and if necessary.			
Artists with wheelchairs are scheduled during the dry season (September-February). Terrain can be difficult to maneuver in wheelchair.			
. .	■		
Housing and artists' office location are not accessible.			
Living quarters are not accessible. City can be difficult to maneuver in wheelchair.			

Accessibility

continued from previous page

	WHEELCHAIR			
	Fully Accessible	Living Quarters	Studios	Public Areas
Sea Change Residencies/Gaea Foundation				
Sitka Center for Art and Ecology			■	■
Lillian E. Smith Center for Creative Arts		■		
Snug Harbor Cultural Center, Newhouse Center for Contemporary Art	■			■
A Studio in the Woods				■
STUDIO for Creative Inquiry				■
Taipei Artist Village		■	■	■
Ucross Foundation Residency Program	■			
University of Saskatchewan, Emma Lake Kenderdine Campus	■	■	■	■
Vermont Studio Center		■	■	■
Virginia Center for the Creative Arts	■			
Weir Farm Trust				
Women's Studio Workshop				■
Workspace for Choreographers		■	■	
Writers and Books Gell Center of the Finger Lakes				■
Writers' Colony at Dairy Hollow				■
Yaddo	■			

Comments	Accessibility for the Visually Impaired	Accessibility for the Hearing Impaired
Efforts made to accommodate wheelchair users.		
Limited accessibility.		
Limited accessibility in living quarters.		
Limited accessibility.		
Working to expand accessibility.		
. .	■	■
Working to expand accessibility.		
Limited accessibility.		
Some locations are accessible depending on the season.		

Companions Allowed

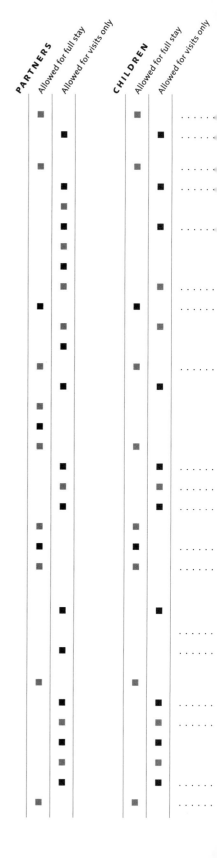

	PARTNERS	Allowed for full stay	Allowed for visits only	CHILDREN	Allowed for full stay	Allowed for visits only
18th Street Arts Center	■			■		
Edward F. Albee Foundation/William Flanagan Memorial Creative Persons Center		■			■	
American Academy in Berlin	■			■		
Anderson Center for Interdisciplinary Studies		■			■	
Anderson Ranch Arts Center		■				
Arrowmont School of Arts and Crafts		■			■	
Art Farm		■				
The Artist House at St. Mary's College of Maryland		■				
Artists' Enclave at I-Park		■			■	
ArtPace	■			■		
The Art Studio Changdong and Goyang		■			■	
Atlantic Center for the Arts		■				
The Banff Centre/Leighton Studios	■			■		
Bemis Center for Contemporary Arts		■			■	
Bogliasco Foundation	■					
Center for Contemporary Printmaking	■					
Civitella Ranieri Foundation	■			■		
The Cooper Union School of Art		■			■	
Dorland Mountain Arts Colony		■			■	
Willard R. Espy Literary Foundation		■			■	
Evergreen House	■			■		
The Exploratorium	■			■		
Fine Arts Work Center	■			■		
Isabella Stewart Gardner Museum		■			■	
Hall Farm Center for Arts and Education						
Headlands Center for the Arts		■				
Jacob's Pillow Dance Festival	■			■		
Jentel Foundation		■			■	
KHN Center for the Arts		■			■	
John Michael Kohler Arts Center		■			■	
The MacDowell Colony		■			■	
Robert M. MacNamara Foundation		■			■	
McColl Center for Visual Art	■			■		

continued on next page

Companions Allowed

continued from previous page

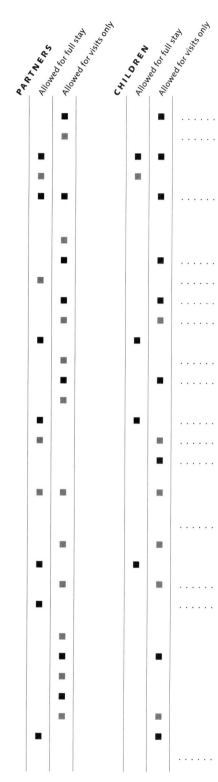

	PARTNERS — Allowed for full stay	PARTNERS — Allowed for visits only	CHILDREN — Allowed for full stay	CHILDREN — Allowed for visits only
The Mesa		■	■
Millay Colony for the Arts		■	
Montalvo	■		■	■
Montana Artists Refuge	■		■	
Nantucket Island School of Design and the Arts	■	■		■
Northwood University Alden B. Dow Creativity Center		■		
Oregon College of Art and Craft		■	■
Penland School of Crafts	■		
Pilchuck Glass School		■	■
Rockmirth		■	■
Roswell Artist-in-Residence Program	■		■	
Sacatar Foundation		■	
Santa Fe Art Institute		■	■
Sculpture Space		■		
Sea Change Residencies/Gaea Foundation	■		■
Sitka Center for Art and Ecology	■		■
Lillian E. Smith Center for Creative Arts			■
Snug Harbor Cultural Center, Newhouse Center for Contemporary Art	■	■	■	
Stonehouse Residency for the Contemporary Arts			
A Studio in the Woods		■	■	
STUDIO for Creative Inquiry	■		■	
Taipei Artist Village		■	■
University of Saskatchewan, Emma Lake Kenderdine Campus	■		
Vermont Studio Center		■		
Virginia Center for the Creative Arts		■	■	
Weir Farm Trust		■		
The Julia and David White Artists' Colony		■		
Workspace for Choreographers		■	■	
Writers and Books Gell Center of the Finger Lakes	■		■	
The Yard			

Comments	PETS Allowed	Comments
Depending on length of residency.		
No overnight stays on premises.		
Spouses/partners allowed full stay if partner is also an artist-in-residence; otherwise, spouses/partners limited to visits only.	■	Limited space, restrictions and fees apply.
Visits should be limited to long weekends.		
Limited space. Additional fees may apply.	■	Prior permission required. Restrictions apply.
Must pay for all meals.		
Contact organization for details.		
Visits may be arranged by special request.		
Children allowed in special circumstances.		
Limited space.		
Limited space.		
Negotiable.	■	Contact organization.
Contact organization.		
Contact organization.		
Spouses/partners allowed visits for 1/3 of residency.		
Spouses/partners are required to pay full meal and accommodation rates.		
Restrictions apply. Contact organization.		

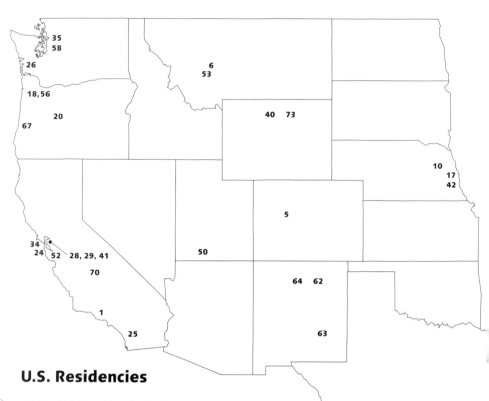

U.S. Residencies

1 **18th Street Arts Center** Santa Monica, CA

2 **Abrons Art Center/Henry Street Settlement** New York, NY

3 **Edward F. Albee Foundation/William Flanagan Memorial Creative Persons Center** Montauk, NY

4 **Anderson Center for Interdisciplinary Studies** Red Wing, MN

5 **Anderson Ranch Arts Center** Snowmass Village, CO

6 **Archie Bray Foundation** Helena, MT

7 **Arrowmont School of Arts and Crafts** Gatlinburg, TN

8 **ArtCenter/South Florida** Miami Beach, FL

9 **Artcroft Center for Arts and Humanities** Carlisle, KY

10 **Art Farm** Marquette, NE

11 **The Artist House at St. Mary's College of Maryland** St. Mary's City, MD

12 **Artists' Enclave at I-Park** East Haddam, CT

13 **Art Omi International Arts Center** Omi, NY

14 **ArtPace** San Antonio, TX

15 **Atlantic Center for the Arts** New Smyrna Beach, FL

16 **Aurora Project** Aurora, WV

17 **Bemis Center for Contemporary Arts** Omaha, NE

18 **The Bullseye Connection** Portland, OR

19 **Byrdcliffe Arts Colony/ Woodstock Guild** Woodstock, NY

20 **Caldera** Sisters, OR

21 **Carving Studio and Sculpture Center** West Rutland, VT

22 **Center for Contemporary Printmaking** Norwalk, CT

23 **The Cooper Union School of Art** New York, NY

24 **Djerassi Resident Artists Program** Woodside, CA

25 **Dorland Mountain Arts Colony** Temecula, CA

26 **Willard R. Espy Literary Foundation** Oysterville, WA

27 **Evergreen House** Baltimore, MD

28 **The Exploratorium** San Francisco, CA

29 **Fine Arts Museums of San Francisco** San Francisco, CA

30 **Fine Arts Work Center** Provincetown, MA

31 **Isabella Stewart Gardner Museum** Boston, MA

32 **Hall Farm Center for Arts and Education** Townshend, VT

33 **Hambidge Center for Creative Arts and Sciences** Rabun Gap, GA

34 **Headlands Center for the Arts** Sausalito, CA

35 **Hedgebrook** Langley, WA

36 **Hermitage Artists Retreat** Englewood, FL

37 **HOME, Inc.** Boston, MA

38 **Hopscotch House/Kentucky Foundation for Women** Prospect, KY

39 **Jacob's Pillow Dance Festival** Lee, MA

40 **Jentel Artist Residency Program** Banner, WY

41 **Kala Art Institute** Berkeley, CA

42 **KHN Center for the Arts** Nebraska City, NE

43 **John Michael Kohler Arts Center** Sheboygan, WI

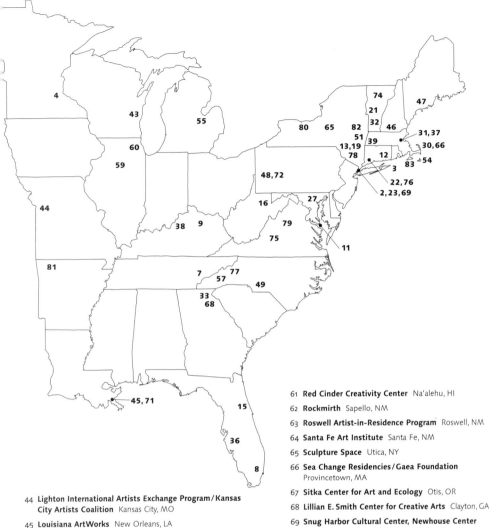

61 **Red Cinder Creativity Center** Na'alehu, HI

62 **Rockmirth** Sapello, NM

63 **Roswell Artist-in-Residence Program** Roswell, NM

64 **Santa Fe Art Institute** Santa Fe, NM

65 **Sculpture Space** Utica, NY

66 **Sea Change Residencies/Gaea Foundation** Provincetown, MA

67 **Sitka Center for Art and Ecology** Otis, OR

68 **Lillian E. Smith Center for Creative Arts** Clayton, GA

69 **Snug Harbor Cultural Center, Newhouse Center for Contemporary Art** Staten Island, NY

70 **Stonehouse Residency for the Contemporary Arts** Miramonte, CA

71 **A Studio in the Woods** New Orleans, LA

72 **STUDIO for Creative Inquiry** Pittsburgh, PA

73 **Ucross Foundation Residency Program** Clearmont, WY

74 **Vermont Studio Center** Johnson, VT

75 **Virginia Center for the Creative Arts** Amherst, VA

76 **Weir Farm Trust** Wilton, CT

77 **Wildacres Retreat** Little Switzerland, NC

78 **Women's Studio Workshop** Rosendale, NY

79 **Workspace for Choreographers** Sperryville, VA

80 **Writers and Books Gell Center of the Finger Lakes** Rochester, NY

81 **Writers' Colony at Dairy Hollow** Eureka Springs, AR

82 **Yaddo** Saratoga Springs, NY

83 **The Yard** Chilmark, MA

44 **Lighton International Artists Exchange Program/Kansas City Artists Coalition** Kansas City, MO

45 **Louisiana ArtWorks** New Orleans, LA

46 **The MacDowell Colony** Peterborough, NH

47 **Robert M. MacNamara Foundation** Westport Island, ME

48 **The Mattress Factory** Pittsburgh, PA

49 **McColl Center for Visual Art** Charlotte, NC

50 **The Mesa** Springdale, UT

51 **Millay Colony for the Arts** Austerlitz, NY

52 **Montalvo** Saratoga, CA

53 **Montana Artists Refuge** Basin, MT

54 **Nantucket Island School of Design and the Arts** Nantucket, MA

55 **Northwood University Alden B. Dow Creativity Center** Midland, MI

56 **Oregon College of Art and Craft** Portland, OR

57 **Penland School of Crafts** Penland, NC

58 **Pilchuck Glass School** Stanwood, WA

59 **Prairie Center of the Arts** Peoria, IL

60 **Ragdale Foundation** Lake Forest, IL

U.S. Residencies
Regions

Northwest

Archie Bray Foundation **MT**

The Bullseye Connection **OR**

Caldera **OR**

Willard R. Espy Literary Foundation **WA**

Hedgebrook **WA**

Montana Artists Refuge **MT**

Oregon College of Art and Craft **OR**

Pilchuck Glass School **WA**

Sitka Center for Art and Ecology **OR**

California / Hawaii

18th Street Arts Center **CA**

Djerassi Resident Artists Program **CA**

Dorland Mountain Arts Colony **CA**

The Exploratorium **CA**

Fine Arts Museums of San Francisco **CA**

Headlands Center for the Arts **CA**

Kala Art Institute **CA**

Montalvo **CA**

Red Cinder Creativity Center **HI**

Stonehouse Residency
for the Contemporary Arts **CA**

Rocky Mountain / Southwest

Anderson Ranch Arts Center **CO**

ArtPace **TX**

Jentel Artist Residency Program **WY**

The Mesa **UT**

Rockmirth **NM**

Roswell Artist-in-Residence Program **NM**

Santa Fe Art Institute **NM**

Ucross Foundation Residency Program **WY**

Midwest

Anderson Center for Interdisciplinary Studies **MN**

Art Farm **NE**

Bemis Center for Contemporary Arts **NE**

KHN Center for the Arts **NE**

John Michael Kohler Arts Center **WI**

Lighton International Artists Exchange
Program / Kansas City Artists Coalition **MO**

Prairie Center of the Arts **IL**

Ragdale Foundation **IL**

Southeast

Arrowmont School of Arts and Crafts **TN**

ArtCenter / South Florida **FL**

Artcroft Center for Arts and Humanities **KY**

The Artist House at St. Mary's College
of Maryland **MD**

Atlantic Center for the Arts **FL**

Aurora Project **WV**

Evergreen House **MD**

Hambidge Center for
Creative Arts and Sciences **GA**

Hermitage Artists Retreat **FL**

Hopscotch House / Kentucky Foundation
for Women **KY**

Louisiana ArtWorks **LA**

McColl Center for Visual Art **NC**

Penland School of Crafts **NC**

Lillian E. Smith Center for the Creative Arts **GA**

A Studio in the Woods **LA**

Virginia Center for the Creative Arts **VA**

Wildacres Retreat **NC**

Workspace for Choreographers **VA**

Writers' Colony at Dairy Hollow **AR**

Northeast

Abrons Art Center/Henry Street Settlement **NY**

Edward F. Albee Foundation/William Flanagan
Memorial Creative Persons Center **NY**

Artists' Enclave at I-Park **CT**

Art Omi International Arts Center **NY**

Byrdcliffe Arts Colony/Woodstock Guild **NY**

Carving Studio and Sculpture Center **VT**

Center for Contemporary Printmaking **CT**

The Cooper Union School of Art **NY**

Fine Arts Work Center **MA**

Isabella Stewart Gardner Museum **MA**

Hall Farm Center for Arts and Education **VT**

HOME, Inc. **MA**

Jacob's Pillow Dance Festival **MA**

The MacDowell Colony **NH**

Robert M. MacNamara Foundation **ME**

The Mattress Factory **PA**

Millay Colony for the Arts **NY**

Nantucket Island School of Design and the Arts **MA**

Sculpture Space **NY**

Sea Change Residencies/Gaea Foundation **MA**

Snug Harbor Cultural Center, Newhouse Center for
Contemporary Art **NY**

STUDIO for Creative Inquiry **PA**

Vermont Studio Center **VT**

Weir Farm Trust **CT**

Women's Studio Workshop **NY**

Writers and Books Gell Center of the Finger Lakes **NY**

Yaddo **NY**

The Yard **MA**

About the Alliance of Artists Communities

The Alliance of Artists Communities contributes to America's creative vitality by supporting our membership of diverse residency programs and advocating for creative environments that advance the endeavors of artists. The Alliance is the only national service organization supporting the field of artists' communities. Cultivating new art and ideas—which cross boundaries posed by discipline, religion, race, ethnicity, gender, class, age, and physical ability—is the fundamental work of artists' communities. Supporting artists' communities in this work, as well as acting as a collective voice for the field, is the work of the Alliance.

The Alliance of Artists Communities grew out of the MacArthur Foundation's 1990 program entitled "Special Initiative on Artists' Colonies, Communities, and Residencies." The eighteen recipients of grants under this one-time program formed the Alliance in 1992 with seed money from the MacArthur Foundation and the National Endowment for the Arts. The Alliance has now grown to more than two hundred members. Since its founding, the Alliance has presented two national symposia exploring the topic of creativity, and released narrative reports synthesizing the ideas discussed: *American Creativity at Risk* in 1996 and *The Future of Creativity* in 2001. Additional projects have included research on program and management practices in the field designed to promote positive practices among artists' community administrators, and numerous professional development seminars for the field enabling greater and better support for individual artists.

The Alliance is supported by dues from its members and contributions from the Patrons Council, as well as private foundations and other individuals. Our membership includes professionally run artists' communities, other nonprofit organizations that support artists in the development of their work, and individuals.

Books from Allworth Press

Allworth Press is an imprint of Allworth Communications, Inc.

The Artist-Gallery Partnership: A Practical Guide to Consigning Art, Revised Edition
by Tad Crawford and Susan Mellon (paperback, 6 x 9, 216 pages, $16.95)

The Artist's Quest for Inspiration, Second Edition
by Peggy Hadden (paperback, 6 x 9, 288 pages, $19.95)

Caring for Your Art: A Guide for Artists, Collectors, Galleries and Art Institutions, Third Edition
by Jill Snyder (paperback, 6 x 9, 256 pages, $19.95)

How to Grow as an Artist
by Daniel Grant (paperback, 6 x 9, 240 pages, $16.95)

Legal Guide for the Visual Artist, Fourth Edition
by Tad Crawford (paperback, 8 1/2 x 11, 272 pages, $19.95)

The Fine Artist's Guide to Marketing and Self-Promotion, Revised Edition
by Julius Vitali (paperback, 6 x 9, 256 pages, $19.95)

The Fine Artist's Career Guide, Second Edition
by Daniel Grant (paperback, 6 x 9, 320 pages, $19.95)

The Business of Being an Artist, Third Edition
by Daniel Grant (paperback, 6 x 9, 354 pages, $19.95)

An Artist's Guide—Making It in New York City
by Daniel Grant (paperback, 6 x 9, 256 pages, $18.95)

Business and Legal Forms for Fine Artists, Revised Edition
by Tad Crawford (paperback, includes CD-ROM, 8 1/2 x 11, 144 pages, $19.95)

The Quotable Artist
by Peggy Hadden (hardcover, 7 1/2 x 7 1/2, 224 pages, $16.95)

Please write to request our free catalog. To order by credit card, call 1-800-491-2808 or send a check or money order to Allworth Press, 10 East 23rd Street, Suite 510, New York, NY 10010. Include $5 for shipping and handling for the first book ordered and $1 for each additional book. Ten dollars plus $1 for each additional book if ordering from Canada. New York State residents must add sales tax.

To see our complete catalog on the World Wide Web, or to order online, you can find us at ***www.allworth.com***.